# *Alarms*

# *and*

# *Epitaphs*

# Alarms and Epitaphs:

## The Art of Eric Ambler

**Peter Wolfe**

Bowling Green State University Popular Press
Bowling Green, OH 43403

To

Henry Miltenberg

—whom the world's Keeney Brennans

and Stella Sweetings couldn't stop

# Contents

Acknowledgments      i

**Chapter One**
The Point of Danger      1

**Chapter Two**
Eric Ambler's Maze      17

**Chapter Three**
Marked Down for Action      31

**Chapter Four**
This Madhouse Called Europe      54

**Chapter Five**
Playing Ball with the Regime      83

**Chapter Six**
Enter Eliot Reed      117

**Chapter Seven**
Baiting the Trap      150

**Chapter Eight**
Echoes of Old Lies      176

Conclusion      216

Notes      219

Works Cited      221

Index      226

# Acknowledgments

The author wishes to thank those whose time and care, expertise and energy, went into the preparation of this book: Carol Moellenhoff, who handcarried the typescript from Warsaw to St. Louis; Marla Schorr, who typed and edited the final draft; Jules Silk, Veronica Koh, and Mark Madsen, who helped fill in the cultural background; Costa Haddad, Terry Jones, Chuck Larson, and Blanche Touhill, who helped organize a grant that sped the book's completion.

The combined help of the following people amounts to a major contribution: Bud Jamison, Gloria Henderson, Brenda Jaeger, Max Watson, Lois Pavell, Phoebe Reibstein, Richard Boardman, Joan Iris Kemp, Isaiah Hawkins, and Clay Dennis.

*N.B.* Please be prepared for the absence of documentation, within the text, for Ambler's novels, his most important work and the main subject of this book. This absence is appropriate. In hardcover alone, the novels have appeared in omnibus editions, in at least one large-print edition by Ulverscroft (five times), and under different titles in Great Britain and North America. Then there are the paperback reprints (in Great Britain by Pan, Fontana, and Oxford of Hong Kong; in North America by Bantam, Berkley, Atheneum, Carroll & Graf, and The Mysterious Press) through which Ambler is best known. These paperbacks can be carelessly produced. But besides containing many more printer's errors than the hardcover originals, they also go in and out of print so fast that they rule out the establishment of a reference upon which reliable documentation can be based. Let nobody complain, though—at least not now. I hope the speed, smoothness, and readability of my book offset what it loses in scholarly accuracy that isn't all that accurate or trustworthy.

# Chapter One
## The Point of Danger

Eric Ambler's first novel, *The Dark Frontier* (1936) opens in England but then moves to the Continent, unfolding in a made-up Balkan state called Ixania. After a short prologue set in London, Ambler's next work, *Background to Danger* (1937), shifts to Nuremberg and moves eastward to Prague. Another prewar novel, *Cause for Alarm* (1938), shows an English engineer working in Italy. This pattern holds, later works unfolding in Indonesia, Syria, and the French Antilles. Most of the important characters in them are multilingual. One, a half-caste Melanesian in *Send No More Roses* (1977), who studied in London and California, is also bisexual, while another is accused of being lesbian. Like their predecessors, they raise intriguing issues. Ambler is implying through them that living abroad muddles the instincts. This Jungian idea (the epilogue of *Dark Frontier* opens with a reference to Jung) fuels the notion that outsiders, like V. S. Naipaul and Paul Theroux, often assess foreign cultures keenly, but at a great psychic cost to themselves. Eric Ambler (1909) stands alongside both them and the older Graham Greene and Lawrence Durrell as one of today's most cosmopolitan English-language writers of fiction. He has always been fascinated with the way foreigners live. Many of them he finds in unstable places, eastern and western, tropical and temperate. Works set in prewar Smyrna, Sophia, and Belgrade or postwar Singapore and Istanbul describe the values, beliefs, and norms governing third-world lives caught between the converging shadows of big business and revolutionary politics. These works also describe the effects of this pressure upon the western visitor.

A reason for his malaise emerges quickly. Whether set in the Balkans, like *The Schirmer Inheritance* (1953), or in Indonesia, like *State of Siege* (1956), the Ambler books portray politicians who care more for self-aggrandizement than for social justice, reform, and human rights. Such leaders use the jargon of violence to dispose of their opponents. Meanwhile, they deny their followers freedom and democracy for allegedly the noblest of reasons. This denial is endemic. The torture and repression they justify in the name of stability finds a disturbing parallel in the world of banking. "A raw, brutal killer...becomes an accepted member of the highest level of legitimate society" (144), says Le Roy L. Panek of the title figure of *The Mask of Dimitrios* (1939), a critique of the ravages of free enterprise plaguing interwar Europe. Dimitrios's climb from the gutter to the executive suite is sped by the evils

1

inherent in capitalism, claims his left-wing creator. A Dimitrios with friends in high places is as logical an outcropping of free enterprise as are poison gas and the bombs that kill civilians in air raids. To protect yourself from this carnage, you need money and power. Dimitrios shows that drug-peddling, treachery, and murder can supply it. Not only will you escape enemy fire; like Dimitrios, you'll also direct a large investment firm and vacation grandly in the Swiss Alps or on the French Riviera, far away from falling bombs.

Despite his Marxist bias, Ambler withholds a simple resolution to moral chaos. Yes, Dimitrios dies, and his victims along the way have been as crooked as he; they die unmourned, too. What rankles is the way that greed and dishonesty have helped so many like them. Their very prosperity is a symptom of social dysfunction. Material interests outpace patriotism in Ambler. In *Background to Danger*, an English-based firm is trying to win concessions that will supply petroleum to Italy, England's enemy. Graham, the engineer-hero of *Journey into Fear* (1940), works for Cator and Bliss, the big English munitions firm that tried to secure the atom bomb in *Dark Frontier* for its own selfish ends. Graham explains his role as a merchant of death with the same breeziness as did his nasty predecessor in *Frontier*, *viz.*, that if he didn't produce the weapons used in war, somebody else would do the job. His carefree immorality carries forward in the Ambler canon. At the center of *Send No More Roses* is a Milanese investment banker who helps foreigners cheat on their income tax without breaking the law.

*I*

But much of this criminal activity is treated casually, Ambler moving his plots subtly and with a nice ambivalence. The cool, dry voice that suspends moral judgment comes largely from W. Somerset Maugham's *Ashenden*.[1] Maugham's 1928 work portrays realistically both the boredom and uselessness of spying. Foreign settings in it lack glamor and adventure. No James Bond, the field spy must practice a strict self-denial lest he and his mission both be blown. Nor can he afford the luxury of morality. Working in what Ambler calls "the sub-world of conspiracy, sabotage, double-dealing, and betrayal" (1965, 16), he must lie and cheat and also resort to bribery and blackmail. A detached, played-down literary style suits his regimen. Thus Ambler's practice of using dates for chapter titles in *The Levanter* (1972) and *Dr. Frigo* (1974) distances the corruption and violence the chapters describe. By suppressing style, Ambler follows Maugham in letting sordid facts speak for themselves.

Another important legacy from *Ashenden* is the nature of the spy himself. Whereas Ambler leaned leftward, earlier spy writers in England were right-wingers. Patriotism was their defining mark. Always fearing an enemy attack, they portrayed an Empire threatened by the Germans, the French, the Boers in Africa, and the Russians in Afghanistan. Defending the Empire was a gentleman-adventurer or hearty clubman like John Buchan's Richard Hannay or

Sapper's Bulldog Drummond. These old-fashioned patriots displayed unusual physical strength and nationalist fervor protecting not only England but also Christianity and the white race. Ambler questions the archetype by infusing his powers in an amnesiac (*Frontier*), a Soviet spy (*Background to Danger* and *Cause for Alarm*) and a Palestinian terrorist who fails to survive the one book he appears in, *The Levanter*. What is more, the Ambler hero is no bored adventurer seeking excitement. Henry Bristow of *Frontier* is an overworked physicist ordered by his doctor to rest. After being arrested for a crime he didn't commit, Josef Vadassy in *Epitaph for a Spy* (1938) can only clear his name by finding the real culprit. Or so he thinks. The police have already identified the culprit. Their threatening to deport Vadassy unless he helps them raises the question of how much a government may ask of its people during a national emergency. In *Dr. Frigo*, the title character is forced to treat the politician believed by many to be his father's killer.

His formal training puts Dr. Ernesto Castillo, a.k.a. Dr. Frigo, close to the highly informed logician-sleuth descending from Poe's C. Auguste Dupin. Other skilled, educated specialists are engineers like Nick Marlow of *Cause for Alarm*, Steve Fraser of *State of Siege*, Greg Nilsen of *Passage of Arms* (1959), and the tax avoidance artists of *Send No More Roses*. Even though none of these men detects, all of them belong to the English tradition of detective writing. Though Ambler's socialism ruled out the conservatism marking country house fiction, it didn't blunt his appreciation of the form's aesthetics. In fact, he wrote a series of detective stories under the collective title, "The Intrusions of Dr. Czissar," the hero of which, Dr. Jan Czissar, has moved to London after retiring from the police force in Prague. Little more than a brain, a sharp eye, and a few quirks, he solves cases by fusing erudition with the close examination of physical evidence. His intrusions consist of visits to New Scotland Yard in which he presents himself to an Assistant Commissioner Mercer, clears his throat, swallows hard, and says sharply, "Attention, please!" Then he solves the case (which will often involve poisoning).

Ambler's early novels embody some of the conventions of English crime writing. Besides modeling his first book on popular spy fiction, he also alludes in *Dark Frontier* to mainstream literary detection. The book refers to G. K. Chesterton's device of hiding a leaf in a tree (the convention of the least likely suspect). Then it shows its main character tricking someone into revealing the hiding place of an important item by fabricating the same kind of emergency as Sherlock Holmes did in "A Scandal in Bohemia." "Scandal" also provides the motif of the jut-jawed investigator moved by a woman for the first and perhaps only time in his life, the dark beauty Countess Magda Schverzinski stirring the heart of Conway Carruthers as Irene Adler did that of Sherlock Holmes. Ambler's next novel forsakes the influence of the cozy English mystery in favor of that of the American hardboiled story. Evil in *Background to Danger* isn't isolated but general, the profit motive contaminating all. Big business has both

infiltrated politics and hired sadistic thugs to squeeze information from kidnapping victims, as in Dashiell Hammett's *Glass Key* (1931).

Ambler may have found a better vehicle for his socialism in American *Black Mask* fiction, with its belief in widescale moral corruption, than in the sunnier English mode. Citing "the leftward leanings of Ambler" (47), Cawelti and Rosenberg explain, "In his prewar novels, Ambler was more of an anti-Fascist than a British nationalist, and this placed him close to Russia in sympathies" (106). Yet the 1939 Berlin-Moscow Nonaggression Pact destroyed these sympathies. What *has* remained intact is the influence of the English detective story, one that came to Ambler much earlier in life than the Soviet influence and was much more visceral than intellectual. In 1974, he wrote an appreciative introduction to *The Adventures of Sherlock Holmes* (London: Murray-Cape), and his prewar fiction shows an indirect but nagging awareness of the English mystery, as if he were trying to sink it. A world in which enemies look and act like friends and in which all causes are tainted rules out the soothing affirmations of the English detective story. Yet like the leftists Christopher St. John Sprigg and C. Day Lewis (as Nicholas Blake), he used some of the codes and conventions of this rearguard literary form.

His efforts to merge the cozy mystery with Marxist writ justifies Panek's belief that "Ambler is not a typical spy writer, even at the beginning" (140). Chapter 14 of *Epitaph for a Spy* finds the amateur sleuth Josef Vadassy approaching a criminal investigation in the spirit of Hercule Poirot: "the thing to do," notes Vadassy, "was to proceed on the assumption that every one of them [his fellow vacationers] was a liar and force them all into the open." Noting ourselves that Vadassy's many blunders omit the need for a Hastings or a Watson, we see later in the chapter another legacy of the English crime-puzzle. The working premise that nothing is to be accepted on face value and that nobody is to be trusted leads Vadassy to assign guilt to the Parisian André Roux. His defining Roux sexually inspires the prudish inductive leap, also found in Conan Doyle's "Musgrave Ritual," that loose sexual habits signal criminal tendencies: "There was a lithe precision in his movements; he was at once aggressively masculine and subtly feminine; probably he was a good lover." He's certainly a busy one. His constant practice of touching, kissing, and nibbling his girlfriend in public is what spurred Vadassy's suspicions.

The reductive equation of sexual indiscretion and criminal guilt continues to move the plot. More suspects will surface before Roux's guilt is established. As in the English country house tradition, many guests beside Roux and Vadassy are vacationing in the French hotel near which crime erupts. All have something to hide, and thus all are suspect. But only one is guilty. Determining his/her guilt will free all the others of blame and restore them to their normal lives. These lives, though grubby and furtive, aren't improved by the naming of the guilty party. Nor does the amateur sleuth outperform the police, who have stayed several steps ahead of him throughout the case.

The book's climax, which shows him together with a police inspector, also departs from crime-puzzle aesthetics. A chase in which the culprit is shot evading arrest replaces the verbal climax in which the sleuth sets forth the evidence in front of all the suspects and then names the culprit. But a disturbing sense of inconsequence blocks any satisfaction rising from the law's defeat of crime. A mere hireling, Roux dies without explaining himself, and the case against his chief builds off stage rather than in our presence. What we have watched—and what Vadassy risked his life provoking—is a minor development enacted by someone too small to change the world or be changed much by it. The finale of *The Mask of Dimitrios* adapts a legend of the English mystery story to its own purposes. Unlike the mortal combat of Holmes and Moriarty at Reichenbach Falls in "The Final Problem," the gunfight between Frederik Peters and Dimitrios in the book's last chapter doesn't show good and evil consuming each other, but two scoundrels—products of capitalism—enacting justice by shooting each other to death.

It is well that the scoundrels kill each other because the book's main character, the author Charles Latimer, probably would have botched the job. Like other Ambler heroes, Latimer is an educated, well-bred ineffectual, lacking both animal cunning and street sense. What he usually discovers in his quests for information is a brutality that threatens to swallow him whole. He does well to survive. In 1975, Ambler called his underlying theme, and he might have had Latimer in mind, "the loss of innocence.... It's the only thing I've ever written" (Hopkins 287); three years before, in a *Punch* interview, David Taylor said of Ambler, "He confesses to only one plot—the innocent abroad suddenly trapped into turmoil" (310). Now Ambler *will* send his archetypal figure abroad because people are less secure on foreign turf than at home. Lacking what is friendly and familiar, they must invent themselves anew every day, a violence that both eats away their reserves and exposes their fragility. Graham's discovery that a fellow passenger on his ship is plotting his death scares him more for occurring on the Bosphorus than it would on the Thames or even in the Channel. His fear drives out to the reader. We forget whether he's married or divorced or whether his failure to complete his job will harm England. Such considerations have vanished in the suddenly facing him.

Graham exemplifies the archetypal innocent caught up in a devious game who survives against odds. Hitchcock called the archetype a passive person to whom things happen. More acted upon than active, he gets drawn into a tightening net of intrigue nearly by chance (vii-viii). But, as in Elizabeth Bowen's *Death of the Heart* (1939) and Graham Greene's *Quiet American* (1955), which is discussed in *Passage of Arms*, innocence can destroy. James M. Cain spoke of the destruction the hero's "naivete leads to" (38) in *Passage*, and Michael Howell of *The Levanter* surprises everyone by shooting his persecutor to death at point blank range. Howell and his counterparts have a sense of inner emptiness which demands filling. All share a taste for adventure

and intrigue. By researching the life of a supposedly dead criminal, Charles Latimer also hopes to learn something vital about himself. His discovery consists of being terrified by imminent death. Innocent dabbling has evoked a danger that threatens to crush him. Desmond Kenton of *Background to Danger* also faces a danger he lacks the training, courage, and temperament to cope with. A stranger was murdered for some photographs now tucked in Kenton's pocket. Like him, as has been seen, Josef Vadassy of *Epitaph for a Spy* must prove his innocence by leading the police to the real culprit. Vadassy is also one of several Ambler heroes trapped between two menacing foes. In *The Light of Day* (1962), Arthur Abdel Simpson can't tell whether he has more to fear from a gang of thieves that have pressed him into service or from the police, who want to use him as an informer. The Levantine manufacturer Michael Howell gets caught between his country's Director of Industrial Development and a mad terrorist.

As in John le Carré, values and ties run in hidden grooves in Ambler. Who is on whose side? Which side is the right one? And who can be trusted? we keep wondering. Are we to sympathize with Piet Maas, the main figure and narrator of *A Kind of Anger* (1964)? At times he seems a cheat and a false friend. Then we think him an ordinary guy looking to make the best possible deal for himself in a hostile world. His counterparts in Ambler's other fiction share many of his traits. Sometimes, the archetype will miscue. A police inspector says to an amateur sleuth in *Charter to Danger* (1954), an Eliot Reed title that reveals Ambler's influence, even if he didn't help write it, "I think you should realize that these matters of detection are best left in the hands of the professional." This advice would help most of Ambler's heroes. After his arrest in Indonesia, Greg Nilsen of *Passage of Arms* hears from a foreign service officer, "Play the innocent. You shouldn't find that too difficult." Foster, the narrator of *Judgment on Deltchev* (1951), doesn't need to be rebuked by others for his folly. He scolds himself. In Chapter 13 he remarks inwardly, "I had behaved with the bumptiousness of an amateur... Mr. Foster was making a tiresome fool of himself. He'd better stop." One deterrent to free-lance investigating inheres, ironically, in succeeding. The amateur who unearths useful clues and leads can't imagine the ruthlessness of those who want the clues and leads kept dark. In a June 1977 article for *People*, Ambler discussed how innocent curiosity can ignite harsh reprisals in a world lacking civilized guidelines and norms:

His [Ambler's] books are marked by a concern for decent, ordinary people manipulated by powers over which they have no control. "The values we were supplied with as children are out the window," he says. "My heroes...can't cope. They demonstrate the truth of the saying, 'If you can keep your head when all about are losing theirs,' then you don't know what the hell is going on." (Ginna 95-96)

Knowledge doesn't bring power or freedom in Ambler. A doctor who blunders upon a printing press used to print anti-Nazi propaganda in "The Army of the Shadows" (1939, 1944) learns that his death is the best insurance the propagandists have against being arrested. Kenton in *Background to Danger* is told by his captor that he must die because he has seen and heard too much. The wife of a spy in *Cause for Alarm* who allegedly "knows more than she should" does die. Told, "You are too well informed," Foster of *Judgment on Deltchev* varies the motif by not knowing what information he has that makes him murderable. In any case, people like him, Kenton, and Mme. Vagas of *Alarm* would have protected themselves by taking their knowledge to the police. Sidestepping the law increases risk and deepens danger in Ambler. Does he wish it otherwise? Though he shows people hurting themselves by holding back from the police, a character in *The Intercom Conspiracy* (1969) complains about finding the device so often in books: "One of the things I can't stand [in a detective story]...is the character who gets trapped in a dangerous situation and is forced to run appalling risks simply because he didn't...go to the police when the trouble started."

This tongue-in-cheek disclaimer about his own narrative technique didn't stop Ambler from having his characters reject the help of the police throughout his whole writing career. Despite his witty self-rebuke, the device has served him well. One can see why. It distributes suspicion; it delays the solution to the crime; because an amateur investigator is likely to miscue and miscalculate often, it builds danger and suspense around him. It also fosters plausibility. Whereas Greg Nilsen's collaboration with the Singapore police wins him both justice and revenge in *Passage of Arms*, Desmond Kenton of *Background to Danger* acts reasonably by resisting an official link with a man who has killed for the photos that he, Kenton, is now holding. What he and Ambler's other heroes do, though, by shunning the police is to place themselves in the hands of others. And these others have motives of their own.

Many of Ambler's heroes wonder if they have leagued with a friend or a foe. In Chapter 9 of *Background,* Andreas Zaleshoff rescues Kenton from his persecutor, the sadistic Captain Mailler. But Kenton doesn't know if his rescuer is delivering him into a crueller bondage than the one he freed him from. The question keeps nagging at Kenton, since the enigmatic Zaleshoff sometimes acts like a crass opportunist and at other times like a concerned friend. In *Alarm*, Zaleshoff keeps helping Nick Marlow out of trouble, but trouble he steered Marlow into, to begin with. Luckier than Marlow or Kenton, Charles Latimer of *A Mask for Dimitrios* surrenders his will to that of Mr. Frederik Peters, an obese blackmailer and drug peddler whose plans for Latimer stay hidden most of the way. Latimer's observation, "Mr. Peters' capacity for making him feel a fool was remarkable," describes the survival of this outclassed, outmaneuvered man as miraculous. Just as lucky to survive is Graham of *Journey into Fear*. When he hears that a Nazi agent's offer to take him to a private clinic was really

intended to lower his guard and make him easier to murder, all that Graham can say of the offer is a feeble, "It sounded convincing."

His gullibility doesn't alienate us. Looking ahead to screen actors like Mel Brooks and Woody Allen 50 years later, the figure of the little man who matters won friends through Charlie Chaplin's Little Tramp, with his defiance of vested power, partisanship of the underdog, and, later in his career, political activism. The ordinary man caught in a web of events he can't understand or control recurred many times in the fiction of the 1930s, as is borne out by novels as different as *Miss Lonelyhearts* (1933), *The Last of Mr. Norris* (1935), and *The Grapes of Wrath* (1939). Like Steinbeck, Isherwood, and Nathanael West, Ambler learned quickly that, unless he took special pains, he could blur his characters' identity while moving them across a morally denatured landscape. He also learned that one of the fiction writer's hardest jobs is to impart human qualities to characters in motion, a feat Chaplin managed so well with his wistful but plucky Little Tramp. Thus Ambler linked his heroes romantically with exotic, mysterious beauties in *Dark Frontier, Journey into Fear,* and *Judgment on Deltchev* and in the Eliot Reed titles (which he wrote with the Australian Charles Rodda), *Skytip* (1950) and *Tender to Danger* (1951). He also endows his heroes with the sweetness of heart that draws them to female beauty. But, like Henry Fielding before him, he believes that sweetness must be tempered by prudence. An imprudent innocent, no matter how virtuous, always courts danger. Thus Kenton, thinking Linz to be as safe as London, is kidnapped, beaten, and nearly asphyxiated in the first half of *Background*, which ends with the disclosure that he's the leading suspect in a murder case. Poor judgment will heap woes upon the Ambler hero—or make him feel clumsy and stupid. A mocking smile that Josef Vadassy is rehearsing in a restaurant for an appointment with a policeman makes a waiter suspect that he served Vadassy tainted food. Arthur Abdel Simpson, the narrator of both *The Light of Day* (1962) and *Dirty Story* (1967), miscues so often that he angers all his associates. Yet as isolated, stony broke, and drained of freedom as he is, this mousy, stateless underdog defies and tricks his powerful chiefs.

He's not alone. Though duped and degraded, the Ambler innocent will usually show enough pluck to win half a victory. Latimer lunges at an armed Dimitrios. Graham defies his tormentor in *Journey*, even though he's at a disadvantage. Though he admits that the tormentor "had seen through him as if he were made of glass," he tells him, while looking down the bore of his pistol, "I have been seriously considering kicking your teeth in." Ernesto Castillo of *Dr. Frigo* responds to a threat from a local commissaire of police by hanging up the telephone. Though at their mercy, he interrupts and contradicts his superiors throughout the book. Near the end, he defies a would-be oppressor in his own lair with several of the oppressor's henchmen standing by. Finally, Michael Howell of *The Levanter* shoots the man who has just killed the captain of Howell's ship. Such displays of mettle, as with Chaplin's Little Tramp, impress

us all the more by coming from an underdog. No paid spy or superpatriot, the Ambler archetype reacts from decency when he holds his ground against violence. In fact, the threat of violence can even strengthen his resolve. When Kenton defies his torturer in Chapter 7 of *Background*, he's also setting the limits he won't exceed in order to keep his self-respect. To smirch these limits, he believes, is to forfeit his humanity. No threat is worth caving into if it means betraying the dignity that has been the slow, painful work of centuries of civilization:

It's not just a struggle between Fascism and Communism, or between any other "-isms." It's between the free human spirit and the stupid, fumbling, brutish forces of the primeval swamp—and that, Colonel, means you and your kind.

*II*

Ambler's grasp of sensory reality gives this struggle force and depth. Trained as an engineer, he stands firmly in the world of material objects. He's aware of their heft and texture, and he understands how they combine. Mindful, too, of their resistance to combine, he knows of their resiliency, their ability to withstand pressure, their sharp particularity, and the moods they evoke by keeping within their physical bounds. His mastery of details has impressed readers over the years. In 1977, Robert Emmett Ginna said, "The hallmark of Ambler's craft is a meticulous delineation of the background for each of his books" (96).

This background takes different forms. In *Dark Frontier*, Ambler speaks tellingly of chemical substances and their interaction. Technical details pertaining to the production and procurement of weapons help flesh out *Alarm*. In *State of Siege*, his knowledge of hydraulics helps him show how to remove standing water without the aid of gravity, as a character assembles a pump that dries a flooded basement. Someone in *Passage of Arms* protects a cache of weapons and ammunition from termites and mildew. Later, he will repair, spray, and paint the boxes in which the cache is stored to discourage theft. Delighting in mechanical process, Ambler also outlines the problems the character must surmount in handling and moving his cache over rough terrain. In *Dr. Frigo*, the expertise is medical. Ambler studied pathology, diagnostic techniques, and other medical procedures to lend grip to his 1974 novel. No mere scattering of details, the medical background of *Dr. Frigo* pervades the action. Part One includes a medical report that's logical and thorough, citing information about a patient's respiratory rate, blood pressure, and heartbeat. More impressively, the report also captures the clinical manner and tone of the attending physician. This physician, Dr. Ernesto Castillo, tries to transfer the same detachment and cool poise found in his medical reports to his narration. Not surprisingly, Roy Fuller singled out the book's "medical details" (1307) for praise in his *TLS* review.

Nor is *Dr. Frigo* Ambler's first foray into medical writing. In 1946, he published "The Case of the Emerald Sky," in which Dr. Jan Czissar solves a murder case by noting the different effects made on the body by sodium arsenite and copper arsenite. But Ambler's curiosity and his gift for documentation cover such a wide sweep that the inside knowledge one of his books will contain can't surprise us. Thus, whereas *The Levanter* furnishes the recipe for a wet battery, *Send No More Roses* describes the politics, economics, and legal risks of international banking. Such detailing imparts both technical expertise and conviction. Because Ambler writes with authority about business and science, he wins our trust when he discusses intangibles, like human feelings. Character, he knows, must focus any work of fiction; we have to care about what happens to the people. Whereas *some* detail lends a story solidness, too much distracts from the people and what they're doing. In January 1975 Ambler said in the *Sunday Times Magazine*, "Accuracy is important, but expertise can be boring....Yes, I include information, but not in great solid chunks. And never unless you can understand without it" (Amory 32). In his first novel, *The Dark Frontier*, he builds a high-voltage laboratory out of glass insulators, copper globes, rows of metal containers, and a switchboard. But the details gain emotional impact from being reported from the fraught standpoint of a person seeing them for the first time—the man who stole into the lab with the intention of destroying it. Ambler also told Joel Hopkins in 1975 that background was secondary to him; he didn't want to bury human issues under masses of detail. On the subject of setting, he voiced the same belief, warning that local color can detract from character, if given too much prominence (288).

His warning withal, he has been accused of overdoing his documentary gifts. Anthony Boucher complained that *State of Siege* was "less of a novel than a coldly illuminating textbook on political and military strategy in which the climate (literal and figurative) of Indonesia is of far more significance than the character and fate of the protagonist" (1956, 31). James M. Cain would have enjoyed Ambler's next novel, *Passage of Arms*, more had it sacrificed some of its detail to human interest in the form of adult feelings: "The detail throughout is superb.....And yet...things begin to sag early on.... Mr. Ambler apparently set out to master his background and wound up with its mastering him" (38). Cain and Boucher can be answered in the same way—by pointing out that both *Passage* and *Siege* unfold in the steamy tropics of the East, a clime where the heat, damp, rank jungle scents and screeching insects can both overpower the western visitor and inject a note of violence into all human transactions, whichever ones can survive the power cuts, food shortages, and street riots caused by political violence. Ambler merits praise rather than blame for showing how character subsists amid this oppressiveness. Character development would be not just irrelevant but even inappropriate in a context where insecurity and danger are the norm.

Cawelti and Rosenberg's *The Spy Story* attacks Ambler for a different

reason from Cain and Boucher. The atmosphere that Cain and Boucher found so intrusive and distracting Cawelti and Rosenberg find lacking. According to them, the Ambler books contain no scene painting, local color, or social ambience:

Eric Ambler's interest in the sense of place is remarkably superficial. He is seldom able—he seldom bothers?—to describe vividly even the exotic places where his characters operate....He must have felt that merely mentioning their exotic names would suffice to evoke an exotic and mysterious presence. (110-11)

From the start of his writing career, Cawelti and Rosenberg to the contrary, Ambler took special care to convey the spirit of his settings—and not only through landscape, architecture, and dress styles but also by means of the values and manners that make a place what it is. The imaginary Balkan republic where *The Dark Frontier* takes place has its own (Turko-Slavic) language, a topography, and a history. The buildings of Zovgorod, its capital, have both a western and a Byzantine flavor. Further variety stems from its racial mix; aliens of all sorts, but mostly Slavic and near eastern, have poured into Zovgorod because of its location—a valley through which plundering armies have marched en route to richer spoils. Problems in sewage and trash disposal have discouraged the modern foreign invader—the tourist—and, as happened so often in eastern Europe in the 1930s, efforts to boost tourism by improving sanitation have flagged. That the town's newest building, located on the main street, is also its ugliest spells out the vulgarity of Zovgorod. "The Chamber of Deputies," Ambler says, "an abominable affair in the neo-classic manner, scars the horizon at one end" of the main street, putting his metaphor ("scars") in his main verb. This deft usage, rare in a first novelist, both speeds sentence flow and provides a sharp sensory image.

The colorful world raying out from Zovgorod's tasteless Chamber of Deputies shows that, from the start, Ambler knew the dramatic potential of setting and worked hard to make good his knowledge. Pictorial and narrative elements continue to mesh in his work, regardless of setting. In his autobiographical *Here Lies* (1985), he tells of a stranger who said to him at a book club dinner, "You have a great sense of place" (11). The full force of this praise only comes through after we account for his outstanding range of setting. Each of his books provides a map of society and a system of local landmarks. A town in French-speaking equatorial Africa in *Dirty Story* has a main square, a network of roads and waterways, some churches, hotels, government offices, stores, and residential districts varying in social prestige. Thanks to his instinct for the dramatic, he first selects facts and then shapes them into a legend. All of his books, regardless of setting, create a society with a climate, heritage, and politics. Reviewing *The Schirmer Inheritance* (1953), C. Day Lewis said, "Mr. Ambler's familiarity with...the intestacy laws in Pennsylvania, the organization

of the Komitajis [a Macedonian terrorist band], and the postwar political set-up in Greece throws the glamor of reality over the features of romance" (5). To Charles Elliott, *Time* reviewer of *The Levanter*, Ambler can make a locale his own; he writes about exotic places so well that he becomes identified with them: "Nobody else is quite so much at home down there behind the Middle Eastern gasworks where the real horrors breed" (92). Priscilla Buckley brings the same warmth to her praise of *Dr. Frigo,* which is set, not in the Middle East, but in the Caribbean: "Ambler brings to his story the descriptive edge of a painter.....The tastes, the smells, and colors of the tropics, the dust, mosquitoes, and dirt...all play a part" (1475), Buckley said in *National Review.*

Years earlier in his review of *Judgment on Deltchev* (1951), Ambler's first novel in 11 years, Graham Greene summarized the artistry with which Ambler touched in background data of different sorts:

How cunningly Mr. Ambler builds up the political background of his imaginary state....We [also] get to know the geography of the unnamed capital, the boulevards, the villa residences, the government offices...and Mr. Ambler does this glancingly by chance references; description is slipped into the story a single sentence at a time. (50)

The subtlety and offhanded resourcefulness that Greene admires finds a voice that is supple, evocative, unmannered, and tuned to the immediacy of speech. Ambler writes about violence and distrust in the relaxed cadences often associated with the English public school man turned adventurer. The counterpoint created by this well-bred nonchalance serves admirably as a control. Though his plots presage the fast-paced, overheated international thrillers of Robert Ludlum and Tom Clancy, he keeps his tone clear, precise and well distanced. His prose, at its best, is simple, unaffected, and rhythmical. But not simplistic; though basically fixed and denotative, it does have poetic values. Already in *Dark Frontier*, his style, though uneven, showed distinction. The following paragraph, for instance, begins badly, with a cliché. But the unforced auditory images ending the paragraph reveal a level of stylistic accomplishment that both surprises and impresses:

Pandemonium broke loose. The whistles of the police and the aimless shouting of the crowd which immediately gathered were punctuated by the cries of the young men in the cart and the angry ringing of the tram bells.

The next passage, also from *Frontier*, shows accomplishment of a different sort, that of parodist. Making fun of the stiff self-importance of scientific prose, his version of an article printed in a scientific encyclopedia shuns active verbs, adopts a formal technical vocabulary, and piles on the verbiage. The use of an active verb, as Ambler well knows, would have cut the first sentence by two-thirds, as in "These conditions can change atomic

structure":

It has been shown that this change in atomic structure can be effected under these given conditions. In an experiment carried out recently, a charge with a pressure of one and a half million volts was built up in a succession of specially designed dielectric condensers.

Much of the fun emitted by this labored, hackneyed writing stems from the glimmers of recognition it awakens in all of us who have trudged through scientific journals or lab instruction manuals. Unfortunately, Ambler's dislike of the cliché doesn't always show in his editing. The phrase, "the fat would be in the fire," occurs twice in *Epitaph for a Spy* (1938), once in narration and once in dialogue, and a variant of it, "the fat's in the fire," is said by a character at the end of Chapter 12 of *Cause for Alarm* (1938). *State of Siege* (1956) includes the easily blocked "broke the ice" and "the game would be up," and *Dirty Story* (1967) forfeits some vigor by admitting the phrases, "bitten off more than we could chew" and "see what the score is."

But such stylistic flubs are rare. More often than not, Ambler's control and inventiveness muster a wide array of verbal effects. The 1963 book of essays, *The Ability to Kill,* for instance, shows a sure instinct for the ironic tag line. In the essay, "Dr. Finch and Miss Tregoff," Ambler says of a contract killer who reneges on his contract, "All he killed was a bottle or two of bourbon" (55). Just as tersely, he says of an L.A. County man who, after driving 600 miles without resting, killed his wife, "Then, the doctor went to bed. He had had a tiring day" (61). The comma inserted after "Then," though not necessary, captures playfully the rest that the weary killer craved at day's end; the stressed monosyllables after the comma recreate his plodding weariness.

This apparently effortless ability to build tone and mood sends us looking elsewhere for stylistic niceties. A part of speech Ambler uses with both flair and tact is the verb. In the following passage, active verbs placed in order of rising momentum get his second novel, *Background to Danger* (1937), off to a happy start:

One sunny morning in July, Mr. Joseph Balterghen's blue Rolls-Royce oozed silently away from the pavement in Berkeley Square, slid across Piccadilly into St. James's, and sped softly eastward towards the City of London.

Throughout his long career, this action writer has made danger vivid and immediate by describing rather than summarizing or explaining it. Let two examples suffice to display the skill with which he can convey the juddering physicality of a physical shock. The first example shows, through the first-person narration of *Cause for Alarm,* what it feels like to touch ground after jumping from a moving train:

The next moment the ground was flailing the soles of my shoes with astounding force. I felt myself pitching forward on my face and put out my arms to save myself. My legs strove madly to reach the speed of the rest of my body.

The next example, from the postwar *State of Siege*, describes the shock effects of an exploding artillery shell—again from the point of view of the person experiencing it:

Sanusi started to say something....At the same instant, there was a quick rushing sound. Then, the floor jumped, a blast wave that felt like a sandbag clouted me in the chest and my head jarred to the whiplash violence of exploding TNT.

The influences behind Ambler's style, outside of the dry understatedness of Maugham's *Ashenden*, aren't always apparent. Occasionally, an echo will sound, as in the Joycean first sentence of *The Ability to Kill*: "Word goes round outside the court that the jury is returning" (11). But such echoes are as rare as they are playful. Occurring more often in Ambler is the Conradian simile that concludes a person's discovery that his room has been broken into and ransacked. As in Conrad, the animal reference in *A Mask for Dimitrios* (1939) conveys both the discoverer's dismay over what he sees and his helplessness in dealing with it:

Strewn about the floor in utter confusion were the contents of his suitcases. Draped carelessly over a chair were the bedclothes. On the mattress, stripped of their bindings, were the few English books he had brought with him from Athens. The room looked as if a cageful of chimpanzees had been turned loose in it.

As in Conrad and Kafka, some of Ambler's descriptions catch us between fear and nervous laughter. In Chapter 6 of *Journey into Fear* (1940), Graham remembers a shooting victim who looked like a clot of blood spreading on the concrete beneath him—until the clot screamed with pain. Latimer's overheated psyche also transforms the strange into the fantastic. Gripped by fear as he awaits the arrival of the murderous Dimitrios, Latimer sees familiar textures and contours losing their configuration. "The silence," he notes with dread, "seemed almost intangible; a dark gray fluid that oozed from the corner of the room." Menace can also uncoil suddenly from the commonplace in Ambler. The following description of a contract killer in *Journey* uses parallel phrasing and a flat deadpan tone to counterpoint the mean, mousy appearance of the killer with his deadliness: "His appearance is crumpled and mediocre. He wears a shabby raincoat, has pouches under his eyes....His professional reputation is excellent." This tonelessness validates the terror gripping his intended victim; Graham's impending death has a matter-of-factness about it that makes him feel lost and hopeless. The passage also shows Ambler's ability to unleash terror without

raising his voice or resorting to sensationalism. This ability was noted by Tim Heald in the [London] *Times* in 1985: "Unlike cruder practitioners he [Ambler] can convey menace and fear without ladling on the gore" (9). In line with this preference for describing the psychology of dread over raw violence, Ambler writes books that turn inward. Most of the killings in his work take place off stage, and bodies rarely pile up. The first death shown in the 307-page *Levanter* (New York: Atheneum, 1972) comes on page 287, and nobody dies in our sight in *The Care of Time* (New York: Atheneum, 1981) until 15 pages from the end.

The understatedness that impressed Greene in *Judgment on Deltchev* has given Ambler's thrillers a human presence. Good thrillers resemble good tragedies by showing the speed with which trauma can invade and then overtake a person's life. And speed in Ambler grows from tautness or suspense. Knowing that the threat of violence is more dramatic than violence itself, Ambler will use fear as a motive. And because tautness depends on an imminent danger instead of on one that has already broken, Ambler will develop it by doing what he does best—conveying the physical and psychological effects of fear. Latimer is more vivid to us looking into the bore of Dimitrios's revolver than he is wrestling with Dimitrios on the floor. Once the physical struggle begins, melodrama takes over. Thus Graham seizes our attention when he discovers that he has accidentally stepped between a Turkish patriot and a Nazi spy determined to sabotage the naval preparations Graham is helping with.

### III

Ambler uses many of the conventions of popular adventure fiction: foreign intrigue, the motif of the chase, and gunplay. Yet he usually either plays down or discredits this influence. First, he rejects the simplistic drive to split the world into camps of good and evil. Tone in his books is not a function of fast-paced plots and glossy characters but, rather, of menace and incongruity. His giggle, pudgy fingers, and fringe of gray hair make Graham's protector look as harmless as his would-be killer. Graham's passiveness while these two are fencing hard for an advantage helps the action build around him. Now Ambler appreciates the manly virtues of leadership, quick thinking, and physical courage. But it suited neither his outlook nor technique to instill these virtues in his archetypal hero, a loner-outsider who does the bidding of others. Like a weekly television adventure, the Ambler books describe actions that have political, financial, and criminal ramifications. These actions warrant our attention. To a degree, they test characters morally and challenge their self-knowledge.

Perhaps they would impress us more if they did more of this—by conveying more insight into personality and possessing more human angles. Though well timed and clever, Ambler's work can suffer from thinness of invention; the issues the work addresses, one feels, could be framed with greater

complexity, intelligence, and feeling. They lack reach. But if an Ambler novel diverts more than it enriches, don't feel cheated. The creative intent behind it may have precluded enrichment, calling forth profundities only to slight them in favor of other, lighter matters.

"That's what I like; a rattling good yarn that takes your mind off things," says someone in *Dark Frontier*. The short last paragraph of *Epitaph for a Spy* shows Josef Vadassy glimpsing the roof of the Hotel Réserve, where he had just spent an anxious week, from the train taking him back to Paris. Then he says of the hotel, in the book's last sentence, "I was surprised to see how small it looked among the trees." The most dangerous interlude of his drab life is already receding from him. And from us, too? Vadassy's farewell to the reader, totally opposite to that of the tragic hero's, shows no enlargement of vision. Rather, it implies that the book we're finishing is merely a play of verbal strategies concocted to divert us. The reaction of a woman in Chapter Six of *The Mask of Dimitrios*, when told that Latimer writes detective stories, "You do not need to know human nature for that," also denies the importance of literary detection. Does Ambler agree with her? If his books don't celebrate or criticize life, they certainly go beyond diversion or entertainment. The throwaway brilliance of his best effects makes us wonder who is sending up whom. If he has detached his people from transcendent ideals, what is he trying to find in them, instead? More importantly, what is he trying to find—or perhaps hide—in himself? And why does he believe that his search, or smokescreen operation, tallies with the conventions of the thriller or spy book?

## Chapter Two
## Eric Ambler's Maze

It's when Ambler seems to slight himself as an artist that he must be taken most seriously. He tricked us into looking for something clever but lightweight at the outset of his career—by writing in a good-natured but somewhat limited fictional mode. Though spy novels may flow smoothly, they usually lack bite. Ambler's poise and nonchalance can give the impression that his writing needs to be criticized, refined, and worked over in order to achieve a stronger effect. Whether cultivated or not, this impression is misleading. Discrediting it is the idea, set forth by Cawelti and Rosenberg in *The Spy Story* (1987), that plot interests Ambler more than character. The idea has merit. Despite being observant, engaging, and sometimes funny, the Ambler hero holds our attention because of his shortcomings and ineffectiveness. He never transcends the plot into which he is dropped. Whatever success this man of paltry resources enjoys stems mostly from luck and the efforts of other people.

And whatever defining marks he possesses fade into the dangers that threaten his life. Ambler's intrigue novels stand as far from comedy as from tragedy. Perhaps our best comic novelist, Henry James, frees his people from work routine in order to challenge them with a variety of choices. The Ambler hero has no such options, at least for long. His situation rivets him. Within moments, choice will narrow sharply for him, and he'll have to jump (once from a moving train) in order to save himself. But the quick fix fails him. An Arthur Abdel Simpson of *The Light of Day* and *Dirty Story* will see his mistake; what looked like a way out of trouble has deepened trouble. And as desperation grips him anew, his instinct to survive crowds out everything else, particularly those refinements and shadings of personality that underlie moral development in a Henry James. The threat of danger and death makes such nuances irrelevant.

Obviously, Ambler isn't using the structural conventions of intrigue fiction to support bigger themes; no parlor trickster, he. Yes, his people lack mystery. He favors action and plot. Dialogue and physical detail replace analysis for him. His language usually sacrifices poetic nuance and ambiguity to straightforward exposition. Yet his flat narrative surfaces give off dark traces. What you see in Eric Ambler is less than what he says. Beneath the simple reported action of one of his books lie obscure imperatives. His work expresses his deepest sense of life. Let's go behind the veils to see how. To understand

**17**

how he injects subtlety and complexity into a genre usually dismissed as literary escapism, we should turn to an article called "A Better Sort of Rubbish" that he wrote for the *Times Saturday Review*. Subtitled "An Inquiry into the state of the thriller," Ambler's 1974 article claimed that younger contemporaries of his like John le Carré and Len Deighton surpass the earlier spy writers William Le Queux and Sidney Horler. The qualitative difference between the two sets of writers is one of inventive power: "What holds you in a good thriller is what holds you in any other good novel, the originality and interestingness of the author's mind and vision" (8). Having voiced this belief some forty years after breaking into print, what has Ambler done over the decades to convert it into practice?

*I*

Narrative excitement in Ambler stems from several different sources. One of these is his conservative morality, a slant of mind that usually expresses itself clearly and predictably. Borrowed money goes unreturned; avoiding the police when crime threatens you will deepen your distress; criminals betray each other, sometimes to the police, for personal gain, self-protection, and spite. Falsehood compounds in Ambler, too; trouble can never be lied out of. Graham of *Journey into Fear* shows dishonesty rotting all that it touches. "His business was to stay alive," he muses in Chapter Eight; "Six weeks on the Ligurian Riviera could not do any harm. It meant lying, of course," but not to just anybody: "lying to Stephanie [his wife] and to their friends, to his managing director, and to the representatives of the Turkish government." Graham enacts Ambler's belief in the contagion of falsehood. He is preparing to lie to the people he defines himself by, his closest intimates and paymasters, for the sake of his bond with a Nazi spy who is planning to kill him. This man can't recognize his best interests, let alone act on them. What he has overlooked is how much more his Nazi would gain by killing him than by hiding him in the Ligurian Riviera near Genoa. Graham is even helping the Nazi Moeller kill him. Were he suffering from typhus, as Moeller plans to tell the harbor officials, the law states that he'd have to take his complaint to the Italian medical authorities. Telling a lie has stripped Graham of his ability to protect himself.

Graham's gullibility touches on another principle of self-protection, seen again in *Background, Epitaph,* and *Dirty Story*: don't league with anyone stronger than yourself; the powerful will change the terms of your bond if doing so helps him. When Simpson joins a so-called mining and metallurgy group in *Dirty Story*, he and his colleagues hear from their commander that they're "in no sense members of a military...or paramilitary organization." Yet once the men reach their duty station in Central Africa, they're told that the area they've been hired to guard can't be guarded before it's seized. The assignment first undertaken as a business operation has become a military one. Simpson and his

friends are too far from civilization to defy their chief. Though they all incline to mutiny, they do as they're told—mount an armed invasion they lack the training and will to carry out.

Ambler shares the confusion and the anger of his Simpsons and Grahams. And his malaise pits the calm surfaces of his books. In the best thrillers, plot unfurls effortlessly, drawing us along and involving us ever deeper into the pattern of deceit. So smooth and easy is the process that it goes unnoticed. Yet thrillers also need touches of perverse comedy to challenge their shapeliness and urbanity of design. This imperative will prompt Ambler to lace his work with an apparent irrelevancy or *non sequitur*. Also imparting a film-noir subtext to his writing is a fascination with the dark side of humanity. Grotesques recur in his books. *Background* includes a coquettish, perhaps sex-mad blimp who also has a medical degree. Then there is the fat crook, Frederik Peters, of *A Mask for Dimitrios*. When Peters sees a pretty woman drive away, he wonders about her, but only briefly: "I prefer the million francs" to spending time with the woman who delivered the money, he adds quickly. In the two years that lapsed between *Background* and *Mask*, Ambler may have decided that crime blunts the sexual drive in the overweight.

More disturbing than his occasional attraction to grotesques is a deep, albeit usually hidden, sadistic streak. Going beyond the idea that spying is violent, much of his work discloses a relish for torture reminiscent of Rudyard Kipling and Peter Cheyney (1896-1951), British creator of the hardboiled FBI agent, Lemmie Caution. The sadism that has never been wholly absent from Ambler erupts in his first two books. *Dark Frontier* shows a man tied to a chair being smashed repeatedly on the knee cap with a rubber truncheon. Along with the screams of the victim, Ambler's knowledge of anatomy enhances the horror of the scene. Physical cruelty again imparts a salt edge in the chapter where the truncheon-wielder, who is called "necrophilitic," cracks his screaming victim's collar bone and where, later, his chief threatens to crush two intruders under a slowly descending ceiling, as in Wilkie Collins's "A Terribly Strange Bed." The Ambler of *Frontier* cared enough about torture to keep returning to it. Though his earlier description of the death agonies of a man trapped on an electrified fence shows restraint, its very inclusion in *Frontier* attests to Ambler's fascination with pain. Torture can occur outdoors as well as in, and it can torment people in pairs or on their own.

In *Background*, it takes on a raw sexuality. With sadistic glee, Kenton's torturer punches, shakes, kicks, and saps Kenton with his phallic truncheon; Mailler's relish in Chapter 8, called "The Truncheon," resembles that of Jeff, Shad O'Rory's brutal henchman, in Hammett's *Glass Key* (1931):

Kenton looked at Mailler's face. An unpleasant change had come over it. The jaw had dropped slightly, his cheeks were sunken, he was breathing rather quickly and kept darting little sidelong glances at Kenton with eyes that had become curiously glazed.

Already rather frightened, Kenton began to feel an almost hysterical terror stealing over him.

The hideous and the grisly suffuse the book. In Chapter 16, a tied-up Kenton bounces and rattles helplessly on the floor of a speeding car while being driven to the cable factory where his enemies plan to suffocate him inside a sealed tank. He must die for reasons familiar enough in Ambler; he has seen and heard too much. What is excessive is the torment Ambler puts him through. The factory containing his presumed death tank has in it "a long row of curious machines looking in the gloom like huge crouching insects." It's almost as if Ambler were torturing Kenton to compensate himself for letting Kenton survive the sealed tank ordeal, a requirement of the plot. A more gratuitous form of torture occurs in *A Kind of Anger*. In this 1964 novel, a weekly magazine printed in France runs a news story in which a man is tortured before being shot: "The state of the genitals left little doubt of it."

The persistence of cruelty in Ambler, together with his preference for weak heroes, shows him groping for an identity both solid and masculine. His making so many of his heroes engineers confirms this engineer's kinship to them. The heroes of *Cause for Alarm, Journey into Fear, State of Siege, Passage of Arms,* and *The Levanter* are all engineers, as is Manual Villegas, who dies minutes after becoming his country's President in *Dr. Frigo*. Ambler's killing off this sickly engineer before he can enjoy his political spoils recalls the painful ordeals he visits on his other engineers. The engineer-heroes of both *State of Siege* and *Levanter*, for instance, must repair faulty machines belonging to power-mad revolutionaries or they'll die. The death threat facing them tallies with other hardships involving engineers in the canon. Nor is the engineer always hardship's victim. The first killer discussed in the nonfictional *Ability to Kill* (1963), J. C. Haigh, who dissolved his victims in sulfuric acid, was English, like Ambler. He was also born in 1909, and, though no engineer himself, had an electrical engineer for a father. Though questionable as evidence, both the resemblances between Haigh and Ambler and the trouble Ambler takes to point them out imply the same self-questioning and self-criticism featured in the fiction.

Among other things, they help spell out his rejection of technology as a way of both explaining and interacting with the world. It is as if the technician has forfeited male maturity. To Ambler, technology and science both fail to test the self. The comment in *The Ability to Kill*, "There's a criminal and a policeman inside every human being" (142), applies to the split in Ambler's psyche between the engineer planted at his desk and the creative writer who travels the world finding subjects to write about. Though sometimes countersupporting, these two sides of Ambler war against each because his appetite for danger is at odds with the safe cerebral activity of the engineer. The persistence of this clash in his work indicates, if not self-contempt or an

impatience with self, then an extended sigh of relief for having left engineering. Typically, the engineer-hero in Ambler travels to a foreign country and makes a mess of things. Not that advertising, fiction-writing, and film-making, other work Ambler has done, offers richer rewards; writers in *Judgment on Deltchev, A Kind of Anger*, and *The Intercom Conspiracy* and people who work on films in *The Light of Day* and *The Care of Time* also suffer. The author of books with titles like *Dark Frontier, Background to Danger, Cause for Alarm, State of Siege*, and *A Kind of Anger* wants a rougher, wilder encounter with life than a desk job offers, especially if the desk sits in a scientific laboratory. The formalized discipline and control undergirding scientific method distorts the moral perspective. Ambler's first and last novels feature mad scientists, both of whom use science for destructive ends. Both Jacob Kassen's physical ugliness and his lechery in *Frontier* spell out his unfitness; the great power enjoyed by the Arab ruler who wants to experiment on human subjects with nerve gas in *The Care of Time* (1981) invokes the dangers of dovetailing science into the making of public policy. At best, science offers a false security; at worst, a rationale for implementing cruelty and other forms of moral chaos.

Ambler's treatment of the scientific achievement that may have touched more westerners than any other, the automobile, reflects this suspicion and anger. Forming another pattern, his first and last novels have identical dramatic climaxes—a car chase resulting in violent death. Cars invoke our mortality elsewhere in Ambler, too. The autobiographical *Here Lies* (1985) begins with a car wreck, c. 1952, on a strip of highway between Geneva and Zurich. A faulty exhaust system lulled Ambler to sleep in his new car. As if opening what may be his last book with a near-fatal car crash didn't voice some distrust of cars, his first answer in his 1975 *Journal of Popular Culture* interview with Joel Hopkins was, "I used to steal cars" (286), and the second essay, called "The Reporter," in *The Ability to Kill*, discusses the theft of his own car (38-44). In addition, a French illustrated weekly displayed in the first chapter of *A Kind of Anger* depicts a naked woman driving at high speed down a mountain road; it later comes out that her mother, a passenger in the car, died in the ensuing crash.

This fatal wreck conveys the same lesson as the mad scientists of *Frontier* and *The Care of Time*. Based upon a rigidity of method that opposes our primitive destructive instincts, scientific endeavor whets those instincts and sends them out of control. People keep misusing this blind amoral force. Otherwise the car, popular symbol of scientific advance in our time, wouldn't keep damaging people. Three car abductions take place in *Background*, while *Journey into Fear, The Intercom Conspiracy*, and *The Care of Time* all include one. The prologue of *Cause for Alarm* shows an English engineer in Milan getting killed by a charging car. Though no automotive engineer, the ordnance specialist Graham of *Journey* has only one name, suggesting a half life. Known only as The Ruler, the sadistic Arab leader of *The Care of Time* has no name at

all that we're told.

A much more sympathetic scientist, Marlow's doctor-fiancée in *Cause for Alarm* is much more accomplished, earns more money, lives better, and enjoys more social prestige than he. And although he performs well enough, he must do it in danger-ridden Italy and Yugoslavia rather than in England, where Claire lives and works. Moreover, his reward for surviving danger, marriage, never occurs within the text; we never see him attain the clarity symbolized by union with Claire, the book's representative of domestic joy and avatar of healing.

This omission is intentional. And Ambler invited us to think about it because he sees the frustration it suggests ruling the world. And, more's the pity, its source is malignancy rather than indifference. Not only do crime and war give cause for alarm; the impulses behind these depredations often connect to the sea, life's cradle. Graham's four-day journey into fear is a sea voyage. Both the gunplay that explodes on a ship near harbor at the end of *The Levanter* and the rockets fired from a pleasure launch at the villa where most of *Send No More Roses* (1977) takes place emit a darker meaning—that the shoreline, the margin between the civilized and the raw, the solid and the fluid, crawls with dangers. Ambler might have an engineer's preference for the stable, the tangible, and the secure. Note the following conceit from *Journey*. Disoriented and anxious while sailing on the Bosphorus, Graham observes, "Amid the flood of questions pouring through his mind there was only one patch of dry land." The sea stirs another association with danger in Chapter 9 when a terrified Graham hears that he's safe so long as he remains shipboard. Ironically, the person he hears this from will next appear as a corpse, stabbed to death in his cabin while the *Sestri Levante* is still at sea.

A fear of the sea, and perhaps of life itself, flickers over Ambler's career. Besides describing the sea as a source of menace in his books, he also adapted Jacques-Yves Cousteau's *The Cruel Sea* (1953) to the screen, and he scripted the films *A Night to Remember* (1958) and *The Wreck of the Mary Deare* (1960), which both feature ocean calamities. Like Charles Latimer of *The Mask of Dimitrios*, he tests his manhood by inviting danger. This practice could well take root in his including in *Here Lies* his recollection (if it ever happened) of a young lady's asking of him to a friend, "How big do you think his prick is" (36)? The question may have induced in Ambler a doubt of his maleness. Just as Latimer turned from writing crime stories to real-life crime, so does Ambler keep revisiting the hidden violence of the immortal, rolling sea. (The violent dramatic climax of the Eliot Reed title, *Tender to Danger*, also occurs on a barge.) Having spent most of his career at a desk, the sedentary Ambler has probably never satisfied his primitive urge for male power. His discrediting of high-tech artifacts, like international communications systems, in his late books carries his urge forward. The narrator of *Send No More Roses* finds truth so elusive that those who pretend to have it can't be trusted:

I happen to be one of those who believe that the ability to tell the whole truth about anything at all is so rare that anyone who claims it...should be regarded with the deepest suspicion.

Even the best surveillance systems forfeit our trust. The narrator says later in the action, "They say dialed calls are hard to trace, but that was last year. Who knows how hard or easy it may be now?" Technology keeps outpacing and diminishing the human factor. People can't keep up with advances in artifacts. But ironically, they're just as well off, judging from the violence climaxing the novel. As in Ambler's earlier work, technology makes no one in *Roses* happier or wiser; it only creates clever new ways to get money and power. This windfall soon confuses and divides. That the book's last two scenes unfurl in islands describes its separating effect. Ambler's manhood, meanwhile, starves for outlets.

Having rejected technology, Ambler shows signs of looking for truth in the spirit world. Paz, a shrewd Caribbean masseur in *Dr. Frigo*, practices witchcraft, or "the old religion." Though Ambler never explains, he encourages us through dramatic incident to yoke Paz's wisdom to his religious beliefs. This dark wisdom generates power in *Roses*. Sorcery has helped the half-caste Melanesian Mat Williamson more than his formal training at the London School of Economics and Stanford. At novel's end, he has returned to Melanesia, the part of the world where he learned to cast spells. An added fillip to Ambler's denial of technology as a way of knowing and enjoying the world consists of his showing the voodoo-man Mat as his island nation's ruler. Mat is the book's only surviving character who prospers materially for any time while keeping close to his roots.

To support the idea that Ambler has supplanted technology with the primitive, one can look again at his fixation with the sea. Also germane is the prominence of teeth in *A Kind of Anger* and *Roses*; both books contain characters whose outstanding physical feature, according to the books' narrators, are their big white teeth. This apparent incidental could reveal a great deal. Orality is the earliest phase of sexual adaptation in Freud; also, Ambler seems swept increasingly backward into our precivilized heritage as he ages and, ironically, as his technique refines. On the subject of early influences, *Here Lies* says little. Judging from this wayward autobiographical memoir, no cloud from his early childhood darkened his adult life. His childhood home doesn't seem to have cheered him much, either. His father played several musical instruments, did magic tricks, and worked marionettes. He and his wife, as Reg and Amy Ambrose, danced and gave concerts in churches, music halls, hospitals, and army camps. But even though Ambler played the piano himself, music and theater hardly exist in his books. And neither does family life, Ambler all but ignoring marriage, parenting, and the sexual tie.

The intimate relationships he does show bypass the redemptive power of

love. The main characters of *Frontier, Epitaph,* and *Mask* are all bachelors who spend little time with women or family members while in our company. Simpson of *Light of Day* and *Dirty Story* spends little time with his wife, period. Colonel Jost of *The Intercom Conspiracy* (1969) is a childless widower; the founder of the *Intercom Newsletter* in the same book has a once-mentioned daughter in Baltimore. The men who live with *their* daughters in *Conspiracy* and *Judgment on Deltchev* don't fret when their daughters pair off with younger men and leave the nest. In *The Levanter,* the title character, Michael Howell, is already alone, Ambler having sent his wife and children away for the summer so they won't interfere with the book's plot. Also whisked from sight are the immediate family members of Dr. Frigo; Castillo's parents are both dead, and his sisters have gone to live abroad with their foreigner-husbands. Carlo Lech, a big international swindler in *Roses,* has a son who "disappointed [him]... profoundly by going into the Church." But the defection pleased Ambler, whose fictional interests exclude domestic realism. Thus many of Castillo-Frigo's meetings with his lover Elizabeth are summarized. The few that unfold before us do so in the presence of a third party. Obviously, the Ambler canon offers few insights into either the everyday plod or the passionate outbursts of erotic love. The sex that takes place in *State of Siege,* a mere plotting device, vanishes from the memory of the book's hero, Steve Fraser, a moment after he tells Rosalie goodbye; the two researchers who have sex in *Roses* do so because nearly all healthy, attractive people between ages twenty and forty in British and American novels of the 1970s were also jumping into bed together.

Much of the flatness of Ambler's presentations of sexual closeness inheres in the vapidness of his women. Either shadowy and thin or vulgar and melodramatic, his women lack the dimension of his men. Graham's wife never appears in *Journey,* and the woman he spends time with instead is a sultry nightclub dancer whose actions are governed by the plot. *Skytip* (1951), the first of the Eliot Reed titles Ambler wrote with the Australian Charles Rodda (1891-?), offers insight into the predictability of Ambler's women. The book's hero, Peter Ackland, riding a train between London and Cornwall, refers to "the cooped-up torment of the long journey" (208). Earlier, he had spoken of the westbound train as having "a tearing urgency, ripping out into the country, throwing off the untidy skirts of London" (201). Speed, energy, and the freedom of open country all yoke male force to defiance of the female. What is unclear is why the female needs to be defied. And what turns the rampaging male force of the train into a "cooped-up torment" later in the trip? No female passenger shares Ackland's compartment with him; no residue of perfume hangs in the air. Other passages in Ambler incorporating female sexual symbolism cause the same confusion. The dark, clammy vulcanizing tank enclosing Kenton and Zaleshoff in *Background* seems like a female sexual symbol. But the people who shut Kenton and Zaleshoff inside it are men. Foster

is locked twice inside rooms in *Judgment on Deltchev*. Although his fears and his dizziness both suggest entrapment inside the claustral womb, no seductress lured him anywhere and locked the door behind him.

The female as siren or madonna is always outshone in Ambler by the father. Based on the angry, punishing Victorian father who demands strict obedience, this authority figure stands forth most boldly in the two Arthur Abdel Simpson books. His most powerful incarnation is the schoolmaster. Though in his fifties, Simpson still cringes at the memory of his college schoolmaster threatening to cane him for misbehavior. The schoolmaster's Englishness heightened his ability to cow this lad with an Egyptian mother. And so did the Englishness of the lad's father, together with his status as a British Army sergeant. Simpson still enjoys quoting his father on a variety of subjects, and he never quarrels with his pronouncements. Having retained a boyhood admiration for colonial adventure, Ambler seems impressed with him, too. But he tries to hide his lingering fondness for this Victorian legacy. The swindler, Captain Henry Lukey of *Passage of Arms* (1959), works his will upon Greg Nilsen, an American engineer in his forties (Ambler had just turned fifty when the book was published) because of his pukka-sahib nonchalance. Ambler's making Nilsen American doesn't mask his own vulnerability to the wiles of the English colonial adventurer, regardless of his transparency. The father figure who can't be denied pervades the entire canon, with Ambler represented symbolically as the *puer aeternus*, or eternal boy. Despite his anger, the son buckles and folds when he collides with the paternal will. An anecdote included in Oscar Levant's *The Unimportance of Being Oscar* (1968), but, curiously, not in *Here Lies*, sheds revealing light on the roots of this submissiveness. Note Ambler's age at the time of the anecdote, 12 or 13, a time of life usually marked by the first stirrings of individuality. Of at least equal import as his age is the material object his father used to bilk him of the chance to define himself—the phallic motorcar:

In 1922 [Levant says] his father suddenly bought a motor car. It made Ambler furious at the time. The reason for his rage was that his father spent the money which had been put aside for his tuition in school. It still makes him turn purple. (176)

The symbol of all that is wrong with life and all that has damaged Ambler thus refers to the father. His fiction revisits the helpless rage he felt at age 12 or 13. What the father wants, the son enacts, no matter how wild the demand. In *A Kind of Anger, The Intercom Conspiracy*, and the two Simpson books, a powerful surrogate assigns the captive son a mighty task, failure at which includes loss of job or home, statelessness, and, perhaps, violent death. This Kafkaesque motif recurs in *State of Siege* and *Levanter*, the heroes of which must perform engineering feats outside their areas of expertise—or die. A comparison with the father-ridden Kafka is again apt. As in "The Penal

Colony," a regime will sacrifice a functionary to help itself. It matters little that the regime may not be duly vested or that its victims are outsiders. Steve Fraser and Michael Howell obey orders given by rebel leaders with near absolute power, like the headstrong father who cheated his son out of an education in order to preen his ego with a new car. (In *State of Siege*, the leader is wearing a military uniform and has military rank.) Patriarchal supremacy has again crushed the son.

The canon includes many other examples of the paternal archetype causing the son's disintegration (the phrase, "playing ball with the regime," recurs several times in the later fiction). Josef Vadassy of *Epitaph* must work for the police or have his application for citizenship revoked; Ernesto Castillo or Dr. Frigo will be stopped from practicing medicine unless he agrees to treat the politico who may have engineered Castillo's father's death. That legacy of Kafka, the father who makes wild demands, dominates the Simpson books. By sending Simpson's fragile spirit back to his troubled boyhood, the book's various father figures awaken the sense of inferiority drilled into him as a half-caste fatherless schoolboy in exile. His bitterness toward authority, especially British authority, can't fuel an effective rebellion. His flesh will always smart from the canings his headmaster at Coram's gave him. "Persons in authority—headmasters, police officials—can do a great deal of damage," he mutters to himself in Chapter 1 of *Light of Day*. Yet authority figures rivet this cheap crook. When his much-younger wife is pleased with him, she rewards him by calling him "Papa." And if he can't win the paternal initiative for himself, he searches out others to confer it on.

Looking to be led, he falls in quickly with the big-time racketeer called Harper. Perhaps he approached Harper in the Athens airport to begin with because his instinct told him that Harper was a crook and thus an enemy of the phallo-centric establishment. More likely, he was looking to relive the shame, humiliation, and physical punishment of school ("The worst thing at school was being caned," he says in Chapter 2). A Harper will reinforce the inferiority complex that he has always taken for granted. Anyone who threatens him with the symbolic cane can control him. After hearing the security regulations imposed on him and his fellow mercenaries in *Dirty Story,* he says of his commanding officer, "He was like a bloody schoolmaster." But his anger spurs no rebellion; as always, the schoolmaster is obeyed.

It doesn't matter that he is old, feeble, or sickly; he needn't even survive the book in which he appears. In all cases, he stops the son from developing positive social attitudes and attaining full emotional growth. The son often resents his own failure to defy the father more than he does the father himself. In the snowy Balkans of the Eliot Reed work, *The Maras Affair* (1953), the political boss is dying, as he will be in *Dr. Frigo*, a work set a generation later and more than an ocean away in Latin America; in *The Care of Time*, he's mad. But in each case, he sinks the protagonist-son. *Maras* makes the defeat sexual.

The similarity between the front name of old Anton Maras and that of his daughter Anna, like the word *Affair* in the book's title, implies in Anna's tie with her father an intensity beyond any she could experience with Charles Burton. Only after her father dies does she agree to leave her corrupt, depleted country and let Burton take her to America. Ambler, meanwhile, remains locked in a losing battle with the mighty dead, building his novels around ineffectual men and relying upon *dei ex machina* to resolve his plots. The father needn't occupy the throne; all that is necessary to thwart the son is that the throne be darkened by the father's shadow.

Perhaps the Berlin-Moscow Nonaggression Pact of 1939, by souring Ambler on Marxism (*Here Lies* 153), both killed his faith in humane leadership and reinstated the treacherous image of the father using the son's tuition money to buy a car. Zaleshoff, the heroic Soviet spy of *Background to Danger*, disappears after *Cause for Alarm* (1938); the Ambler canon would feature no Soviet series hero. *Judgment on Deltchev,* Ambler's first novel in 11 years, centers on a Stalin-type trial taking place in an Iron Curtain country that hasn't known justice or freedom for decades. Ambler's failure to find an ideology to replace Soviet Communism may have stunted him artistically while starving his soul. Though his postwar fiction differs in ways from the works he published between 1936-40, his protagonists continue to yield to the paternal archetype. The buffoon-like picaro Simpson and the withdrawn Dr. Frigo, different as they are, both fall as short of an assured male maturity as Henry Barstow, who appears last in *Dark Frontier* as a hospital patient, and Charles Latimer, who is last glimpsed in *Mask* sitting alone in a moving train and wondering why his recent ordeal is already losing meaning for him. Ambler restores Latimer in *Intercom Conspiracy* in order to kill him. That he never appears alive in the book represents one of Ambler's most effective protests against the son's failure to grow up. A youth who flubs his initiation rites forfeits passage into manhood. A man who has waived maturity loses the right to exist on the page where he can be seen.

## II

If this man does appear, he's usually adrift and anxious. Symbolizing life's frightening confusion is the hotel where Kenton stays amid the narrow, squalid streets of Linz, Austria. Looking for his room in Chapter 3 of *Background*, he notices "a maze of small corridors in which doors were set at unexpected angles and [in which] culs-de-sac abounded." Even the countryside in Chapter 9 throws up "a maze of large, straight tree trunks." The Paris that greets Latimer in Chapter 10 of *Mask* is just as menacing. Noticing a bank of low, black thunderheads rolling into the city, he passes a "still and secretive" row of houses, each window of which seems to hide a watcher. This menace can overwhelm. Nick Marlow talks in *Cause for Alarm* of "a journey through a country of fantastic confusions and strange images." The lonely streets, train

stations, and hotels where the early chapters of *Background* unfold make homelessness and insecurity staples of modern life, an idea that Ambler reinforces by using chapter titles like "Linz Train," "Room 25," and "Hotel Werner." Logically enough, just when Kenton begins to get his bearings in Linz, a stranger steals into his hotel room and knocks him out. This motif is one of Ambler's favorite ways of describing the danger that hedges us all. The hero's living space is invaded and ransacked in *Dark Frontier, Epitaph, Mask, Journey, The Schirmer Inheritance*, and *Tender to Danger*. Armed rebels break into the hero's quarters and claim it for themselves in *State of Siege; The Levanter* shows the hero being tied up and kidnapped in his hotel room; more quietly, in *Care of Time*, the hero returns to his hotel room to find some high-level security officers waiting to talk to him.

The years have darkened Ambler's pessimism. The benign, or at least ambiguous, rescuers in the early work damage the later Ambler hero and make deeper cuts into his psyche. Perhaps a crucial turn in Ambler's outlook comes in Chapter 5 of *The Levanter*, where a music box is described with great exactitude before being shattered by a bullet. This symbolic death of harmony, and, because Ambler's parents played music, of the security of childhood, recurs on the Table of Contents page of his next book. The three parts of *Dr. Frigo* are called "The Patient," "Symptoms, Signs and Diagnosis," and "The Treatment." The hospital setting for the book's first scene underscores the idea of a sick society. But the social discord heralded by the exploding music box in *Levanter* unleashes a greater danger than that of the 1930s. Dark enough on their own, the six books Ambler published between 1936-40 send out scant hope other than through the Marxism he soon abandoned. The grimmest and best of the early books, *The Mask of Dimitrios*, divides effort from event. The retired Polish master spy Grodek gets less than he expected when an elaborate, weeks'-long operation nets him nothing. All that remains for this empty-handed man to do is to protect his reputation in the spy community; thus he stops his former accomplice Dimitrios from profiting from his treachery by explaining it to the police and making obsolete the naval secrets Dimitrios stole from him. The title of the book's last chapter, "The Strange Town," reinforces the impression that life is a jungle where justice means little and where the civilized graces are merely ruses to distract would-be victims.

The jungle negates the hero's expertise and derails his undertakings. Ambler's fictional world is light years away from that of Ross Macdonald, where acts usually attain successful execution. If it hangs together in a piece, the connecting principle is hidden. Positive results rarely crown vigorous, systematic effort. Why look for symmetry and balance in a world that's pointless, random, and chaotic? The action of *The Intercom Conspiracy*, like that of *Dirty Story*, ends in a stalemate. It also validates that stalemate, describing a topsy-turvy world which reverses expectations at the linguistic, social, and moral levels. The obscure *Intercom Weekly* begins to print bulletins

consisting of military secrets belonging to both superpowers. Embarrassed and bewildered, the CIA and the KGB try to suppress these bulletins. Gavin Lambert's *The Dangerous Edge* (1976) shows how electronic communication inhibits positive, forceful action. Rather than bringing people together, the new technology divides and frustrates:

Information and misinformation have become almost impossible to separate, motives are disguised as identities. The devious structure of *The Intercom Conspiracy* parallels the structure of the new power. The editor never meets his employers. The lawyer never meets his clients. The clients don't even know who they are silencing. "Intelligence" means the use of mind to confuse and intimidate. (130)

This carefully orchestrated deviousness fades into inconsequence in Ambler's later books. If satire describes wasted effort, then a *Dr. Frigo* directs this futility to our age of telecommunication and cheap, speedy air travel. One of the virtues of Ambler's 1974 novel consists of linking the modern failure to connect with the troubles of the past. Echoing Flaubert's *Madame Bovary*, the book shows an eminent physician flying to the Caribbean from France to examine a patient, merely to confirm an earlier diagnosis and to offer the dying patient no help. The parallels found by Castillo's lover, Elizabeth Duplessis, between Hapsburg politics and the *coup* forming on her island republic depict moral stagnancy. The swing from Europe to Latin America and from the seventeenth to our twentieth century hasn't taught the rule of justice and love. *The Care of Time* also describes a world that has battened on technological advances. Yet nearly every undertaking elected by the book's skilled, sensitive characters fails. The many contingency plans, fallbacks, and cover operations that prove to be red herrings show that the world's technology can't produce positive results unless the human factor is in place.

As he did in his early fiction, the Ambler of *Dr. Frigo* makes politics his metaphor for the desperation of modern man. But rather than invoking Marx, he harks back to the idea, voiced as early as *Oedipus Rex*, that the welfare of any polity both reflects and grows out of the health of its leader. Castillo's chief responsibility sidesteps the question of Manuel Villegas's health. His country's political bosses merely want Castillo to sustain the illusion of health in Villegas so that this sick, dying man can both assume the country's presidency and give his presidential address without collapsing. The madness of the leader in *The Care of Time*, the most powerful figure in all of Ambler, is already so acute that the strain of giving a TV interview sends him to a mental home.

Perhaps Ambler believes the world is already a madhouse. At any rate, the old definitions and standards no longer hold good, leaving our rapidly advancing technology in a moral void. As Lambert explained, business associates don't meet. Blood lines and national identities also blur in A.A. Simpson and Michael Howell. Like these two, many of the important characters

in the late work are multilingual. Mat Williamson, or Tuakana, of *Send No More Roses* not only speaks several languages; he can also do vocal impersonations. A possessor of many aliases and passports himself, Paul Firmin, the book's narrator, never reveals his true name, even to us. Now Ambler had already given his characters names expressive of both modern life's confusion and their own wish to remain shadowy. *The Dark Frontier* contains a Kassen and a Kortner, a Magda and a Marassin, and a Casey, a Carruthers, and a Coltington. In *Judgment on Deltchev* can be found people called Pashik, Pazar, Prochaska, Petlarov, and Pechanatz. Moving to Ambler's later fiction, we see in *The Levanter* two enemies named Howell and Hawa. In the new technocratic state, guidelines smudge, behavioral norms bend and snap, and enemies resemble friends. Perhaps Ambler set his 1972 novel in the Near East to show how such normlessness promotes terrorism. Safest for the individual is to hide from those in power and their enemies.

But at what cost? *Here Lies* calls the Eric Ambler of 1935 "an English...more or less heterosexual writer" (119). At least once in the canon, homosexuality emerges as an issue, perhaps as a function of mobility. A night journey through the Balkan city where *Deltchev* is set brings the book's narrator together with a gay journalist named Sibley. But Sibley and Foster haven't only traveled to the same city for the same reason. Sibley's name also invokes the word, sibling, and Foster first sees him in Chapter 17 in a mirror rather than face to face. Why did Ambler stage this mirror meeting? Foster is a playwright, as was Ambler before he turned to fiction. He's also well intentioned but weak, and enjoys no great success with women. A remark applied to the book's title figure by his wife in the last chapter, "Yordan is a self-torturer," could well explain Ambler himself. The revelation capping Foster's night journey in a foreign land stirs both his and Ambler's homosexuality. The settings of the last two scenes of *Roses* on islands summarize the sad extended confession Ambler's twenty-odd books represent. Tricky and evasive enough on its own, the self in Ambler seeks more veils, disguises, and smokescreens to hide behind as the canon moves forward. The isolation and denial of closure implied by the two island settings of *Roses* carry the cover-up operation to an alarming extreme. The sour, indeterminate ending of *The Care of Time* also shows the book's narrator alone. Social life has lost its power to nourish and sustain. Inertia has taken over. Despite the airy chic of his busy, verbally gifted characters, the silence of island distances transmits its soft, hollow moan through the canon, blocking the march of events and installing stalemate and frustration as the mainspring of Ambler's art.

# Chapter Three
## Marked Down for Action

Some writers of thrillers, detective stories, and literary intrigue are so clever that they look like artists rather than the entertainers they are. Smooth, trim, and polished, their work lacks the weight and resistance of important writing. Ambler's early novels fit this category. Fast paced, cinematic, and marked by frequent scene changes, they divert more than provoke. Ambler pares his characters down to convenient size and shape in order to fit them to his plot. When he doesn't pare and trim, he blocks lines of moral and psychic growth. The plot always comes first. Afraid that rich, complex characters would threaten its tidiness, he will drop them into an action already in progress rather than freeing them from the action and letting them grow on their own. But they still manage to transcend the limits imposed by the hard, logical structure of the works in which they appear. And what gives them the heft and gleam of major characters is their author's social conscience and gift for prophecy. In 1943, Alfred Hitchcock explained how insight into the long-term dangers created by European business and politics lifted Ambler's early work above the level of most intrigue fiction of the day:

The crimes [in Ambler's prewar novels] grow out of fascist intrigues and the greed of big business; they grow out of a Europe run down, decadent, dirty, rotten ripe for war and revolt. (x)

Ambler conveys this corruption in different ways. A big munitions manufacturer in *The Dark Frontier* pleads innocent to the charge that he's a merchant of death by claiming that the needs felt by governments everywhere to maintain large arsenals must be met by someone; if he didn't make and market lethal weapons, somebody else would do it. Moral responsibility is never an issue. What matters instead is the need to maintain a show of power. But arsenals stockpile at the cost of cultivating soil, developing trade, and building schools. Sometimes the losses include an immediate threat. An English firm in *Cause for Alarm* sends an engineer to Italy without telling him that the man he's replacing was murdered. In *Background to Danger*, a murder suspect is given a bloodstained overcoat to wear while evading the police. The motives of the enemy spy in *Epitaph for a Spy* remain dark. "I expect he needed the money," is the only explanation a security officer gives for the spy's treachery;

the vagueness of his words capture the meanness and venality of a world ruled by lust for money and power.

*I*

Ambler's deepest self wanted to believe that the traditional English public school virtues of duty, honor, and fair play could curb this lust. "I had set out to upgrade the thriller genre...by doing a parody of secret agents who never fail. But I got swept up in it" (95), he said in *People* magazine of *The Dark Frontier* (1936). What swept him into his yarn was his fascination for the heroic archetype of the gentleman-adventurer-patriot whose efforts avert global catastrophe. But, writing in the Marxist decade of the 1930s, he knew his readers to be too cynical about heroism to buy either the sharp-cut good-evil dichotomy used by John Buchan or the old-fashioned trust in the power of individual action. He dealt with this cynicism by giving his main character a case of amnesia. Physicist Henry Barstow's amnesia lets Ambler celebrate the Victorian values of his youth that he was afraid of voicing directly to contemporary readers.

The amnesia-as-interface motif works well enough for a while. Called "The Man Who Changes His Mind," Part One of *Frontier* deserves the title, "The Man Who Changed Himself" or perhaps even "Walter Mitty Revenant." Barstow, in his preface, disclaims not merely responsibility for, but, rather, knowledge of, his actions during the five weeks covered by the novel. This systematic, tidy man is a forty-year-old bachelor with a cat. Because of overwork, his doctor has noticed in him the onset of a nervous strain and orders him to take a vacation. The open road to England's west county beckons. But so does his lab. Like the early heroes of Graham Greene, he's deeply divided. His heavy work load has revived his boyhood craving for excitement and danger. It is this wild side that a fellow diner in a hotel, 180 miles from London, addresses when he recognizes him bent over his well-done steak. A director of Cator and Bliss, "one of the largest armament manufacturing organizations in the world," Simon Groom offers Barstow a job as his technical adviser. He also says that his offer stems from a development so fantastic that nobody would believe Barstow if he went public with it.

Groom's need for an atomic scientist on his staff of advisers surfaces quickly. The first atom bomb has been made, he insists, in Ixania, a rusty, tattered Balkan country that reminds Peter Lewis of Albania (26). Were Ixania to produce the bomb, she could either sell it to the highest bidder or use it to threaten the world with extinction. Barstow sees through this argument. Unmoved by Groom's fine words about saving civilization, he claims that wresting the secret plans for the bomb would profit, not civilization, but only the shareholders of Cator and Bliss. His conscious, responsible self rejects Groom's offer of a job. But then another side of him takes over. He sees an opportunity to sabotage Groom's plans. Though ordered to rest, he will step up

his activity, mounting a search-and-destroy mission the aim of which is to halt the production of the bomb—by anybody. This mission addresses large questions of both public policy and public morality. What Barstow is challenging specifically is the modern application of Karl von Clausewitz's belief that war is an extension of politics and diplomacy: "The largest item in national budgets today was for past and future wars," he notes, adding, "It seemed almost as if war were the greatest and most important activity of government."

At first, Barstow's fervor lacks a positive outlet. Echoing the famous sentiment of English poet C. Day Lewis (1904-72), he'd choose the bad over the worst, could he sort them out. He questions his first humanistic urge to destroy the bomb, only to reaffirm it. The worst may be nationalism, that engine of pride, greed, and vanity. By leaguing with Cator and Bliss, on the other hand, Barstow will help distribute military firepower more widely—even if the distribution is based on the ability to pay. But how beneficial is the *status quo* that Cator and Bliss want to preserve? It has already promoted injustice, inequity, and war. Yet if Ixania controlled the bomb, she could blackmail and eventually terrorize all her neighbors. And her success might encourage her to put the same pressure on her neighbors' neighbors. Barstow rejects both sets of claims—the one based on expansionism and that grounded in material profit. But his overworked mind gets still more material to sort and scan. Just after trying to imagine a superhero who could stalemate *all* efforts to control atomic weapons, he chances upon the novel, *Conway Carruthers, Dept. Y*. The heroics of the novel's eponym, named for the hero of Erskine Childers's classic spy novel, *The Riddle of the Sands* (1903), fill the gap dividing Barstow's romantic and his sober, cautious selves. Why pursue the path of system and reason? Barstow wonders. It has only brought him to exhaustion and near-collapse. His composite Barstow self melts inside his Carruthers fantasy; Carruthers can save the world from annihilation. But how to find—or become—Carruthers? Inviting a psychological reading, Ambler sends the weary, care-laden Barstow out on the open road, distracts him with the sound of Groom's offer booming in his ears, and, having induced this heated state, impairs his driving ability. The car accident that follows Barstow's losing control of his car also jars his memory. He awakens from the accident with both a concussion and the delusion that he's the intrepid Carruthers.

His delusion gives Ambler the artistic problem of conveying the excitement of adventure fiction while avoiding the genre's triteness. The car wreck that caused the delusion offers a good solution. It not only turns Barstow into Special Agent Carruthers; it also allows him, as Barstow, to accept Groom's offer to work on the Kassen bomb (named after its inventor) in Ixania. His selective amnesia has shaped the plot. Relying on the knowledge of physics carrying over from his days as Barstow, he can fuse the scholar's knowledge with the man-of-action's daring. The combination sparkles his blood. Nobody

before him has had such a chance to secure world peace.

Were he to put into action the mettle of his fictional hero, he'd reach any goal he aimed for. "Impervious to ordinary human feelings, a man of steel, cold and unemotional," the storybook Carruthers is athletic, observant, discreet, and bold. Heads of state have petitioned this model of physical grace and insight. They would also petition Barstow in his Carruthers imposture were they to know of the verve with which he merges his energies with those of his hero. So hard does he punch a newspaper reporter that it takes this knockout victim half an hour to regain consciousness. Later, he plans, organizes, and executes a series of dangerous break-and-entry operations; he improvises a phone hookup to another man's room in order to overhear a strategic conference; he dresses and binds the gunshot wounds of a friend. Ambler handles the Carruthers/Barstow identity shift smoothly; moving easily between the two names, he always takes as his cue the sort of act his man is performing. His very calling of Professor Henry Barstow Conway Carruthers betokens an acceptance of his man's outlook and self-image. As in *Don Quixote*, belief in a reality confers dramatic existence upon the reality. But if Barstow's car accident pushed his suppressed actionist self to the fore, it didn't altogether sink the scholar in him. As has been seen, Carruthers accepts Groom's job offer as Professor Henry Barstow. He also travels on Barstow's passport, and he draws upon Barstow's knowledge of atomic physics to make sense of the technical secrets he unearths. All this suits his master plan. As a gullible, harmless academic drudge, he can win Groom's confidence, lower his guard, and destroy the very bomb Groom hired him to develop.

Ambler himself explained in *Here Lies* how this intrigue, promising as it is, rests on a conceptual flaw: "I played dual-personality games with the hero. This was plain cheating" (121), he confessed. By blocking psychological complexity and moral seriousness, Barstow's selective amnesia stops *Frontier* from developing, expanding, or resonating. Barstow is less of a person than a plotting device. As soon as the action deepens, Ambler drops him as the book's controlling intelligence and turns the narrative over to William L. Casey, a reporter for the *New York Tribune*. "A lean-faced rather untidy young man," Casey is thorough, sharp, and dedicated. Ambler validates his quickness and expertise before putting him in charge of the narration. Winning credibility for Casey in this way is shrewd technique. The reader shouldn't worry about any lowering of dramatic intensity once he/she discovers that the voice of Part Two belongs to Casey, not Carruthers. What is more, both men have internal divisions, a fact that creates a similarity in approach between the two narrations. Casey's reference in Chapter 13 to "the transition from newspaper man to desperado" recalls the split in Barstow between the dry, methodical scholar who chews overcooked steak and the valiant champion of civilization.

The motif is cleverly underscored. Both men start taking charge of the action after suffering concussions; the names of both men start with letters that

turn the mind to Cator and Bliss, the big armorer that drives the action.
Deserving of mention, too, is the balance with which Casey views Carruthers.
He disparages the would-be Savior of Ixania as "the ham lead of a third-rate
stock company playing the Englishman in a bum crook melodrama." He also
complains that "Carruthers had a way of making you behave and think like a
dime novel." But then he'll praise his man's ingenuity and even extend
admiration to him for diagnosing a problem quickly and then finding the best
way to solve it. Seeing Carruthers through Casey's eyes keeps us alert.

What Casey's shifting assessment of Carruthers lacks, unfortunately, is
psychological depth or complexity. Casey's standpoint dwarfs Carruthers
because the book's first part had introduced issues that couldn't have been
addressed had he remained at center stage. Ambler himself tells how his
decision to turn the narrative over to Casey twisted the plot's spine:

This was simple desperation on my part. It was this intrusive late-comer who made it
possible for me to resolve all the story problems I had created for myself earlier on by
breaking, or ignoring, other sound storytelling rules. (*Here Lies*, 121-22)

Is Ambler being too hard on himself? Perhaps he forgot that, by angling the
closing chapters through the point of view of Casey, he was able to speed
narrative tempo. The emergence of Casey's voice when the action accelerates
frees the daredevil Carruthers to take charge of events. What's going on in his
mind doesn't slow the action. For instance, Ambler would have faced great
technical problems had he described this paragon's reaction to finding that he
had killed the woman he loved after his bullet burst a tire on her fleeing car.

The death of Countess Magda Schverzinski climaxes the book. She is
flung from her car while speeding toward the Ixanian border (the story's dark
frontier?) with the surviving set of plans for the Kassen bomb in tow. Rejecting
Carruthers's request to burn the plans, Casey returns them to his friend and
watches him throw them into the burning mass of her car. This spectacle both
surprises and pleases Casey. For a moment, he had feared that Carruthers was
going to commit suicide as punishment for killing his lady love, even though
her death was necessary for the survival of humanity. Needless to say,
Carruthers is no more gladdened by his bitter victory than any number of
successful heroes in Greene and le Carré. On the other hand, were Ambler to
delve into the pain accompanying Carruthers's victory, he'd have both
wrenched the mood of the book and violated the ambience set by the book's
first three quarters.

But even Ambler's wisdom in distancing Carruthers's torment can't
redeem the book. *The Dark Frontier* is ridden with flaws. By introducing the
dark exotic Countess Magda on a train heading from Paris to Bucharest, Ambler
resorts to a cliché. The easy way out will re-emerge. His plot structure is
weakened by several instances of eavesdropping. One of these, coming in

Chapter 8, shows Carruthers going to the high tension lab of Jacob Kassen, the bomb's mad inventor, and overhearing a discussion of the very issue that had been puzzling him—what caused the power overload that darkened Zovgorod's Opera House the previous night. The closing chapters contain a lapse just as farfetched as this coincidence. After catching Carruthers trying to steal the plans for the Kassen bomb, Countess Magda gives him 24 hours to leave the country. But she fails to enforce her deportation order. Ten days after it's issued, Carruthers is running the revolution of the Young Peasants' Party. But why should any revolution be taking place at all? we wonder. The incumbents have an effective intelligence network together with a military arm strong enough to crush any rebellion forming to oust them.

This lapse proves that a novel's structural weaknesses can only stay hidden for so long. The deeper we read into *Frontier*, the more glaring its flaws become. Most of them stem from the truth that the book is full of characters whose asserted presence outweighs their dramatic force. Launched by one set of characters, *Frontier* takes its growth from another. The spirit behind the revolution is a man named Andrassin, whom Casey had known in New York. But we only see him once briefly before learning that he got killed by Ixania's secret police. Casey's outcry, "He seemed now an infinitely tragic figure," sounds forced and unwarranted. Andrassin simply hasn't spent enough time in our presence to serve as a major plotting device. Yet Ambler accepts his centricity. And, as the book moves ahead, he grants more and more thematic importance to the Young Peasants' Party and the Red Gauntlet Society, agitation groups operating behind the reported action. The Red Gauntlets drop out after organizing some political murders, but without showing why they leave the field to the Young Peasants. If the Ambler of *Frontier* had a Tolstoyan faith in rural values, he neglected to infuse it into the agrarian revolution that triumphs at the end.

The collective goals of a peasant *coup* normally rest upon the creation of a decentralized, self-ruling democracy that restores land, forests, and waterways to the people. But the closing chapters of *Frontier* hark to none of these issues. Instead, they consist of a journalistic summary of the *coup*, detailing various power shifts close to the executive branch. Casey becomes Ixania's director of external communications, or press secretary. He will help rebuild Ixania's economy by improving her image abroad; the impression that Ixania is renewing herself steadily will inspire the credibility she needs to borrow money from foreign investors. But do we care what happens to her when no human drama engages our hearts? Jacob Kassen, the inventor, is killed casually; Magda dies too without speaking. Though named and discussed, her brother leaves the country before the action begins, and Ambler gives him little reason to come back home. Carruthers can't provide any revelation himself. Ambler hides him behind the dramatized action, planning strategies and formulating policies to help the *coup* lest his emotional outpourings, resulting from Magda's death,

subvert the plot. The need to keep Carruthers's grief from the page dictated both the evasiveness and the externality of the closing chapters. By addressing this grief and the issues it raises, Ambler would have had to increase the book by 100 pages while also setting himself artistic demands beyond his powers as a first novelist.

Nor does he fall short of *all* the demands set by the novel that went to press as *The Dark Frontier*. Even though Ixania rhymes with zanier in a way that might have pleased Noël Coward, the action set there provides more than blunders. Perhaps Clive James judged *Frontier* correctly when he called it affectionately "an engagingly awful book" (64). Despite its faults, the book does touch us—enough to make us wish it better than it is. First, Ambler's knowledge of Slavic culture lends credibility to the action. By naming Ixania's capital Zovgorod, he's using the Slavic root word for city, as in the Modern Russian *gorod*, found in places like Petrograd and Belgrade. Also, the Zovgorod street, Sa' Maria Prospek, hews to the Russian convention of naming streets, as in Moscow's Próspekt Marxa and Petrograd's Nevsky Prospékt. (The religious reference in Sa' Maria Prospek conveys the truth that Christianity always enjoyed more favor in the eastern bloc nations outside the USSR.) Other nice narrative touches sustain the impression that Ambler knows what he's doing as a storyteller. By using dates as chapter titles, he creates both suspense and urgency. Our knowing at the outset that the action to follow extends from 17 April to 26 May of a single year in the 1930s frames our awareness of what we see developing. As the calendar rolls ahead with each new chapter, Ambler skillfully conveys the idea that time is running out on both his heroes and their cause. Our attention sharpens.

And it holds firmly when the book's first act of criminal violence explodes. In a well-foreshadowed development, Magda's Ixanian traveling companion, or envoy, is shot dead just three days after secretly conferring with Simon Groom, the munitions maker, in Basel. Obviously, he didn't fool the Ixanians he was plotting to betray. Although his meeting with Groom takes place off stage, it could have only dealt with an offer being proposed for the Kassen bomb recipe. Ambler's way of killing off the treacherous envoy shows a fine hand for plotting. The envoy dies soon after the train carrying him and his fellow passengers has cleared customs and passport control at the Ixanian border, that is, when Carruthers's (and the reader's) guard is down. Having seized our attention with this shock tactic, Ambler then holds it. The last two sentences of the chapter in which the envoy dies heighten our involvement: "Carruthers shuddered involuntarily. For the first time he felt afraid." And why not? Ambler validates his fear. Carruthers has just discovered a murder victim who was performing the same mission as Carruthers himself. The next chapter brings another shock, the news that, rather than going after the envoy's killers, the Ixanian police have called the death an accident. Carruthers's fears mount. What chance will he have if local officials find his presence inconvenient or

offensive?

Ambler's skill as an action writer sustains the question in our minds. The ambushes, shootouts, and searches through the winding streets and rough terrain of this Ruritanian republic on the brink of revolution move the action forward swiftly and involvingly. In this storm of activity, Carruthers's personal fortunes rise and fall in unpredictable but realistic ways. When he and Casey go to Magda's palace to steal the plans for the bomb, they're menaced, not by the palace guard, but by Groom and his agents, who turn up at Magda's within minutes of the heroes. The heroes' next visit to the palace—an involuntary one—comes after they're gassed in the passengers' area of a taxi they had innocently hailed to take them somewhere else. This motif occurs in Raymond Chandler's "Nevada Gas," which, having run in *Black Mask* in June 1935, Ambler could have read while writing *Frontier*.

Also reminiscent of Chandler is the book's alternation of danger and safety. A daredevil mission will take Carruthers and Casey into a heavily guarded building. Just as the men are slipping out of the building, their mission successfully performed, they find themselves surrounded by armed enemies. The advantage has suddenly shifted away from them, as it does often in Chandler. It will continue to shift. The enemies' plan to kill the heroes will give way to a last-second entry by a surprise visitor. In Chapter 13, Carruthers stops Groom from shooting Casey by turning off the lights in the room where Casey is about to die. Then Countess Magda sweeps into the lab in the next chapter just as one of her aides is going to electrocute Carruthers and Casey.

The language that this action writing invokes can sound overblown and naive. Carruthers says inwardly after discovering the death of the Ixanian envoy, "This was reality, and he was dealing with powerful people. He must be decisive in his turn. Mistakes would be dangerous. He was very soon to realize just how dangerous." This overcharged writing becomes even more embarrassing when presented as dialogue. Casey sounds so much like a movie cowboy when he vows to avenge Andrassin's death in Chapter 12 by raging, "I'll get those dirty skunks…if it's the last thing I do," that he makes us want to laugh. But Ambler, the perpetrator of such crudities, can also impress us with his delicate touch. Just as the secret message in Hitchcock's *The Lady Vanishes* (1938), for which several people risk their lives, turns out to be a scrap of a popular song, so do the plans Carruthers is searching for turn up in a roll of lint or gauze. That Carruthers was using it to dress Casey's gunshot wound shows one virtue creating another. Already in 1936, Ambler had the instinct to convert a motif he may have stumbled upon into artistic profit.

He'll sometimes bring the same maturity to large thematic issues. We have already seen moral protest infusing Carruthers's wish to destroy the Kassen bomb. Sound enough on its own, the protest channels neatly into a major premise of science fiction—What if? Since 1945 it has become clear that the atomic bomb was both invented and implemented as an answer to war; it

sped the end of World War II and thus saved American lives. But what if it had been invented in peace time when its inventor or his agents might have created global panic by selling it to the highest bidder? Or used it to back his own country's demands for money, land, and power? *Frontier* does address these matters, even though Ambler denies it in *Here Lies*: "My reduction of the atom bomb threat into melodrama" (121), he said in 1985, trivialized the threat. He's too harsh on himself. More balanced and perceptive is an Author's Note, written in 1972 and intended to preface any collection of his work. Located in a Boston University archive, the unpublished Note disavows any "special prescience" (1) concerning thermonuclear war. Yet is does praise "the author of *The Dark Frontier*" for being "among the earliest members of the Ban the Bomb Movement," adding playfully, "I may have even been the first."[1]

This insight into the public sphere is enhanced by a glimpse the book provides into Ambler's psyche. Jacob Kassen calls the lethal explosive inside his bomb magdanite, after the dark beauty Magda Schverzinski. "Power and beauty go hand in hand," he claims, linking destruction with female radiance. But as Ambler's later work will prove, he's pointing a wrong direction. Kassen's linkage and the thematic line it implies both collapse quickly. Even in *Frontier,* the threat to male wholeness isn't the *femme fatale*, but male authority. Magda dies, and the formula for the explosive named after her burns in the wreckage of her death car. Casey's remark in Chapter 12 while he and Carruthers are facing some angry questions—from Magda no less—"We waited …like a pair of schoolboys before their master"—looks ahead to those passages in *The Light of Day* and *Dirty Story* where the memory of being caned by his schoolmaster revives A. A. Simpson's worst boyhood fears.

Malcolm Oram's statement in *Publisher's Weekly* in 1974 looks in the same direction: "Ambler's first novel…started out as a parody but, he says, it changed halfway through into the sort of story it was parodying" (6). Any parody honors the work or genre it refers to by displaying its force; why bother parodying something frail and feeble? *Frontier* pays a warmer tribute. By progressively dissolving all critical distance between itself and the Victorian spy novel, it asserts the ability of the form associated with William Le Queux and John Buchan to survive ridicule. But, in the process, it also discloses Ambler's entrapment by the genre despite his socialism and the many images of industrial squalor his book borrows from the poetry of W. H. Auden and his circle, so popular with fellow left-wing intellectuals of the day. The collapse of the parodic in *Frontier* forecasts the son's subjugation to the father, the main source of power in the Ambler canon. Watching his first novel melt into the gentleman-adventurer tale of heroism he had set out to spoof must have recalled for Ambler the helplessness he felt at age 12 or 13 when he saw his father drive away in the motorcar that was paid for with his own tuition money. One can imagine this helplessness curdling into distress as he found himself unable to restore the coolness and the distance needed to reverse the melting process.

*II*

*Here Lies* rightly calls Ambler's second novel "a more disciplined piece of work than the first" (123). Much of the poise and craftsmanship of *Background to Danger* (1937), published in Great Britain as *Uncommon Danger*, stems from the book's limited scale; *Background* achieves more by attempting less than *Frontier*. Designed as a straight adventure tale, it grazes the deep psychological questions worried by its predecessor. But it also defies the truism that second novels carry less weight and pose fewer challenges than first novels. Its politics may be even more keen than those of *Frontier*. This keenness was both noted and praised from the start. Reviewing the novel in the *New York Times Book Review*, Stanley Young called "this sophisticated thriller" "a good yarn and up-to-the-minute in its political implications" (37).

This praise has merit. The Ambler of *Background* displays a prophetic streak as impressive as that of the forecaster of the atom bomb in *Frontier*. And he displays it from the very start, in the novel's epigraph. Quoting from an undated issue of *World Petroleum*, he makes a prediction that eluded a novelist much more widely hailed for his gift of political prophecy, the George Orwell of *1984* (1949). Petroleum becomes vital in a world bracing for war because it moves weapons, explosives, and troops: "To-day, with Europe assuming he appearance of an armed camp," the epigraph says, "the...supply of petroleum is of the first importance." This importance is shown in the book's prologue, where the directors of the Pan-Eurasian Petroleum Company of London, a blind partner of the big munitions firm, Cator and Bliss of *Frontier*, investigate ways to shore up Italy's war capability with Rumanian oil.

But *Background* does more than just forecast the privilege and prominence that the world's oil moguls would enjoy 35 years after the book's publication. Writing with the Marxist bias found in the rest of his fledgling work, Ambler explores the tie between a nation's military strength and the large multinational firms that provide it. Bankers, industrialists, armorers, and oil executives make military policy today, he says in Chapter Eight:

It was the power of Business, not the deliberations of statesmen, that shaped the destinies of nations.... The Big Business man was only one player in the game of international politics, but he...made all the rules.

This warning about the evils of the military-industrial complex that would later rule global politics includes the effects of big weapons contracts upon the international exchange rate. Without depicting the idea, Ambler does evoke some of its woes. The chief goal of any business, the novel shows, is to turn a profit. Perhaps misled by his socialism, Ambler argues further that the large suppliers of war materials ignore values like patriotism and national loyalty. Thus the London-based Pan-Eurasian Petroleum Company has no qualms about strengthening the military arm of Italy, England's enemy.

Ambler sharpens his attack on a profit motive that supposedly overrides all ethics. Knowing that moral issues in fiction must be made particular and individual in order to touch us, he describes the chairman of Pan-Eurasian Petroleum as much scurvier than his earlier counterpart, Simon Groom of *Frontier*. Called "a complete wart," by a colleague, the runtlike Joseph Balterghen works out of an office that is both ugly and tasteless. Though a British subject for 20 years, this Armenian-born schemer speaks English "as though he had a hot potato in his mouth." His face is as repulsive as his speech and his business ethics: "A disgruntled business associate had once described it," we read in the prologue, "as looking like 'a bunch of putty-colored grapes with some of the crevices filled in.' He should have added that the grapes were also very shrivelled." Surely a system that elevates such a toad to political and industrial power needs reform, Ambler asks us to believe. The invitation is well taken. That Balterghen is chairman of Pan-Eurasian Petroleum "and of fifteen other companies and a director of thirty more, including one bank," shows power concentrated in too few hands—the wrong ones, at that. How can justice and equity prevail with this "complete wart" controlling so much of the machinery of production? They obviously can't, we infer.

This attack upon capitalism, extending and intensifying from *Frontier*, suggests other similarities between Ambler's two earliest books. First, the numerous apparitions of vacant yards, deserted factories, and garbage dumps put forth by *Background* build the same mood of industrial desolation found in *Frontier*. Next, in 30-year-old Desmond D'Esterre Kenton, *Background* features an astute, energetic journalist similar to Bill Casey. Also repeated, but to a lesser degree than in *Frontier*, is the motif of eavesdropping; in Chapter 13, Kenton hears himself being discussed by two border guards who are searching for him near the Austro-Czech frontier. A more important motif repeated from *Frontier* is that of the daredevil mission of two people breaking into a large estate in order to filch highly classified materials (the much coveted prize in *Background* being some highly classified photos of Soviet military instructions).

Such capers restore the alternating rhythm of danger and safety that Ambler may have borrowed from Raymond Chandler's early short stories. Danger erupts quickly for Kenton at the end of Chapter 13. After crossing rough ground patrolled by hostile border guards and then taking both a bus and a train to Prague, he feels relieved. But before leaving Prague's train station, he is seized by two men, a pistol is jammed against his ribs, and a car is speeding him to an unknown destination. Yet the destination turns out, happily, to be a house occupied by his friend, Andreas P. Zaleshoff. Zaleshoff and Kenton are together again in Chapter 15, in which two life-threatening dangers are reversed. As in *Frontier,* the shuttle of danger and safety conveyed here and earlier both draws in the reader and builds expectations that Ambler can later handcraft in order to sharpen our involvement.

Our involvement is sharp, indeed, at the book's climax—as in *Frontier*, an auto chase in the dark with live bullets flying. Again, the car in pursuit must stop its quarry from crossing a frontier (here, the one between Czechoslovakia and Germany) because, once over the frontier, the person being chased will give his friends the top-secret plans his pursuers covet. Again, too, a woman is driving one of the cars, but this time her Mercedes is the one in pursuit. And just like the fleeing Countess Magda, who was driving a Mercedes in the climactic chase of *Frontier*, Tamara Zaleshoff, Andreas's sister, is an exotic beauty who stirs the interest of the book's hero. But the tenderness she rouses in Kenton is scant. He spends much more time with her brother than with her; his experiences with Andreas are more intense; Andreas moves him more deeply. And though he's trapped at least twice in womblike interiors, his captor in each case is a man. What is more, the two strangers who lead him to safety are both men, too. Men continue to exert more force on the Ambler hero than women, female beauty counting less than the leadership and authority connected with the father figure. If the father punishes the son, it's not for his incestuous cravings.

Kenton leans upon others as much as Henry Barstow would have done had he not believed himself Conway Carruthers of the Special Branch. In this regard, he's the first of many Ambler heroes who fit the paradigm set forth in 1976 by Ronald Ambrosetti:

Ambler's central character is always the innocent amateur.... The Ambler protagonist does not understand what is happening; he cannot go to the police; he probably will not survive the embroilment; and he must comply with the game-plan of the foe. Somehow he survives (usually by chance) and emerges a chastened but wiser man. (103)

From the very outset, Kenton blunders badly. He's standing alone on the dark, cold platform of Nuremberg's rail station waiting for the Frankfurt-Linz local because he has gambled away all his cash save that needed for a third-class train ride, and he hopes to borrow some more from a friend in Vienna. The chain of events that keeps him from Vienna develops quickly and involvingly. It also discloses Kenton's lack of coping power. Sharing his compartment on the eastbound train is a small dark man wearing "a dirty starched collar...and a crumpled dark-striped suit." This furtive, anxious creature who calls himself Herman Sachs offers Kenton 600 marks to take an envelope allegedly containing securities, first, past the customs examiners stationed at the Austrian border and, next, to Sachs's Linz hotel. Kenton doubts Sachs's story about being a Jew badgered by Nazi spies; in fact, the man's accent makes it clear to the polyglot Kenton that he's not German at all. These doubts make good sense. Kenton was right to distrust Sachs. He went wrong, though, by helping him.

He discovers his mistake quickly. When he goes to Sachs's hotel room to deliver the envelope, he finds that Sachs has been murdered. Fear lurches to the

fore. If the murder was related to the envelope that Kenton is holding, then he, too, is murderable. His mortality continues to gnaw at him. Looking out of Sachs's hotel window, he sees two men standing near one end of the street below and two more sitting in a car near the other end. And though he flees the hotel unharmed, he soon learns that the Austrian police want to arrest him as Sachs's murderer. Other troubles follow. These, he manages to fend off in a way characteristic of most of Ambler's heroes. He is helped by others. Now the non-self-starter can create a false, and damaging, picture of Ambler's narrative strategy. As a writer often praised for his realism, Ambler seems to depend heavily upon providence. The number of *dei ex machina,* or rescuers, in his work invite the charge that he slights both motivation and plot structure. But the charge, a misleading one, needs to be withdrawn. As Kenton shows, the Ambler hero is an ineffectual who needs the help of others, not merely to outlast conflict, but simply to survive.

Just as Kenton is about to hand over the photos of Soviet military instructions that Sachs died for, Zaleshoff rescues him. Later, his decision to return to England through Czechoslovakia sends him to a travel agency in Linz, where he joins a coach tour that skirts the Austro-Czech border. Despite his resolve to be inconspicuous, an English sales representative spots him immediately from his picture in that day's newspaper. Then Mr. Hodgkin shows him the best escape route out of the country. Kenton's attempts to hide his identity have been cheap, clumsy, and self-incriminating. Besides attracting attention to himself in the travel agency, he also lies to Hodgkin about the time he's scheduled to take the Vienna-bound train that evening. Each of his blunders sharpens the truth that, more than anything else, dumb luck sees him through his ordeals. But he's more than lucky; otherwise, Ambler wouldn't have built the novel around him. Despite his flubs, he has a redeeming humanity that justifies his centricity in *Background.* Some Trotskyite spies invade his hotel room, knock him out, and take him to their lair—all for the sake of the photos given him by Sachs (whose real name was a resoundingly Russian Borovansky). For some moments, what appears to be common sense prevails. The photos mean nothing to him, and surrendering them to his captors seems like a good bargain if it means going free.

But his captors have underrated him. The ugly methods of persuasion they use on their victims, like torture, outrage him morally. His rejection of the cruel Stefan Saridza's offer of freedom is soon justified. Shocking us with the ghoulishness of his imagination, Ambler has Saridza offer Kenton a job at gunpoint as his press secretary (much like the job Bill Casey took with the Ixanian government), but on one condition—that Kenton shoot his two fellow prisoners to death. Kenton's response to the offer, "I'd say...that you ought to be in a home for homicidal maniacs," shows his entire humanity rejecting Saridza's offer. Anticipating a similar scene in John Fowles's *The Magus* (1965), this total condemnation of brutality reconfirms the human decency and

dignity that undergirds the novel but that may have also become hidden by the fast-paced action.

One of Kenton's fellow captives, Zaleshoff supplies much of this humanity. He has also angered Saridza enough for Saridza to want him dead. Called "the official representative of the U.S.S.R. in Switzerland," this ugly, broadshouldered man of 38 reflects Ambler's Marxist sympathies. Resourceful and self-acting, he brings a background of international intrigue into the action. He speaks fluent English with an American accent because he lived in the United States for some years before being deported for his pro-communist activities. His deportation didn't seem to hurt his standing with the Kremlin. He and his sister Tamara live well. In fact, for workers in the people's revolution, they enjoy a great deal of luxury, perhaps suggesting some naïvete, wish projection, or distortion of vision on the part of their author. They drive a Mercedes. And they're occupying a "large, expensive house" outside of Prague at the end of Chapter 13, when Kenton is taken to them. Their Prague colleague, Olga Smedoff, lives well, too, the bathroom shelf in her spacious apartment "loaded with face creams, skin foods, astringents, and cosmetics."

The Zaleshoffs are in Prague because Saridza has come there with the strategic photos. These, Andreas must destroy before they're seen by enemy authorities. Their circulation would encourage Rumania's fascist leader, the real-life Corneliu Zelia Codreanu (1899-1938), to sell Rumanian oil to Italy (with Pan-Eurasian Petroleum acting as broker), a deal that would strengthen Italy, Nazi Germany's friend and thus the Soviets' and the United Kingdom's foe. The skills and energies Andreas displays in recovering the photos are outstanding—making him an English socialist's ideal who deserves all the windfalls coming his way. His ability to evaluate and improvise quickly when in danger shows a gift for survival that recalls Carruthers at his best. Some of his heroics are all the more remarkable in view of the terrific beating he takes right before enacting them. Still reeling from a wicked head blow, he calculates the amount of air space and breathing time remaining to him and Kenton in the vulcanizing tank where his enemies leave them to die. His presence of mind continues to help him and Kenton. Thanks to Ambler's command of physics, he knows the tensile strength of the cast-iron door that divides them from freedom. And once out into the fragrant air, he takes charge of their escape every step of the way. He leads Kenton across the roofs of one of Prague's busiest commercial districts, maintaining cover throughout. Unafraid of inflicting pain, he clubs a German guard from behind before taking his keys. Then he impersonates a policeman to free Kenton and himself from a building where they're trapped.

These improvisations gain conviction by unfolding in a mood of flexibility. Invoking his author's lively sense of incongruity, Kenton's fears that he's about to be killed in Chapter 4 dissolve in a wild impulse to giggle. Incongruity focuses our involvement again in Chapter 16, where a flair for the

macabre abuts intriguingly upon the gentlemanly code of maintaining grace under pressure. The tone of the meeting of the sworn enemies, Saridza and Zaleshoff, surprises Kenton: "The two might have been business acquaintances talking over old times," Kenton observes, even though Saridza would relish squeezing the trigger of the revolver he's pointing at Zaleshoff. The chapter sustains the tension between murderous intent and a gentlemanly style, Saridza telling Zaleshoff, whom he has immobilized with tight lashings of wire, "I regret . . . that we must soon part company again. *Partir est mourir un peu*; but I am afraid that it is you and your companions in misfortune who are going to do all the dying."

Despite their nasty recoil, these touches of well-bred nonchalance help relieve a vision as dark as that of Graham Greene's *Brighton Rock*, which came out the year after *Background*. The freakish and the grotesque will ruffle the book's smooth planes at any time. In Chapter 18, Zaleshoff presses an elevator button marked "Basement" in order to rise to the sixth floor. Once upstairs, he and Kenton meet "one of the fattest women Kenton had ever seen." She also flirts so outrageously with Kenton that Zaleshoff has to restrain her. But Dr. Olga Smedoff isn't just obese and oversexed; in order to hide the scars caused by some vitriol thrown at her face, she also applies layers of heavy makeup. Nor is this former strike organizer the book's only person who has suffered for his/her Marxist beliefs. Chapter 6 introduces another M.D., the "incredibly thin" Rashenko, whose brutal handling by Czarist officers took away his powers of speech. Freakishness can burst forth at any time, presumably to convey the brutality governing human ties under an unjust system. One of Saridza's aides is "a tall thin man with a disfiguring birthmark down one side of his face." Shortly after the disfigured man's introduction, Saridza, who spoke zestfully about modes of torture in Chapter 7, slams his revolver against Zaleshoff's head. Then, after forcing Zaleshoff and Kenton to share the rear of a car with a corpse, he stows the corpse inside the vulcanizing tank with his two bound victims.

Padding the jolt of such horrors, unfortunately is slipshod writing. As has already been seen, the Ambler of *Background* allows his people to eavesdrop. Clichés still cause trouble, too. In Chapter 5, for instance, Ambler refers to "a bone of contention," while successive paragraphs in Chapter 11 include the shopworn "bed of roses" and "played his cards a little better." He needed a crankier editor. As if he had grown bored by his main figure, Ambler's concentration also slipped while discussing Kenton's age. The second paragraph of Chapter 1 claims that "thin, intelligent-looking" Kenton is 30 years old, and a detail in Chapter 10, dating his birth in 1906, seems to provide confirmation. Yet a passage in Chapter 3 says that he's "*nearly* thirty years of age" (italics mine); his reference in Chapter 10 to "the 1936 trials" of Leon Trotsky confirms this impression, but only just. Though the book opens in November, its time-setting could only be 1936 if Kenton were born in the last

six weeks or so of the year. Yet Zaleshoff's phrase, voiced later in the chapter, "Until 1936," rather than "Until this year," implies that the year is over. The implication only makes sense, though, if two conditions are met—that the action unfolds in late 1937, i.e., after the book's publication date, and, again, that Kenton was born very late in 1906. But Ambler did nothing in his 1937 novel to satisfy these conditions, and his omission diverts our attention from his main business, the action story built around Borovansky's photographs.

On balance, though, the omission can be ignored. The opening chapters of *Background,* in particular, show more technical sophistication than can be found in the broken-backed *Frontier.* Ambler's patience in both playing out and interweaving the book's various narrative strands makes for a richness of effect in the early going that foreshadows the excitements to follow. After setting the prologue in the London office of Pan-Eurasian Petroleum, Ambler devotes a chapter to the meeting of Kenton and Borovansky aboard the Linz-bound train. His cutting to the Zaleshoffs' Zurich office in Chapter 2 organizes the previous action, joining the book's plot lines rather than weakening them, as the shift in setting might have implied. A highly classified file identifies Stefan Saridza as the "Colonel Robinson" who visited Joseph Balterghen's office at the end of the London-set prologue. Also identified in Chapter 2 is Kenton's compartment mate aboard the Frankfurt-Linz train. These identifications enrich the action. The Zaleshoffs' ignorance of both Robinson/Saridza's meeting with Balterghen and Sachs/Borovansky's agreement with Kenton creates a nice irony of discrepant awareness. The reader knows more about what's going on than any character in the book. This knowledge takes on a happy glow before the chapter ends. Tamara's asking her brother if they're returning to Moscow and, then, if they'll always have to work as spies imparts a warmth that lifts the action out of the realm of the coldly operational.

This warmth seeps into the plot. Tamara's questions create an ambiguity that arrests the reader, as it should Kenton. Do the Zaleshoffs snipe at each other later, we wonder, because for years they haven't had a vacation from their dangerous, unrelenting job? Or are they pretending to be at odds in order to trick Kenton into disclosing the hiding place of the Borovansky photos? In Chapter 3, Kenton and the Zaleshoffs converge upon Borovansky's death site. Who will die next? we wonder. We also suspect that Zaleshoff's knowledge of how to protect himself will keep him alive. Among his sister's parting words to him at the end of Chapter 2 was the reminder to wear his thick woolen muffler. Obviously, he takes her advice. Three straight paragraphs in Chapter 5 show Kenton referring to him as "the man with the muffler" after spotting him in Borovansky's hotel room. But the first sentence of Chapter 1, where Kenton came into the novel, began with the adjectival phrase, "With a thick woolen scarf wound twice around his neck." If Zaleshoff can survive trouble, perhaps Kenton can, too, though less tough and street smart.

In a pattern that will recur in *Cause for Alarm* (1938), where Zaleshoff

reappears, the Soviet spy will sometimes exploit this gift for his own benefit, whereas at other times his concern for Kenton seems genuinely personal. Behind his ambiguous behavior lies the question of motive. Is he interested in Kenton for himself? Or is he only helping him in order to wrest the photos of military secrets from Saridza before Saridza gives them to his friends? Such questions charge the adventures recounted in *Background* with an affecting humanity. And besides touching our hearts, they also clinch the impression that readers who came to the book after enjoying *Frontier* couldn't complain about being let down.

### III

Surpassing its two predecessors in tenderness and warmth, *Epitaph for a Spy* (1938) also unfolds in both a milder climate and a warmer season than *Frontier* and *Background*. Ambler's highly accomplished third novel takes place in southeast France, in a small Mediterranean fishing village and resort near Toulon called St. Gatien. Again, contrast serves Ambler as an organizing principle. The festive atmosphere given off by this holiday resort in mid-August will clash with the dismay gripping the book's main figure and narrator, Josef Vadassy, a 32-year-old language teacher who is taking his first vacation in five years.

The gulf between his plans to relax and the trouble that greets him shortly after he checks into St. Gatien's Hotel Réserve challenges Ambler's description of him in *Here Lies* as paranoid (139). But if Vadassy suffers from no persecution complex, neither is he a shrewd cosmopolite who knows all the angles. In Chapter 3, he calls himself "an insignificant teacher of languages without national status." He's not inviting self-pity. Being stateless has left him unprotected; he has no consulate to go to for help. This underpaid bachelor's aloneness is deepened by his having no parents or sibs and by his living in a foreign country where he must negotiate in an adopted language.

His plight hasn't jaded his heart. In the same paragraph in Chapter 4, he calls an American tourist "far from pretty" and "almost beautiful." Greater confusion has already befallen him. To his chagrin, he was arrested in Chapter 1 leaving the pharmacy where he had taken a roll of film to be developed. The exposed film, he learns at police headquarters, contains pictures of naval fortifications snapped in a restricted zone. Accused of espionage and other crimes against the state, Vadassy faces conviction, four years in jail, and deportation. His statelessness makes deportation the most daunting of these threats. He is carrying an out-of-date Yugoslavian passport because the part of Hungary where he was born got swept into Yugoslavia by the Treaty of Trianon in 1919. Since that time, both his father and elder brother were killed by the Yugoslavian police as political enemies. Were Vadassy to return to Yugoslavia, he'd probably die, too, as Michel Beghin, the French naval intelligence officer who interviews him, explains. Fat, bald Beghin, who knows the art of

persuasion, also explains that he can block Vadassy's application for French citizenship unless Vadassy cooperates with him.

Beghin believes that Vadassy's camera, a fairly common model kept in a standard case, was taken by mistake before being used to snap the forbidden photos. Thus he offers Vadassy parole under the condition that he find out which other guest at the Réserve has a Zeiss Contax like his. This condition is hard to meet. Vadassy has no training or experience as a spy, and he lacks the spy's instincts. By this time, too, the owner of the camera Vadassy is now holding probably knows about the camera switch, regardless of who perpetrated it. He may already be on his guard, too. And he's a dangerous enemy. As a professional spy, he can act quickly and decisively if he feels cornered, which is to say, as Vadassy knows all too well, that he won't shrink from violence.

Vadassy's fear over being outmatched by a cunning desperado builds at the end of Chapter 4 when he discovers that the only German on the hotel's guest list has been replaced by a Swiss. His assignment seems to have gone awry before it begins. The name of the Swiss guest was missing from the list given him by the police. He wonders if the police have deceived him. Or, what is worse, were they simply outsmarted? The odds against him seem to have mounted. At the same time, his spirits have dropped. He must leave St. Gatien in two days, i.e., on Sunday, in order to report to work in Paris the next morning. If he doesn't show up at Monsieur Mathis's language school on time, he faces dismissal. And without a job he can't qualify as a French citizen. Loss of job indicates loss of life. Lacking employment, he will have to leave France, a fate that means being shipped to Yugoslavia and stowed in a jail, where he'll await his death sentence.

Panek's admiration of the novel turns on Vadassy's helplessness:

This novel is not only vital for Ambler's later development, but also for the development of the spy novel as a whole. It contains Ambler's first genuinely unwilling spy who does not choose to participate in the action but whom malignant authority forces to do distasteful and dangerous things. He is the man in the middle who is battered by both sides. (143)

Panek is addressing the question, returned to in both Greene's *Ministry of Fear* (1943) and Hitchcock's *North by Northwest* (1959), of how much a government has a right to ask of those it protects to safeguard national security. French naval intelligence is endangering Vadassy at a time when France is officially at peace. They're using him as a catspaw, moreover, without telling him why. Ironically, his incompetence serves their purpose. If the taker of the forbidden photos realizes he is being watched, he might flee the Réserve and lead his pursuers to his chief; Vadassy's job consists of tricking him into giving up the safety of the Réserve. But it turns out that this safety was nonexistent. *Epitaph* is a whodunit that lacks a mystery. The police knew the spy's identity very

early in the book from having traced the serial number of the camera that had been mistakenly changed for Vadassy's. Yet they ignore the truth that the spy might kill Vadassy to avoid capture. Unafraid of sacrificing the innocent, security agencies endanger civilians without first getting their consent.

Judging from his ineptitude as a spy, Vadassy stands at great risk, as his controller, Beghin, well knows. Beghin tells him three times in Chapter 3 that he's an imbecile, a judgment he accepts, calling himself in Chapter 7 "a weak, cowardly fool" and, at the start of Chapter 8, a "helpless noodle." This berating makes sense. Unerringly, he blunders worst upon congratulating himself on his wit. The two deaths recounted in the closing pages of Chapter 6, though peripheral to the plot, portend ill for the burst of confidence from him that opened the chapter. The portent is quickly justified. Shortly into the chapter, he says of the findings that excited him so much the night before, "How stupid it all sounded." And how stupid his forays into detection will look, too. He will bypass the obvious and base his conclusions on flimsy, sometimes nonexistent evidence. The people he singles out as likely suspects are innocent, whereas the culprit escapes his notice most of the way. Sometimes, as in Chapter 6, he finds new ways to miscue. Here, he places his camera so that he can spot anybody trying to take it. His plans miscarry. Even though he stations himself to avoid being seen while commanding a clear view of the camera, he is quickly outflanked. A door behind him slams and locks shut, and, after he finally opens it, he sees that the camera, the only bit of evidence that can win him freedom, has gone. He has nothing left with which to prove his innocence.

Not surprisingly, each of his succeeding attempts to brighten his fortunes only darkens them. He's knocked out from behind, and his pockets are searched. Then his room is searched. When he complains to the hotel manager, he is again foiled. The police had told him both to burst the locks on his suitcase and to lie about the theft of some of his property. An experienced hotelier, Albert Köche, methodical, controlled, and systematic, sees through the fraud quickly. And he wastes no time dismantling it. Thrown badly off stride, Vadassy only embarrasses and incriminates himself more deeply in his efforts to look innocent. This typifies him. Regardless of any initial advantage he may enjoy with an interlocutor, here and elsewhere, he moves quickly to the defensive. Twice he finds himself volunteering information to suspects he approached with the goal of unearthing information himself. The deft burglary of his room inspires him to try his hand at burglary, too, with the predictably woeful results. Not only is the suspect whose room he is searching innocent and thus undeserving of his fumbling efforts; the suspect also catches Vadassy in his room uninvited. When Vadassy is arrested at the end of Chapter 12 and taken to the police station, he fully merits Beghin's angry salvo: "You haven't any sense and you don't know what you're doing. You're a fool. You've blundered so many times that I've lost count of them."

Although his blunders and woes both occur in France, they look to

England, the guests assembled in the Réserve recalling those at an Agatha Christie weekend house party, as in *Ten Little Indians* (1943) or *The Mousetrap* (1952). Like Christie's people, all the guests have something to hide, and none is what he/she pretends to be. First, the engaged American cousins of 20 and 23, Mary and Warren Skelton, have registered as brother and sister in order to occupy the same room. Next, Köche, the hotel manager, is having an affair with a local woman, and a guest who claims to be a leading industrialist is just a clerk. A stodgy Swiss couple turn out to be spies, while a retired British Army major endowed with old-world breeding and elegance is so poor that he tries to borrow money from strangers. Except for the disclosure that French naval intelligence had identified the spy at the outset, *Epitaph* stands as a real whodunit. And it stands foursquare because the book's point-of-view technique limits our knowledge to what Vadassy sees and understands, which is very little. The first-person narration discloses the identity of the spy, the French-Italian André Roux, to Vadassy at the same time it's disclosed to us. This climax of recognition is followed by a technical departure from country-house aesthetics that keeps the action hot. An exciting chase sequence replaces the verbal climax in which the Great Detective gathers all the witnesses and suspects in order to name the culprit. After an exchange of gunfire, Roux is shot while jumping from one roof to another in Toulon's shabby warehouse district. The cheerful, open-air bayside setting of the Hotel Réserve has yielded to a depressing network of dingy, narrow streets, a fitting place for a death of dubious import.

Perhaps Ambler had this lower-depths *verismo* in mind when he said in his footnote to the first American edition of *Epitaph* (1952) that the book was "a mild attempt at realism."[2] Realism also stems, first, from his portrayal of Vadassy as both hunter and hunted man and, next, from the way this intellectual gets swept into the pursuit of Roux at the end. His joining Beghin and his colleagues as they chase Roux looks ahead to the escalating verve with which Charles Latimer tracks Dimitrios. But, perhaps more significantly, it describes, long before writers like Saul Bellow, Norman Mailer, and Yukio Mishima, the spell that criminals exert upon intellectuals. The object of Vadassy's enthusiasm, André Roux, also conveys a realism in keeping with nasty, bitten-up Europe on the brink of war. Unsavory Roux is. He boasts about his prowess at billiards, sulks when he loses at ping-pong, and both nuzzles and nibbles his traveling companion, Odette Martin, in public. This cynic also believes all men to be cowards and liars who are ruled by the love of money. Here he invokes Ambler's remark that *Epitaph* contains "no professional devils."[3] For all his villainy, Roux doesn't treat Vadassy any worse than Beghin does. The explanation that Beghin is defending France's security hardly excuses his unscrupulousness in risking Vadassy's life; no spying operation can justify the death of an innocent civilian.

Roux's motives are no uglier. Only when he felt threatened did he attack

Vadassy. In any case, he dies before explaining himself. This is unfortunate. Any time that a fictional culprit is denied the chance to take the witness stand and defend himself, authorial wire-pulling has intruded. Yet Panek, intriguingly, sees this wire-pulling as part of Ambler's creative intent: "*Epitaph for a Spy* emphasizes the mundane, seedy, sordid, and pathetically inconclusive nature of espionage" (143). This interpretation gains strength from Beghin's explanation of why Roux agreed to spy on France, to begin with: "He was probably paid on results. I expect he needed the money." In a world ruled by self-interest, money has replaced honor, justice, and mutual trust as guidelines for personal behavior. Why shouldn't it inspire treason, too?

Readers who might complain about Ambler's decision to bilk Roux of his chance to explain himself might find firmer grounds for complaint elsewhere in the book. First, Ambler misleads us by devoting much of Chapter 10, the midmost chapter of his 19-chapter book, to the off-stage actions of characters who prove secondary. He has trailed his red herrings deftly through a thematic void. A reader coming to *Epitaph* in 1938 would rivet on the disclosure that Major Herbert Clandon-Hartley has an Italian wife, just as he/she would note carefully that Roux's mother comes from Mussolini's Italy. (In *Background*, the failure of Italy to strengthen her military arm served *both* Soviet and British interests.) Never mind that Mussolini and his Fascisti are rarely thought of or spoken of today. The speed with which the Clandon-Hartleys leave the book after dominating its central chapter makes us feel misled. Structure bedevils Ambler elsewhere, too. He weakens the forward drive of the novel by putting Roux forward as the most likely suspect in Chapter 15 and then dropping him until Chapter 18. In Chapter 18, where Roux dies, Beghin's summary of the investigation centering on him rings false. Beghin is speaking of Roux's paymaster, a creature who only appears before us for one sentence: "The one I *am* glad to get is Maletti, or Metraux, as he calls himself. He's the brain behind all this. Roux was never important, just an employee. We shall get the rest soon. All the information is here."

But if Roux was a pawn, then we can argue that the man used to coax him out of hiding, Vadassy, is also a pawn, especially because French security relied on his incompetence, rather than his skill, to serve their interests. France, one of the Allied powers, has exploited an individual to foil an Axis nation which rated persons below the state. In other words, Beghin is using the very tactics that make his country's enemies so pernicious and important to defeat. His country, in fact, will soon fight a war whose chief aim is the suppression of state worship. Besides being bad literary art, Beghin's bald statement of victory makes us feel cheated, for our own sake as well as Vadassy's.

We don't feel cheated for long, though. Vadassy's arrest in Chapter 1, no red herring, grips us straightaway. Unifying what follows are Vadassy's deepening worries and the telephone calls he makes to Beghin to report on his progress. Another telling structural motif comes in Chapter 7, where he plays

billiards with the man he had labelled "Suspect Number One." Using a device found in works as different as Thomas Middleton's *Women Beware Women* (c. 1621) and *A Game of Chess* (1624), Ingmar Bergman's *The Seventh Seal* (1956), and Greene's *Our Man in Havana* (1958), Ambler shows the progress of Vadassy's billiards game reflecting that of turns in his conversation with his opponent. No true contest takes place at either level. But if Vadassy's dual defeat by Paul Heinberger, a.k.a. Emil Schimler, is more discomfiting than shattering, then Ambler's intention has been served. A totally defeated and demoralized Vadassy couldn't go on investigating, even as badly as he does. Style has chimed with narrative tempo. Because Ambler wanted to mute a sense of urgency or finality in his descriptions of Vadassy's many blunders, he couched *Epitaph* in a spare, precise style. Perhaps Howard Haycraft was referring to the unhurried, noiseless accuracy of Ambler's prose when he praised the book's "understated realism."[4]

The book finds it voice quickly. Its short opening paragraph counterpoints the dry, flat tone that will prevail in the following pages with the adversity being described: "I arrived in St. Gatien from Nice on Tuesday, the 14th of August. I was arrested at 11:45 a.m. on Thursday, the 16th, by an *agent de police* and an inspector in plain clothes and taken to the Commissariat." Writing with a new confidence, Ambler knows that this verbal irony has captured our attention. Thus he moves away from the high drama of Vadassy's arrest in order to describe St. Gatien and its surroundings for the next three paragraphs. Not until his leisurely description ends some 700 words later, does he return to poor Vadassy's troubles.

But *Epitaph* has more to recommend it than language and pace. The stylistic achievement that sends the plot through some sidewinder loops gains warmth from humane insights into character. The humbling effect of these insights upon Vadassy discloses in Ambler new ways to win thematic goodness from first-person narration. Forgetting his own problems, Vadassy resists lying to Köche about his property being stolen because he shrinks from incriminating an innocent chambermaid in the burglary. He's humbled again when he hears how Heinberger/Schimler, a victim of Nazi persecution, has taken greater risks and suffered more deeply than he. Posing as a traveling salesman, Heinberger/Schimler crossed into Hitler's Germany 30 times one year to circulate anti-Nazi propaganda before being spotted by the Gestapo. Now he can't return to Germany lest he be arrested and killed. The pain of being parted indefinitely from his wife and child, Nazi hostages both, together with the news that a Gestapo agent has slipped into France, perhaps to kill him, have roused in him a dread that Vadassy has never felt.

This fusion has inspired in Köche, who has clothed and bankrolled Heinberger/Schimler while putting him up at the Réserve free of charge, a generosity that Vadassy would never have credited him with. This "amazing friend," the fugitive he has befriended, and the out-of-pocket Major Clandon-

Hartley, whose money-cadging looks different when seen from the perspective of the lung damage inflicted on him by poison gas during the War, all enrich the reported action. Ambler deserves special acclaim both for communicating this vigor and for describing its upsurge so well. The heartbeat of *Epitaph for a Spy* makes the book's most surprising feature the fact that it had to wait 14 years after its British publication to go to press in the United States.

# Chapter Four
## This Madhouse Called Europe

Ambler's second trio of novels carries forward many of the traits found in his first. Unfolding in foreign settings, they offer a richness of event and action developed by sharply drawn characters who, though lacking depth, invite large issues. Some of these refer to Ambler's private insecurities. The others, though less vital today than fifty-odd years ago, stem from the Marxist standpoint from which the arms race, the ensuing war hysteria, and the demands of spying is viewed. As in Ambler's first three books, suspense rises from the heroes' close escapes from both danger and death, either through luck or through the efforts of others. Both these escapes and the events leading up to them create more excitement than Ambler credits, thanks to the clean, spare, ringing effects that bring them to life. Speaking of the novels published between 1937-40, he told Joel Hopkins in 1975, "those were cartoons for later books" (286).

Among those disputing this self-detraction are Allen J. Hubin and Graham Greene. Writing in 1951, Greene claimed that Ambler's prewar books established him "unquestionably as our best 'thriller' writer" (49), while Hubin begins his 21 September 1969 review of *The Intercom Conspiracy* for the *New York Times Book Review* by saying, "Eric Ambler's reputation rests most securely on the half-dozen novels he wrote before World War II" (44). These two yea-sayers come closer to the truth than the self-disparaging Ambler. We can see why. While noting his tendency in the 1970s and 1980s to downgrade his early work, we must also cite the buoyancy and lyricism, the swiftness, and surprise found in *Cause for Alarm, The Mask of Dimitrios,* and *Journey into Fear.* These books have very little flab; their dialogue flows smoothly; characterization in them is both convincing and consistent enough to move the well-worked plots.

Whether these novels surpass artistically Ambler's later work is hard to say. Any comparative judgment between the two sets of books depends largely on taste, mostly because they differ so much. The earlier works move more quickly, engage their issues more directly, and convey the social atmosphere in which they take hold just as faithfully as their later counterparts. The sign-posts are also clearly marked in these well-crafted books. A contemporary reader would have found his/her way into them very easily. That Ambler would write more subtly interconnected books about a more puzzling world as his career advanced can't discredit the penetration and drive of his prewar fiction. These

early books stand the same good chance of being read more often than their later counterparts a hundred years from now as do Greene's entertainments *vis-à-vis* his more avowedly serious work.

*I*

*Cause for Alarm* (1938) recreates the grimness and uncertainty of 1930s England more deftly than any Ambler to date. Industrial squalor intrudes itself in the second chapter, where the book's hero, Nick Marlow, visits a factory described as "a dingy, sprawling collection of buildings at the end of a long and very muddy road." Layoffs, drops in both production and salaries, and a trade recession have also darkened English life. The recession—which has hurt wage earners while enriching investors and shareholders—has boosted the popularity of socialism. Marlow's best friend in London is a socialist, and the Soviet spy Marlow spends more time with than anyone else in the book, Andreas P. Zaleshoff of *Background to Danger*, outshines all the other characters. Business is portrayed cynically. The Spartacus Machine Tool Company of Wolverhampton sells machines used for the making of arms for the Italian Admiralty at a time when Italy and Great Britain are feuding. Greed also means more to the Italians than patriotism. Instead of buying goods from Germany, his country's ally, an Italian purchasing agent contracts with a British firm that will pay him a secret two per cent commission.

Even allegiance to one's firm outpaces national loyalty. Promoting his company's interest in Milan, Marlow has no qualms about building up Italy's striking power despite the widespread dislike of Britons among Italians. The weasel words he utters to justify the selling of war materials that could destroy British lives violate all standards of decency and humanity: "I am merely the agent.... There is a job to be done. If I do not do it, then someone else will." Not surprisingly, in one of Ambler's most deftly understated effects, this moral defeatist takes a job at the end with the notorious armorer, Cator and Bliss, a firm that once employed the book's arch-villain, Lt. General Johann Luitpold Vagas.

This outcome seems unlikely at the book's start. The day after proposing to Claire, Marlow, a production engineer, learns that he has lost his job. After two and a half months of joblessness and sinking self-confidence, he agrees to manage the Milan office of Spartacus, a maker of machine tools used to produce munitions. From all that goes wrong in his first week in Milan, it follows logically enough that the man he has replaced, one Sidney Arthur Ferning, was a murder victim. Marlow's passport is taken and then reported missing by the local *Amminiztrazone*; his incoming mail is steamed open and read; while walking through the Public Gardens, he notices that he is being shadowed; a note pressed into his hand after an evening at the ballet claims that Ferning *was* murdered; midway through the book (in Chap. 9), he is beaten up by thugs from the OVRA, Mussolini's version of the Gestapo; a warrant is

issued for his arrest.

As if these setbacks weren't vexing enough, he suspects that everybody has been putting him at risk for selfish reasons. His chiefs at Spartacus sent him to Milan without bothering to investigate Ferning's death. His freedom of access to Italian arms factories encourages the Nazi spy, General Vagas, to buy seemingly harmless military secrets from him which Vagas then uses to blackmail him (the suspicions riddling the Berlin-Rome Axis, a big issue of the day, also came across in Charlie Chaplin's *Great Dictator* [1940]). Besides lying to Marlow about being an American citizen, the communist agent Zaleshoff also tells him to league with the dangerous Vagas so that he, Zaleshoff, can use Marlow to channel misinformation to Vagas and thus aggravate tension between Berlin and Rome. Marlow's welfare in the transaction seems trifling to him. When Marlow says later that he was beaten by thugs, Zaleshoff can only reply with a puzzled look, "I don't understand it." Either he never pondered the risks to which his mission of counterintelligence exposed Marlow or he believed them worth taking, since they didn't endanger his own neck.

And how much is Marlow's neck worth, anyway? Ambler invites us to ask. Not much, if we take Marlow's word for it. Like Vadassy and Kenton before him, he tends to downgrade himself, claiming, in Chapter 13, "I don't see why I should be so important." Perhaps this tendency explains his willingness to become Vagas's spy and then his blackmail victim; any possessor of a good sense of self-preservation would have given Vagas wide berth as soon as he/she heard his first offer. On the other hand, Ambler shows through Marlow, as Greene did in *A Gun for Sale* (1936), *The Confidential Agent* (1939), and *The Honorary Consul* (1973), that an ordinary person can perform extraordinary feats. Marlow's privileged access to Italy's military capability can fuel the mutual distrust between Germany and Italy and, perhaps, serve world peace. And this innocent does vault from the ranks of the jobless to delay global disaster by serving *both* the Soviets and his homeland, Britain. Perhaps Ambler is claiming through him that the most unlikely person can achieve heroism.

But not on his own; he needs plenty of luck and outside help. At the outset, we wonder why the "very promising surgeon" Claire wants to marry this self-styled "insignificant engineer," since both her training and her outlook surpass his, together with her sense of purpose. When Marlow asks her what her father will say about her plans to marry a jobless man, she snaps back, "He'll say exactly what I tell him to say." Then she prods Marlow into working for Spartacus in Milan because she suspects that, without a job, he'd lack the self-worth to marry her. Like a medieval knight, he must prove that worth by withstanding physical danger before claiming the beautiful damsel. This he does in a grudging, backhanded way. Easily led and manipulated, he hires on with Spartacus after insisting that he wouldn't, just as he will agree to spy for Vagas, even though he knows that poor Ferning's downfall began with the same

agreement.

Claire (no last name given), it needs saying, is Ambler's first female prod. Though less of a person than a plotting device, she both sends Marlow to Italy and provides the reason for his wanting to come home. Perhaps women were taking on new importance to Ambler at the time. He married Louise Crombie in 1939, the year after *Alarm* came out, and he dedicated his 1940 novel, *Journey into Fear*, to her, as well. *Alarm* also brings back Tamara Zaleshoff, along with her capable, iron-willed brother. But her relative insignificance in the book foils any intention Ambler may have had to portray a woman in realistic depth. Though striking looking, enigmatic, and as given to bickering with Andreas as she was in *Background*, she plays a much smaller role than in her literary debut. Her reunion with her brother in Belgrade in Chapter 17 after a long separation shows more restraint than a similar one in *Background*, and she both appears less frequently and has less to say than before. If Andreas's reappearance suggests that Ambler might have been thinking of using this Soviet spy as a series hero—an idea negated by the notorious Berlin-Moscow Nonaggression Pact of 1939—*Alarm* contains little or no evidence that Tamara would rise to the eminence of a Nora Charles from Hammett's *Thin Man* (1934) or a Pam North from the Mr. and Mrs. North series by Richard and Frances Lockridge.

Her subordinacy, like that of Claire, stems from Ambler's ongoing practice of portraying heroes who react more vitally to men than to women. As in his earlier books, the influential male in *Alarm* embodies the leadership, the power to punish, and the magnetic authority of the archetypal father. As hard as the son tries, he can't resist or rebel against this authority and might. If the Tamara Zaleshoff of *Alarm* blanches alongside the Tamara of *Background*, her brother re-emerges with new splendor. The Ambler of *Alarm*, meanwhile, discloses a consistency of attitude traceable not only to *Background* but also to *The Dark Frontier*. Still drawn to the heroism popular in his father's day, he transfers to Zaleshoff the virtues he had instilled in both the amnesiac Barstow and, more subtly, the Zaleshoff of *Background*.

Like the English clubman-hero, Zaleshoff keeps impressing us with his expertise, self-command, and sheer nerve, virtues that support an enormous thematic load. The book's source of information and political morality as well as the mastermind of the long escape sequence at the end, he wins the admiration of Marlow. Marlow will blame him for his troubles as in Chapter 14, when he says, "He was responsible. But for him, I should be sleeping comfortably in my room.... Zaleshoff was the villain of the piece." But in the next chapter, Zaleshoff redeems himself. What looks like tactlessness proves to be a stroke of wisdom when he addresses a guard wearing a mysterious tattoo on his arm as "comrade." "No, you could not help liking Zaleshoff," Marlow notes while parting from his deliverer a few days after observing, "Zaleshoff's was not physical superiority, but moral."

Political activist and guerrilla, man of action and humanitarian, Zaleshoff

deserves this praise. In Chapter 15, he dashes brandy into his captor's eyes and then smashes a light bulb to darken the rail shed from which he and Marlow will soon escape. Outstanding courage goes along with his sharp reflexes. "In a fraction of a second," he knocks out the man who had found him and Marlow hiding atop a cattle van. His expertise with disguises includes insights into the way changes in facial hair and wads of cloth stuffed inside the cheeks can alter a person's appearance. Also included in the course in survival tactics this brilliant field spy must have taken, and mastered, were the ability both to speak flawless Italian and to squeeze an extra mite of vim from his exhausted body. At one point, he surprises a weary, aching Marlow by coaxing him into sprinting and then making him feel refreshed.

Zaleshoff enters the novel because his Milan office occupies the same building as Spartacus. Still wearing the same jut-jawed pugnacious look and heavy muffler he favored in *Background*, he accosts Marlow in the hallway outside his office in a way that looks more planned than accidental. He compels Marlow immediately. Marlow disbelieves his description of himself as "a simple American with a little more money than I need" and "a simple American who hates war." In fact, he calls Zaleshoff "not at all my idea of an American." Nevertheless, he keeps doing Zaleshoff's bidding. He lets Zaleshoff both arrange his meetings with Vagas and concoct the phony reports he hands the General. During the toilsome trek from Milan to Belgrade, he yields to Zaleshoff completely. His surrender of will from the time Zaleshoff meets him at Milan's main train station and orders him back into his coach begins a chain of events that makes him Ambler's most compliant hero to date. Compliance serves him better than he could have expected. When told in Chapter 13, "Get wise to yourself and do as I tell you," he answers with a shrug, "Well, I suppose it doesn't make much difference." Wrong. He couldn't have found an abler, shrewder person to rely on than Zaleshoff. Zaleshoff knows how to avoid detection and arrest; he's an expert with a map and compass; he knows train routes and schedules; besides buying clothes for the long ordeal, this quick-change and disguise artist also decrees when they should be worn and shed; he tells Marlow when to sleep. As witty as he is self-controlled, he never admits that he's a communist spy even though his telling last gesture shows him waving farewell to Marlow with a bright red handkerchief.

Through it all, he pushes himself harder than he does Marlow, letting his mate sleep while he gets food, clothing, and information about their next move. And it's his friendly overture that ends the one big fight the two men get into. He shows much more of himself to and interacts much more vitally with Marlow than he did with Kenton in *Background*. What is more, his patience, his putting Marlow's comfort before his own, his feeding and sheltering Marlow, and his leading him from danger to safety also show him in a fatherly role. And in case there's any doubt that the paternal archetype has tightened its grip upon Ambler's psyche, we should note that Zaleshoff isn't the book's only father

figure. Controlling Marlow also is the Nazi spy, General J. L. Vagas.

Like Zaleshoff, Vagas has an international background and a linguistic flair which add a mystique to his power. He is also paired with a woman of lesser thematic importance than he; in fact, his wife Elsa dies before the novel ends, whereas Tamara survives. Representing the far right wing, just as Zaleshoff is a radical leftist, he rejects compromise. But, lacking Zaleshoff's good heart and nurture, he also enacts the punishing father who won't be denied. He offers Marlow 3000 lire a month for information about the shell-production machines that Spartacus has sold to various factories around Italy. Then, having won Marlow's cooperation in what looked like a harmless arrangement, he steps up his demands. His hands already tainted, Marlow lacks the moral leverage to resist, even though he knows that his predecessor Ferning's violent death came from collaborating with Vagas.

The *coup de grace* in Vagas's shattering of Marlow's resistance comes in his reversing an argument Marlow used with him when negotiations began between the two men. When Marlow asks him whether his chief in Wolverhampton should know of the General's offer, he hears that making official a private agreement between gentlemen would be indiscreet and possibly embarrassing; why burden the chief by telling him about an arrangement that doesn't affect him? Yet later when Marlow protests Vagas's stepped-up demands for military intelligence, he hears, first, that he's already a spy and, next, that copies of the Spartacus reports now in Vagas's hands could easily be sent to Wolverhampton to prove it. But blackmail isn't Vagas's most sinister persuader. To win Marlow's compliance, Vagas approaches him in a feminine way, wearing powder, rouge, and perfume, and, in Chapter 12, touching his knee. His blandishments imparted a hideous sexuality from the start. In Chapter 3, called "The Painted General," he telephones Marlow at a time of night when Marlow is thinking about sleep; the phone with which Marlow speaks to Vagas is next to his bed; observing proper courtship etiquette, Vagas takes him to the ballet before making his proposition, bringing along his wife as chaperone. (Vagas isn't the novel's only effeminate power figure; the Fascist captain of police who interviews Marlow in Chapter Four wears a corset.) The array of seductive associations called forth by Vagas infers a serious threat. Ambler let both himself and his unformed thirty-five-year-old engineer-hero off too easily—first by having Zaleshoff write the reports Marlow passes on to Vagas and, then, by sending Vagas to Belgrade, where he can't harm Marlow, after Elsa's death.

The Vagases cause other blemishes in the book. To move forward, the plot rests on a good deal of asserted material involving them, like Elsa's alleged hatred of the General, an impulse that prompted her both to spy on him for OVRA and to tell Marlow that he killed Ferning. The matter of her death is also mishandled. Disregarding the rumor that her husband pushed her out of her fourth-floor window, we can still indict Ambler for cheating. He uses Elsa

Vagas to advance the plot by making her Marlow's informant. But then, after explaining her motives by hearsay, he kills her off. His inability to portray lifelike, sympathetic women also mars the book's plot structure. As has been seen, Claire merely gives Marlow a reason both to go to and then return from Italy. The love story involving them is casual and brief because Marlow's real ties yoke him to Vagas and Zaleshoff. When these two high-level spies leave the book, Marlow drifts about, perhaps because he prefers the extremism they represent over the safe middle-ground nest that awaits him with Claire. He lacks the maturity to replace melodrama with comedy. Thus the book ends weakly, with interviews between him and two minor characters, both men, the latter of whom is appearing for his first and only time.

But this weak finale matters little alongside the book's many virtues, the first of which is the admirable way in which the prologue prefigures the harshness to follow. Described here is the gruesome death of Ferning. After seeing that their car's first attack upon Ferning didn't kill him, his attackers climb back into their car and ram him again. Never mind the two sets of tire marks on the body. The police, who are controlled by OVRA, will explain the murder as accidental. Their compliance typifies the regime they serve. The fascist emphasis upon discipline, order, and military hierarchy brings to vivid life Il Duce's Italy. Taking the larger view, Ambler also shows how totalitarianism can't suppress the artistic sensibility that crosses both international frontiers and generations of refined tastes. Characters attending a performance of *Swan Lake* at Milan's La Scala enjoy champagne and caviar from their private box. Later, during intermission, German, French, and Spanish are all heard in the lobby, while "a Hindu, a Chinese, two Japanese, and a grey-faced man wearing a tarboosh" appear in the middle distance.

But the book's main virtue takes root in a realm far from the cultured graces connected with La Scala. That realm is the hostile terrain—"a country of fantastic confusions and strange images"—Marlow and Zaleshoff slide, trudge, and roar through in their quest for freedom. Challenging himself artistically, the Ambler of *Alarm* reverses his practice, from the finales of *Frontier* and *Background*, of describing the hero's enemy speeding toward a friendly border. He invests more than a third of the action of *Alarm* in the struggles of Zaleshoff and Marlow to reach Yugoslavia, and his investment brings solid gains. After jumping from a moving train, the men cover 35 kilometers (about 22 miles) in an all-night overland trek; they change clothes several times; board a freight train and then climb a cattle van to foil their pursuers. Through it all, as has been seen, Zaleshoff carries the day with his mastery of survival tactics both on the road and in town.

He needs all of his skills to get himself and Marlow through their last ordeal before reaching safety, a climb through heavy snows over dangerous highland in the dark and wind:

We started to climb again. The way was steep and dangerous. With each difficult step I could feel my strength going. The cold and the altitude were slowly overcoming me. My heart was pounding furiously.

Their heads swimming and their blood thudding, the men must keep walking because they'll either catch pneumonia if they stop or get arrested if they board a train. Ambler's stylistic brilliance both makes this last part of the trek the most brutal and imparts the vivid, harrowing climax the trek deserves. As the freakish May snow reaches the men's waists and both cold and darkness set in, a sense of malevolence in nature imposes itself:

The top of the ridge was partly screened by trees, but the shelter they gave was negligible. The snow did not fall in flakes, but in great frozen chunks. There was a frightening savagery about it. There was no wind and it fell vertically; but when we moved forward it beat against our faces with stinging force.

Numbed by the cold and barely able to see through the hissing, beating snow, the weakened travelers must pick their way across steep, rocky ridges. The terrors posed by the footing beneath them are conveyed by a frightening image: "The side of the ridge was scooped out in a series of hollows like huge teeth marks." Originality like this spells out with sharp immediacy both the fear and the near helplessness seizing the two men. It also allows us to share their relief when they reach safety without having been mangled or chewed by the tricky rocks they have crossed.

This breathtaking finale and the long adventure sequence preceding it are both anchored in a richly varied human drama. Ambler's praise of Conan Doyle, written in 1974, applies just as much to *Alarm* as to the Sherlock Holmes stories Ambler first read and admired as a boy: "Today the things that most impress me about these stories are the natural skills with which they are told and the quite subtle ways in which even the most fanciful plots are made believable" (10). Some of the best effects in *Alarm* look effortless. Details pertaining to both the production and procurement of weapons reflect authority while avoiding pretension. Writing in different voices, Ambler composed Chapter 10 as a series of letters by men and women, the subject matter of which is both business related and personal. He also injects surprise into the plot. In Chapter 7, Zaleshoff details Vagas's villainy for Marlow's benefit. After ending his recitation with a reference to Ferning's murder, he then urges Marlow to accept Vagas's offer to do the same work performed by his dead predecessor. Ferning's killers threaten Marlow for the last time in Chapter 11, where he and Zaleshoff use a street parade to escape their OVRA shadowers. This scene builds unusual excitement with its waving flags, marching bands, bellowing loudspeakers, and swarming, cheering crowd packed ten deep on the sidewalk. The ability of Zaleshoff and Marlow to profit from this chauvinist hysteria

supplies one of the book's most pleasing ironies. By the time their OVRA shadowers reach the edge of the street the two men have just crossed, the procession is filing past and blocking their way.

Since the person who foils OVRA here and the Nazi Vagas elsewhere is Zaleshoff, a Soviet agent, Clive James's disclaimer about the political naïveté of Ambler's early fiction deserves attention:

The nature of the Soviet Union has not been perceived at all.... He...doesn't catch the implications of totalitarianism on the Left. He has seen the descending hammer without realizing that he is standing on the anvil.

James argues well. By the time *Alarm* was published, Stalin had already been ruling the USSR for 15 years, and some of his atrocities had leaked to the western press. The book's title refers to the threat posed by the Berlin-Rome Axis, and not to Soviet atrocities, though. The last chapter, "'No Cause for Alarm,'" has this focus. By citing, in the epilogue, "the unexpected but welcome coolness which has developed lately between two partners of the Axis," Ambler is indirectly crediting Marlow with having brought it about. The reference in the book's last paragraph to the "extended cooperation" of France, Great Britain, and "our ally, Soviet Russia" reminds us that Marlow couldn't have brought about anything without the help of Zaleshoff, the book's spokesman for decency and humanity as well as a man of action. Ambler's portrayal of this dictator's stooge as a paragon was, admittedly, wrongheaded. On the other hand, Ambler's bitterness over the Berlin-Moscow Pact of 1939 kept Zaleshoff, along with any other sympathetic Soviets, out of the later books. Moreover, Ambler's first postwar novel, *Judgment on Deltchev* (1951), describes both the repressiveness and the futility of Soviet bloc politics. Ambler had seen his mistake and not only learned from it but also used it to sharpen the reader's political awareness.

This same sharpness distinguishes *Alarm*. Even when Ambler is naïve, he expresses himself with a clarity that reveals exactly where he stands. This same clarity infuses his impressionistic, or point-of-view, technique with vividness and immediacy. We share Ferning's impression that he is going to be run over in the prologue: "The headlights grew suddenly larger, blinding him," Ambler says, describing the terror of facing an oncoming car rather than telling us that the car was closing in on its intended victim. His ability to strike in with the precise devastating detail, as he does in Chapter 13, shows the commonplace turning suddenly into nightmare, i.e., the desperation of feeling trapped, alone, and helpless. Marlow had looked at the wheels of a railroad train countless times. As he is about to jump from a moving train, though, the wheels turning beneath him remind him "irresistibly of bacon-slicing machines." Two chapters later, while being held prisoner in an engine shed and fearing for his life, he shows the effects of prolonged nervous strain—by yawning. Insights like this,

together with the book's many other merits, more than make up for the rare blemishes that mar but briefly the luster of *Cause for Alarm*.

## II

Justly called Ambler's "finest book" (1972, 239) by Julian Symons and "one of the undisputed masterpieces of the genre" (4) by Joseph Wood Krutch, *The Mask of Dimitrios* (1939) finds both its subject and its rhythm immediately. Charles Latimer, the main figure, was a university lecturer in political economy with three books to his credit. Then he wrote five crime novels, the success of which freed him from academe. But he needs more change. He wants to move closer to the crime and the criminals he has heretofore only written about. Aware of the Jamesian clash between the messiness of life and art's shapeliness and order, he feels compelled by the artist's passion for wholeness. He also believes his compulsion can be gratified. His detective writing has helped him establish motives consistent with people's actions. As an academic, he also knows how to find the data that undergird motives. Thus, sometimes helped by an interpreter, he will study police archives, court records, letters, and news stories, and he will hold personal interviews. But being systematic and methodical doesn't always answer his needs. Hamstrung by delays and wasted effort as he goes to Istanbul, Smyrna, Athens, Sofia, and Paris, he sees the trail dividing him from his goal fade and cool. But then, thanks largely to his patience, persistence, and researching skills, it will heat up. A visit to Athens in Chapter 4, for instance, gives him a key fact that has eluded Turkey's chief of secret police.

And one such item will give rise to another. In his hunt for clues and leads, Latimer learns that people would rather talk than hold back. His detective writing has also taught him how to tease out information from witnesses, giving them the excuse they want to unburden themselves. Besides speaking their hearts, they enjoy talking to Latimer, a person they believe sensitive and intelligent, because they too want to be esteemed as sensitive and intelligent. Then there is the magnetic subject of their talk. Everybody speaks at length about Dimitrios; he has lodged himself in the psyches of all who knew him, even those he has hurt. But he also lodges himself in Latimer's psyche. And the new materials unearthed by Latimer's investigations feed his obsession. In Chapter 5, he interviews an Athenian bawd who knew Dimitrios personally. Ironically, he had already met one Frederik Peters, or Petersen, a former colleague of Dimitrios's without knowing of their tie. A second meeting with Peters at the end of Chapter 6 shows his supposed intellectual exercise to have advanced further than he suspected. Upon entering his hotel room, he finds the place ransacked and Peters pointing a pistol at him.

What starts the process that materializes the pistol is a dissatisfaction with both the tameness and predictability of his safe, sedentary life. No longer content to write about detection, he wants to live it. And because he presumably

saw the criminal Dimitrios's corpse in a Stamboul morgue, he believes that he can conduct his "experiment in detection" safely. The sight of the corpse frees his imagination. The cruelty and violence perpetrated by a supposedly dead man provide the civilized intellectual Latimer with an excitement he can't beget on his own. Enhancing the excitement is the belief that his investigations into Dimitrios's past can't harm him. Thus he sinks a great deal of money and energy into a project he denounces as idiotic while also chiding himself for wasting time. The "emotional element" he confesses to having invested drives him to reconstruct Dimitrios's past. Combining the techniques of the historian, the biographer, and the psychologist, his reconstructions bring shocks. The more data he discloses, the more the emotional element builds. But the element is destructive, and his increasing recklessness puts him at greater risk than he had imagined possible. Even though reason tells him to drop his quest, he moves forward with it. And, in one of modern British fiction's most stunning metaphors for creation, his obsession materializes Dimitrios.

Fittingly, the last six chapters of *Mask* take place in Paris, the center of artistic activity for the West from 1918-40. Latimer's transformation of a corpse into a living man rivals the feats being performed nearby at the time by Gertrude Stein, Joyce, Picasso, and Stravinsky. The identity of the corpse Latimer had seen in the Stamboul morgue has proved as fictitious as any found in his novels. As in James's *The Aspern Papers*, a legend has sprung to life, but with more shocking results. The living Dimitrios proves just as menacing and ruthless as was claimed in the reports Latimer had seen or heard.

The terror he unleashes says a good deal about him and, with him, his creator Ambler. Like Latimer, Ambler was growing restless with his writing career when Dimitrios snagged his imagination; his next novel, *Journey into Fear* (1940), in fact, would be his last until 1951. His fascination with the brutal Dimitrios rivals Latimer's. It may even surpass it, in view of the outlaw's lineage. Again, in an Ambler novel, the person of special powers is a non-English male older than the hero, like the Russian-American Zaleshoff and those brave anti-Nazis, Koche and Heinberger/Schimler of *Epitaph for a Spy*. (The Dane Frederik Peters also belongs to this elite since he kills Dimitrios.) In each case, Ambler's avoidance of an Englishman as his manly ideal laces his social protest with eroticism. This lacing is perhaps more trenchant in *Mask* than in any Ambler to date.

Having failed in his characterization of Claire, Marlow's fiancée in *Alarm*, the Ambler of *Mask* returns to the bachelor hero of *Background* and *Spy*, keeping the hero romantically unencumbered. He returns with a sense of relief. Latimer's interest in women runs so low that it would be difficult to imagine him married. The first two people he spends time with alone are both men, the Istanbul banker Collinson and Colonel Zia Haki of Turkey's secret police. A Sofia nightclub he visits in Chapter Six features "a youth dressed as a woman." Two women are dancing "solemnly together" when he and a journalist enter the

club. The journalist's first words upon seeing the women, "Too early.... But it will be gayer soon," foreshadow his thinly veiled qualification concerning them voiced minutes later, "if you don't want to be bothered with them." Perhaps he has seen something in Latimer that Ambler isn't sharing with us, at least not directly. Latimer's retort, delivered "firmly," "I don't," discloses an attitude that will persist throughout the book. In Chapter 8, Latimer says of a retired male spy, "You could picture him without effort in the role of lover...a thing...that you could say of few men of sixty and few of under sixty." He certainly finds nothing loverlike in Irana Preveza, the ex-prostitute and brothel keeper who owns the Sofia cabaret he and Marukakis, the journalist, visit in Chapter Six. In the first sustained description of a woman to date in Ambler, Latimer singles out her ugly voice, bad teeth, and "loose raddled" facial skin, devoting but a few words to her body. Neither does he spend time alone with either her or any other woman in the book, whereas he seals himself off with men for long spells.

Sometimes called Dimitrios Makropoulos, Talat, or Taladis, the book's title figure also uses the sexually charged alias of Rougemont. The name evokes both the *mons veneris*, or mound of Venus, the pubic arch between a woman's legs, and the famous sexual anthropologist, Denis de Rougemont, author of *Love in the Western World* (1939). But these erotic associations refer to the force with which others respond to Dimitrios rather than to Dimitrios himself. Although his heroin trafficking would lead to his later addiction, the book contains no evidence that his career as a pimp or white slaver turned him into a womanizer; Irana Preveza, the cabaret owner, in fact, believes him incapable of love. Perhaps crime kills the sexual urge altogether, Ambler wants us to believe. Though Dimitrios does spend time with a rich socialite known to us as Madame la Comtesse, his practice of leaving his apartment through the back door challenges any claim that he's an active heterosexual. Nor is he alone in his asexuality. Peters will pat Latimer's knee, but not for fun. His preference, later, for a million francs over the pretty young woman who gives him the money shows how a long career in crime can jade one's sexuality.

But the man whose knee he pats, Latimer, is no professional crook. Much younger and half the weight of the outsize Peters, he has retained some instinctive drive, as is borne out by his ongoing fascination with Dimitrios. Whereas money leads Peters to Dimitrios, Latimer's attraction has deeper roots. His impulses flare out surprisingly in the book's last chapter when he sees that Dimitrios, having just shot his blackmailer, Peters, is about to shoot *him*. Contrary to all expectations, Latimer jumps at his would-be killer; his sense of self-preservation should have led him to widen the distance between himself and Dimitrios. Ambler calls his reaction "inexplicable," adding that it saved Latimer's life, as it accidentally caused him to trip on a rug, sending the bullet meant for him over his head and giving him time to charge Dimitrios. The ensuing struggle allows the badly wounded Peters to recover his pistol and then shoot Dimitrios dead, an act that symbolizes Ambler's claim that he has broken

free of the paternal archetype.

But to ground such a personal and narrative climax in an accident would constitute cheating, and Ambler knew it. He meant Latimer to hurl himself at Dimitrios because perhaps Latimer wanted to be killed, perhaps even raped, by him. If he must die, he won't settle for an impersonal bullet fired from a distance. As a successful crime writer, he feels guilty, having escaped all the dangers facing both real-life criminals and the lawmen who stalk them. His guilt demands that he close with Dimitrios physically. Even after his sense of self-preservation resurfaces, he craves contact with his opposite. Finding him dead, he dabbles in his blood. Then he wipes off the pistol bearing his fingerprints and wraps Dimitrios's fingers around the butt. This gesture is meaningless. As a crime writer, Latimer had to know that dead fingers yield very poor prints. He put his pistol in Dimitrios's hand because he wanted to touch him one last time. Having Dimitrios touch the phallic pistol also confirms his own male maturity, even if the confirmation remains hidden to him.

How does it impress us? A look at the immediate background of Latimer's bizarre act may help us frame an answer. Latimer had left the wounded Dimitrios and Peters in their cordite-filled room, presumably to get medical help, but knowing full well that Peters would use the dregs of his waning energy to kill Dimitrios, an act he, Latimer, wanted to happen but couldn't watch. His return shows that his deepest wishes have been met. His wild, violent father-lover, the man who was his greatest reproach, is dead, and Latimer neither lifted a finger to cause the death nor did he witness it. He is last seen, as was that other blundering asexual of thirty-odd winters, Josef Vadassy of *Spy*, riding homewards on a train. He is planning a new detective novel, and he is planning it along the lines of the traditional English country house murder story. Further evidence that he has learned little from his bout with factual crime comes in the book's last sentence, "The train ran into a tunnel." Like the title of the last chapter, "The Strange Town," this finale blunts the hope created by the death of the two crooks. The enveloping strangeness and darkness can't be explained by the country house formula Latimer has retreated into. Though cleansed from his hands, Dimitrios's blood still marks his soul.

The book's other searcher for Dimitrios, Frederik Peters, misses Latimer's chance for absolution. Dimitrios had betrayed Peters, his colleague in an international drug ring, to the police seven years before. Today, Peters knows much more about Dimitrios than Latimer does. Yet he leagues with the writer because the writer can identify the body he saw in the Stamboul morgue, and Peters can use the identification to satisfy himself that Dimitrios still lives. Within the Ambler canon, Peters resembles the sadistic Colonel Robinson of *Background*; like Robinson, he's a foreigner with a fake English-sounding name who speaks English with a heavy accent. He also has forebears outside the canon. The villain of Sapper's Bulldog Drummond books is Carl Peterson. More revealing is the likeness between Peters and Casper Gutman of Dashiell

Hammett's *Maltese Falcon* (1930). Both men (played by Sydney Greenstreet on film) are fat; both blend refinement and greed, delicacy and deceit. The speaking styles of both, furthermore, use friendly reassurance and well-bred orotund charm to mask treachery. Ambler hints at the line of descent joining Peters and Gutman by naming the Istanbul banker Latimer meets in Chapter 1 Collinson, Peter Collinson having been the pseudonym under which Hammett published his first short story in 1922. The careful portrayal of Peters shows that Ambler took the Hammett legacy seriously and didn't want to cheapen it. Besides giving his fat crook a distinctive voice, he maintains the practice throughout of calling him "Mr. Peters." This practice makes Peters unique besides bestowing upon him both distance and mystery, qualities enhanced by his shady international past that keep us, along with Latimer, wondering about his motives.

Peters's introduction into the action in Chapter 4, appositely called "Mr. Peters," removes all doubt about his coming importance. Ambler says of this "fat, unhealthy-looking man of about fifty-five" that his "absurdly" sagging trousers give his walk the look of "that of the hind legs of an elephant." Then, immediately, he draws our attention away from this brilliant detail by fixing upon Peters's face:

Latimer saw his face and forgot about the trousers. There was the sort of sallow shapelessness about it that derives from simultaneous over-eating and under-sleeping. From above two heavy satchels of flesh peered a pair of pale-blue, bloodshot eyes that seemed to be permanently weeping. The nose was rubbery and indeterminate. It was the mouth that gave the face expression. The lips were pallid and undefined, seeming thicker than they really were. Pressed together over unnaturally regular and white false teeth, they were set permanently in a saccharine smile.

This highly imaginative description ends with an extravagant conceit, Conradian in both its incongruity and the far-fetched, but perfectly valid, association it evokes: "He reminded Latimer," Ambler says of Peters, "of a high church priest he had known in England who had been unfrocked for embezzling the altar fund."

A person as unlikely as Peters to enter a church for any purpose besides theft is Dimitrios. But this former fig packer who becomes a rich, highly respected banker enjoys more power than Peters, scales more hurdles, and exerts a greater claim on our imaginations. Gauging his dynamism is his emergence from an ill-clad waterlogged corpse in Chapter 2 to the financier who vacations grandly in the Swiss Alps and on the Riviera with the social elite. Reversing Colonel Haki's estimate of him as "a dirty type, common, cowardly, scum," Dimitrios emerges piecemeal from accounts of his doings in Smyrna 1922, Sofia 1923, Belgrade 1926, and Paris 1928-31, so that we know more about him than about anyone else in the book. What we learn validates the

dazzle he exerts. Besides having pimped and dealt drugs, he has also been a spy, a murderer, and a political terrorist. Mixing fact and fiction, Ambler even credits him with having organized the killing of Alexander Stambulisky, the Bulgarian Prime Minister from 1919-23 who was overthrown by reactionaries.

As remarkable as his long criminal record is his success, the most ready explanation for which must be his outstanding gift for self-protection. He has always avoided capture both by the police and the confederates he betrayed, none of whom ever knew either his address or telephone number. Analogously, information about him in police files is scant and contradictory. No photo of him exists either in any official record. This is intentional. Self-control is his great asset, his sometimes anxious velvety eyes inspiring fear and dread. Irana Preveza let him cheat her out of money because she thought he understood her better than she did herself. Insightful and manipulative he is, this more desperate, unprincipled gutter version of Andreas P. Zaleshoff. But unlike Zaleshoff, he serves no ideal, validating Panek's claim that social conscience and ideology count less and less in Ambler as power rises in importance (150).

Smyrna 1922 saw him escape the wrath of marauding Greeks by hiding in the home of a black Moslem, winning his host's loyalty with the claim that he, too, was Islamic. He tricked his host again by asking his help in robbing a Jewish moneylender. This is where he first displays to us his amazing gift for decisiveness and calculation. After cutting the moneylender's throat, this unflappable man gives Dhris Mohammed half of the spoils and then leaves him. Here is his victim's explanation of Dimitrios's treachery: "I wondered why he told me of the money.... He could have found the money for himself after he killed the Jew. But we divided the money equally and he smiled and did not try to kill me. We left the place separately." Dimitrios parted from Dhris Mohammed because, in perhaps another echo from Hammett's *Maltese Falcon*, he knew that he couldn't profit from his crime unless he first gave the police someone to convict for having committed it. No matter that in choosing Dhris Mohammed to die for his own crime he was betraying a former protector. Capable of perverting any virtue, he will later use Irana's love for him to rob her more easily. He both quiets the Moslem's suspicions and wins his confidence by giving him money. Then he leaves Smyrna immediately, confident that this heavy-drinking, loose-mouthed braggart will talk himself into jail. His calculating skills have bought him his safety very cheaply.

Latimer's calling Dimitrios in Chapter 5 "a unit in a disintegrating social system" supports Gavin Lambert's belief that *Mask* conveys "the atmosphere of a society preparing for death" (112). Dimitrios focuses this disintegration. Because his bank, the Eurasian Credit Trust, finances much of Europe's drug traffic, his criminality supports the prestige he enjoys as a banker. This attack upon capitalism is not communist in spirit, even though Latimer credits most of the communists he knows with intelligence. The sole Soviet who appears in the action, Latimer's Turkish interpreter in Smyrna, left Odessa in 1919. And

although the ex-Menshevik Fedor Muishkin sympathizes with the Soviets, he has avoided returning to the USSR. What is more, the book's climax, though not inconsistent with communist writ, barely grazes it. The two criminals, Peters and Dimitrios, enact natural justice by ridding society of each other.

Yet both men are products of their market society. Dimitrios is a predatory capitalist who sins against humanity. And he sins on such a large scale because he hews to the capitalist ethic so closely. Latimer sees him in Chapter 3 as an avatar of the new European morality: "It was useless to try to explain him in terms of Good and Evil. They were no more than baroque abstractions. Good Business and Bad Business were the elements of the new theology. Dimitrios was not evil. He was logical and consistent; as logical and consistent in the European jungle as poison gas." Following his society's formula for success has served him well, even if his ascent to riches, honor, and privilege is marred by gore. The first time Latimer sees him, he is impressed by Dimitrios's "dark, neat French clothes...his slim, erect figure and sleek grey hair." Dimitrios, he concludes, is "a picture of distinguished respectability." Yet Latimer also likens him to a lizard and a rattlesnake. Is there a tie between Dimitrios's reptilian aspect and Peters's admiration of his unusual powers of calculation? As spectacular as he is, Dimitrios's success owes more to a cold-blooded economy of means than to impulse. Peters says of him in Chapter 11, "He dominated us [the other members of his drug ring] because he knew precisely what he wanted and precisely how to get it with the least possible trouble and at the lowest possible cost."

If Ambler is saying that practical efficiency and organizing genius serve evil ends under capitalism, he's saying it very subtly. He only shows the effects of Dimitrios's evil, not its formation. And he shows it from the point of view of Peters, an enemy and a gangster, who can't be trusted. Yes, Dimitrios seasons his ruthlessness with fiendish economy by murdering Manus Visser, a former colleague who was blackmailing him. His dumping of Visser's corpse into the Bosphorus with false papers sewn into his coat that identify him as Dimitrios helps Dimitrios twice: it rids him of a blackmailer, and it closes the police record on a murder (of the moneylender Sholem) Dimitrios committed 16 years before. But how relieved can Dimitrios feel? A figure from his past like Visser or a stranger like Latimer can break his peace at any time and force him to murder again. A shootout like the one he has with Peters is inevitable, keeping him always on his guard. He can't enjoy safety or freedom any more than Shakespeare's Macbeth or Greene's Pinkie from *Brighton Rock* (1938).

What he does revel in is a charisma that seizes everyone who knows him. It lifts him above national borders. He can transact business in French, German, Turkish, and Greek. Besides gulling the Greek Irana Preveza, the Yugoslavian Bulic, and the Pole Grodek, he causes the deaths of the black Moslem Dhris Mohammed, the real-life Bulgarian Stambulisky, the Dutchman Visser, and the Dane Peters (an Englishman like Latimer would have fit well in this roster of

victims). At times, he appears beyond causality, as his part in Stambulisky's death suggests. Irana finds his death hard to believe, as though his special powers exempted him from dying. Her skepticism makes sense. He was already presumed to have drowned and to have burned to death when she first meets him. The inability of his colleagues to discover where he lived or of any law enforcement agency either to get a photograph of him or to learn the truth about his parentage and birthplace shows him defying ordinary categories and definitions.

His name or names enhance the enigma. Not only does he use the surnames of Makropoulos, Talat, Taladis, and Rougemont; in his prosperity as a banker, he is known to us only by the initials, C. K., as if any attempt to know him only wraps him in denser fog. As he flourishes, he becomes more and more skilled in self-protection. An even greater mystique surrounds his first name. It comes out in Chapter 6 that he's known to the Turkish police only as "Dimitrios." This designation conveys his elusiveness and rascality but also his immaturity and banality. Like Harry Lime of Greene's *Third Man* (1950), he's like the sharp schoolboy who stole the prize but never grew up. Yet being known by his first name also shows his ability to win the trust and affection of others. His having touched their hearts encourages his former colleagues and acquaintances to speak at length about him. This mystique also keeps Latimer hunting for information about him despite his better judgment. The title of the book's first chapter, "Origins of an Obsession," foreshadows his growing addiction to his so-called "experiment in detection."

His failure to conquer this addiction must be weighed against Dimitrios's success with heroin. First, the taking of heroin humanizes Dimitrios and even makes him likeable. Flawed enough to yield to temptation, he shows, through his habit, that his head can be turned from matters of practical self-interest. Thanks to Peters's long recitation on the horrors of heroin abuse and withdrawal in Chapter 11, he also proves, by conquering his habit, the strength of character that merits Latimer's, and our, close attention. Dimitrios's addiction matters less, finally, than the enormous resolve and inner strength that overcame it. These qualities prepare us to expect anything, even a resurrection, from the supposedly dead criminal.

Echoes resound from our expectations, thanks to the book's deft organization. As Lambert shows, Latimer gets information about Dimitrios from police records, newspaper archives, an ex-prostitute (Irana) turned cabaret owner, a criminal (Peters), and the retired spy Wladyslaw Grodek (112-13). As has been seen, the information comes piecemeal, sometimes slowly and reluctantly but then with swiftness and surprise, elating Latimer as much as the long delays between developments bored and depressed him. The *TLS* reviewer of Ambler's "most brilliant book" explains how the setting forth of events in *Mask* creates so much tension that it diverts us from the lack of forward flow:

Flashback follows flashback, and very little direct action takes place until three-quarters of the way through the story. To maintain, and even develop, interest through a book composed in such a way is a mark of the highest technical skill. (434)

Some developments reach us through set pieces rather than dramatic interaction. Inserted into the action at strategic moments, these passages contain so much intriguing background material, enriching our knowledge of Dimitrios, that they don't need to advance the action. First, there's the translation of the record of the trial for the murder of the moneylender Sholem in Smyrna in October 1922. Having committed us imaginatively to Dimitrios, Ambler can afford to back away from him. Thus Chapter Five contains a 600-word recitation on the Bulgarian Revolution of 1923, its background, and its bearing upon the land-reforming Prime Minister Dimitrios is said to have helped kill, Alexander Stambulisky (1879-1923).

As the action advances, the set pieces grow in length and power, as if Ambler had discovered their value and saw his chance to improve *Mask* by relying more heavily upon them. Two thirds of the way into the work, in Chapter 11, he will include two set pieces. First, Peters explains the problems of drug trafficking—establishing lines of supply and transport, maintaining supply levels, and distributing the supplies, all the time protecting oneself, through bribery, blackmail, and violence, from arrest and prosecution. The chapter's second set piece, a rehearsal of the nightmares of heroin abuse, constitutes a major triumph. It had to. Ambler knew that if he was going to interrupt his chapter a second time with an undramatized speech, he would have to write at peak form to avoid alienating the reader. To help reach his goal, he inserts the speech inside the long account Peters had been giving on the subject of Dimitrios's drug ring.

Then there is the suspense the speech builds. Peters recreates the euphoria felt by the abuser in the early stages of addiction. Next, he shows how the abuser's need to increase the dosage to sustain his/her euphoria goes together with denial: "This time it is a little disappointing. Your half a gram was not enough.... A trifle more; nearly a gram perhaps.... And since you don't feel any the worse for it, why not continue?" As the addict's dependency mounts, he/she experiences a drying of the nose and throat, accompanied by loss of memory and appetite. Then comes the sensation of being vexed by an omnipresent buzzing fly. The addict loses weight, the eyes go heavy and dull, and he/she can no longer function except to commit the crimes that will lead to the purchase of more heroin. By the time Peters stops talking, he has convinced us that drug abuse ruins lives and families, an argument self-evident today but less vital to unwary readers fifty-odd years ago, when the novel first appeared.

But the book's most gripping set piece, coming in Chapter Nine, summarizes Dimitrios's collaboration with Wladyslaw Grodek, "at one time the most successful professional agent in Europe," in Belgrade 1926. Reprinted

with small changes in the Ambler-edited anthology, *To Catch a Spy* (1964), the summary takes the form of a letter, which creates an economy and drive that might have been lost in directly reported action. The episode is central to the plot. It provides, first of all, the book's most sustained and concentrated look at Dimitrios to date—his cunning, villainy, and ruthlessness in exploiting others. Intriguing in its own right, this look comes at a strategic time, in Chapter 9 of the 15-chapter novel. Ambler knew that if he wasn't going to materialize his title character until the end of Chapter 13, some 80 pages later, he had to show him in past-tense action in order to maintain reader interest. But he actually heightened that interest by showing him from the point of view of the master spy he betrayed. Besides giving insight into the details of intelligence gathering, Grodek's account calls attention to Latimer's ineptness as an investigator and thus sharpens our understanding of the risks he faces by continuing his fool quest.

The most memorable part of Chapter 9, though, bypasses Latimer. It concerns the duping of a minor clerk in Yugoslavia's Marine Ministry. Timing their overtures perfectly and anticipating his every response, Grodek and Dimitrios pry out of Bulic the charts locating the mines planted by the Yugoslavian navy in the Adriatic to foil an Italian sea invasion. The skill with which the two spies pander to Bulic's vanity, greed, and sense of bilked justice creates the most poignant episode in all of Ambler. Foolish, gullible Bulic is convicted of treason and gets a lifetime prison sentence because he steals classified material from the Ministry to pay the huge gambling debt he was tricked into contracting. And, unlucky as he is, he might have escaped jail if Dimitrios hadn't stolen the secret plans from Grodek. In order to protect his professional reputation, Grodek had to tell the Belgrade police about the theft; he couldn't afford to let Dimitrios profit from his betrayal. But by nullifying the value of the stolen plans, he also incriminated Bulic. The speed with which Bulic is puffed up, brought to his knees, and then jailed for the rest of his life as a traitor, shocking enough on its own, spells out the disaster awaiting the unwary in the European jungle. More specifically, it describes the great good luck of Kenton, Vadassy, Marlow, and Latimer, all of whom, like poor Bulic, surrender control of their lives to others.

This comparison invites others. Just as Latimer thirsts for the excitement of real-life crime, so does Colonel Haki want to write crime fiction. The mirroring relationships continue. Shaking with fear and anger in his ransacked Sofia hotel room, Latimer hears with disbelief an armed Peters, the room's despoiler, tell him, "You are wondering exactly where I stand. If it is any consolation to you, however, I may say that my difficulty is in wondering exactly where *you* stand." More than chance has joined the two men. Like Latimer, Peters spends a great deal of time and energy tracking Dimitrios. And, like that other intrepid stalker, Manus Visser, his efforts undo him. The deaths of Visser and Peters make Latimer, who searches for Dimitrios just as hard and

long, Ambler's luckiest hero to date.

Nor is Latimer the only writer implicated with Dimitrios. Grodek is also writing a book—on St. Francis. But whereas Grodek writes at home, Latimer's research for his alleged biography of Dimitrios takes him all over Europe. And matching the saintly subject matter of Grodek's book is the devil who inspires Latimer. Perhaps Latimer did well to invest in him. Grodek's career as a spy has earned him the tranquility of his intellectual pursuits. Tracing an opposite course, the writer Latimer invokes his demon, literally wrestling with him and getting his blood on his hands. Jungian in spirit, his quest for Dimitrios sends out Sophoclean, if not Freudian, reverberations. The hunt for the shadow self can disclose more than we were looking for; also, more than we can handle. Peters's search for Dimitrios reverses when Dimitrios hands over a million francs in blackmail money. Now the heretofore sought-out Dimitrios mounts his own hunt. He mounts it with his usual skill. Looking into the muzzle of his pistol, Latimer understands that he, the searcher, has become the person sought out and that the one-time questioner must now provide answers if he hopes to survive.

The accident that saves Latimer is just a small flaw in view of his responding to an unconfessed inner need by lunging at his would-be killer. A more serious objection can be directed to the book's title. The American title, *A Coffin for Dimitrios*, conveys just one facet of the eponym's villainy, his having for a short time smuggled drugs into France in the lining of a coffin. *The Mask of Dimitrios*, the novel's title in Great Britain, misleads even more. Much of the book's command stems from the unsettling truth that Dimitrios wears no mask. His success as a pimp and a terrorist is one with the honor and luxury he enjoys as a banker. The violence and greed that served him in the gutters of Smyrna and Sofia secure his leisure 15 years later in fashionable, exclusive Cannes.

Boosting our interest in him is technique. In order to build irony and suspense, Ambler will adopt a standpoint of omniscience, as in the last sentence of Chapter 4, which comes at the end of the train ride from Smyrna to Sofia where Latimer meets Peters: "In his eagerness to get a bath and some breakfast it did not occur to Latimer to wonder how Mr. Peters had discovered his name." Up to now, we had no more information about the events recounted in the book than Latimer. The insight that we suddenly know more than he does, creating the impression that Ambler has confided in us, inspires us to read on; Latimer has become vulnerable in ways unknown to him. As the novel nears its roaring climax, Ambler will use another stratagem to keep our attention; he places a key development at the end of a chapter. Thus Chapter 10 ends with Latimer looking at a photo of Manus Visser, whom he saw in Stamboul's morgue but identified as Dimitrios. The identification is challenged at the end of the next chapter when Peters tells him both that the person in the photo is Visser and that Dimitrios is still alive. The last sentence of Chapter 12 finds Dimitrios not only living but also thriving as a director of the powerful Eurasian Credit Trust.

Finally, his walking into the action at the end of Chapter 13 has probably inspired some of the fastest page-turning of any English novel of the decade.

Form and content mesh neatly in *Mask*. The thriller plot functions as a light serviceable framework on which Ambler hangs his observations about the dangers of European life between the wars. Controlling the movements of Latimer without making them look prearranged, the plot also helps Ambler express his concern with what he describes. *Mask* conveys a significance beyond its reported action by both putting forth a deeper sense of judgment and suggesting the recesses and shadows that constitute human ambivalence. It's Ambler's best novel because it's the only one that takes sufficient stock of the true nature of evil and our abiding attraction to it. Dimitrios blinds us with his moral darkness as he does Latimer, fascinating us despite our better judgment. Hans C. Blumenberg judges well to call the work featuring him the most elegant criminal novel of the century (72). Though wild, extreme, and a bit incredible, *The Mask of Dimitrios* rings absolutely true.

### *III*

The success of *Mask* honed Ambler's ambitions for *Journey into Fear*. His 1940 novel peaks earlier than *Mask*. Its hero, Graham (no first name given), at age forty, is older by at least five years than Latimer, Marlow, Vadassy, and Kenton. And even though Stephanie never appears, she is the wife of the first married Ambler hero. The action building around this hero opens early in 1940. Graham is spending the night in Istanbul after having worked for six weeks in Smyrna and Gallipoli, where he was sent by his firm, a large arms maker. The Anglo-Turkish peace pact has freed the firm to ship arms to Turkey, arms needed to repel any attack coming from Nazi Germany. Judging from what happens to Graham, the pact has already sent out shock waves.

The first two chapters of *Journey* begin with short subchapters showing him aboard the *Sestri Levante* in Stamboul Harbor. Bandages are swathing his left hand as a result of a bullet wound. The last page of Chapter 1 shows him being wounded after returning to his hotel room from an evening at a cabaret. Just as the cabaret visit occurs earlier in *Journey* than in *Mask*, so does the book's first murder attempt. And a potential murder victim Graham *was*, despite his denials. Because his attacker stole nothing and didn't even try to open Graham's luggage, he must have broken into the room to kill Graham. Neither was the shooting incident at Stamboul's Adler-Palace the first attempt on Graham's life. The police had already dismantled a murder plot aimed at him in Gallipoli.

Why is he so murderable?

"He had a highly paid job with a big armaments manufacturing concern," we learn of him in Chapter 1. The job is that of chief designer for naval ordnance. And this "brilliant engineer" does it well enough to represent his firm on a sensitive overseas mission. Sensitive his mission certainly is to Colonel Zia

Haki, who reappears from *Mask* to tell him, "You *are* indispensable." The artillery Graham's firm is shipping to the Turks must be mounted and ready to fire within two months. Were Graham to die, this deadline couldn't be met, and the Turks would suffer militarily. Some of the technical knowledge needed to install the vital weapons is so restricted that, rather than putting it on paper, Graham had to memorize it. Replacing him with a new ordnance expert would cost a great deal of time, since the replacement would have to undertake extensive training at Turkish naval sites. Naturally, Turkey's enemies, who are now Great Britain's enemies, Ambler reminds us, would gain by such a delay. Anxious to get Graham home quickly and safely, the Turkish government sends him by sea; a train would be too dangerous, and air service has been suspended. Unknown to him, Colonel Haki has provided him with an escort aboard the *Sestri Levante*, the spy Ihsam Kuvetli, who is posing as a tobacco merchant.

What happens shipboard makes us wonder increasingly about Ambler's decision to build a novel around Graham. Specifically, the more we see of Graham, the more doubts he raises as to whether we should care what happens to him. Yes, he has won the trust of his chiefs in the north of England, and, obviously, he merits that trust, having served the Turks well enough in Smyrna and Gallipoli to be deemed both worth killing by the Nazis and worth protecting by the Turks. But the technical skills that have won him so much attention seem to function in a void. To begin with, he's not observant. An Arabian dancer in the Stamboul cabaret he visits in Chapter 1 notices his would-be killer looking at him from the bar, a fact that bypasses Graham himself. Nor can his unwariness be explained by the strain of being away from home for the past six weeks and working through an interpreter. After being shot at in his hotel room, he phones Kopeikin, his firm's Turkish agent and the man who had earlier taken him to le Jockey Cabaret. And, like the pretty Arab Graham had danced with a couple of hours earlier, Kopeikin spots an important item that Graham had overlooked, a brass cartridge case on the floor near the window through which the gunman had entered the room.

The sharp-eyed Kopeikin also notes that both the windows and the shutters of Graham's room have been forced. Ever the dullard, Graham not only ignored the shutters, windows, and floor of his hotel room; he also rejects Kopeikin's inference, based upon noting the problems the gunman overcame to enter a room he never looted, that someone wants him dead. Rather than accepting Kopeikin's findings, however grounded they are in hard evidence, Graham accuses him of stupidity and hysteria. The sea air doesn't improve his judgment. When told by a fellow ship's passenger that he has been talking to a German spy, he insists that the man "couldn't possibly be anything of the sort." Graham obviously lacks an eye for spies. Four chapters later, in Chapter 9, when Kuvetli, the Turkish agent with whom he has already spent considerable time, identifies himself, he adds the sideswipe, "I am surprised that you have not discovered me before this."

We could sideswipe Graham ourselves. Alas, he stumbles as badly as a moralist as he does an observer. Though returning home to Stephanie, his wife of ten years, he plans to stop in Paris with Josette Gallindo, a dancer he first met in Istanbul. He kisses her for so long in Chapter 9 aboard their westbound ship that his arms tire from holding her. Finally, the maker of war materials that employs him is Cator and Bliss, a cause of strife in three of the five Ambler novels that preceded *Journey*. He takes this destructiveness in stride, his mention of the firm's "tireless internationalism" in Chapter 6 referring to its practice of arming enemy combatants during war. His attitude toward the practice of getting rich by helping people kill one another, if he ever framed one, would recall that of Frederik Peters toward peddling narcotics: if he didn't do the job, somebody else would take his place and profit from the sale of his lethal goods. Lacking moral fervor, Graham acts only on the principle of self-interest, as Ambler makes clear in Chapter 1: "For him, the war meant more work; but that was all. It touched neither his economic nor personal security. He could not, under any circumstances, become liable for combatant military service." And neither will his smooth, fair skin be rent by the *Luftwaffe*, since, as a north of Englander, he lives outside the target area of German bombs.

In view of Graham's flaws, Ambler faced a stiff challenge in making his main figure sympathetic to us. He meets this challenge impressively. In fact, his ability to open our hearts to Graham after showing his failings constitutes the book's finest achievement. Let's watch it develop. First, Ambler wins favor for Graham by making him the book's central intelligence. We share Graham's confusion and fatigue together with his homesickness as he awaits the long, hard train journey to England. Besides being discomfited by living in a foreign country whose language he doesn't speak, he has also been shot at. His bandaged hand will make him the underdog in any fight. And, lest we forget his wound, a sign of his vulnerability, Ambler keeps his bandaged hand in sight from the very start and also tells us from time to time that it throbs with pain. Graham's nerves ache and throb, too, when he sees his former attacker board the *Sestri Levante* in Athens.

This professional gunman could have only booked passage for one purpose, reasons Graham. He also reasons that his sole advantage over his would-be killer consists of acting calm and unsuspecting. He still has the revolver Kopeikin had given him in Istanbul, and, if his nervousness doesn't betray him, he could use it to surprise and disarm Petre Banat. But nearly everybody in the book has more street sense, self-control, and basic perceptiveness than Graham. His nervousness declares itself to the most casual observer. More transparent than he thinks, he has fooled nobody. Placed between his protector Kuvetli and the hired gun Banat, he has attracted more attention than he'd have ever imagined, attention which the civilized graces he learned in an English public school can't divert. The murder of Kuvetli, his only friend and aide, at the end of Chapter 12 leaves him completely exposed. The

boldness and originality marking Ambler's description of Kuvetli's corpse justifies the fear and helplessness gripping Graham. Literally at sea, he has lurched into a mad, violent place where mainland justice can't help him:

Most of the bleeding seemed to have been caused by a scalp wound.... The movements of the ship had sent the slowly congealing blood trickling to and fro in a madman's scrawl across the linoleum. The face was the color of dirty clay. Mr. Kuvetli was clearly dead.

Feeling panic "welling up into his mind like blood from a severed artery," Graham wins our sympathy as he tumbles into danger.

Touching us equally is the pluck he shows in Chapter 8. Even though the Nazi spy Moeller is aiming a pistol at him at point blank range, Graham tells him, "I have been seriously considering kicking you in the teeth." This grit foreshadows the maturity he displays at the end. He feels indebted to Kuvetli. Resolved that ignoring Kuvetli's murder would be an insult, he boards a car together with Moeller, Banat, and three of their friends. Offsetting the five-to-one advantage enjoyed by his foes is the revolver hidden in his pocket. He fires it with the same impulsiveness shown by Charles Latimer when he rushed an armed Dimitrios. Here is why. Moeller had told him not to resist when asked to leave the car prior to his being murdered. When he adds that a struggle could damage the car's upholstery, he infuriates Graham. The insult drives him to immediate action. "Before he knew what he was doing," he takes out his revolver and fires it into the grinning face of Banat. His bullet has both avenged Kuvetli's death and confirmed his own self-worth. Perhaps Ambler's heroes impress us more by acting instinctively than deliberately. Perhaps, too, the knowledge that Graham, like Ambler, is an engineer and thus a fictional self-projection merits him our special attention. By portraying him as an adulterer in spirit if only partly in the flesh, the newlywed Ambler (he married Louise Crombie in 1939) shows that he isn't afraid to pose deep questions about himself.

Deep questions infuse the text. Both Graham's having lost his father at age 17 and Colonel Haki's identifying the archetypal father with a virile god direct some of them to Ambler's smothered paternity. Fathers abound in *Journey*. Kopeikin welcomes the travel-weary Graham to Istanbul, entertains him in a cabaret, and, after reconstructing Banat's movements at the Adler-Palace Hotel, gives Graham his revolver for protection on his homeward trip. Colonel Haki also protects Graham by putting him on a ship rather than a train, where he'd be an easier target for a German bullet. Last of all, Graham asks the help of a stranger, his fellow passenger, the Frenchman Robert Mathis, just before their ship is ready to dock in Genoa. Like a good father, the older Mathis both delivers an important message for Graham at the Turkish Consulate and gives Graham *his* revolver—the same one Graham will use to kill Banat and save his

own life. Whether Mathis's communist sympathies and the Russian background of Kopeikin both reflect Ambler's nostalgia for his leftist heyday can be argued; many left wingers in the 1920s and 1930s lent communism the authority and power of the paternal archetype.

What is more certain is Ambler's continued difficulty in sorting out the meaning of the fatherly tie. Aboard ship, Graham meets two father figures, both of whom, political rivals, contend for his loyalty. (A third, the communist Mathis, whom he spends time with later, would decry the nationalism of both of them.) One, Moeller, plans to kill Graham and, to achieve that end, first kills Kuvetli, his opposite number. But before dying, his victim saves Graham's life by convincing him of Moeller's bloody intentions. Then, after saying that he would give his life for his country, the fatherland, Kuvetli does die as a result of helping his symbolic son, the innocent Graham—but, curiously, not before he pats Graham's knee and tells him that no woman is trustworthy.

Perhaps Ambler means that no woman is safe with a spy nearby. Using a woman to protect his cover, Kuvetli's sworn enemy, Moeller, represents the evil father and exploitative husband. As with Kuvetli, Graham has trouble resisting him. Early in the voyage, believing him to be the married archaeologist Haller, whose passport he's carrying, Graham finds himself sitting at the same dining room table as the German. As graciously as he can, he explains that he intends to change tables before the next meal, voicing moral opposition to dining with a national of an enemy country. His neglecting to tell the steward about the desired change may be more than a memory lapse, despite his claim. Perhaps he can't resist the company of an older, more accomplished man. Perhaps, too, despite Moeller's age (he's 66), Graham senses in him the same violence that attracted Latimer to Dimitrios. Withal, Graham doesn't shoot him, the man who insulted him, any more than Latimer killed Dimitrios. Instead, he fires his revolver at Banat, who didn't perpetrate the insult, but laughed at it. Advisedly, the whole incident occurs in a car, invoking the rage Ambler felt in 1922 (Levant 176) when his father spent Eric's tuition money on a new car.

Ambler's problems with closeness go beyond the father-son tie. Not only is Stephanie absent from the action of *Journey*; the woman who comes closest to doing her wifely job is also married. Josette's marriage to José Gallindo looks vital and strong. The two dance together as a team. First seen in a Stamboul *boite*, they reappear aboard the *Sestri Levante* en route to another job. What is more, their names suggest that they're either twin halves of a single self or mirror images. But this doubling motif, less vital to Ambler than to the poets Shelley and Whitman, recedes quickly. In Chapter 4, Josette calls her marriage "an arrangement," adding, "We are partners, nothing more." Apparently, the partnership includes sexual profit sharing. Slipping away discreetly, Josette lets José arrange her prospective tryst in Paris with Graham. José explains that the tryst (which never takes place) will cost Graham money: "You do not expect something for nothing.... You want to amuse yourself in Paris, eh? Josette is a

very nice girl and very amusing for a gentleman.... Two thousand francs a week." Even though Josette slanders José and offers to steal his pistol for Graham, she uses him as her pimp. Obviously money colors her decision, since so much of her conversation deals with it. Her allowing José to manage her business thus indicates a high level of trust. Yet when the business is sex, she degrades this trust and, with it, the marriage on which the trust is based.

This ambiguity carries forward from Ambler's earlier work. The teasing and occasional flare-up of tempers that pass between Zaleshoff and his sister, like the one stemming from her longing to take a holiday with him in *Background*, befit a marriage more than a brother-sister tie. The Americans, Mary and Warren Skelton of *Epitaph for a Spy*, have registered into the Hotel Réserve as brother and sister. Yet their being first cousins, i.e., as close to a brother and sister as is possible, hasn't stopped them from staying together at the Réserve or planning to marry. Ambler did well to keep an Italian widow and her son, passengers on the *Sestri Levante*, shadowy. Like the Skeltons, they share a room, or cabin. To give the Beronellis more time in our view might have put the book out of balance. It might have also conveyed some painful, perhaps textually inappropriate, insights into Ambler's problems in sorting out life's basic ties. These problems surface persistently, if indirectly, and their source seems to be the family. The name of the ship on which intimidation, card-sharking, theft, and murder all occur deepens the pattern, *Sestri* being a form of the noun, sister, in Russian and Polish. The pattern widens. The setting for the devastation that takes place shipboard is the sea, commonly known over the centuries as the cradle of life and the universal mother.

But Ambler says more about the father than the mother. Some of his insights shade into the argument that the spy in World War II, no agile, athletic Conway Carruthers, has aged. Called an "elderly man," Moeller appears first as "a thick, round-shouldered man with a pale heavy face, white hair, and a long upper lip." Pretending to be an archaeologist returning home to Germany after two years of field work in Persia, he speaks brilliantly on subjects like the Parthenon, the Vedas, and pre-Hellenic remains. But he perverts both his well-stocked mind and the respect that goes with his years. A real menace, he's the methodical Nazi devil of Greene's *Ministry of Fear* (1943) and Hitchcock's *Lifeboat* (1944). Ambler was warning contemporary readers through him to concede nothing to their Nazi enemy. A formidable enemy Moeller is. His name recalling that of the sadistic Mailler in *Background*, he escapes arrest at the end. He also explains pridefully to a captive Graham the trick he used to board the *Sestri Levante*. If Moeller lacks youthful vigor, he does exude a fatherly power, enhanced by Nazi brutality, that overpowers Graham.

Standing for the bright, daytime side of the paternal archetype is aging, fumbling Ihsan Kuvetli. Always called "Mr. Kuvetli" in narration, this giggling, pudgy-handed master spy (whose name means *power* in Turkish) looks as harmless as Moeller in his first appearance:

He was short, broad-shouldered and unkempt, with a heavy jowl and a fringe of scurfy grey hair round a bald pate. He had a smile, fixed like that of a ventriloquist's doll: a standing apology for the iniquity of his existence.

This innocuousness persists. When Kuvetli explains to Graham in Chapter 12 his presence on the ship, he appears as a "grubby little man with a stupid smile." Yet he speaks four languages, one of which, Greek, he uses to drive down the fare for a taxi he and Graham use to sightsee in Athens. As has been seen, he also explains clearly and irrefutably that Moeller has offered to take Graham to a rest home near Genoa in order to kill him. And he tries to blend his patriotism, his skills as a spy, and his fatherly care for Graham to get the prodigal home safely. The escape plan he devises for Graham is logical, plausible, and economical, centering on his own diplomatic *laisser passer*. Had his foes not killed him, the plan would have worked.

His killer, the professional hit man from Rumania, Petre Banat, carries forward Ambler's belief that menace can uncoil from the unmenacing. A degraded, corrupt world endows nobodies with power and trust. The mousy, rumpled Banat first appears to Graham as "an inoffensive creature" with his "lumpy padded shoulders" and "stupid face." "Crammed with filthy shirts and underwear," Banat's suitcase confirms Graham's impression that "there was something pathetic about him," an impression put forth by both his puniness and his addiction to gambling, a vice that leaves him broke most of the time. A person he beats at cards is "small, unhealthy" José Gallindo, Josette's husband, dancing partner, and pimp. As unsavory as Banat is, his victory over Gallindo pleases us. Having already been jailed for theft, the squalid Gallindo enjoys boasting of his prowess at cards. And like that other braggart, André Roux of *Spy*, he deserves the embarrassment he suffers when he gets thrashed in the game in which he had declared himself an expert.

Curiously, we invest more emotion in José than in his wife, even though we see much more of her. What discourages any emotional response to Josette is her predictability. The Serbian-born Josette is a cartoon stereotype of a nightclub dancer. She keeps popping up on the deck of the *Sestri Levante* to ask Graham either for a favor (like showing her around Athens) or an explanation (why he's on the ship). Yet, even though the questions keep coming, the flashy blonde who asks them denies that she's inquisitive. Contradiction seems to be her specialty. She impugns her disavowal of any interest in money by prating endlessly about the cost of things—clothes, restaurant food, and hotels. Believing him rich, she contrives both to spend time with Graham and to prolong their time together. But by making arch pronouncements like "I am bored," "You are not at all polite," and "I do not like you as much as I thought," she can only put him off and thus discourage him from paying heavily for her company in Paris.

Cawelti and Rosenberg may have been thinking of the preponderance of melodrama in Ambler's sixth book when they said in 1987, "*Journey into Fear*, though published in 1940, is still prewar in spirit" (101). They're partly right. Though the book lacks the treachery within ranks found in postwar spy books like Len Deighton's *Ipcress File* (1963), John le Carré's *Tinker, Tailor, Soldier, Spy* (1974), and Ambler's own *Dr. Frigo* (1974), it has a bolder, more original outlook than Cawelti and Rosenberg credit. Istanbul's Le Jockey Cabaret, for instance, recalls Irana Preveza's nightclub in Sofia with its wall decorations consisting of "ash-blond hermaphrodites." Kopeikin's remark about the club, "It is very gay here," reflects the suspicion that guidelines and norms are collapsing in a Europe mired ever deeper in moral decay. Another sign of the danger and insecurity of life is the ease with which one's living space is violated. Gunmen invade Graham's quarters on both land and sea, and Graham himself, though unarmed, searches Banat's stateroom on the *Sestri Levante*.

Those who occupy the ship's other staterooms, Graham's fellow passengers, provide a convincing background. Like the guests at the Hotel Réserve in *Spy*, they represent different age groups and nationalities; some travel alone, some in pairs, like a French husband and wife (the Mathises) and an Italian mother and son (the Beronellis). They behave as expected of travelers with time to spare. They complain about damp sheets and dirty sinks, play cards, quarrel about politics, and discuss the war. Breaking this routine is the appearance on board of Banat at the end of Chapter 5 in Athens. Graham's pleas to a disbelieving ship's purser that he be let off the ship because his life is in danger provides a standard plotting device. But Ambler handles it well, as he does the book's finale, where the commonplace is restored. The last sentence of *Journey* says of Graham, "He turned and made his way back to his beer and sandwiches." This simple fare has probably never tasted so good to him. But if Josette, Banat, and Moeller no longer vex his thoughts, no friend has taken their place. He is eating alone. And like Vadassy and Latimer before him, he's in transit—on a moving train. His view consisting of "grey smudges...on the horizon," he can't boast a happy outlook. But neither could any Briton in 1940, despite what Graham thought at the book's outset.

Though lacking the force of *Mask*, *Journey* belongs qualitatively to the period that produced Ambler's best book. It's only marred by one motivational flaw, which Ambler covers quickly enough. When Graham finds Kuvetli's dead body, he panics. Besides feeling saddened and shocked by the death of his protector, he believes that he has lost his chance to leave the ship safely. Actually, safety and freedom are both within closer reach than he knows. Had he reported Kuvetli's death, he'd have been arrested and then held by the shore patrol as a witness or suspect. The ensuing investigation would have brought in both the British and Turkish Consuls, whose participation would have formed a shield of defense around him. Though, as a suspected murderer, he'd have been put in custody, his detainment wouldn't have postponed the delivery date of the

weapons the Turks need to defend themselves against Germany. Most important of all, by reporting Kuvetli's death, Graham would have foiled Moeller's plot to kill him.

Graham's getting into a car at Genoa harbor with Moeller and four of his aides was a desperate risk. Ambler also strained our credulity by having the five enemies all forget to search Graham and take away his revolver. The moral revulsion that moves Graham to shoot Banat after being warned not to damage the car's cushions shows the triumph of common decency. If evil and its foes are both mousy and grubby, why shouldn't the outrage of an ordinary man prove decisive? The same kind of moral recoil created the climax of Graham Greene's *Quiet American*, a much more acclaimed novel than *Journey*. The book's title figure, Alden Pyle, worries about spoiling his shoeshine with the blood of an innocent victim who died in a bombing raid mistakenly ordered by Pyle himself. The casualness with which he ignores the wreckage caused by his own error spurs the book's narrator to plan his death in the same way that Moeller's rating his car's upholstery over a human life incenses Graham.

The slamming recoil generated by Moeller's casual inhumanity is no artistic aberration. *Journey* finds Ambler at home describing a dance routine in a Turkish nightclub, the bustle aboard a seagoing ship, or a duel of wits between enemies. Regardless of the effect he wants to produce, he rarely or ever strains for it. Instead, his inventive power asserts itself in vivid offhand details that work at multiple narrative levels. *Journey into Fear* wins him new friends while reassuring old ones, none of whom would have predicted having to wait 11 years before the appearance of his next book.

# Chapter Five
## Playing Ball with the Regime

The four novels Ambler published between 1951 and 1959 grow from their predecessors. Rather than breaking new ground, the books reaching from *Judgment on Deltchev* to *Passage of Arms* carry forward skills and preoccupations reflected in the earlier work. They still define women narrowly, as daughters and wives who are creatures of either repressed or rampant sexuality. But they also move women into the spotlight. Ambler's treatment of women has matured even if his view of them remains static. The wife of the title character of *Judgment* comes before us three times, but never with her husband. The years will narrow this gap. By the time Ambler was to write *Passage of Arms,* he could move his married hero to center stage alongside his wife. His two intervening books, *The Schirmer Inheritance* (1953) and *State of Siege* (1956), both show young singles becoming lovers.

The settings of the four novels he wrote in the 1950s show Ambler looking at foreigners with wit, horror, and, sometimes, affection. But this brace of books ranges wider geographically than the earlier ones. After opening in Pennsylvania, *Schirmer* moves to southeastern Europe, which also provides the setting for *Judgment. Siege* and *Passage* both unfold in distant, sweltering Indonesia and include a gallery of multiracial characters. Responding to this exoticism, Ambler moves the action of *Passage* between Hong Kong, Singapore, and Manila, arguably the three most international cities in the Far East at the time of the novel. The central intelligence at the book's outset, furthermore, is an Indian. But he's a restless Indian. What Girija Krishnan and most of the other people in Ambler's novels from the 1950s look for in vain are democratic values. Absent in the fiction of this period are the right to criticize political orthodoxy, freedom of expression, access to information, and the accountability of those in power.

Adrift in a dangerous place on the brink of revolution, the Ambler hero once again faces the demands of a crafty, sometimes powerful, stranger with opaque motives. The stranger who makes demands upon the hero often exudes authority, like a military officer, political boss, or revolutionist. The 11 years since *Journey into Fear* kept Ambler busy. He served in the Royal Artillery, winning a Bronze Star and rising to the rank of Lieutenant Colonel; he both wrote and directed films, sometimes working with John Huston; he earned a great deal of money on both sides of the Atlantic. He also saw *Journey* (1942),

*Background* (1943), *Mask* (1944) and *Spy*, as *Hotel Reserve* (1944), turned into successful films. What he didn't do was to make peace with the archetypal father, who continues to haunt him as he plods deeper into midlife.

*I*

In ways, *Judgment on Deltchev*, the starting point for Ambler's second literary career, resembles *Dark Frontier* (1936), the book that launched his first. Another first-person narration, Ambler's 1951 novel also unfolds in the Balkans; it describes once more an imaginary Kremlin-dominated republic threatened by insurrection; it discloses a relish for pain: corresponding to the torture scenes in *Frontier* are the diabetic tremors of the title character and the heroin addiction of one of the rebels. Gone, though, is Ambler's old Soviet bias. Intelligent and clearheaded, *Judgment* studies corruption and exhaustion within the eastern bloc. Clive James has commented on this studiousness:

> *Judgment on Deltchev* is *The Dark Frontier* revisited, but in adulthood instead of childhood. The small Balkan country might as well be Ixania, but this time there are no illusions about the People's Party. (67)

Shabbily clad people wearing cheap, broken shoes and sullen looks foster no illusion of prosperity. Nor do the food rationing, backward technology, bureaucratic gridlock, tight censorship, and thriving black market hamstringing the people give cause for hope. Ambler records the strife and woe of the Soviet satellite nations with drypoint sharpness. While dissidents are arrested and then shipped to forced labor camps, the prestige of party membership confers the privileges of holding good jobs and shopping at the best stores. The party thwarts justice everywhere. Champagne and caviar unavailable to the public are served at press conferences to impress foreign journalists. Meanwhile, the country's Propaganda Minister addresses his guests with a wily evasiveness that imparts both the menace and grubbiness of life under a communist dictatorship.

These constraints flatten the book's tone. *Judgment* has less brightness, snap, and pep than the six novels preceding it. The long sentences composed of abstract nouns and intransitive verbs that open the book evoke the congested dryness of a social scientist's prose:

> Where treason to the state is defined simply as opposition to the government in power, the political leader convicted of it will not necessarily lose credit with the people. Indeed, if he is respected or loved by them, his death at the hands of a tyrannical government may serve to give his life a dignity it did not before possess. In that event his enemies may in the end be faced not by the memory of a fallible man but by a myth, more formidable than the real man could ever have been, and much less vulnerable. His trial, therefore, is no formality.... He must be discredited and destroyed as a man so that he may safely be dealt with as a criminal.

This stiff, sanitized writing will depict the doings of characters who are either older or middle aged, as befits a study of postwar eastern bloc politics. A notorious killer is described in Chapter 11 as being "about fifty, short and very slight, with wispy and receding gray hair." Like him, even the younger people in this grim book have no sex life. Foster, the book's narrator, first lets on in Chapter 14, two thirds of the way in, that he's a widower, as is his harried interpreter-guide, we learn three chapters later. The lackluster has displaced the raw. Foster discovers the twenty-year-old daughter of the book's title figure sleeping on his bed. But he needn't worry about sexual overtures. Katerina has come to his hotel to ask him to publish evidence bearing upon her father's trial.

Readers of Ambler's first novel in 11 years saw its pallor verging upon the bloodless. The reviewer for the *New York Herald Tribune Book Review,* for instance, was expecting a work of more flourish and sting: "It's a subtler and grimmer type of intrigue that Ambler exploits in his new book," said the reviewer, continuing, "sometimes one feels a little nostalgic for the old cloak-and-dagger stories that made him famous" (15). The new book must have also confused or even annoyed popular audiences unfamiliar with Ambler's earlier stories. Television series of the decade like *Perry Mason* and the films/Broadway hits, *Twelve Angry Men, The Caine Mutiny Court Martial, Witness for the Prosecution,* and *Inherit the Wind* had made the courtroom a unified setting for the give-and-take of dazzling rhetoric, the springing of surprise disclosures, and the sudden reversal of advantage. The trial in *Judgment* exploits little of this dramatic potential. The accused acts bored throughout; nor does the time-serving lawyer appointed by the court to defend him bother to cross-examine hostile witnesses.

History explains why. In *Here Lies,* Ambler said that he based Yordan Deltchev's trial upon "the Bulgarian show trials ordered by Stalin" (229). His specific source was the notorious Petkov trial in Sofia. The Bulgarian leader, Nikola Dimitrov Petkov (c. 1892-1947), who is mentioned in the second paragraph of *Judgment,* stood trial in June 1947 for conspiring with a terrorist plot to overthrow the government. Arguing from flimsy evidence, the court found him guilty, and he was executed on 23 September 1947 despite formal protests from the United States. Stalin wanted Petkov stopped because, like Deltchev, he had been friendly with the West, an accusation never made during his trial. As opponents of official Kremlin policy, Petkov and his fictional counterpart never got a fair hearing. The guilty verdict levelled against them pre-existed both the giving of evidence and the naming of the court officers. Cawelti and Rosenberg understate the truth in their claim, "Though only obliquely expressed, *Judgment on Deltchev* marks Ambler's disenchantment with Russian political influences" (109).

The actions of the kangaroo court that convicts Deltchev reach us through an English playwright named Foster, who is reporting the trial for a newspaper.

His being a playwright has sharpened his instinct for balance, consistency, and dramatic build. In Chapter 17, he remarks inwardly, "There was a contrived, bad-third-act feeling about the whole thing." Not content merely to recount, he looks for motives, plausibility, and patterns of behavior. But this quest for artistic unity and shapeliness collides with official policy. Like that other imaginative writer, Charles Latimer of *Mask*, he finds his artist's instinct for wholeness thwarted. The censorship imposed by Deltchev's accusers has muzzled him. Because the regime wants to avoid foreign criticism, it stops him, not only from reporting the trial honestly and accurately, but also from sending his stories to his American publisher straightaway, i.e., while the trial is still in progress. By going to press after the verdict is given, Foster's stories will forfeit both their news value and their chance to sway public opinion.

Like Ambler's last hero, Graham of *Journey*, Foster is met at the train station where the action begins by an interpreter-guide. Both men are widowers, but Georghi Pashik, unlike Kopeikin, has two names. Like Graham before him, Foster has only one. By withholding his front name, Ambler heightens the impression, created in part by his dead wife, that he's incomplete, a half-lifer. And because he follows Latimer by trying to unearth truths that people more powerful and ruthless than he want hidden, he's lucky to cling to his half life. Defying common sense, he keeps exceeding his charter. "I had behaved with the bumptuousness of an amateur," he says in Chapter 13 of his practice of playing private investigator rather than simply reporting what goes on in court. He's right to add, "Mr. Foster was making a tiresome fool of himself." Whenever he feels clever and bold, he invites trouble. At the end of Chapter 7, he performs "one of the most foolish actions" of his life when he agrees to deliver a letter for Katerina Deltchev.

Common sense should have stopped him from carrying messages. He risks being searched by the guards patrolling the building where the message changes hands. Having already heard about Katerina's political extremism, he shouldn't have believed her, either, when she said that the message was intended for her lover. He pays for his folly forthwith. The slum apartment where he takes the message materializes a murder victim. Following him into the apartment is an armed Pashik, who later tells him, "You are wandering like a fool between...opposing forces." Like Latimer and Graham, he has stepped between two dangerous foes. Thus it can't surprise him, in Chapter 16, that he's followed, ambushed, and shot at. What he doesn't know is that he has knowledge which makes him murderable. He has proved, once again, that in Ambler knowledge doesn't bring power; it puts your life at risk.

Badgered from the outset is Yordan Deltchev, one-time leader of his country's Agrarian Socialist Party and Minister of Posts and Telegraphs. Like the spies and desperadoes in *Journey*, this bent, weary elder exudes little menace, as Ambler makes clear in our first look at him:

After a moment or two the glazed doors were flung open and three men entered the court.... Two of them were uniformed guards, tall, smart young fellows. Between them was an elderly man with a thin gray face, deep-set eyes, and white hair. He was short and had been stocky, but now his shoulders were rounded and he was inclined to stoop. He stood with his hands thrust deep into his jacket pockets.

This frail, trembling object of pity has been charged with 23 crimes against the state including treason, terrorism, and conspiring with foreign powers for personal gain. Like Bulgaria's N. D. Petkov, his only crime consisted of being friendly to the West. He has served his country honorably. With his usual courage, he opposed his country's alliance with the Axis during World War II. After it, he rejected a high post in the cabinet of a puppet government installed by Moscow. His rejection speech, made before a huge crowd in a local football stadium, caused a riot, even though he never finished it. Within seconds of his denouncing the "stupid, frightened men" running the country, his microphone went dead. Within four days, an attempt was made to kill him. A month later, he was jailed for supposedly mounting a murder plot of his own.

Ironically, Deltchev lacks the fanaticism of both the political assassin and the revolutionary. Any court of law in a civilized land would have acquitted this dry, colorless figure of the crimes his enemies have charged him with. Steadiness, organization, and the ability to deal with the daily plod of office routine distinguished this man of principle during his term of public service. In fact, had he laced his conscientiousness with political shrewdness, he'd have avoided angering his chiefs. Yet this "gray, shaking man" shrugs off his apparent boredom during the trial to display the quickness that helped make him his party's leader. The prosecutor chides him for keeping his hands in his pocket because they're trembling. Were they to come into view, he continues, they'd attest to his guilty conscience. This indictment backfires. Trembling Deltchev's poor hands are, as he displays them to the court. But they can't be used as evidence against him. For the past month, his captors have withheld the insulin he needs to control his diabetes. Wisely, Deltchev explains his plight in German because nearly everyone in the courtroom knows the language. Though perhaps opposed to him politically, his audience sympathizes with him on emotional grounds. But no groundswell of support builds in his favor. His evidence is ruled inadmissible by the bench because, allegedly, it was given in a language unknown to the members of the court.

Ambler has purposes of his own. As unfair as it is, the judge's ruling only angers us briefly. Within three pages of its occurrence, Foster learns that some of the accusations made against Deltchev may be true. It comes out two chapters later that Deltchev had joked about the fuel shortage and black market activity besetting his country. Then a friendly colleague questions his

innocence. Rehearsing the details of the trial in Chapter 14, Foster can say no more than, "Probably he was innocent." *Judgment* discourages moral certainties. J. D. Scott, reviewing the book for the *New Statesman and Nation*, saw it as a maze with Deltchev at its misty center:

> What is the truth about Deltchev...? It is possible...that Deltchev is in fact a hero.... But as things develop it becomes clear that there are too many tiny pieces of evidence which won't fit in with this explanation, too many queer, dubious incidents. (211)

Foster shares this bewilderment. He hears so many explanations of Deltchev's conduct that he doesn't know which one to believe. As in Henry James, cleverness and stupidity can switch places. Katerina Deltchev, the book's youngest character (and thus the one with the clearest sight?), tells Foster in Chapter 18, "I think you are pretending to be more stupid than you really are." Earlier, she had said of her mother, "She is too clever to be simple." The truth isn't merely elusive; there's no agreement as to how it should be approached. The people in the book—which quotes a passage from Plato's Socratic dialogue, *The Crito*—seem to use every known dodge to avoid answering direct questions. Like their reticence and their flair for distortion, the skill with which they will either change the subject when feeling cornered or answer a question with one of their own shows Ambler to be a fine social comedian. But social comedy isn't the proper medium for a novel set in a police state whose depressed inhabitants face the constant fear of arrest. Such people won't speak their hearts lest they imperil the security of their homes by confiding in a government spy.

A person the ruling regime wants to keep silent is Mme. Deltchev, wife and later widow of the accused. Living under house arrest, she insists on her husband's innocence. Yet she avoids telling the whole truth. Foster visits this enigmatic ex-schoolteacher three times, always at dusk. Even though he questions her more closely each time he sees her, he pries no revelations from her. It's as if the thickening dusk outdoors had seeped into the family estate and formed a protective web around her. But does she need protection? A journalist tells Foster in Chapter 17 that two years ago she, and not her husband, was running the country and that she's the Deltchev standing trial in the local courthouse. Yet she never testifies in court. Her concession of defeat in the next-to-last chapter ignores the question of both guilt and guilty knowledge. Her role in any failed *junta* centering on her husband remains a secret.

This imponderable wouldn't have hurt the book if it weren't surrounded by others uncoiling from the Deltchev home. The short last chapter says of the condemned man, "It was the word 'Papa' that defeated him." The "note of wry affection" behind this nickname made him self-conscious. Feeling compelled to act the benevolent father, he made mistakes both in policy and its implementation. Perhaps they still weigh on him. Midway through the action,

we're told that Deltchev, later called by his wife "a self-torturer," will die for crimes committed by his son. To protect Philip, he will remain silent, even though he and Philip are political enemies. The father emerged as a protector in *Journey* in the figures of Kopeikin, Mathis, and Kuvetli. *Judgment* shows him for the first time as a sacrificial victim.

But it slights his inner drama. The most gripping aspect of Deltchev's trial remains lodged in his heart, unwritten and unshared. Father and son never appear together. At the outset, Philip is said to be studying law in Geneva. He is actually hiding out, a political fugitive, in his parents' city. In Chapter 11, the book's midmost chapter, he shows his face for a quarter of a page, looking, in line with the book's costiveness, "dark and very tired-looking." This artistic nicety soon loses its virtue. Ambler not only miscued by building his plot around a walk-on character; he also deceived the reader by giving Philip an alias. Jiko/Philip appears before us so briefly and does so little that before he's identified, he has been forgotten. Ambler's aim here is way off. He hasn't illuminated his Oedipal theme because he hasn't dramatized it. In most of his fiction—as in his life—the father cheats or bullies the son. The Ambler of *Judgment* lacked the conviction, the imagination, and the plotting skills to redeem his devious, selfish father. If his attempt to forgive Reg Ambler shows moral courage, it also, unfortunately, reduced *Judgment* to logical chaos.

*Judgment* contains many hints that it isn't the novel Ambler intended to write. Merely a device to snare the reader's attention, its flat, noncommittal title soon loses its relevance. Deltchev's trial has little to do with the violence following it in the monster rally held in the city square, during which a cabinet official gets murdered just after becoming his country's leader. Yet some readers have praised *Judgment*. The reviewer for *Time* claimed that "Ambler can make more fictional sense out of Balkan intrigue than anybody now writing" (118). And, as recently as 1977, James Fenton, writing for the British *Vogue*, called *Judgment* "Ambler's best novel," adding, "it is the most interesting politically and the most profound" (102). Some of this praise makes sense. Standing in a box near Brankovitch, the Minister of Propaganda, at the rally in Chapter 20, is his colleague Petra Vukashin, who will become head of state after Brankovitch's murder. Ambler conveys subtly both Vukashin's foreknowledge of the murder and his political ambitions by dressing him in a black suit and cloth cap—garb often worn by Lenin for his public appearances. Another kind of wit comes in Chapter 7. After meeting Foster, Katerina Deltchev turns away to announce him to her mother. Her departure, funny on its own, gives this grim episode, in which armed guards both pound and threaten to shoot Foster, some needed comic relief:

She turned on her heel and went into the house again. She was wearing neat white shorts, a *maillot*, and sandals. I felt a little sorry for her. It is difficult, even for an attractive young woman, to make a dignified exit in shorts.

Though dominated by smells, *Judgment* also features bold visual imagery. Besides noting Foster's parting view of Katerina, we can also point to his first impression of Georghi Pashik. The details Ambler picks to describe Pashik convey both the squalor of life in the Soviet bloc and his losing battle to transcend it:

I saw him standing on the platform...a short, dark, flabby man in rimless glasses and a tight seersucker suit with an array of fountain pens in the handkerchief pocket. Under his arm he carried a thin, black dispatch case.... I think it was the fountain pens that identified him for me. He wore them like a badge.

The simile ending this description recalls Graham Greene, as does the one Foster uses to give his reaction to the two guards who manhandle him in front of the Deltchev estate in Chapter 7: "my hatred of them welled up like a sickness." The expectation created and then denied by these similes, as they move from the concrete to the abstract, foreshadows the incongruity in Chapter 19 created by Pashik's calmly eating a sandwich while discussing the upcoming murder of Brankovitch.

The murder and the riot following it form just part of the excitement running through the final third of the book. It's in these chapters that Katerina turns up in Foster's hotel room and that Foster faces both ambush and gunfire. Unfortunately, this excitement neither begets nor develops any issue. *Judgment* lacks the plotting and the heartbeat to make sense of its politics. In Chapter 17, for example, Ambler rehearses at length Pashik's wartime and postwar ordeals. Though informative and entertaining enough, this rehearsal sidetracks the plot. And so do the strangers and puzzling incidents that pepper the closing chapters. The plot of *Judgment* depends upon characters Ambler hasn't troubled to commit us to emotionally. Any novel enacted by people the reader doesn't care about faces trouble. It will either make unsound claims, by ascribing importance to the trite, or it will explain, rather than enact, its major plot lines. The closing chapters of *Judgment*, in fact, founder beneath masses of bald narration because Ambler saw that his people lacked the substance to move the action themselves. Motivation, in the meantime, has gone to pieces, and what was once dramatic has flattened into dull summary. Ambler's inclusion of a three-page chapter at the end, which takes place in London some weeks after the continuous action recorded in Chapters 2 through 20, does weave together some of the loose plot strands besides balancing the London-set prologue printed as Chapter 1. But by the time we reach the end, the characters who once intrigued us have long departed, and we're glad to be finishing the incoherent, ungainly book they once made interesting.

Deltchev, the focus of the last chapter, hasn't been in view since Chapter

6. Ambler's reasons for restoring him remain his own. Perhaps giving its title figure more time on the witness stand would have improved *Judgment*. By dragging him back at the end, Ambler only resurrects issues he didn't resolve—Deltchev's non-role in the shooting incident in the public square and the Deltchev family drama. Ambler's declaring and then retreating from his Oedipal complex jams the engineering of the novel. Unable to describe Deltchev's convoluted tie with his son Philip, he substituted data far from his heart. This data doesn't connect. *Judgment* is crowded with more material than it can house, some of it silly. For instance, one of the leaders of a projected *coup d'état* responsible for coordinating, copying, and distributing messages vital to the *coup* is—a heroin addict. Such implausibilities sink the book. Greene complained justly of it, "The mystery is lamely solved. The violence of the end is confused and oddly dull" (51). It has to be. It concerns people and issues we don't care about. Its connections are loose and forced, and it lacks follow-through. *Judgment on Deltchev* isn't intense and engrossing at a challenging adult level. A work of some authority that wants tension, it earns Ambler few haloes.

*II*

If Ambler's failure to control his materials marred *Judgment*, the historical and emotional sweep of his next book, *The Schirmer Inheritance* (1953), restores his artistic form. It does so straightaway. Though set in 1951 or 1952, *Schirmer* opens with a 4500-word prologue that unfolds during Napoleon's 1806-07 campaign against the combined forces of Russia and Prussia. The prologue, moreover, is vital. No self-indulgent foray into history, it introduces both ideas and plot lines essential to the novel's growth. *Schirmer* mingles the familiar with the new. It brings back the ordeal of trudging through rough ground found in *Background*, *Alarm*, and the 1939 story, "The Army of the Shadows," which begins when a doctor's car runs out of gasoline on a dark, lonely road during heavy snows. *Schirmer* also uses a plotting device from *Mask*, that of the hero whose investigations disturb a smoldering past. This past again belongs to a supposedly dead man, a figure of blood and fire, who incites foreign travel, causes money to change hands, and accounts for the presence of an armed burglar in the hero-investigator's room.

Carrying over from *Judgment* is an interest in the law. The search for an heir, which begins in a Philadelphia law office in 1938, ends nearly 15 years later and 8,000 miles away in Macedonia. The searcher is George Carey, scion of a rich, successful, and smug east coast family. Ambler's first American hero and the first to be called in narration by his front name, Carey took his law degree at Harvard after earning a Bachelor's at Princeton. He's working at the time of the book for a prestigious firm of Philadelphia attorneys. Like several Ambler heroes before him, he leaves a sane, cozy routine for eastern European storm clouds, from which he emerges rattled but wiser. In *Here Lies*, Ambler

called Charles Latimer a "scholarly" person "in search of reality" (224). Carey resembles him. As a corporation lawyer, he has seen little of the darkness and depravity infusing criminal law. As a bomber pilot during the 1941-45 War, he only knew violence from a great height. He has tasted little of life's night side. Though in his early thirties, he needs seasoning.

His search for it seems misdirected. One Amelia Schneider Johnson of Lamport, Pennsylvania, died intestate at age 81 in 1938, leaving an estate worth three million dollars, about $500,000 of which will go to her rightful heir or heirs. Carey correctly views his assignment to the Schneider Johnson case as "a disagreeable blow." The boring, stupefying work of going through the firm's storage vaults promises to improve neither his professional standing nor his store of useful knowledge. It only foretells more boredom and stupor. After five weeks of inspecting files, archives, and registers, he has little to show for his efforts. Nothing in his dreary labors hints at the lessons he will soon learn—that the world is rougher and nastier than he had imagined, that things aren't always what they seem, and that feelings count more than money or social prestige.

Carey has been investigating, in his dusty cave, the credentials of 8,000 claimants to the Schneider Johnson estate, including those put forth by the state of Pennsylvania. Nor is he the first investigator. A senior party in his firm, now retired, had already gone to Germany, ancestral home of the deceased, looking for an heir. But the claim on the estate made by the Nazis and the ensuing outbreak of war froze the investigation. Bob Moreton came home, and all interest in the case, which was based on that of Henrietta Garrett,[1] stopped. A further obstacle, set forth in the prologue, comes in the truth that the Prussian dragoon, or cavalry sergeant, Franz Schirmer, the family patriarch, changed his name to Schneider to foil any military investigation that would label him a deserter. Only his eldest son, the first of 11 children he would have, remained a Schirmer.

Schirmer/Schneider reappears only once after the prologue—in a daguerreotype portrait, a century after his death. Stern, scowling, and erect, he typifies the imperious German papa. He also helps explain Ambler's longstanding father complex. One of his first acts in the prologue consists of killing the horse that carried him in combat. He's impelled by the basic needs of food and shelter. Cold, feverish, and weakened by the loss of blood, he has chanced upon a dilapidated farm house. The emaciated father and daughter occupying the hovel could help him regain his health and strength. In exchange for the roof and care he needs from them, he offers horsemeat. His shooting of his horse spells out his will to survive. It also refers to Freud's famous case of Hans and the Castrating Father. Little Hans's timidity, a failing that also shackled him as an adult, stemmed from the fear that his father would punish any wrong he committed by castrating him. Sgt. Schirmer's killing of his horse shows him either bypassing or sinking this fear. And it wins him a great deal. The flesh of the dead horse not only restores his health. It also feeds the young

woman he later marries; it redeems his faith in God, lets him thrive in business, and brings him a brood of 11 children, making good the symbolism of his name (*Schirmer*, in Modern German, meaning protector).

Ambler is pleased by the gains stemming from the Sergeant's slaying of his horse; the father must be sacrificed to the son. Franz Schirmer/Schneider's dates are 1782-1850. Though Ambler's father Reg was born 100 years after the Sergeant, as Alfred Percy Ambler (*Here Lies* 20), he died in the late 1920s (*Here Lies* 91). Ambler's setting up a parallel only to destroy it bespeaks a troubled past, but one that has been partly shed. Healthy and forward looking on its own, this process gains conviction from a similar one occurring alongside it. The Nazi villain was a stock figure, even a cliché, of the international thriller during the postwar decades; Ambler himself, writing with Charles Rodda under the pseudonym of Eliot Reed, used the stereotype in *Tender to Danger* (1951). In his treatment of the German ex-paratrooper, Franz Schirmer, the great-great-grandson of the horse sergeant, Ambler includes both moral ambiguity and sympathy. Having heard about Carey's errand, Franz agrees to meet the lawyer. But he doesn't want money. He's looking for a prize money can't buy—a sense of wholeness and belonging within a family tradition. This inheritance is lodged in his Schirmer ancestry. Once he claims it, he can live fully.

As is shown in the many resemblances between him and his military forebear, his outlook promises well. For the strong, the future grows happily from the past. A carrier of this past is the blood. The first Sgt. Schirmer, a practical, experienced campaigner, has his saber wound dressed in a way that forms a circuit with another cut: "He knew something of wounds. His had been bound up in its own blood, and could, therefore, be reckoned healthy," Ambler says of this intrepid cavalryman at the start of his long overland trek. The second Sgt. Schirmer re-enacts this continuity. First, the German word for paratrooper, *Fallschirmjager*, includes his name. This inclusion is revealing. Rather than denying himself, he meshes with his various energies, roles, and drives. As a paratrooper, he does a job to which he's suited. This harmony invites many similarities linking the two Schirmers despite the generations dividing them (young Franz was born in 1917). Besides looking alike, with their strong, determined faces, both Schirmers have the toughness, stamina, and wit to survive in rough open country. Both can also shrug off setback and bad luck.

As one who has escaped the constraints of linear time, Franz the younger repeats many of the deeds of his heroic forebear. This cyclical pattern, always a blow to the weak, both soothes and cheers the strong, as it does in Nietzsche, advisedly a German philosopher. Weak, wounded, and hungry, both Schirmers are left by their comrades behind enemy lines. Both recover, and neither rejoins his unit. Both marry a Maria. Each Maria, furthermore, lacks vim and spark when she meets her future mate. Hunger has wrecked both the shape and youthful good looks of the Prussian farmgirl, Maria Dutka. Her modern-day counterpart, Maria Kolin, conveys *her* separation from life by drinking. Yet

we're meant to believe that union with Franz will free her from drink. Within a year of taking his namesake into her home, Maria Dutka, her figure filled out, has married him, had his child, and left Prussia. Maria Kolin's wish to marry Franz and to raise a family with him puts her on the same happy course of self-renewal.

The agent of her rebirth, like Dimitrios, that earlier avatar of male force, enters the action late, at the end of Chapter 9 in a 12-chapter work. Our first look at him discloses his manly decisiveness, composure, and inner strength, i.e., qualities George Carey covets himself. Franz has arranged a secret meeting with Carey because he's in hiding. A survivor of an enemy army of occupation which, technically, he deserted, he faces trouble from Germans and Greeks alike. This paid mercenary must avoid the bullets and bombs flying across the Greek-Yugoslavian border, near which he is stationed. His survival skills match those of his forebear. He was hurt so badly by an exploding mine that both his mates and his enemies (like those of his namesake nearly 140 years before) left him for dead. Ambler details his hardships behind enemy lines to create an affinity with his forebear. Alert and sensitive, Ambler describes Franz's needs during the long push for food and clothes, rest and shelter. Some of these needs are met easily, whereas others are deferred or even thwarted. Through it all, good and bad luck confront the ex-paratrooper in realistic proportion.

Later, he disregards luck to create his own opportunities. Showing the ruthlessness of the born conqueror, he sentences to death two deserters from the guerrilla outpost he commandeers. Then, perhaps mindful of his own desertion from his unit, he pours himself a glass of wine. The fellow NCO he asks to drink with him, an Englishman named Arthur, also fought in World War II, but against the Germans. Yet it doesn't matter that Franz's and Arthur's countries were wartime foes. "In Arthur the Sergeant found a kindred spirit. They were both professional soldiers and had both served in *corps d'élite* as NCO's," Ambler says in Chapter 10. At times, he seems to be proclaiming a creed of male strength, even male supremacy, recalling that of Kipling's "Ballad of East and West," in which manly force transcends obstacles of nation, distance, and race. Then he will back away from the heroic ideal he is promoting. The life of adventure and daring, though exciting, shouldn't be prolonged. Franz can forget border skirmishes. As the book's title implies, union with his Schirmer past frees him to give up soldiering in favor of the anchoring warmth of home. His choice of Maria Kolin is one of social integration over schoolboy bravado. He has deepened his reality while discovering it. The Iron Cross he won belongs to an earlier existence. The mettle he displayed to win it stays with him. Hearing about his family history and looking at his namesake's picture move him more than the prospect of inheriting half a million dollars. The family tie teaches him both who he is and what he wants. The publicity surrounding his claim to the Schneider Johnson estate could attract hostile eyes, he suspects. Better for him to stay in Europe, find a civilian job, and raise a family with Maria.

Carey's search for him demands energy and conviction. Military records claim Franz to have been wounded in action and then reported missing. Though a former neighbor, an ex-commanding officer, and a member of Greek Military Intelligence all declare him dead, none produces confirmation. Grudgingly, Maria and Carey cross Europe to confirm the death their common sense believes to have happened. The end of the book's first half, the last sentence of Chapter 6, finds them in Greece, where they have come on the even chance that Franz is still alive. Ambler handles the search well, making good the hope created by the congruence of middles. Observing a rhythm of rising and falling hopes, the search will all but close, only to be reopened by an unexpected detail. Reasonable explanations for and pieces of circumstantial evidence pointing to Franz's death both pile up. Developments breaking to the side of the search will either derail or focus the search; nor is the connection always clear.

But the rebirth of the hero and his assimilation into society can't occur in a vacuum. The process requires the efforts of the unheroic, one of several ironies marking Franz's translation. For instance, the emergence of a new complication in Chapter 11 breaks the growing mood of wholeness, but only to reinstate it more fully and richly than before. Rabidly anti-German because her parents and her brothers were all killed by the Nazis, Maria wants to hurt Franz. She gets her chance when she notices that the truck that has been taking her to his hideout was the same one used in a recent bank robbery. To help the police find Franz and his cohorts, she leaves a trail of bright yellow tubes from the truck during her second ride to the hideout. Franz's reaction to this treachery shocks us only briefly:

> The Sergeant's fist hit her full in the mouth, and she crashed into the corner of the room where the empty bottles stood.

The woman near the empty bottles is herself a vessel that needs filling, even though she has emptied many a bottle herself. She has helped the police, not to abet justice, but to punish Franz for moving her sexually.

Attractive and multilingual with "an almost phenomenal talent for languages," Maria hires on as interpreter to Carey after being recommended by a U. S. Embassy official in Paris. This Serbian-born polyglot in her early thirties serves Carey well. No passive interpreter, she saves him time by acting as a confidante, a colleague, and a source of information. But her personality is bland and passive. The brandy she gulps impairs neither her equilibrium nor her speech. Franz proves that she needs a violent man to excite her. Toward the end, after telling Carey that she can't keep her hands off of Franz, Arthur, Franz's *aide de camp*, adds, "She's been waiting for a man like that all her life." Is Arthur to be believed? Her statement that she has never visited Cologne, Köln in German, implies a lack of self-sufficiency on the part of Maria Kolin. In leaguing with Franz, she may be simply making herself another victim of

German brutality, like her parents and brothers. But it's a healthy brutality, one that cleanses as it scourges. Like Carey, her colleague and traveling partner over half of Europe, she needs freshening and redirection. But she's a bit older than Carey, has suffered more deeply, and lived longer with repression. She faces a stiffer indoctrination. Like a Tennessee Williams heroine, her lust rises to what her moral self condemns. She discovers to her amazement that the kind of man she has been fleeing is the one she both craves and needs.

By leading the police to Franz, whom she calls "a German of the worst kind," she acts out of revenge. What she gets is love, but a love charged with some of revenge's gall and sting. The Maria-Franz relationship is the most complex, and perhaps most vital, in Ambler. At the end of Chapter 11, when Carey hears Maria's "fierce, shuddering cry of passion," uttered only an hour or so after her beating, he notes inwardly, "He was at last beginning to understand Miss Kolin." Love and hatred are fed by the same source in this linguistic prodigy. But what kind of future does she face? we wonder. In Chapter 11, Carey tells Franz that his illustrious forebear had the same military rank and was about the same age in Eylau, Prussia, in 1806, as Franz was when he landed in Crete a few years ago. What he omits is that his forebear's time in Eylau won him a wife called Maria who died a few years later. Perhaps Maria Kolin's life hangs by a thinner thread than anyone suspects.

The many repetitions, implied and stated, in *Schirmer* describe a world that is tidy and tight, in contrast to the wild, stormy psyches of the people. Franz's family history is full of sudden outbursts and moral complexities. Ambler explains these by looking into the love-hate core of people's lives. Just as Franz will beat and then make love to Maria, so does his great-great-grandfather shoot his horse to death within hours of patting "the animal's neck affectionately." The recurrences persist. Both Franz Schirmers find refuge with a female national of an occupied country. Franz the younger is betrayed by two women, Maria and, before her, Kyra, his former lover, in Salonika, who dies for her treason. Now, up to *Schirmer*, sex in Ambler had been nearly nonexistent. In its rare manifestations, it either took place at a great distance from the reported action, and/or it invoked the incest taboo, as with the Skeltons of *Epitaph* (who were brother and sister, though not lovers, in the 1938 version of the book), the Zaleshoffs of *Background* and *Alarm*, and the twinlike husband-wife dancing team of Josette and José Gallindo of *Journey*. Josette (who, like Maria Kolin, was born in Serbia) used it as a tactic to get money. *Schirmer* includes it as part of an intergenerational family drama.

Though a source of vitality and renewal, sex can also bring shame. Franz's grandfather, for instance, died in a rest home in lonely disgrace because of it. But, even though he left no money or property, he did bequeath to his heirs a powerful legacy of wildness. This collector of pornography made lewd passes to his son's wife (again grazing the incest taboo). His indiscretion cost him the solidness and security of home. Yet behind it throbbed a keen energy. Whereas

his son, Franz's father, was lazy and dishonest, old Friedrich's skill and drive made him rich. Ambler apparently believes like Darwin that excellence often skips a generation within a family line before resurfacing. He also believes, together with the kingpin writers D. H. Lawrence and Patrick White, that a person is the sum of his/her energies, even the destructive ones. To kill the demons of a Franz or a Friedrich Schirmer would also mean killing his angels. We must swallow these men whole if they're really going to move us. We can't pick and choose and isolate for approval those parts of their behavior that fit our ethical programming. Ambler channels this important issue into the upcoming marriage of Maria and Franz. In Chapter 10, just after meeting Maria, the Sergeant sets forth the qualities he's seeking in an ideal mate;

> If he ever married, it would be to some girl who would not weep even if he beat the living daylights out of her. Let her scream as much as she liked, *let her try and kill him if she wanted to*, and dared, but let there be no weeping. (Italics added)

Obviously, Franz is a dangerous man. But his willingness to absorb as much pain as he inflicts shows his desire to live fully with his future wife. As in *Mask*, Ambler still believes that cruelty and violence provide better access to manhood than the life of the mind.

The subtext of *Schirmer* pits the civilized professional against the desperado. The comparative worth of a Franz Schirmer *vis-à-vis* a George Carey is decided by Maria, the Lawrencean sleeping beauty roused to life by manly animal vigor. Ambler's endorsement of her decision, a stand enforced by his six years in military service, bespeaks self-doubt. Yet the self-doubt is qualified. Carey has taken better charge of his life than a Vadassy, a Latimer, or a Graham. By joining Franz to his roots, he has helped the Sergeant court Maria successfully. He has thus helped two people attain their deepest hopes, hopes rooted in tradition and branching into the future. His last act of the book— laughing—stems from the knowledge that he has defied authority in the persons of the Colonel who wanted to arrest Franz for robbing the Salonika bank and the graybeards in Philadelphia who had hoped to unload the Schneider Johnson estate. Carey's efforts haven't merely frustrated authority; they have, rather, honored a greater authority, that of closure and continuity as a function of self-discovery. In the *Bildungsroman* that is *The Schirmer Inheritance*, Ambler is both Carey and Franz; all three men gaining self-awareness together with insight into life's deeper rhythms.

Ironically, the American Carey, supposedly the bearer of new world energy and the book's youngest major character, stands on the sidelines. It's the Europeans who brim with passion. Like many other English-speaking professionals in Ambler from Kenton to Foster, Carey must leave the safety and security of home to discover his reality. His overturning the hopes of his law firm's senior partners yokes him to western legend, the classical roots of his

pre-urban European past. Though neither Greek nor Balkan in origin, he must spend time along the Macedonian border, a bare, wild, dangerous place, one of the few European locales in the early 1950s where bursts of gunfire passed between warring armies. The circuit Carey establishes with his primitive roots has enabled him to follow Maria and Franz. He has, like them, linked himself creatively to society. That we don't hear the linkage snap into place within the confines of the book reflects good authorial judgment. Ambler has already shown two of his major figures falling in love and eloping. Avoiding redundancy, he describes the third, Carey, symbolically tracing the same steps that Maria and Franz trod before *they* became whole.

The book has other virtues besides that of economy. In addition to using geography to note the depths and distances of the human psyche, it imparts freshness and luster. Its colors are bright, its contours well defined. As John le Carré did in *Smiley's People* (1980), Ambler also enriches his quest motif with the plotting device of the obscure ex-functionary who readies the quester for his ordeals away from home. Carey spends much of Chapter 3 interviewing Bob Moreton, the elderly retiree who hoped to find in Europe before the war an heir to the Schneider Johnson estate. The important truths Moreton conveys to Carey are filtered through the medium of deep personal sorrow. The news that Moreton's son was murdered by the SS during the war upset the son's mother so much that she died soon after hearing it. The poignancy of this disclosure to Carey, himself a combat veteran, makes him both a torch bearer and a surrogate son to the sickly bedridden ex-lawyer. In talking to Carey, Moreton shows an active interest in the future for the first time in years.

Old Bob Moreton also sounds more British than American when he says "engage" for "hire" and "banknotes" for "bills." And though he doesn't call gasoline petrol, the word "parcels" is used for "packages" in Chapter 2, and the second paragraph of Chapter 1 refers to the "High School" Carey attended without naming it. But Ambler's ignorance of the American idiom will alienate fewer readers than will his fascination with terrorism. Carrying over from a pocket history of the Carbonari, which Napoleon III belonged to, in *Judgment* is a long passage on the violent International Macedonian Revolutionary Organization, or *comitadjis*, founded in 1896 and still flourishing at the time of the novel as a recruiting source for redshirts and blackshirts alike. Ambler's talking in Chapter 10 of "the irresistible strength of the *Wehrmacht*" and his statement that "the penalty for disloyalty [to the *comitadjis*, or IMRO] was death" show him looking for precedents or guidelines. Perhaps he wants a new control, or authority, to replace his roguish, but treacherous, father. What his search also discloses, unfortunately, is a sadomasochistic streak that tallies with the male supremacy bodied forth by the two Sergeants Schirmer, by the motif of male bonding under arms, and by the novel's emphasis upon military hierarchy, discipline, and combat readiness.

Strangely, critics and reviewers have been overlooking this penchant for

brutality. Seymour Krim's attack, for instance, in *Commonweal,* cited blandness, not sexist pungency, as the novel's main failing: "In overall writing and total impact this is a bad falling-off from the high standard of his earlier books" (451), Krim said of Ambler's 1953 novel. A friendlier, more insightful reading comes from Paxton Davis. Writing for *The Hollins Critic* in February 1971, Davis says of *Schirmer:*

It mixes history, contemporaneity, scene, and character to form a blend that provides one of the broadest and most vivid views of the aftermath of World War II in European or American fiction. (8)

Davis understands the merit of Ambler's agile, well-turned book. *Schirmer* puts the hidden griefs and voids of people within a historical and a political frame and then treats them with empathy. Richly satisfying, this spread of human warmth combines restraint, evenness of temper, and sensuality without being showy or betraying signs of strain. Ambler's ability to season emotional insight with historical depth while maintaining a strong narrative pulse makes *The Schirmer Inheritance* his best book since *Mask,* published 15 years earlier.

*III*

*State of Siege* (1956) both departs from and resembles Ambler's other works. Like the prologue of its immediate predecessor, *Schirmer,* its first chapter gives the military and political background of what will follow. And what follows, as in *The Dark Frontier* and *Judgment on Deltchev* before it and *Dr. Frigo,* the Eliot Reed book *The Maras Affair,* and the 1970 short story "The Blood Bargain" after it describes an attempted *coup d'état.* Recalling *The Mask of Dimitrios,* a chubby Dane named Petersen appears briefly in Chapter 8 following the abortive *coup.* Most strikingly new about *Siege* is its setting, a fictional island republic called Sunda in the Indonesian Straits near Java, Borneo, and Sumatra. Ambler's portrayal of this steamy, violent place shows him branching out artistically. His deft use of history during the postwar decade of decolonization explains some of this growth. The Japanese had ousted Sunda's Dutch rulers in 1942. When the Dutch returned three years later, they ran into Sundanese demands for independence. These demands were met. Some of the Dutch settlers driven out by the Japanese went back to their farms and rubber plantations; some left Sunda altogether; by turns, all renounced any earlier claim upon public office on the island. But their renunciation created a new threat. Having helped drive the Dutch from power, the rebels now await their share of the spoils of victory. President Nasjah has withheld rewarding them for a good reason. He and Ambler both know that revolutionists serve their chiefs better on the battlefield than in public office. The skills needed to oust authority differ from those required to preserve it. But the rebels crave

power. An insurgency, led by General Sanusi, their commander, has invaded the republic's capital of Selampang and declared a *coup d'état*.

Rebels now occupy the telegraph office, the power station, and the train terminal. To entrench themselves, they have also imposed martial law, which they invoke in the name of Allah in order to purify the nation. Unlike the rebel leaders in *Frontier* and *Deltchev*, General Sanusi's forces call themselves God's messengers. They also fancy themselves shrewd strategists. They have planned their *junta* to coincide with the time when the government's troops are out of the capital performing maneuvers. What they don't know is that the garrison was ordered to leave Selampang unprotected in order to trick them into laying claim to it. Instead of bivouacking in the hills and marshes, President Nasjah's troops are waiting to comb the rebels out of the city and destroy them. Ironically, the rebels are most vulnerable with their confidence sky high. Nor do they face danger alone. In luring them into the city, their enemies, the incumbents, prove that they don't care about the loss of property and life caused by the *junta*. The Selampang they occupy at the end is a waste of shards and rubble. The government has squeezed and smashed the people it allegedly serves in order to consolidate its power. Expressing the shakiness of its claim is its rhetoric. Both the government and its would-be deposers use the same language to justify devastation. Each side claims to have public support; each insists that its rival is both acting without authority and violating the country's constitution. Both present themselves as armies of liberation upholding freedom and democracy while denouncing mob violence.

Ambler favors the incumbents by default. Agreeing in principle with the thoughtful Major Suparto, whom Lewis calls "the most interesting character in the novel" (112), he shows the Sundanese unfit for self-government. Independence came to Sunda as a fluke; the natives filled the power vacuum caused by the departure of the Japanese in 1945 and then blocked the returning Dutch administrators from resuming control of the country. The rebels, the government forces of President Nasjah, and the Dutch colonists have all committed atrocities. None deserves to control Sunda. But least deserving of the three are the Dutch in a post-imperialist age that saw the independence of India, Algeria, and the West Indies. Between the two remaining contenders there is little moral difference. The Nasjah government, in Major Suparto's words, is "corrupt and incompetent." But at least it has kept in place the means of representative democracy, unlike its rebel-foes, who, if given the chance, would try to silence public protest by building more mosques. Whatever small chance for social justice and economic well-being the Sundanese enjoy lies with the Nasjah gang, incapable of rule as they may now be.

The center of the struggle for power on Sunda is Selampang, the city of some 300,000 dazed, traumatized souls where most of the action of *Siege* takes place. Recalling Walt Whitman, Ambler builds his tropical city by both naming various neighborhoods, firms, and landmarks into existence and infusing this

local color into a warm, vital street life. To gain spontaneity, he will sometimes leave a Dutch or Malay term untranslated. Also creating the impression that he is immersing himself in Sundanese life rather than explaining it to a fellow outsider is his awareness of colonialism. Thus he names the hub of Selampang, once called Nieu Willemstad, the Van Riebeeck Square, and he calls one of the city's main motorways the Telegraf Road. Then he gives the city a race track, a dockyard, and an agricultural college. To support the activity generated by these places, Selampang has an international population. Sitting in a bar in Chapter 2 and listening to an Indian pianist are Chinese, Sundanese, and Europeans.

Beyond hearing range of the piano lie those local features that create our strongest impressions of Selampang—the reeking canals, the overflowing drains, and the cooking smells wafting from the vine huts that comprise the town's residential slum, where the very air, after a downpour, can both feel and smell like hot mud. Then there are the jeeps, tanks, and armed, helmeted soldiers patrolling the fraught, fetid streets. Sunda has become militarized for a good reason. The drowsy innocence of the East Indies has vanished since Joseph Conrad's day. The longstanding presence there of the British, the Dutch, and the Japanese, with their expansionist greed, has corrupted the natives, who now outdo their former masters in vice. The absence of mainland law has created a jungle morality tempered only by vigilante outpost justice. Selampang supports a thriving black market, particularly in high-ticket items like refrigerators and motorcars, which has both polarized local society and caused rampant inflation. Worsening these woes are smuggling, the bribery of public officials, and protection racketeering. The profit motive and suspicion infect nearly every human transaction in Selampang. Amid the bullets and bombs exploding on her maimed, pot-holed streets, the chances of survival have also shrunk. Neither is survival worth much. Infusing the conflict is the oriental fear of losing face. A rebel officer predicts for himself and his friends the worst defeat imaginable. After being forced to beg for mercy, they will be shot, anyway. They will forfeit face, or self-respect, together with their lives and be made to die in shame.

But if Ambler brings a city to vivid life, he also destroys it. And his descriptions of the battle scenes which culminate in the rebels' defeat include some splendid action writing. In prose at once observant, accurate, and energized, he conveys the stabbing, spine-wrenching shock of being surprised by a falling bomb. Then, bazooka blasts will fling both furniture and people from wall to wall, bring down parts of ceilings, shatter windows, and slice curtains into ragged, charred strips. Keeping perspective, Ambler will also show how this turmoil of plaster dust, glass shards, and bucking floors conveys a deceptive make-believe security. The book's narrator says, during an armored tank attack, "The smoke and the glare and the noise made it all seem like a sequence from a somewhat improbable war film." Sunda's internal strife prompts some of Ambler's best stylistic effects. "A pleasant room" savaged by

bombs, grenades, and pistol fire in Chapter 10 is reduced to "a hideous disfigurement." The antiphonal auditory images of the following passage, from Chapter 5, orchestrate the subtle and the strong: "I heard footsteps crunching towards us over the broken glass on the terrace.... Then, the footsteps ceased, the curtains were brushed aside, and Major Suparto stepped into the room."

Such stylistic counterpoint serves Ambler's political skepticism. If he's frightened by fanaticism, he's also worried about the pluralism and easygoing tolerance that characterizes western liberalism and often lands likeable people like Nick Marlow and Graham on the payroll of a big arms maker like Cator and Bliss. *Siege* exudes some of the nostalgia for Empire that led Ambler to build *Frontier*, in which Cator and Bliss stood for capitalist evil, around the archetype of the Victorian gentleman-adventurer. Logically enough, Steve Fraser, *Siege*'s English narrator, says in Chapter 4, "I have always sympathized with those legendary Empire-builders who changed for dinner in the jungle," before perpetrating the racist innuendo, "Because I had been able to change into clean clothes and feel for a few minutes like a rational European, I had made the mistake of behaving like one."

By rational, does Fraser mean civilized? And if so, does Ambler buy the equation himself? An author's values shouldn't be confused with those of his characters. Yet Ambler accepts the racism underlying several of the transactions in the book. An Australian airplane pilot tells the native driver of the *betjak*, or pedi-cab (or trishaw) taking him to a bar in Chapter 2, "Shove it along, Mahmud! We need a drink." He sounds like a member of the British Raj in Forster's *A Passage to India* (1924). Once inside the bar, Fraser compares at some length the attributes of two Eurasian women in order to decide which one is more western and thus more preferable for a spot of boozing and sex.

Being witnessed here is a symbolic enactment of Ambler's Oedipal complex. Before *Frontier,* Ambler started, but didn't finish, a novel "in the manner of Arnold Bennett about his father" (10), says Peter Lewis in the only book-length study of Ambler to date. Bennett always felt threatened by his despotic father. Even though he left the northern midlands, or Potteries, as a young man, he published *Clayhanger,* an autobiographical novel about his tyrannical father, in 1910, at age 43. The influence of Reg Ambler upon *his* writer-son probably exerted equal force. Giving up his own father-centered novel, Ambler published a first book intended to send up a popular fictional convention of his father's time. But the move from Bennett's naturalism to satire didn't ease his inner strife. As has been seen, he wound up endorsing the clubman-hero of John Buchan that he had tried to spoof and thus exorcise. Having witnessed, by the mid-1950s, when he was writing *Siege*, the failure of Marxism, the barrenness of moral relativism, and the futility of political violence, he could have easily pined for the sturdy Victorianism that ruled a simpler world.

But he didn't pine for long. Reason overcomes sentiment, and the

fragmentation informing modernism defeats the Victorian passion for certainty and abundance in *Siege*. The rout occurs most vividly in the person of the narrator, Steve Fraser, a parody of the scientist-explorer hero of Victorian life. (In Chapter 8 of Ambler's next novel, *Passage of Arms*, one American greets another in an Indonesian jail with the words, "Dr. Livingstone, I presume.") Brokenness has described Fraser from the start. Orphaned as a child, he later divorced his wife after finding her in bed with another man. He has just finished three hard years of duty as an engineer in the Indonesian tropics. But he's more of an outsider than Marlow or Graham, those engineer-heroes of *Alarm* and *Journey* whose work also took them abroad. By serving in the East, Fraser has put more physical and cultural distance between himself and England than both of these men. He has also, moreover, lived and worked for most of his professional career outside of England. At the time he comes before us, he's waiting in Selampang for a plane to take him to Djakarta, where he'll connect with a London-bound flight. Everything promises well. During his short stay in Selampang, he's staying at the flat of a friend. But the flat occupies part of the top floor of a building called Air House, so named because it contains the city's radio station and airline ticket office, prime targets for any rebel takeover. Like several of Ambler's other heroes before him, Fraser has his living space invaded and despoiled. His flat is broken into by soldiers belonging to the *junta*. Knowing that Fraser's friend, Roy Jebb, the flat's renter, is out of town, but ignorant of the fact that Jebb has loaned the flat to Fraser, the rebels plan to make it their main headquarters.

Besides having a central location, the flat has attracted the rebels because of its nearness to the radio station. But a falling bomb has burst some drains nearby and flooded the generator that powers the station. In an echo from *Frontier*, which influences *Siege* more than might have been expected, Fraser's captors tell him to make the generator work. Their leader has scheduled a speech to be aired in Canberra, London, and New York, places where neither the justice nor the firmness of his regime can be doubted. Though no hydraulic engineer, Fraser, threatened by death if he fails, does rig up a pump to suck the water out of the flooded basement housing the generator. General Sanusi gives his talk as scheduled, and Fraser will live. But awaiting him is the life-menacing drama he has drifted into, like many of Ambler's other heroes. He is trapped in a danger precipitated by others and then forced to comply with their demands. (Like Bill Casey of *Frontier*, he's also invited to help rebuild the revolution-torn country.)

Enriching the Amblerian drama of the trapped innocent is a familiar plotting device. Like Graham of *Journey*, Fraser goes to a nightclub early in the action and meets a woman who will hold his attention for most of the following chapters. The woman, a Dutch-Indonesian prostitute named Rosalie Linden, agrees to spend his remaining nights in Selampang with him. Like Maria Kolin's in *Schirmer*, Rosalie's father was a political fatality, killed by enemy

soldiers. Revelations like this one, made in Chapter 4, bespeak a new technical sophistication on Ambler's part; he is learning how to bring a man and woman together romantically. Other signs of his education declare themselves. The rebels invade the apartment where Rosalie and Fraser are just nodding off to sleep after having made love to each other for the first time. As innocents swept into violence, they share a plight conducive to both suspense and emotion along with the exchange of home truths.

The artillery attacks and the street fighting in *Siege* thus reach us from the standpoint of noncombatants whose lives are at risk. Even though Rosalie and Fraser aren't partisans or participants in the war, the slimness of their chances of survival maintains dramatic tension. Air House, Ambler keeps reminding us, is particularly vulnerable to bombs and bazooka shells. And explosives of all kinds have already razed much of Selampang. The novel's English title, *The Night-Comers*, carries the hint of Christian redemption in a plot acted out mainly by Moslems. One night-comer is Rosalie. She meets Fraser one night, and the next night she sleeps with him. Before parting, they speak intimately, take risks for each other, protect each other, and surprise themselves by probing new emotional depths. But this internal growth serves no purpose beyond itself. If the danger that ripened the hearts of Rosalie and Fraser also promotes Sundanese justice, we never hear about it. Selampang has been wrung, strangled, and bled. The wreckage caused by Sunda's civil war only came about because the government tricked the rebels into mounting their *coup* at a time when it had to fail. This trickery stemmed more from self-interest than from a social conscience.

But does it beget some measure of hope and joy, however muted? In Chapter 9, the rebel leader, General Sanusi, recites a prayer from the Koran containing the following words: "But what shall teach thee what the night-comer is? It is the star of piercing radiance. Truly every soul has a guardian over it.... Well able truly is Allah...to restore him to life." This radiance seems to have bypassed the Sundanese, whose immediate legacy includes only debris, filth, and broken hearts. The fighting has transformed the commonplace into the squalid instead of the beautiful. Rather than describing the triumph of character over circumstance, *Siege* portrays survival itself as heroic. It's enough to endure in our hard, fighting world, symbolized by third-world violence in multiracial Indonesia. Fraser buys Rosalie's sexual favors and pays for them before leaving her. Perhaps his time with her needn't uplift him. (Perhaps, as an Englishman with an engineering degree, he wouldn't acknowledge her, a half-caste Eurasian, as a source of uplift, anyway.) Lucky to be alive, he does well enough to honor the bond he made with her near the noisy, crowded bar where they met. His parting words to her reflect the guardedness of the loser who, rather than risking his rare good luck, settles for the few shreds of joy an uncaring fate drifted his way:

I bent over and kissed her once more.

"We love each other," she said.

"Yes."

"But we are also wise."

"I believe so."

"Yes." She smiled. "This way we shall always remember each other with love."

So far fallen from the Victorian ideal of male heroism is Fraser that he needs outside help to detach himself from Rosalie and Selampang. Lim Mor Sai, owner of the bar where Rosalie works and the husband of a Lancashire woman, intervenes for him. Mor's ownership of the Harmony Club suggests an ability to transcend discord and strife. Introduced in Chapter 2, Mor stays out of the novel till the end, where, having used his political influence, he hands Fraser an air ticket to Djakarta together with his passport, which was believed lost. *Schirmer* found Ambler thinking about continuity, closure, and wholeness to the point where he pondered attaining these ideals by unorthodox means, like physical cruelty. In *Siege*, which ends in rubble and division, he doesn't challenge himself so deeply. Perhaps the three years that passed between *Schirmer* and *Siege* disclosed so many pitfalls that bare survival took on a new allure and glow. But perhaps these three years also taught Ambler something new about bonding. Fraser needs the Eurasian Rosalie for sex and companionship during his stay in Selampang. He relies just as heavily upon the Chinese Lim Mor Sai to leave the place. His dependence upon non-Caucasians hints at three potent truths of the postwar ecumenical decades—that brief personal bonds can live fully, that they deserve our efforts, and that they can override distinctions of race.

Another non-Caucasian who matters a great deal to Fraser during his time in Sunda is Major Suparto, "a slim, handsome little man" with near-perfect English (though English is the country's second official language, few Sundanese speak it). Suparto confides in Fraser and takes chances for him, even though Fraser never knows why, since the Major befriends *both* the rebels and President Nasjah's incumbents at different times. Let future critics compare the ambiguity of his political loyalties to that of a figure out of Graham Greene or Ralph Ellison. It's enough to say now that he rates his and his countrymen's chances of outlasting General Sanusi's *junta* so low that he has endowed life with a new urgency and sacredness. Lewis stumbles when he complains about "the comparative lack of attention given to Suparto, the key figure in the *coup* and potentially a fascinating psychological case" (113). Ambler's technique of characterization in *Siege* rests on the grim truth that war and revolution destroy individuality. Although the book invokes psychological dimensions, it won't probe them. *Siege* is enacted by figures who are sketched vividly with the odd

subtle brushstroke implying inner riches rather than portrayed in depth.

Reviewing the book in the *San Francisco Chronicle*, William Hogan said of Ambler, "He can create the most sinister situations right in the noonday sun" (25). But then, reversing field, he indicts *Siege* for lacking "the shadowy grace" (25) of *Mask* and *Journey*. How valid is his indictment? How can a novel set in the glaring tropics in a town most of whose trees and buildings have been flattened by artillery fire exude "shadowy grace"? If Ambler had to decide between shade and sunlight to build mood in *Siege*, he chose well by opting for the unshaded blaze of the sun. One of the beauties of *Siege* consists of the way the book's physical environment conveys both plausibility and conviction. Practicing a selectivity both unforced and unintrusive, Ambler gives his Indonesian setting a lurid nightmare reality, even in the book's sun-stopped daytime scenes. This nagging undercurrent of fear makes *Siege* a triumph of mood.

Would that Ambler had orchestrated his plot with the same skill. In order to communicate vital information to the reader, he has Fraser eavesdrop on at least three different conversations. Admittedly, he uses irony to soften the arbitrariness of his contrivance. The talks Fraser listens in on sometimes unfold in his presence, and they're held in Malay, a language he himself speaks. The locals' ignorance of his proficiency encourages them to speak freely and thus gives him information helpful to his and Rosalie's survival. No comparable irony redeems the book's jerry-built conclusion. Because of poor planning, Ambler had to reintroduce Lim Mor Sai, who had been out of sight since his brief turn in Chapter 2, to resolve the plot.

But his smuggling in a *deus ex machina* at the end doesn't sink the book. The plot points of *Siege* connect nicely most of the way through; the sentences run cleanly; the details making up the local color are distinct and exact with the proper toning. *State of Siege* isn't deep, original, or brilliant. But it does reflect a sharp eye, a swift pen, and a political shrewdness. The emotional tension it builds stems more from deft timing and descriptive skill than from character. Yet the people aren't flat and predictable. Thanks to the book's inventive plot twists and rising suspense, they confound our facile notions about motivation under stress. Perhaps more boldly, they describe the survival skills needed to cope with both the danger and hysteria of entrapment inside a combat zone.

## IV

*Passage of Arms* (1959) again finds Ambler in soggy, revolution-torn southeast Asia. Perhaps his most cinematic novel, it features a complex, many-sided plot that moves to a strong dramatic climax. This impact is foreshadowed at the start. Girija Krishnan, an Indian clerk in Malaysian, finds a cache of arms including rifles, machine pistols, and grenades belonging to a guerrilla band that was ambushed and then wiped out by a British infantry patrol. Instead of focusing upon a specific character, Ambler shows how the cache touches a

dozen or so lives before its final disposal. *Passage* belongs in the literary subgenre of the story of hidden treasure. As in Poe's "Gold-Bug" (1843), Hammett's *Maltese Falcon* (1930), and Steinbeck's *Pearl* (1947), an object of great value tempts different people with the temptation defeating most of them.

Eager for money to begin a rural bus service, Krishnan wants to sell the cache of weapons despite the many problems facing him. These extend over three years. Luckily for him, several small encouragements dissuade him from abandoning the project. Ambler's telling, witty use of detail in his descriptions of Krishnan's care in maintaining and protecting his find gives the book a strong start. Krishnan is seen clearing the jungle underbrush leading to the cache, preserving the cache by repairing the roof and screen of the cache's storage place, spraying for termites, and camouflaging the newly repainted and waterproofed shelter to discourage trespassers. The Indonesian rebels for whom the arms were originally intended fused war and politics; business and clandestine activity were one and the same for them. Reflecting the skepticism found in Ambler's other postwar books, the prolonged, many-sided transaction that coaxes the shipment of arms to Singapore includes distortion, evasion, and lying at all levels. The dishonesties range from withholding information that might deter a prospective collaborator to treachery.

As is usual in Ambler, the person who suffers the most among the corps of agents, subagents, and touts is the innocent passive type who drifts into danger. Greg Nilsen's fictional lineage goes back to Desmond Kenton of *Background to Danger*, a journalist who stumbled into big-time spying as a result of losing money at poker-dice. The gun-running operation that Nilsen blunders into is more dangerous, since it threatens his wife along with him. Heightening this danger are the lies told him by all of his partners in the operation, lies he accepts as the truth and thus can't protect himself from. The Hong Kong limousine driver who proposes the arms deal to him says that the weapons were taken from a communist junk near Hainan. The driver's father-in-law in Manila, posing as the owner of the weapons, claims that the cache came to him when its owner, who used it as collateral for a loan, went bankrupt. Then he assures Nilsen that the transfer of the cache, now being held in bond, is merely a formality.

Nilsen is somewhat older than the usual Ambler hero, having a college-aged son. He has earned enough money from his die-casting firm in Wilmington, Delaware, to take himself and his wife, Dorothy, on a round-the-world cruise. His description of himself and his firm, "It's not a very big plant...and I'm not an important man," in Chapter 5, though too modest, hints at the process by which the Ambler archetype, an ordinary, or even an obscure, man, acquires importance. Nilsen's importance enriches the plot of *Passage*. Some years before the time of the reported action, a midlife crisis led him into an affaire with a 19-year-old. But he did muster the good sense to stop the affaire and save his marriage. He has remained committed to Dorothy. He gives

her both affection and emotional support, and puts her safety before his own when his misplaced trust betrays them both into danger.

Greater care went into the portrayal of Nilsen than into that of most of his literary forebears. His being older and more settled than his fellow engineers Marlow, Graham, and Fraser could explain his legacy of moral ambivalence. The person most deeply hurt by this ambivalence, Dorothy, is also by his side. (Fraser was divorced, while both Marlow's fiancée and Graham's wife remained in England while work took their men abroad.) Furthermore, entering the action in Chapter 3, he comes before us later than is usual for the Ambler archetype, who sometimes even serves as first-person narrator, a role that requires his presence from the very start. Nilsen's being an American reintroduces a variation in plotting first seen in *Schirmer* with the Philadelphian, George Carey. Like Carey before him, Nilsen is more innocent and gullible than a man of his accomplishments has a right to be. First, he agrees to participate in an action at best marginally legal; misled by a warped sense of patriotism, he relishes the idea of selling communist weapons to their American-supported enemies, as his collaborators knew he would. And this man who doesn't know when he's being manipulated or lied to can't resist subtler forms of persuasion, either. After agreeing to see Mr. Tan Tack Chee, the father-in-law of Jimmy Khoo, the Hong Kong chauffeur, Nilsen finds himself and Dorothy entertained so lavishly in Manila that his resistance is crushed. So beholden does he feel, in fact, that his moral indebtedness to Tan survives his dealings with Tan's vicious brother, a union thug and gambler on Singapore's "pickle market," an illegal trade in raw rubber.

Though frustrated and angry, Nilsen won't walk away from the arms deal after new conditions are added to it. It doesn't even matter that some of these conditions are unfair. For instance, his $2100 fee can't be paid until a buyer for the arms is found. Concluding the sale also involves more and more new requirements, each one more problematic than its predecessor. Just when he expects to be paid, Nilsen learns that he'll have to fly to Labuanga, an outpost in Sumatra, to get his check signed by an officer of the Independent Army of the Faithful, the anti-communist Moslem buyers of the cache. The Party's Singapore agent, the shady ex-British Army officer, Captain Henry Lukey, minimizes the inconvenience of the trip. He even has his wife accompany the Nilsens to lower their resistance to the alleged half-hour's flight. Actual flying time is two rough hours, all three visitors to Labuanga are soon jailed for arms smuggling, and the only thing that saves their lives is the political expediency, rather than the humanity, of their captors. Nilsen's Polish cell-mate, Voychinski, an ex-Nazi soldier whose well-being exerts much less political leverage, dies during a brutal interrogation.

The trip to Labuanga, which occupies most of the book's second half, features some brisk, inventive prose. The paragraph introducing this sprawling harbor describes the tropical luxuriance of the flora planted in gardens and

flower beds meant to hold smaller, tidier blooms from Holland. The simile ending the paragraph captures the mood created by the collision of nature and artifice: "The center of Labuanga was like a respectable Dutch matron seduced by the jungle and gone native." The life-threatening drama that ensues uncoils with the same unreason. The three visitors are greeted by delays and indignities. After a long wait at the airport, they're then herded into a cramped, insect-ridden hotel room lacking both shower and toilet. Next comes their arrest and some rough questioning whose purpose is to pry from them the sea route being used for the shipment of arms which the questioners want to intercept. Then, around the time Nilsen's cellmate is murdered by these same questioners, a squad of rebels seizes the jail where the visitors have been stowed.

Throughout the raid—the shouting, the explosions, and the clouds of plaster dust—the action has been developing at different levels to sharpen its human focus. In a reversal, Betty Lukey, the Captain's wife, a long-time resident of Asia, breaks down during the raid and needs Dorothy to calm her. Ambler knows that reversal can serve different narrative ends. In Chapter 2 he showed the Indian discoverer of the arms cache, Girija Krishnan, the recording intelligence of most of the book's long first chapter, through the suspicious Chinese eyes of a potential business partner. Here and elsewhere, body language, vocal inflection, and nuances of tone can influence a social or business transaction. Ambler's sure sense of timing also enlivens the plot. Telegrams pass between members of the Tan family in Hong Kong, Manila, and Kuala Pangkalan, Malaysia, following visits involving one of them with Nilsen, Ambler widening the rift between our knowledge of the operation and that of the innocent American engineer. This irony will be refreshed by variety. For instance, an account of the physical toil demanded by the operation may follow a duel of wits. Much of Chapter 4 describes the problems of handling and moving the arms cache over rough ground while concealing it from would-be thieves. Delighting in mechanical process, Ambler shows Krishnan fitting a suitcase trolley with wide wheels to facilitate the crossing of spongy, rain-sodden ground under a heavy load. Displaying an admirable range of voice and subject matter, the same chapter describes a large, heavy-boned American woman looking ridiculous in a silk formal dress made for graceful, slender Chinese frames.

Variety can also promote narrative drive in *Passage*. The next chapter opens in Singapore and introduces the veteran security officer, Colonel Soames. The Nilsens' ship, *The Silver Isle*, has already docked in Singapore's harbor, and Nilsen has lied to the immigration officials about the purpose of his visit. Though technically innocent of arms smuggling, he claimed that he has only come to Singapore as a tourist, omitting all mention of the shipment of arms being held in bond for his signature. The rush of new characters introduced into the action, both military and diplomatic, in the Labuanga sections, gauges the troubles caused by Nilsen's innocent undertaking. These troubles exceed all

expectations. That two of the new characters are the British and American vice-consuls in Labuanga describes them as political. That another leads a local raiding party shows the contagion of violence bred by the arrival of the Nilsens and Betty Lukey.

The book's exciting finale has been deftly prefigured. After a flurry of violence in Chapter 1, *Passage* moves slowly and sometimes playfully until its sixth chapter, describing the feinting and maneuvering behind a complex sales operation in-the-making that's at once military, political, and commercial. And legal? Now that Malaysia is no longer under martial law, Krishnan's weapons can be sold. They're not stolen property either because they have no owner. Yet Malaysian law forbids the export of arms by Malaysian nationals. Even though the Indonesian government in Labuanga needs rifles, grenades, and bazookas to crush its communist foes, it can't import Krishnan's well-stocked cache until the cache is made respectable. The process resembles that of laundering black money. Clearance papers must be signed by a nonresident foreigner to get the goods legally bonded in Singapore. What follows, in Ambler's most intricately plotted novel to date, is a psychological melodrama. To describe it, Ambler shifts both setting and point of view. Having already been threatened with arrest by one American tourist, chauffeur Jimmy Khoo carefully assesses Nilsen in order to win his confidence before broaching the subject of weapons. Much of Chapter 3 describes the tricks Khoo uses both to disarm Nilsen and to forestall Nilsen's objections to his proposition.

As has been seen, the multiple narrative threads forming *Passage* converge toward an exciting climax. Yet the book transcends the genre of adventure fiction, providing a moral vision lacking in *Siege*. Not content to write a well-crafted novel of intrigue and violence, the Ambler of *Passage* enriches the genre by infusing it with poetic justice. The Americans in view for most of the second half make the international theme, as set forth by Henry James, a natural guideline for the growth of the book's redemptive vision. As in James, the confrontation of rich American travelers and their less-moneyed foreign hosts brings out the worst in both—the wily foreigners' greed and the Americans' gullibility and arrogance. Because of his imprudence, the shackles slip over Nilsen's wrists and tighten imperceptibly. The unsuspecting Nilsen is gulled by Jimmy Khoo in Hong Kong, by Tan Tack Chee in Manila, and by Captain Lukey in Singapore. The Singapore police officer who tries to help him, Colonel Soames, he defies. His duping by Captain Lukey shows his unreadiness. Having already obligated himself to Mr. Tan by accepting his hospitality, he should never have let Lukey provide him and Dorothy with an evening's entertainment. Ambler prefigures Lukey's gulling of Nilsen by showing the speed and ease with which Soames pries information from the American while offering little himself.

But the stripping of Nilsen's defenses alerts him to larger issues. Like a Catherine Sloper of *Washington Square* (1880) or a Merton Densher of *The*

*Wings of the Dove* (1902), he'll forsake material profit for deeper insight. He leaves us with his soul shaken but intact and his grasp of reality strengthened. "Oh yes, I found a Communist bastard," he tells Soames of his time in Labuanga. "But," he adds, "I found a Fascist bastard there as well." Recalling Ambler's disaffection with Stalinism, Nilsen learns that political ideology often prettifies material greed, justifies butchery, and masks the power lust underlying tyranny. Nilsen has paid heavily for this lesson, and he's content with it. Yet he's also human enough to grab the chance to settle accounts with his scheming ex-partners. After giving his commission on the arms deal to charity, he arranges for his receipt of payment to reach Tan Tack Chee in Manila two days after he himself leaves Singapore. By this time, he reasons accurately, Tan's brother, Yam Heng, will have embezzled the funds from the sale and gambled them away on Singapore's pickle market. The anger of Yam Heng's family over losing both money and face in the arms transaction will reverberate in Hong Kong, Malaysia, and Manila, but not in Colombo or Bombay, sites toward which the Nilsens' cruise ship is heading.

Another pleasing note, also technically earned, graces the book's finale. Here we learn that the main passage in *Passage* is one from death to life. The first event of the book showed the burial of some Malaysian terrorists killed by British troops. The book's last two chapters return to Malaysia and restore Krishnan to center stage. The supervisor of the burial at the outset has now achieved his life's ambition by owning and operating a bus line. The only keepsake he asked for as a boy, upon learning of his soldier-father's death, was an illustrated color catalog from a London bus manufacturer. From the time of his first glance at the catalog, bus transit always symbolized for him the convenience and elegance of motorized travel together with the chance for both money and social prestige. His using his share of the profits from the passage of arms to gain his childhood hopes while also serving his neighbors in (fictional) Kuala Pangkalan creates as neat a dovetailing of plot strands as can be found in Ambler.

The vital signs of *Passage* run high. Not only are the events the book recounts stimulating; the human interest linking the events also rivets us. American speech still worries Ambler a mite, as in *Schirmer*. In Chapter 3, he has Nilsen call a bulletin board a notice board. And in Chapter 7, when asked which of his possessions were confiscated when he entered Labuanga, Nilsen answers, "Everything—money, wallet, watch, *the lot*" (emphasis added). But the end of the next chapter does find him referring to a drug store rather than a chemist's. Now if Ambler's odd misfire with American speech distracts us, his deft use of local terms, like the Hindu charpoy and the Malay godown and kampong, imparts convincing mood and color. *Passage* is written with authority and verve. Ambler's ear and nose are both excellent and his comic sense, acute. The distance he keeps between himself and his people also strengthens his satire; sentiment won't smudge the clarity of either his political or moral views.

As he will do later in *A Kind of Anger, The Intercom Conspiracy,* and *Send No More Roses,* he describes the frustrating toil—financial, legal, and political—of transacting international business in the postwar age. As he did in *Siege,* he forsakes in-depth characterization in favor of the vivid sketch. To develop the complex, far-ranging plot that brings his people together, he prefers narrative development over analysis, prophecy, or explanation. The action both carries the story and reveals character.

The success of the action, like that of the samplings of exotic culture the action displays, depends upon selection. Ambler subdivides his 1959 novel into alternating blocks of time and/or settings in order to set off the successive movements of the action. This alternation also shows the movements slewing away from each other and then merging, as in a fugue. Using a cinematic analogy, Lewis has shown how this scenic counterpoint suits Ambler's comic intent while also unifying the rapidly shifting action:

There are ten chapters but forty-six sections, some less than a page in length. This permits rapid shifts from one place and character to another, as in cinematic montage, so that intercutting, as opposed to a continuously unfolding sequence, is a major structural principle. This has the effect of creating the distance and detachment necessary for comedy. (116)

Phoebe Adams's review of *Passage* in *Atlantic* looks differently at the union of narrative technique and theme. To Adams, the book deals more with the problems of protecting, moving, and selling a cache of arms than with the people faced by the problems: "The central character is not really a character at all but a cache of weapons, and the story is simply the successive and increasingly complicated maneuvers required to turn these objects into money" (114). But she would agree that, in *Passage,* Ambler wasn't trying to write a *nouveau nouveau roman,* i.e., a novel deliberately lacking a human center, in the manner of Alain Robbe-Grillet (b. 1922) or Philippe Sollers (b. 1936). To secure reader interest, he built most of the book's second half around Greg and Dorothy Nilsen, a couple his Anglophone readers could identify with, even if he waited till Chapter 3 before introducing them. He also brings the action full circle by restoring Krishnan in the book's final two chapters, satisfying a human appetite for symmetry rarely met in experimental fiction.This shapeliness didn't impress Lenore Glen Offord. Writing in *This Week,* a weekend supplement of the *San Francisco Chronicle,* she finds Ambler's climax "somewhat diffused" (25) by the complicated plot. "Some of us," she continues, "may have wished that he [Ambler] allowed himself a bit more simplicity in subplotting, even at the expense of realism" (25). This complaint ignores the intercutting referred to by Lewis. As Lewis said, *Passage* cuts from one scene and one set of characters to another, all of whom get snared inside the mosaic they're making, strand by strand. Any subchapter can advance the action independent of the people who

appeared in the previous one. Yet these people, though offstage, will feel the new developments. General Iskaq, the Governor of Labuanga, for instance, both distrusts and dislikes a clever junior officer serving under him. That Major Gani has become indispensable to him will later prod the General to take his advice and extend mercy to his prisoners, the Nilsens and Mrs. Lukey, rather than following his bent to kill them.

This echo from *Siege* prompts a search for others. The quickening pace of *Passage* demonstrates anew Ambler's skill in building mood, motive, and suspense. Voychinski, the technical staff adviser for the rebels who dies during an interrogation is Polish, as was the lover of Steve Fraser's wife. The Labuanga sections of *Passage* evoke other echoes from *Siege*. The three unlucky visitors from Singapore check into the island's ironically named Harmonie Hotel, recalling Selampang's Harmony Bar, where Fraser met Rosalie Linden. Also called forth by the Labuanga melodrama is the need for a *deus ex machina*. But *Passage* contains three such rescuers, at least one of whom laces the action with a familiar legacy of pain. Resembling Fraser, Keith Wilson, the Honorary British Vice-Consul in Labuanga, has spent most of his working career in Southeast Asia. He also follows Foster of *Judgment* in being a widower who has never remarried. In Foster, Fraser, and, to a degree, Maria Kolin of *Schirmer*, Ambler has already built novels around alienated characters with a tragic past. Keith Wilson, who enters *Passage* too late to occupy center stage, he uses differently—both to induce a mood of isolation and to help the trapped, frightened visitors, the Nilsens and Betty Lukey, leave the island.

Material help comes, too, from Wilson's American counterpart, Ross Hallett. Hallett defies local officials by demanding—and getting—a private interview with Nilsen before the engineer is questioned by the law. Later, Hallett secures a safe conduct to the airport for the distressed trio after their release from prison, putting them aboard a Malayan Airways plane rather than an Indonesian one, which would fly them back to Labuanga if General Iskaq ordered it to. A fluent speaker of Malay, the decisive, compassionate Hallett certainly improves upon Greene's Quiet American, the economic attaché officer, Alden Pyle, who is mentioned along with his creator earlier in the book. Whether Ambler was still smarting from Greene's unfriendly review of *Judgment* eight years before and used Hallett to settle an old score can't be known, even though the revenge motif featured late in the book shows that getting even was on Ambler's mind. It's enough to point out that Hallett has the training, the grit, and the humanity to assert his worth as a foreign service officer. Colonel Soames, Singapore's British security chief, is a *deux ex machina* of a different stripe. By proposing the sting operation that helps Nilsen avenge himself upon his swindling ex-collaborators, Soames restores both Nilsen's self-esteem and sense of humor.

But how does he affect Ambler? As we learned from writers like the Brothers Grimm, Kipling, and Greene, vindictiveness often stems from

childhood pain. A great deal of suffering undergirds *Passage*. We shall probably never know whether Ambler punished the Polish lover of Fraser's wife by killing his compatriot Voychinski in *Passage*. Nor can we know what the killing meant to Ambler. But looking at the names of some of the other characters does disclose an authorial unrest that Voychinski's brutal death could refer to. Arlene Drecker, an obnoxious passenger aboard the *Silver Isle* who is politely called "the ship's bore," has a last name close to the word for dirt, and even shit, in Yiddish. Analogously, there's the scowling, thickset Governor of Labuanga, a man whose movements resemble "those of some powerful yet cumbersome animal." Brutal General Iskaq hates all white people because of the indignities suffered at white hands by his coolie father. A hunger to avenge these indignities has never left him. Only the threat that the United States and Great Britain will disown his Central Government keeps him from killing the Nilsens. His name, Iskaq, also sounds like "his cock," a phallic identification strengthened by Ambler's giving him the august military title of General instead of a first name.

This vengeful bigot exerts enough primitive male force to be called a Sumatran Dimitrios. But while he possess Dimitrios's ferocity, he lacks the charm and sophistication the ex-fig packer cultivates. The distance between him and the civilized values represented by the Amblerian hero has widened. And so has the split between Ambler's reason and his instincts. If his rational, socialized self deplores the animal cunning and violence that have lifted Iskaq to power, his heart feels starved by the absence of this crude volcanic fire. His inner malaise hasn't brightened since he published his first book in 1936. But he continues to confront it regardless of the risks, using invective for the first time, in *Passage,* in his name symbolism. The confrontation may have addled the book's deep structure, creating the need for three *dei ex machina* to resolve the action. This scamped resolution didn't offend contemporary readers, though. Besides selling well, going into a second printing a month after publication, *Passage* won a Crime Writers Association Award for 1959. Clearly, it enforced the loyalty of old friends while gaining Ambler new ones along with some overdue professional acclaim.

But Ambler paid heavily for these gains. Iskaq isn't the only father-ridden man in *Passage*. The book's last sentence, which records Krishnan's final thoughts on securing a bus line, reads, "He wished that his father, the subahdar [a junior officer in the British Army], could have been there." Sharing an elemental drive to self-being, Krishnan wants his true worth both recognized and appreciated by his father, the original owner of the bus catalog that became Krishnan's "most treasured possession" and furnished his life's ruling passion. The reference to his father in the novel's last sentence bespeaks Ambler's ongoing father-anxiety. Revealingly, Arthur Abdel Simpson, the narrator of his next free-standing book, *The Light of Day* (1962), and a man fond of quoting *his* father, is so nasty and rundown that he'd never impress anybody. A British

vice-consul in *Dirty Story* (1967), where he next appears, calls him "a disgusting creature."

Back in *Passage*, though, Ambler is still trying to ease the stress caused by having failed to win his father's respect. His stand-in, Greg Nilsen, a fellow engineer of about his own age at the time he was writing *Passage*, is accused of being too hard on himself, a charge earlier directed to Yordan Deltchev. Nilsen also hears from the wise Colonel Soames, "The real bogey-man crawled out of the mud with our ancestors millions of years ago. Well, we all have a piece of him." This veiled expression of belief in the doctrine of original sin carries the warning not to expect too much from people, ourselves included. Yet the thief, pimp, and pornographer Simpson meets no reasonable expectations at all. The point is worth making in connection with Ambler's Oedipal complex because Simpson's father not only influenced his son as strongly as the subahdar did Krishnan but also, like the subahdar, died while serving with the British Army. Nor need the military connection be dropped. The devious Captain Henry Lukey, who risks the lives of the Nilsens and of his own wife by sending them to Labuanga, comes from Lancashire, as did Reg Ambler (*Here Lies* 20-21).

In *Here Lies*, Ambler reviewed the struggles he faced returning to novel-writing after an absence of ten years:

I had not written a book for ten years and in the army had lost the habit of a concentrated and solitary writing routine. The process of recovery was slow. Besides, during those ten years the internal world which had so readily produced the earlier books had been extensively modified and had to be re-explored. (226)

How much of this can be believed? The difference between "the internal world" disclosed in the four novels published between 1951 and 1959 and that of the earlier fiction is smaller than Ambler claims. In fact, the works of Ambler's middle period reinforce psychological patterns found in the interwar books, making them intensified versions of their predecessors. The multiplication of *dei ex machina* in *Passage* conveys Ambler's longing for a benevolent father figure to ease his inner stress; the Ambler archetype no longer wants to defy or impress the father to confirm his own autonomy. But is his development arrested? Apart from the three *dei ex machina* in *Passage*, Ambler's subservience to the father declares itself in the recurrence of addictive behavior in his middle phase. The addiction to drugs and gambling dramatized in *Mask* returns in *Judgment* and *Passage*. Another pattern that carries forward centers on motorized transport. Once Krishnan starts operating buses, he stops riding in them. Simpson, on the other hand, earns much of his living as a cabdriver. As has been seen, his ethics are slimier than those of that other professional chauffeur, the unangelic Jimmy Khoo. Reg Ambler, we're told (*Here Lies* 71), drove badly. Unable to impress, defeat, or grow past him, Ambler can only paw out feebly at Reg by going public with his lack of driving

ability and, indirectly, inviting a moral comparison between him and a pair of swindlers. Perhaps, on the other hand, he disavows the same comparison he asks us to buy. His statement that his father's driving prowess fell far below the professional level denies any likeness between Reg and Simpson or Khoo. Supporting this idea is his involving the heroes of *Siege* and *Passage* in problems which they can't solve without the help of an older male authority figure.

The emotional logic informing the plausible, contradictory ideas about Reg Ambler's relevance to *Siege* and *Passage* makes immediate, if absurd, sense. The flow of years hasn't soothed Ambler's anxiety about his father. Ambler will mute his painful psychodrama in the next brace of books we'll look at, the ones he wrote with Charles Rodda and published under the name of Eliot Reed. Belonging to the same period as the works we have just studied, the five Eliot Reed titles disclose in brief gleams and glimmers the troubled psyche of Ambler even though, curiously, he didn't have a hand in every one.

## Chapter Six
## Enter Eliot Reed

The novels published between 1950 and 1958 under the pseudonym of Eliot Reed find Ambler most vividly in their heroes. The triumph of virtue over villainy in the five Eliot Reeds may bespeak a more conventional morality than that of the fiction appearing under Ambler's name. But the happy endings crowning the Eliot Reed books come at a heavy cost. The heroes of these works suffer a great deal before reaching their goals. Nor can they be defined as goal oriented. Unlike the tough, laconic man of purpose found in American hard-boiled private-eye fiction, the Eliot Reed hero follows the Ambler archetype in being a skilled professional, like a doctor or an architect, who stumbles into danger. This creature of routine, who lives alone, nearly drowns amid the troubles that engulf him, and he doesn't blaze with those grand, world-altering passions that might power him through those troubles. As with his Amblerian counterpart, the sane, peaceful life style he follows has dulled his response to danger. The world isn't as safe as he thinks. Thus after suspecting that he's being followed, he'll chide himself for having paranoid delusions and lower his guard. Soon, the jaws of the trap open.

Perhaps because the problems Ambler had with *Judgment* showed him the difficulty of resuming his novelistic career, he lost interest in Eliot Reed as the decade advanced. He says in *Here Lies*, "of the five [Reed] books...only the first two, *Skytip* and *Tender to Moonlight* [published as *Tender to Danger* in the United States] contained substantial contributions from me" (227). Ace bibliographer of crime fiction, Allen J. Hubin confirms Ambler's statement. Hubin says that, in descending order, the last three Eliot Reed titles reflect little or no involvement by Ambler. Though Ambler helped a bit with *The Maras Affair*, claims Hubin, he had no hand at all in the writing of either *Charter to Danger* or *Passport to Panic* (1984, 331). What all this means is clear. Matching Ambler's dwindling participation in the Eliot Reed books is a drop in literary merit; each book in the series falls off artistically from its predecessor. This decline speaks poorly of Ambler's collaborator, (Percival) Charles Rodda. Unfortunately, it's also one of the few surviving statements about him. Born in South Australia in 1891, he lived in England, France, and Cornwall, writing music criticism and publishing fiction under his own name and those of the pseudonymous Gavin Holt and Gardner Low. As the worsening of the Eliot Reeds implies, this busy author of murder mysteries that sometimes included

**117**

musical motifs never attained artistic eminence; Barzun and Taylor, in fact, disparage him in their *Catalogue of Crime* (240). Perhaps the clearest sign of his unimportance in twentieth-century literary detection lies in the absence of any death date in the reference works I've consulted for information about him. A letter from literary agent Gerald J. Pollinger, of London's Laurence Pollinger Ltd, 8 October 1990, says he died in 1976 or 1977 but without citing any obituary notice. Clearly a minor figure, Rodda died forgotten by his agents, publishers, and readers—a heart-wrenching situation in view of his forty-odd books, but one more suitable for discussion elsewhere.

*I*

The similarities between *Skytip* (1950), the first and best of Eliot Reeds, and Ambler's freestanding work outweigh by far the differences. Unlike any other Ambler (or Reed) title, *Skytip* unfolds entirely in England, spanning London and Rodda's adopted homeland of Cornwall. Yet the novel's English setting calls forth many motifs found in the Ambler books, with their foreign venues. The holiday that gives more turmoil than ease returns from *Frontier* and *Epitaph*. The hero, a man whose professional expertise eclipses his common sense, gets abducted in a car by enemies he should never have trusted, as in *Journey* and *The Intercom Conspiracy* (1969). Other similarities suggest themselves. Like that of Josef Vadassy, George Carey, and Steve Fraser, the hero's living space is invaded. Borrowed money is not repaid. A stranger the hero meets, supposedly by accident, calls him by name. This person, Jessica Trask, first seen in the Cornish village of Bosverran, follows the Countess Magda of *Frontier* in being a dark beauty. Also returning from *Frontier* is a zest for physical punishment. In an attempt to squeeze information from the book's hero, his abductors gag him and hoist him by block and pulley so that his toes barely graze the floor. While the pressure builds in joints and muscles, one of Peter Ackland's abductors drives his thumbs into Ackland's nerve centers.

Echoes from Ambler's other fiction can be stylistic. A writer who will soon be murdered enters the novel thus: "He came out on the porch holding his arms slightly in front of him.... It was...as if the man were trying to squeeze through a narrow gap in a hedge." Another murder victim, who doesn't survive the prologue of *Cause for Alarm* and who is also first seen out of doors, holds *his* arms in the same odd way: "He was a stoutish, middle-aged man with rounded shoulders and a way of holding his arms slightly in front of his body, as though he were trying perpetually to squeeze through a very narrow opening."

But the clearest influence among Ambler's early books on *Skytip* remains *Frontier*, a work that also casts long shadows upon *Schirmer* and *Maras*. The overworked architect, Peter Ackland, like Henry Barstow before him, is told by his doctor to take a vacation. Prescribing "rest, fresh air, and quiet," the doctor sends him to Cornwall. His prescription yields the unexpected—and the

unwelcome. Though Ackland follows it, he also faces more stress and upheaval than he would have by staying home in London. His problems start straightaway. Having miscalculated his arrival date, he waits in vain for the truck he had expected to meet him at the station. Then he gets lost. Because he was either misdirected or failed to follow the directions given him to the farm where he had booked lodgings, he turns up at the wrong house. The calm his doctor ordered has been deferred, while his need for it has grown. Nervous, fragile, and easily rattled, he feels as marooned in England as most of Ambler's heroes feel thousands of miles from home.

Some of his disquiet comes from being in Cornwall, a place as confusing as a foreign country. First, it's the heart of England's clay country, which accounts for the huge cone-shaped mounds of rubble known as skytips disfiguring its surface. The foreboding created by the spectacle of this "lunar fantasy" coexists with the Arthurian legend that has long sustained Cornwall. Ackland notes inwardly the proximity of Merlin's Cave, Tintagel (King Arthur's birthplace), and Camelford (reputedly the site of Camelot) to Bosverran, the village where he's vacationing. Vacationing? The Cornwall of *Skytip* is as violent as that of the Sam Peckinpah film, *Straw Dogs* (1971); a fight breaks out in a pub, a house is ransacked, and its occupant is murdered. Causing this violence is political turmoil. As in Aldous Huxley's *Point Counter Point* (1928), England is undergoing dislocation and upset. An ultranationalist group called the National League of Patriots has been gaining support at all social levels. Even Ackland sympathizes with parts of the NLP's program.

His sympathy flags when he runs afoul of two party functionaries. Looking ahead to Goldberg and McCann, Harold Pinter's cartoonlike abductors in *The Birthday Party* (1958), are ponderous Nat Murrison and his supposed valet, the bandy-legged Alfie. Alfie, small, bitter, and ferretlike in his movements, contrasts with the wheezing, grunting Murrison. Like that other fat man, Peters of *Mask*, Murrison inspires some virtuoso stylistic flights:

The stranger was enormously fat, a Falstaff, a colossal man, globular. His chubby pink face had rolling cheeks, and ridges of fat concealed his eyes when he laughed; china blue eyes in an innocent, baby face.

Murrison also follows Peters in his resemblance to Hammett's bloated Casper Gutman of *Maltese Falcon*, the 1941 film version of which, along with its cast, gets named in *Here Lies* (192). The jovial first words Murrison speaks in our hearing recall the richness of Gutman's talk: "Good-morning, good-morning, good-morning! How is mine host this fine morning? Have you any mead? I think I'll have a goblet of mead. It's just the weather for mead." But this heartiness reminds us that Gutman was a vicious liar whose plummy, resonant words hid his villainy. The reminder is useful. The coughing and the gasping of the asthmatic Murrison suggest how quickly fascism can pollute

England's very air. That the air is the same Cornish element that gave rise to some of England's most vital legends shows how the NLP, allegedly formed to protect English values, threatens English life as it has been known and lived for centuries.

The threat takes hold quickly. The speed with which political extremism can overtake society declares itself in the book's hero, Peter Ackland. Not only does he find some of the NLP's policies attractive; he also falls in love with a woman he first sees as a party staffer. Perhaps more revealingly, he turns up in many of the same places frequented by the NLP agents, Murrison and Alfie. He sees the two men in the Green Dragon Inn, the clay pits, and the bar of the Commercial Hotel, where he inadvertently lets on that the local political journalist, Henry Braddock, whom the two agents have come to Cornwall to question, is planning to take the next train to London. The two grotesques do more than question Braddock, who supposedly has evidence hurtful to the political career of their leader. Misled by the urgency of their errand, the crypto-fascists Murrison and Alfie fluster while questioning Braddock and accidentally kill him. Although Eliot Reed doesn't blame Braddock's death on Ackland, he does yoke the death to Ackland's indiscretion.

He continues to use the architect to convey the speed with which extremism can infect everyday life. On a train Ackland takes from London to Bosverran, he observes that a fellow passenger is traveling without luggage while also wearing the same kind of brown mac he saw on a man he suspected of spying on him. Then he rebukes himself: he, too, is wearing a brown mac, ten thousand more of which have probably been made and sold in England the past year. What is more, he has no luggage, either. Accusing himself of falling "victim to his own imagination," he goes into the stranger's compartment for a match. His behavior is puzzling. The stranger does turn out to be an NLP thug, and he later kidnaps Ackland with the help of Murrison and Alfie. That his name is the resoundingly German Keutel would have alienated many Anglophone readers in 1950, five years after the end of Hitler's War. But knowing about Keutel mightn't have stopped Ackland from approaching him, anyway. The architect's dangerous behavior, besides having political ramifications, also discloses the lack of self-worth hobbling the archetypal Ambler hero. Why else did he ask Keutel for a match when he could have gone to any of a number of other passengers? "There were people in all the compartments," he notes just before approaching Keutel. Like Kafka's Joseph K., he searches out his oppressor.

The emotional anxiety that sends him to Keutel manifests itself throughout. In Chapter 6, he calls his desire to invite Jessica Trask to tea "preposterous." Yet, at the end, amid images of gloom and desolation expressive of his own inner barrenness, he does ask her for tea, and his invitation is accepted. This architect has started to rebuild his life. To do so, he has had to come a long way. Work only bled him. While threatening him with a

nervous breakdown, it also screened him from reality. His arrival in Cornwall finds him too anxious to relax. He wants to fill a void in his life. Resembling acquiescent, deferential heroes like Kenton, Marlow, and Nilsen, he lets himself be led by others. He's forever doing disagreeable chores and spending time with people he claims to dislike. Against his better judgment, he loans Braddock money for his London trip, agrees to forward his mail, and calls for a cab to take him to the local train station. He believes the many lies he's told. No Sherlockian reasoner, he admits in Chapter 8, "Twice within twenty-four hours …[I] had to face up to a false conclusion."

Yet the series of events he had misread will endow him with a new magnetism. Otherwise, he wouldn't have been followed, and his room wouldn't have been searched. He has caught the attention of others. Clearly, he fails to control the danger he has stumbled into. What he does is to convert it to gain. He unearths the evidence that dismantles the evil NLP and thus snaps the link joining Jessica to the group's leader, Arthur Lamorak-Britt. Britt had won her loyalty by claiming to have befriended and helped her soldier-brother, Benny, who probably died in a Nazi prison camp. In discrediting Britt's false claim, Ackland frees Jessica to live. This breakthrough matters to him, too. As a divorced man, he follows several Ambler heroes. As the romantic lead who gets the girl, he's nearly unique, Piet Maas of *A Kind of Anger* (1964) being the only Ambler hero who wins the woman of his heart during the course of the narrative where they first meet.

But Ackland's love for Jessica follows a more hesitant, guarded path. (Chekhov is mentioned in Chapter 8.) Edgy, anxious, and vulnerable to annoyance and trauma, Ackland becomes fixated by the leak to the flush box behind Braddock's toilet. He had traced this leak from the dripping waste pipe overhanging the eaves of Braddock's home. Both his fixation with the leak and his determination to fix it make sense. He has already seen Jessica, and she has made deeper inroads on his psyche than he admits; after he describes her to an NLP functionary, he tries to ignore the comment that she has made "quite an impression" on him. His evasiveness is understandable. His divorce has jarred his faith in his ability to win the love of a woman. Specifically, Braddock's leaky plumbing symbolizes the sexual dysfunction haunting Ackland since his divorce. This victim of performance anxiety fears that he can only produce urine instead of the sperm required for a vital sexual tie. Fittingly, no sooner does he stop the leak than he speaks to Jessica for the first time. She walks into Braddock's house as if to reward him for repairing the flush box. If not restored, his sense of potency is on the mend. (Before repairing the flush box, or cistern, he had mused, "Perhaps the ball-cock that supplied the cistern needed an adjustment.")

His recovery proceeds. Judging by the reactions of those around him, it proceeds quickly. Because his NLP abductors believe that he knows the location of the document incriminating their leader, Britt, they torture him. His

silence forces them to take the desperate next step. Having failed to learn the document's hiding place, they can't afford to let him live; he has witnessed their wrongdoing. After knocking him out, they dump him into one of the skips, or carts, that carry waste material up the flanks of the skytips. But he regains consciousness and leaps from the moving skip before its jaws mangle him. Bruised and bleeding, he lurches down the cone-shaped mound. The voice he hears during his descent doesn't belong to one of his abductors, though, but to Jessica. In one of the book's many reversals, the climber he assumed to be his assassin saves him. Jessica has climbed the phallic skytip, symbolic of his earlier desolation, to offer help. Like the interceding female of Christian myth, she profits from her loving act. The life that she'll presumably share with him will revive his manhood. But, in a fillip worthy of D. H. Lawrence, it will also help her sink the grief vexing her since her brother's death and give her the chance to be happy.

Less lucky than either she or Ackland is Henry Braddock of Trevone Cottage, Bosverran. Both as a writer and keeper of the forbidden secrets that could crush the NLP, he resembles the archetypal Ambler hero at least as strikingly as does Ackland. And he's mistreated so badly by nearly everyone in the book that he probably dramatizes Ambler's inner pain more sharply than Ackland. From first appearance, the paunchy, jittery Braddock is decidedly unheroic. This pigeon-toed widower lives in a squalid house in Cornwall's remote clay country. The obscure political books he writes have reached few readers. He's so poor that he has to borrow money from a stranger. Yet, like his luckier counterpart, Ackland, he rises from obscurity; Ackland remarks inwardly in Chapter 8, "Braddock was the link. Braddock had something that they were after, all of them." This something, we recall, is written proof of Britt's treachery and unfitness for public office.

Enhancing its value is the way it's protected. And what of the protector? Braddock's treatment in the book invites some large issues. Though tortured and killed offstage, he suffers enormously. Would Eliot Reed have him suffer more? As if his home weren't squalid enough, Reed has it turned inside out, with its cheap, shabby appointments scattered everywhere by Murrison and Alfie. Braddock lives in the sinister shadow of a skytip. The London hotel where he books a room is as poor and gloomy as his depressing home. But Eliot Reed (or the Ambler half of the Reed partnership) hasn't finished wringing him. The onslaughts continue. His enemies become Ackland's enemies at his death, Ackland absorbing most of the ridicule and physical punishment dealt out in the book.

On the other hand, Braddock's stewardship of the crucial document shows great wit and courage. He hides the document with such skill that his NLP enemies can't find it. And he never gives it to them, even though he's tortured and killed. This down-at-heels solitary who lives in a hovel indeed has something the others are after. That something is an integrity that combines

moral principle and physical bravery. Besides possessing the crucial secret, he also knows how to protect it.

His death turns *Skytip* into a whodunit. The crime-puzzle element runs stronger in the first Eliot Reed novel than in most of the Amblers combined. The novel contains a missing person, an amateur sleuth, some physical clues, a chase extending across England, and a logical solution to the mystery. Imparting a nice unity to the action, the chase narrows to a search for a physical object—the cocoa tin holding the evidence that confirms Britt's collaboration with the Nazis while a prisoner of war. Like Poe in "The Purloined Letter" (1845), Eliot Reed builds his mystery around the device of the crime of the most obvious place. The coveted document is nestling in a spot where very few would bother to look. Perhaps thinking as much about Greene's *Heart of the Matter* (1948) as about "The Purloined Letter," Eliot Reed has Braddock hide the document in the cistern, or water tank, behind his toilet. This last motif extends our list of allusions to other crime writers. As in Raymond Chandler's *Big Sleep* (1939), the solution to the crime comes early in the action. Ackland saw Braddock soldering the lid on the cocoa tin holding the crucial papers in Chapter 4. Ackland also put his hand inside the water tank while fixing the leak there; in fact, his hand might have even touched the cocoa tin that blocked the flow of water. But if it did, he failed to notice. The object Braddock died for is as commonplace as its hiding place. It refers, too, to the triumph of the ordinary over the spectacular. Britt's very awareness of its contents scares him into leaving the country and snuffs out the NLP.

In this commonplace household item is symbolized the yeomanry that has both animated and sustained England. The image of Excalibur rising from the water adopted by the NLP as its party emblem belongs to English tradition. Like the triumphal raising of the Sword Excalibur (from water, according to one version of the legend), the removal of Braddock's document from its hiding place promotes the continuance of English life. It also reflects real artistry. Eliot Reed has placed his clues fairly. The drainpipe that drips because of a malfunctioning water tank rivets Ackland forcibly enough to warrant our attention. The phallic drainpipe also reminds us of the closeness of sexuality and excretion; the proximity, if not the identity, of the sexual organs and those of excretion have muddled the sexual tie. Eliot Reed accepts this dark ontology in order to brighten it. By setting right the overflowing drainpipe, Ackland improves his sexual outlook. And why shouldn't he? Braddock's hovel resembles a refuse heap in view of the filth and debris strewn around it; so badly is it neglected, in fact, that Ackland spends several minutes inside of it before realizing that it was ransacked. The crazy logic of *Skytip* endorses the idea that a shabby, refuse-strewn house might well contain treasure in a place as unlikely as a toilet fixture. Underlining this endorsement is Ackland's later plucking life from his ordeal on a skytip, itself the product of waste.

The sharpening of focus leading to these two reversals occurs smoothly.

Ackland returns to London to look for Braddock in Chapter 8, the book's midmost chapter. At the end of it, the plot has taken speed. Ackland's flat has been stolen into and searched. Recalling Latimer of *Mask*, his involvement in danger is running deeper than he had expected. Chapter 8 reveals him as a searcher who is also being sought—by persons more determined and aggressive than he. Yet he's not cowed. The chapter also takes him to the London offices of the NLP. As has been seen, these superpatriots invoke Arthurian legend to win public support. Besides using the Sword Excalibur as their party's emblem, they call their newspaper the *Round Table*, and their leader, who has the chivalric name of Arthur Lamorak-Britt, lives in Camelford. But no substance informs the Arthurian tie. Though boldly political, *Skytip* doesn't promote social revolution. NLP policy rests on fascist writ, and its leader betrayed his mates to the Nazis.

Although that leader has shown his face only briefly, he fuels the argument, found in *Judgment, Dr. Frigo*, and *The Care of Time*, that, rather than enhancing the self, political power negates selfhood. *Skytip* develops the point by contrasting appearance and reality. Adorning an office wall of the NLP is a picture of Britt looking "handsome...noble, a pledge of devotion to the chivalrous ideal." His actuality clashes with this heroic image. His sole appearance in the novel reveals him to be ineffectual, frightened, and near collapse from the strain of preserving his image. A puffy, weary caricature of his public persona, with his paunch, sagging cheeks, and thick, down-dragging lips, he forecasts the great attention given to the physical looks of candidates for public office in the 1980s. This "inflated toad" is clearly unfit to rule. Cringing and easily rattled, he lacks the shrewdness, toughness, and drive of a leader. Both his defenses and negotiating skills collapse immediately when he's opposed; his offer of £100 for Braddock's evidence jumps to 5000 within a minute. Last seen sitting "motionless," this treacherous coward can't govern himself, let alone a country. Only a place gone wrong could take him seriously as a candidate for public office.

What's wrong with the postwar England of *Skytip* is the death drift. Though Eliot Reed ignores the causes of this drift, he does portray its baleful effects. The divorced Peter Ackland is saddled by a dead marriage. A neighbor claims of Henry Braddock that he has never recovered from his wife's death. Jessica Trask's fixation upon her dead brother has both twisted her vision and dried her heart. The book's fullest, grimmest symbol of death's hold upon such people comes in the skytips defacing the Cornish landscape. These conical mounds of rubble take their being from the granitic remains of kaolin, or decomposed feldspar, which grows in the local bedrock and forms the chief ingredient of a porcelain product called "china-clay." Eliot Reed brings out the eeriness of the tall, spectral cones, with their frosty borrowed light. The menacing bulk of the cones dominates the local inhabitants, blocking their sunlight and sending its gritty dust everywhere. This blowing clay settles on

plants and flowers, creeps inside locked drawers and cabinets, coats teeth and lips, and stings eyes. The drab uniformity of the skytips whence it blows suggests English fascism, a creed that denies individual difference. No wonder that members of the Mosleyite NLP choose a skytip as both killing site and burial ground. The eerie whiteness of this sluggish, inert mass has leached out all living values.

Other memorable images lend distinction to *Skytip*. An inventive simile in Chapter 1 describes a remote, lonely train station where a stranded Ackland waits in vain for his long-overdue ride: "A single strip of platform . . . stretched out sadly in the dusk like a pathway to a tomb." Eliot Reed will gamble with language. Alfie's swift reaction to an acute asthma attack seizing Nat Murrison in Chapter 3 validates the unorthodox use of the verb, slammed, to describe the transfer of a small object to Murrison's mouth in the following passage:

> "Alfie!"
> It was a call for help, a cry of fear. Alfie knew what to do. He pulled a small bottle from a pocket, shook out a white tablet and slammed it into Murrison's mouth.

With economy and accuracy, Eliot Reed will later show the tricky process of falling in love as a matter of impulse rather than reason. Of Ackland's response to Jessica, he says, "Every time he saw her he found something new in her, but these new things were intangibles, not to be catalogued." Whether this insight stems from Charles Rodda or not, the two men who wrote *Skytip* treat us to some excellent writing. The materials making up *Skytip* gain distance through irony and a lively sense of incongruity. The sure-handed plot both includes some keen visual images and combines them thematically. One can only agree with Lewis's friendly assessment of the book: "The antifascist *Skytip*, in which Ambler's participation was at its greatest, is by far the best of the Eliot Reed titles" (87). The book's assured, purposeful technique invites both moral depths and emotional heights, while the people mediating the invitation make the right things happen at the right time. This happy blend offers satisfactions in tones and levels of meaning that make *Skytip* a cause for both joy and thanks.

## II

*Tender to Danger* (1951) stands closer to *Journey* and *Siege* than to *Frontier* and *Alarm* in that its hero is heading home at the outset rather than preparing himself for overseas work. The Scottish eye doctor Andrew Maclaren is returning to British soil full of promise. Eager to begin his new hospital job, he calls London a symbol both "of release" and "of his break with the past and his hopes for the future." He has just spent three years in Greece as a war relief worker for the International Red Cross. But he still can't relax. Because of heavy fogs over southern England, the plane taking him from Athens to London must lay over for the night in Brussels. The layover frets Maclaren, of whom

Eliot Reed says in Chapter 5, "he was alone in the world; but then, he always had been." His long-deferred chance for the wholeness and security connected with homecoming must wait another day. That day unloads some shocks. The device of stranding passengers en route to their destinations has been used by Henry Green in *Party Going* (1939) and William Inge in *Bus Stop* (1955). The device joins people of differing backgrounds and outlooks who wouldn't normally spend time together. Maclaren is forced to adapt quickly to his bad luck. Testy yet also eager for the company of others to see him through the annoying wait, he must use his social skills and good will to fend off the anxiety of facing a foreign city alone. His anxiety level is already higher than he cares to admit. Raised by the Brussels layover, it jumps another notch when he's snubbed by a redhaired beauty for whom he offered to serve as a translator to a Belgian skycap.

The book's first chapter, where Maclaren and redhaired Ruth Meriden meet, leaps ahead some five years in time from the prologue, where the yawl, or tender, the small boat that supplies the book's title, is seen lying at anchor off Yugoslavia's Dalmatian coast. The tender belongs to Ruth's eccentric uncle, and she'll inherit it about three months before the time of the book's continuous reported action, when John Meriden dies. This death, though unmourned, is symptomatic. The world in which the book unfolds is undergoing the upheavals and agonies of postwar reconstruction. The Axis powers have been crushed; their homes, businesses, and schools are being rebuilt; people on either side of the Iron Curtain are growling at each other. But the aspect of postwar life that *Tender* treats is emotional, not political. As is implied by the phrase, "displaced person," which is used several times in the early chapters, people are looking to settle into a place and a mode of being in which they can plant themselves. Nor is Maclaren the only character who craves roots. In Brussels, he shares a hotel suite—two rooms with a connecting bathroom—with Pyotor Grigorievitch Kusitch, "an amiable little man with a pathological need for company." Like fidgety Henry Braddock of *Skytip*, he will lie; he has no wife and child in Dubrovnik, as he claims. And like mousy, fumbling Ihsam Kuvetli, Graham's Turkish bodyguard in *Journey*, he's more important than he lets on. He escorts Maclaren around Brussels just as Kuvetli did Graham around Athens. He also surprises Maclaren by removing a pistol from his luggage. This seemingly pathetic Yugoslavian is a high-ranking government worker. He recovers art treasures stolen from his country by German and Italian invaders during the war. Well trained in techniques of spying, he takes a wall seat in a corner table of the restaurant where he dines with Maclaren to fend off surprise.

Maclaren, who misses the meaning of this maneuver, tends to dismiss him as a crank and an alarmist. Later that night, he disregards the sounds of a stifled cry and a thud coming from Kusitch's room; Kusitch had earlier mentioned a tendency to fall out of bed in his sleep. The next morning, not only is his room empty; he has also vacated the hotel while leaving behind his toilet articles.

More mystery unfurls. Insisting that he spent the whole evening with Kusitch, Maclaren learns that his missing suitemate cancelled his place on the London-bound flight for which he and Maclaren had booked seats. But Kusitch isn't trying to avoid paying his hotel bill. His guilt runs deeper. Called by a Belgian policeman "an absconder, a fugitive, misappropriating his expense money," he has set his sights for gold hidden on the yawl, or tender, now owned by Ruth Meriden. This gold he plans to keep for himself. It was stolen and then hidden by two German soldiers years before in Yugoslavia. Having learned of Kusitch's intentions, these men kidnapped him from his hotel room and, after torturing him into divulging the new location of the gold, killed him. In fact, one of his killers, a rude, stiff-gaited German with hostile eyes, returns to Kusitch's room the morning after the kidnapping. What he's looking for is a manila envelope Kusitch had slid under the carpet before going out for dinner. The contents of this envelope will lead Ruth and Maclaren to the gold for which the German murdered Kusitch. Still later, the German will hold Maclaren and Ruth prisoner while preparing to flee with the gold.

An aloof sculptor with "devastating" eyes, Ruth has antecedents in both the Ambler and Reed canons. Maclaren first spots her on the plane taking him from Athens to Brussels. Recalling Peter Ackland of *Skytip*, he keeps denying his attraction to her. But she'll shed her aloofness and the mystique it creates. The opening of her heart to Maclaren reflects an important artistic breakthrough that Ambler might not have managed without Charles Rodda's help. The mysterious beauty in Ambler had been little more than a plotting device before *Tender*; in *Frontier*, she dies, and *Journey* portrays her as a married prostitute. The first two Eliot Reed books, though, imply that she marries the hero. This sharp difference in fortune suggests that Rodda wrote the passages in both *Skytip* and *Tender* dealing with the love interest. But whoever did the job, did it well, particularly in *Tender*, where the lovers interact more. As an eye doctor whose inner vision is clouded, Maclaren resembles any number of Ambler heroes, and the resemblance is reinforced by his having spent most of his professional career overseas (he worked in both Berlin and Vienna before going to Greece). The sculptor Ruth will model a new identity for him. In the process, she'll also humanize herself, shifting her attention from cold marble to warm, vibrant flesh.

Danger supplies the matrix in which their love takes root and grows. Hiding together in a disused windmill, whose "grinding floors and...great stones that once pulverized the grain" invoke their fragility, they need each other to survive. The speed with which this need asserts itself shows excellent authorial tact. The love that will join Ruth and Maclaren had to develop quickly. Neither could the development be physical. Eliot Reed uses danger as a bonding principle because sex would be off limits for at least 15 years to writers wanting to bring their characters together quickly. Thus Ruth and Maclaren accidentally foil the two German gold smugglers. As in Hitchcock's *Thirty-nine Steps*

(1935), hero and heroine face a life-threatening danger in a lonely, out-of-the-way spot where chances of getting outside help are remote. If the windmill in which Ruth and Maclaren hide recalls another Hitchcock film, *Foreign Correspondent* (1940), Ambler's *Alarm* provides just as clear an influence. Hero and heroine, like Marlow and Zaleshoff before them, are bound and left to die in a remote place. And they also unfetter themselves with a sharp steel edge before escaping to freedom.

Despite being warned, Maclaren insisted upon investigating on his own prior to risking death in Hertfordshire with Ruth. He dislikes the policeman from Brussels whom he had told about Kusitch's disappearance, believing him dull and stupid. Wanting to score at his expense, he even delays handing over to Inspector Jordaens the manila envelope which Kusitch's murderers wanted. His claim, "Leave it to Jordaens and it will never be done. The man was an ass," is fatuous, reflecting mostly Ambler's resentment of male authority. Jordaens, having interviewed Maclaren in Brussels, has already proved himself a shrewd questioner. Maclaren's urge to outperform him stems from his wanting to show off—both to Ruth and himself. By courting danger, he follows many of Ambler's heroes who equate their sedentary routines with male inadequacy. Fearing that he's a half-lifer, he seeks union with a harsher, more bracing reality than he has known. This reality comes forth quickly. En route to Ruth's studio, the address of which he got from Kusitch's fatal envelope, he feels as marooned and vulnerable as Ackland did upon his arrival in Cornwall. At the studio, he's accused of trying to turn life into a spy melodrama when he tells Ruth that her life may be in danger. Here and elsewhere, his warnings are discounted; his pleas for high adventure, frustrated. A supposed watcher crouching in some weeds turns out to be a large bird, and what passes as common sense prods Maclaren into dismissing as coincidence his earlier fears of being shadowed.

Surprisingly, Chapter 12 opens with him and Ruth being held at gunpoint by the very ex-SS men he was warned of. Disintegration and decay continue to serve as a principle of growth for Eliot Reed. This gripping confrontation occurs in a tumbledown setting—an overgrown marsh near which the peeling, rusting *Tender to Moonlight* is bobbing at anchor. Kretchmann and Haller have traveled from Germany via Brussels to recover the gold hidden on this bobbing wreck. The gold obviously deserves their pains. The ability of the ordinary to house the extraordinary (still another Hitchcock motif) comes across in the first look Maclaren gives the tender. A cigarette butt was stamped out recently on the tender's deck; the interior has been gutted; though surrounded by rust and weather-warped appointments, the engine looks fresh and new. Reed's lively sense of incongruity adds resonance to the climax of *Tender*. The gold that policemen from Yugoslavia, Belgium, and Scotland Yard have been searching for lies in the tender's bilge, coated with grease and disguised as ballast.The grand keeps getting punctured by the prosaic in the book's arresting finale. A pistol that is struggled over turns out to be unloaded. Another instance of life's

incalculability defeating the prearranged comes when the two German smugglers lose all because they can't get the engine of the yawl containing the golden ingots to start. A prankish disrespect for pride accounts for a great deal of fun throughout the book. The mustache and beard pencilled onto the heroic statues near Ruth's studio detract from the statues' dignity. A stone figure of Emperor Augustus loses its dignity in a different way; hanging from its outstretched arm is a wooden sign bearing the words, To The Latrine. Reed enjoys himself describing Maclaren's visit to Ruth's Hertfordshire studio in Chapter 7. He also communicates his enjoyment in several different registers. Here he is using Ruth's opinion of an abstract drawing to spoof the pomposities of both modern art and its critics:

I believe that this sort of art must create a new language. There may be here something that cannot be put into words, yet the thought is to be read by the sensitive mind. It must be inevitable, invariable, or the art is false.

Hertfordshire seems to prompt some of Eliot Reed's best stylistic effects. Maclaren's next visit there includes an intriguing, detailed description of the *Tender to Moonlight* (which is also the book's British title). Ambler's engineer's knowledge of the mechanics of both maintaining and motorizing sailing craft bestows vivid life upon the stubborn little yawl. The visit also features an imaginative cinematic rendering of an onlooker's inferring, without the benefit of hearing what is said, the meaning of a fraught encounter. Though a gust of wind blows away the words of a policeman pointing his pistol at the two former SS men, Maclaren understands both the effect of the words and the intent behind them from the speed with which the Germans raise their hands over their heads.

Such stylistic feats tally with the rhetoric of *Tender*. The appearance-reality dualism which resolves itself in the transformation of some greasy bars of pig iron into golden ingots carries forward from earlier chapters. Ironically, Kusitch said in Chapter 2 of the faded, twilit hotel from which he'll be kidnapped and taken to die, "It is quiet, and very respectable. Nothing ever happens here." To alert us to this irony, Eliot Reed shifts immediately from Maclaren's point of view to the omniscient perspective. The very first word of the paragraph following Kusitch's remark about the drab tranquility of the Hotel Risler-Moircy lets on that the overnight stay will bring a nightmarish reversal: "Afterwards, for days on end, Andrew was to dredge his memory in an effort to bring back every little detail of those hours in Brussels."

Deft plotting also controls our responses to the action. Because the mirror in the bathroom he shares with Kusitch is accidentally tilted, Maclaren watches his suitemate arm an automatic pistol and slide the crucial manila envelope under the carpet. "The obvious hiding places were sometimes the safer," Maclaren says inwardly, reminding us of the flush box in which Braddock

chose to conceal his proof of Britt's guilt in *Skytip*. This accidental glimpse, unobserved by Kusitch, lends urgency to Maclaren's indecision over whether Kusitch is a desperado or just a bore. Clever plotting has endowed Maclaren's dawdling with a significance he himself has missed. Reed dispels any confusion resulting from the scene-shifting that peppers the early chapters. Move freely the action does. The short distance between the prologue and the opening page of Chapter 2 has included episodes taking place in Yugoslavian waters, the air space above Belgium, Brussels' airport, and The Risler-Moircy Hotel. Focusing this variety are the discoveries in Chapter 1 that Ruth has checked into the Risler-Moircy and that her last name coincides with that of the old eccentric who bought the *Tender to Moonlight* in the prologue. Various plot strands continue to mesh. Further unity comes from both the disclosure of Kusitch's Yugoslavian origins and his having carried with him a newspaper review of an exhibition of Ruth's sculpture.

Narrative unity always promotes speed and drive. Having established some links and hinted at others, Eliot Reed materializes Inspector Jordaens in Maclaren's London flat at the end of Chapter 5. Maclaren felt that Jordaens dismissed him as a crank during their Brussels interview just days before. The discovery of Kusitch's murder in the interim has turned the bored, patronizing functionary into an eager questioner; he hasn't come to London to humor an alarmist. But another reversal has occurred alongside his new sense of purpose. Still fuming over his earlier dismissal by Jordaens, Maclaren withholds information. His keeping back crucial evidence from Jordaens, besides conveying his anti-authoritarian protest, leads to his investigating on his own, despite having been warned by a friend, an ex-intelligence officer, not to. The warning stays in our minds, if not in his. His amateur forays into detection create suspense by putting him at risk. Several times, he had already sensed that he was being shadowed. He has good reason to worry. His snooping has made his shadowers desperate. Having served in Hitler's SS, these thugs are already seasoned practitioners of violence. Maclaren's decision to step up his investigation gives them a good motive to strike. They've already killed Kusitch. Why should they shrink from killing Maclaren if he stands between them and their long-deferred goal?

Murder had sprung to mind at the end of Chapter 7, the book's halfway mark, where Maclaren returns home to find the place turned inside out. Neither is he soothed by the discovery that his intruders weren't looking for money or other valuables. The only thing removed from the flat is a scrap of paper on which was scribbled information about Ruth's yawl. Maclaren has lost his sole advantage over Kusitch's murderers. This underdog's search whets our interest anew. He can't identify the object of his search; he only knows that it's important enough to murder for. Also, his search doesn't shut out his humanity, even after the search heats up. As in *Skytip*, Eliot Reed introduces a minor character who nettles the hero by creating the false impression that he and the

heroine are lovers. And when the hero, Maclaren, is riveted by the search, Ruth, the heroine, will either phone him or appear on his doorstep unannounced.

Also carrying over from *Skytip* is the use of epithets. After noticing Keutel's scholarly ways on the night train from London to Cornwall, Ackland refers to his fellow passenger as "the curator." But Keutel is the only one in *Skytip* referred to by such shorthand. *Tender* includes characters known as the green soft hat, Mr. Jolly-Face, and the gnome. If the device promotes economy, its overuse creates an unfortunate trivializing effect. The device also calls attention to itself because it's not the book's only blemish. *Tender* contains too many sentence fragments. More seriously, the elements comprising the plot fail to coalesce as in *Skytip*. A very minor figure resolves the action. Off the scene most of the way and unconscious during the heat of the finale, Milan Nimcik, the Yugoslavian policeman heretofore known as Mr. Jolly-Face, supplies the background of the investigation from his hospital bed. This last-chapter recitation wrenches the book's dramatic unity. Trouble multiplies for Eliot Reed. A character we never meet gave Nimcik the information that led him to the golden ingots. Not only does this key disclosure happen off stage; it also comes at the very end, giving the impression that Reed has deliberately held back crucial data in order to resolve his crumbling plot.

Further embarrassment comes from Reed's reliance upon *dei ex machina*. When Maclaren returns to London from Brussels, he takes his worries to his friend, Charley Botten, an ex-intelligence officer turned stockbroker. Botten behaves puzzlingly. Whereas this "expert of experts" gives Maclaren information pertaining to the investigation that he couldn't have found himself, he also warns Maclaren against using it. Then he investigates on his own, helped by Nimcik. His place in the action remains questionable till the end. What has his off-stage detecting unearthed? Why is he detecting, to begin with? Maclaren has misread so many elements of the case that neither he nor the reader tries to guess. What does rouse wonder is Botten's attitude to Maclaren. Why does he both encourage *and* discourage Maclaren from playing detective, a role that could be fatal in view of his lack of training and experience?

A last complaint refers to something more vital than narrative technique. Eliot Reed patronizes his readers by using ex-Nazi soldiers as his villains. Germany no longer threatened Britain in 1951. Besides being an easy way out, the villainy of Kretchmann and Haller played upon some of the worst fears and prejudices of contemporary British readers. Ambler, it needs saying, shrunk from depicting nasty Germans after *Journey* (1940); in fact, the title of *The Schirmer Inheritance* (1953), as we've seen, stems from a sympathetic ex-soldier in Hitler's army. Granted, *Tender* has no pretenses as serious fiction. But to argue that an entertainer like Eliot Reed lacks the moral responsibilities of a mainstream writer is nonsense. His responsibilities may be greater. Though he'll reach fewer people over the decades, he will be speaking to more of his contemporaries, readers more likely to respond with heat to a recent public

crisis than will those coming to it after the crisis has subsided. *Tender* is solid, lively, and intriguing most of the way. That it unravels at the end damns it less than the dangers it unleashes by condescending to its presumed readers.

## *III*

Ambler didn't write much of *The Maras Affair* (1953). In a letter dated 13 October 1952, he asked Mr. C. H. Brooks of A. M. Heath and Company, his London agent, to pay Rodda two thirds of the British royalties earned by the book. He based his request upon "the extra work" Rodda did on *Maras*. This labor was not voluntary. In a letter to Rodda of 15 September 1952, Ambler, pleading a tight schedule, claimed "that it's quite impossible for me to do any work on the book."[1] Perhaps he had already done enough. Though he spent little time writing *Maras,* he didn't have to. His *Judgment on Deltchev* had already supplied the book's plot, setting, and, with some small changes, its leading characters. Like Foster before him, Charles Burton is a journalist working in a Balkan city on the eve of revolution. He's paired romantically with the daughter of an aging ex-hero of the Resistance. Now in bad odor with his Soviet-controlled chiefs for his pro-western sympathies, Professor Anton Maras lives on the outskirts of his nation's capital. Also included in the book are an obnoxious fellow journalist and a mousy helper of Burton's who dies, like Georghi Pashik of *Judgment*, during the action. Again, the plot of *Maras* builds to a large public ceremony in which the country's leader is killed. (And again, the *attentat* is disappointingly irrelevant to the plot.)

Echoes from Ambler's earlier work sound more softly. The ballet, *Swan Lake*, is seen, as it was in *Cause for Alarm*. Ambler's 1938 work, along with *Frontier* and the other Zaleshoff title, *Background to Danger*, all foreshadow the importance of national borders in *Maras*. But borders dominate *Maras* even more than they did the three early Amblers. The book not only ends with hero and heroine crossing a frontier; it also begins with a search for a journalist (whose front name, Andreas, is the same as Zaleshoff's) who has been helping refugees leave the country. References to these refugees and their helper, particularly by angry, or envious, policemen, pepper the action.

Both Andreas and his boss, Burton, fall into the category, already prominent in the 1950s with Walter Winchell and Ed Sullivan, of reporters who not merely report the news but even influence and become news. A foreign correspondent for the *Star-Dispatch*, Burton sees himself as "tough, cunning, ruthless, hardhearted." His vision, which includes his self-image, needs maturing. He innocently expects everything in the police state where he's working to run by the rule of justice, reason, and love, and when things go wrong he thinks he can fix them. His neighbors and acquaintances have to beg him to stop being helpful, explaining that his good intentions can hurt them. His meddling also puts *him* at risk. A local police commissioner warns him in Chapter 11, "Through no fault of your own, you have become involved with...

dangerous criminals." Yet he keeps meddling. He's also flip and sarcastic with policemen, refusing to cooperate during investigations, and he brazenly visits places officially designated off limits. Throughout, he acts tougher, wiser, and more experienced than he really is. He's luckier than he knows. Were he as capable as he believes himself, he wouldn't need to rely on a local photographer, one Carlo Settembrini, to give him information he should have dug for himself.

To his credit, Burton is no political zealot or reformer. He only involves himself in politics to protect his secretary-interpreter Anna Maras, daughter of the famous historian. In ways, Anna resembles Maria Kolin of *Schirmer* more than she does the 20-year-old Katerina Deltchev, who had no romantic interest. Like Maria, Anna is a skilled linguist. "She could read anything from Greek to Episcopal Slavonic," says Eliot Reed of this young woman whose career ambition it is to translate English and American books into her native tongue. She also follows Maria in having had a brother who was killed by the Nazis. But her devotion to Peter's memory carries none of the angry force of Maria's for *her* brother (or of Jessica Trask for hers in *Skytip*). She stands closer to Katerina than to Maria in having a French mother, and she resembles no prior Eliot Reed or Ambler heroine in having visited an aunt in Boston, Massachusetts.

Like the heroes of *Skytip* and *Tender*, Burton keeps denying his attraction to her. This denial is perhaps the only aspect of his relationship that makes sense. His saying to himself in Chapter 5, "The safety of Anna Maras was the only thing that mattered to him," shocks us. Nothing in his interaction with Anna up to this point validates either this pronouncement or the one coming in Anna's letter to him ending Chapter 28, "You have my love." So much of her time with Burton has she spent fretting about other people that she would seem to have no attention or energy left for him. She will worry about either his assistant Stephan Sokolny or her father, and she also shows her friend, the dancer Babette Treplava, more affection than she does Burton. Comforting Babette in Chapter 23, she puts her arms around her friend's thighs and coos, "It will be all right, my dear.... My dear one. My dove." Yet she appears with Babette only once in our view; she's never seen with her father at all before his death; nothing that occurs in our presence between her and Sokolny warrants her deep concern for *him*.

The most potentially intriguing of her relationships is that with her father. In his sole interview with Burton, Anton Maras says that he wants to finish his work before he dies. This work doesn't consist of his research but of seeing Anna settled happily in the United States. Indirectly, he's asking the total stranger Burton to marry Anna; by taking her to America as his wife, Burton will be fulfilling a near-deathbed wish. Yet Anna refuses to leave her dying father. Unfortunately, she plants her heels in sterile artistic ground. *Maras* lacks the plotting to explore the sacrifices father and daughter are willing to make for

each other. The obligations bred by Anna's loyalty to Maras disappear, conveniently for Eliot Reed, when the old historian dies. Nor does Anna's tie to her dead brother get the attention *it* deserves. The end of Chapter 20 refers to her "Antigone-like face." This reference is careless and inappropriate. Peter Maras died fighting Hitler, not a homegrown tyrant like Creon. What's more, Anna never complains of his having been dishonored in death.

Eliot Reed removes her from the action for extended spells both to avoid such embarrassments and to fabricate the illusion of drama. As fatuous as Burton's remark in Chapter 20, "He had never wanted anything so much as he now wanted Anna Maras," are Reed's efforts to convince us that Anna is in danger when she slips from view. Nearly every aspect of Reed's treatment of the Maras family betrays ineptness, a failing that the book's poorly chosen title calls attention to. Which Maras does the title invoke? we wonder. Or does it refer to both of them? The similarity between Anton Maras's first name and that of his daughter implies a tie so strong that it could pre-empt any feeling Anna might direct to another man. But the implication is ignored. As has been seen, the professor dies without ever appearing before us in Anna's company, and he doesn't die to free Anna to go to the United States, either. What kills him is the shock of hearing about the death of an old friend, the country's President. If there's something bogus about Maras's death, it shouldn't surprise us. His lone appearance before us, in Chapter 9, showed him voicing hollow clichés, like "I pray for strength to finish my work.... I am very near the end." More hollowness follows. The history of his country he has supposedly been writing consists only of one chapter, written 20 years before, and a bunch of notes. Like Yordan Deltchev, he may not have been the paragon his admirers claimed he was.

The challenge put to another dominating male, Police Commissioner Paul Sesnik, covers a broader range. Distinguished by a cooing bassoon voice and dainty little feet shod in gleaming leather, Sesnik invites comparisons with a crocodile. Perhaps his cartoon exterior and inner drive are at odds by design. This waddling fat man veils his efficiency in both a sybaritic love of shish kebob and Turkish coffee and a disarming generosity; at different times in the action, he buys Burton lunch, gives him ballet tickets, and provides him with an office helper. Sesnik's prominence at the end, after being out of view for several chapters, adds a note of light comedy that contrasts well with the sullenness generated by the depiction of a society wrung by recent war. The book's closing scene, which takes place on the train taking Anna and Burton to the border, includes several surprises. Burton has already paid a local Greek named Zeno some $2000 to pass Anna into the American zone. The train scene opens with the drama of hero and heroine looking for a compartment to share while waiting to leave the station. But Eliot Reed doesn't let them relax once they're seated together on the moving train. Recalling similar scenes in both *Skytip* and *Tender*, the unexpected entry of an important character materializes "podgy"

Sesnik. Sesnik has boarded the train to dismantle an escape plot he had heard about.

Then many things happen. Presumably under orders from him, soldiers go through the train checking tickets and identity papers. But these men are working for Zeno, not Sesnik. In an off-stage action, they abducted the real soldiers whose charge it was to screen the passengers, took their uniforms, and seized the checkpoint before boarding the westbound train. Sesnik has been foiled. Bypassing its designated stop, the train speeds across the frontier into the American zone. But the surprises aren't over. Sesnik, the Javert figure, defects to the West—without paying Zeno for taking him over the border. His becoming a political refugee rather than repatriating himself to his homeland thus finds him defeating not only authority but also the counterestablishment as represented by Zeno, operator of a lucrative underground railroad.

A person who seems capable of sustaining the excitement that builds around Sesnik is Burton's office assistant, the "nervous, irresolute" Stephan Sokolny. Recalling the undersized, twitching losers in Greene, Sokolny is a natural victim with his aching teeth, low salary, and self-apologetic cringe. Eliot Reed treats him as badly as does Burton, who despises him as "untrustworthy, a weakling." After he's murdered, an investigating team including photographers, fingerprint experts, and a surgeon descends upon the death site; "The unimportant Sokolny was being vastly honored in death," quips Reed about this attention. But then he shows the attention to be an empty formality. Sokolny's death matters as little as his life. A final insult comes in Sesnik's calling the death a suicide rather than investigating it. Sokolny's murderer is never sought, let alone named and brought to book.

The system conniving at this moral outrage is a nameless Balkan country, one of the so-called free democracies created by the USSR after 1945; a phrase Burton overhears, "the new rule of equality and freedom," means that most of the country's inhabitants suffer together. Like other eastern bloc states through 1989 or 1990, the government uses shows of military power to muster public support; tanks and artillery trundle through the capital's main public square while low-flying fighter planes roar overhead. Eliot Reed gives the unnamed town where most of the action unfolds an old-world charm by including in it a river spanned by ten bridges, a national theater, an opera house, and a variety of architectural styles. He also describes the dimming of this charm by recent political events. To begin with, local ballet and opera groups only perform works of Russian composers, like Moussorgsky, Borodin, Tchaikowsky, and Rimsky-Korsakov. Next, the weather is always bad. The first snow of the season falls in Chapter 10, and the thaw in Chapter 17 turns the capital city into a sea of slush. (Augmenting this dreariness, Chapter 5 refers to "the gloomy lake of swans" in *Swan Lake*.) And if the absence of teletype machines weren't frustrating enough, Burton and his fellow journalists often see their overseas dispatches censored beyond recognition when allowed to leave the country at

all.

Then there are the shortages. A ballerina in the national dance company practices in patched tights and an old blouse. Still worse is the scarcity of fuel. Maras can barely heat one room in his shabby, faded mansion. The cold pervades everything. In Chapter 14, Anna and Burton shiver together in a taxi with a broken heater. But physical discomfort alone isn't sending refugees across the border. Though the government in power calls itself a New Democracy, it's far from democratic in practice. Recalling Brecht, Eliot Reed conveys the distress of living between loyalty and treason in a dictatorship that claims to support ideological purity and the love of freedom. Augmenting the nastiness of life in the postwar eastern bloc is the threat of death squads. Afraid to show their hearts, people shrink from speaking the truth to neighbors and friends; anybody could be a police spy. Sesnik even puts a shadow on the policeman shadowing Burton. (And will this second shadow be shadowed, in turn?) No wonder people are fleeing the country. The *coup* that succeeded in *Frontier* fails in *Maras* (as it did in *Siege*). The passage of 17 years between the two books showed that the glorious workers' revolution was merely enslavement by another name.

President Riecke, the "innocent despot" whose advisers run both him and the country, speaks in a "thin, aged voice" and looks "like an unwrapped mummy rather than a living man." So weak and tired is he, in fact, that had his entry into the novel been delayed one more day, it might have never taken place. Like Andropov and Chernenko, who ruled the USSR after Brezhnev in the early 1980s, the leader of his country's experiment in social dynamics is lonely, ancient, and tottering. Fittingly, he's killed while getting ready to deliver the annual Presidential address at the Opera House. This symbolic confirmation of his power ends his power together with his waning life. The high drama surrounding his death masks its emptiness. Disclaiming all motives of personal gain, his killers can only mouth the clichés of revolution. Their victim, an oppressor of the people, died at the hands of liberty, booms a rebel voice heard on a loudspeaker. True patriots will rejoice over the death of the tyrant Riecke. But the voice offers no program of reform or influx of staples to help the cold, hungry people. Perhaps it was just as well that the revolution failed. The book contains no suggestion that the country would have fared better under the rebels than under the ruling regime, as inept and corrupt as it is.

Other matters seize our attention in *Maras*, some of them darkly funny. One of Riecke's high-ranking aides was standing in the Presidential box at the Opera House when the fatal bomb exploded there. The aide, Varlein, will also become a leading candidate to succeed Riecke as President. Of the broken jaw he incurred during the explosion, someone notes dryly, "In times of crisis it is a disadvantage to have a broken jaw." But the gruesome joke isn't over. Though unable to campaign, Varlein does become President, enacting, among other things, one of the improbable power shifts that characterized the eastern bloc

from 1945-90.

Another riveting note comes at the end of Chapter 16, the book's halfway point. Sokolny has just been shot, and the police have descended upon his death site. But before their descent, Burton took the bloodstained watch Sokolny was wearing to identify himself to a local watchmaker known for helping refugees leave the country. Sesnik's words, "I am quite convinced that Sokolny was murdered," end the book's first half. How will he solve the murder? we are meant to ask. Eliot Reed supplies the glimmer of an approach to the problem. Just before insisting that Sokolny was murdered, Sesnik mentioned the missing watch. Perhaps he'll build his investigation around it. Reed keeps restoring the watch to the action, with each restoration increasing narrative tension. An excellent tag line caps Chapter 18, which unfolds at the watchmaker's shop. When Burton buys a strap for his own watch in order to disguise his purpose for visiting Emil Dovinye, he's told what the strap costs in these terms: "One hundred dollars American. It's the best pigskin. Killing pigs is a very risky business." A macabre spin has been put on the dangers set into motion by Sokolny's death, deepening our imaginative commitment to both Burton and his escape plot. But Dovinye is jailed in connection with Sokolny's death, he poisons himself, and Sesnik defects to the West, stopping the drama of the bloodstained watch from reaching full growth.

Unfortunately, this dramatic breakdown typifies the book, running its virtues to waste. Developing obliquely and casually when it develops at all, *Maras* lacks intensity; it doesn't make us want to know what happens next. First, it's stuffed with filler. Rather than misdirecting our attention, Eliot Reed only misleads us and makes us feel cheated. *Maras* peaks when a last-minute injury to a star ballerina lets Anna's friend Babette dance the role of Odette in *Swan Lake*. But Babette's big chance, her poor dancing in the first act, her recovery to form after the intermission, and Anna's nonappearance alongside Burton, her escort, for the second act add nothing to the plot. Also qualifying as dead wood are both the ideological split between Professor Maras and his old friend, President Riecke, and the drama Reed builds around the choosing of Riecke's successor.

Perhaps most damaging to *Maras* is its author's practice of moving the plot with minor characters. One such figure, scarcely more than a walk-on, is Pero Trovic, or Andreas Nimsky, thrower of the bomb that kills Riecke. Believed to have fled the country, Trovic appears briefly at the end of Chapter 7. But his appearance is gratuitous, as is Burton's warning to him, redolent of Dimitrios as it is: "Be careful someone doesn't bring you back to life." The shock caused by Trovic's appearance wanes quickly because he does nothing. Eliot Reed just wanted to give us a look at him before the *attentat* of Chapter 21. And even here, he's negligible, a throwing arm with range and accuracy. First, this known enemy of the state defies credibility by moving about so freely that he can toss a bomb at the President at an official state function. What

happened to the tight security Eliot Reed has been telling us about? And wouldn't the President have his own bodyguards? Next, Anna's Lenin-like description of Trovic as a fanatic ready to sacrifice everything, including himself, to the revolution, leads nowhere. Trovic's second appearance in the book is as brief as his first. A character who carries such a heavy thematic load needs to spend more time with the reader. (His engagement to Babette is more padding, just as his similarity to Lenin is a historical throwback.) Reed had prepared for an intriguing clash between him, the ruthless neo-realist, and the gentle, old political idealist, Riecke. But rather than dramatizing the clash and its offshoots, he stamps out both men, as he did Riecke's other ideological foe, Anton Maras. His practice of killing characters and the ideas they stand for instead of developing and interweaving them aggravates the imbalance that makes *Maras* such a sad comedown from *Skytip* and *Tender*. Perhaps *Maras* doomed itself from the start, based as it was on *Deltchev*, Ambler's weakest novel and the one most badly out of balance.

### IV

The title, *Charter to Danger*, resembles that of *Tender to Danger*, much of which Ambler wrote. In naming his 1954 Eliot Reed, Charles Rodda was hoping that prospective readers would notice the resemblance, match it with the author's name, and then buy the book. Once the reader started the book, he/she might make other connections, some of which recall Ambler. Thus the chicanery in banking and stock-trading actuating much of the plot both looks back to *Frontier* and *Background* and foreshadows *A Kind of Anger*, *The Intercom Conspiracy*, and *Send No More Roses*. The treatment of ships—their design, care, and piloting—carries forward from *Tender*. This work and its immediate predecessor, *Skytip*, with their epithets like the curator and Jolly-Face, also underlie Eliot Reed's practice of referring to a bent-necked man as wry-neck. A minute or so before wry-neck's entry into the action in Chapter 4, the hero, Ross Barnes, suspects that he's being followed but then accuses himself of imagining things. Chapter 4 also materializes a strange beauty who addresses Barnes by name, as Jessica Trask did Peter Ackland in *Skytip* (following the precedent set by Frederik Peters with Charles Latimer in *Mask*).

But most of *Charter* belongs to Rodda alone, like the book's highbrow echoes. Besides including many references to music, the book alludes often to literature, as did *Skytip*, with its host of Arthurian materials, and *Maras*, with its character, Carlo Settembrini, whose last name is the same as that of a major figure in Thomas Mann's *Magic Mountain* (1924). *Charter* mentions the Rue Flaubert in Cannes, and a major event occurs at the Café des Lauriers, which could refer to the 1888 French novel by Édouard Desjardins, *Les lauriers sont coupés*, from which James Joyce supposedly learned the stream-of-consciousness technique. More prominent, though, than the Irish or French strains coursing through *Charter* is the Spanish note sounded by Cervantes.

Recalling the windmill scene at the end of *Tender*, *Charter* both mentions Don Quixote in Chapter 11 and sets crucial scenes aboard the launch, *Roselle*, whose name suggests that of Quixote's horse, Rocinante. These references serve the plot less than they reflect Rodda's literary tastes. More vital to the art of *Charter*, while equally expressive of Rodda's sensibility, is the plot itself.

Unlike *Skytip* and *Maras*, where Ambler's hand was more apparent, *Charter* turns on a financial, rather than a political, *coup*. The action begins with an imposture. An elegant American calling himself Caton Margolies charters *Roselle* from Barnes for his chief, the powerful financeer, Vincent Flavius. To avoid publicity, Flavius, who's traveling incognito, wants to conduct high-level business aboard *Roselle*. His business has to be kept secret, lest knowledge of it cause wildcat stock trading all over the world. To maintain security, Barnes must sail to Cannes by open sea rather than inland waterways. Whatever misgivings he has about his charter are silenced by cash, the same potent device Dimitrios used to lower the guard of *his* victims.

As a protagonist, Barnes invokes many of his earlier counterparts in both the Ambler and Eliot Reed canons. This English bachelor values his privacy enough to spend a great deal of time aboard the cabin cruiser that supplies his only known source of income. But he's not completely a loner, despite his withdrawn life style. He once loved a woman named Mary, who presumably dropped him for another man. And he enjoys the company of his sister Eleanor, her husband Tom, and their 18-year-old son Ralph. The domestic realism conveying his enjoyment, it needs saying, rarely, if ever, occurs in Ambler. The daughters in *Cause for Alarm* and *The Intercom Conspiracy* are both adults with jobs and marriage plans; the fathers they live with are unmarried. What is more, the grown children of the main figures in *Passage* and *Levanter* never appear, nor are the heroes of these books seen at home with their wives when they come before us. Barnes, on the other hand, stands securely as a family man. In Chapter 2, he convinces Eleanor, over a dinner she cooked, to let Ralph accompany him aboard *Roselle* during his Mediterranean cruise to Cannes.

Barnes acts in a dutiful, caring way toward Ralph during the cruise. To reassure Eleanor about the youth's welfare, he also writes her comforting letters, which he has the added thoughtfulness to mail quickly. The highjacking of *Roselle* with Ralph aboard reinforces his family loyalty. He worries more about Ralph than about his missing launch. He also feels ashamed of making light of the danger facing Ralph after a crewmate from *Roselle* is found murdered. Eliot Reed succeeds in portraying Barnes as a caring uncle, fully committed to Ralph's safety, but also as a man whose awareness of his limitations stops him from taking himself too seriously. Seriousness comes in with the off-stage Eleanor, whose letters, cables, and resolutions to come to Cannes herself all impart an impressive resonance to the reported action.

Some Dickensian plotting knits the fortunes of the Barnes circle with those of the kingpin banker-industrialist, Flavius. "One of the wealthiest of all

international tycoons," with holdings in oil, steel, and chemicals, Flavius gets kidnapped by the abductors of Ralph Peters. Unlike Simon Groom of *Frontier*, the "complete wart" Joseph Balterghen of *Background*, and Mat Williamson of *Roses*, the American Flavius wins our hearts; no Marxist wrath colors Eliot Reed's portrayal of him. The slander directed at him by colleagues and rivals says less about him than about his business acumen. Anyone who enjoys his eminence will ignite envy in the less gifted. And admiration, too? Flavius does display a magnanimity commensurate with his wealth by agreeing to secure Ralph's future after he and Ralph are rescued in Chapter 28.

Police Inspector Guizet, who spends much of the novel looking for Ralph and Flavius, adds his own mite to the action. To maintain unity of focus, Eliot Reed has Barnes accompany this harried, hangdog man while he interviews suspects and witnesses. Guizet is pressed into service after wry-neck enters the Café des Lauriers in Chapter 4, followed by a beautiful young woman. After wry-neck makes a phone call, he and the woman start fighting. Their scuffle attracts the attention of Barnes, who had been tricked into coming to the café by *Roselle*'s thieves. He rushes in to protect the woman, who had called him by name and asked for his help even before clashing with wry-neck. When she next appears, she reveals herself to be Alicia Mars, a singer who has come to town to perform with a local opera troupe. The man she was fighting with was her half-brother, a war casualty and small-time crook who came to the café to tell the thugs planning to steal *Roselle* whether their plot to lure Barnes away from the yacht had worked.

Aside from bringing Alicia into the novel, wry-neck, or Jean Seyrac, has little importance to *Charter*. More vital to the book's narrative flow is Max Varenine. Russian Max, as he's sometimes called, first appears in Chapter 11, probably to bolster the sagging plot. Eliot Reed had just wasted a chapter showing Barnes searching in vain for Alicia, and he needed to drive the action forward. The introduction of a Soviet emigré who forsook the class war for a career of gambling imparts a welcome infusion of fun. It also helps the plot, since Max has spent some of his gambling gains on an airplane that is later used to search for Barnes's missing craft. The search succeeds. But it also directs our eyes elsewhere. After *Roselle* is found, Barnes spots a canal barge displaying a shirt that is pegged at cuffs and shoulders and has its sleeves turned twice on the clothesline holding it. Ralph had recently learned this technique of drying a newly washed shirt, and he's now using it to signal Barnes or any other would-be rescuer.

The success of the shirt motif calls our attention to others. In fact, the attention Eliot Reed directs to the disconcertingly elegant hands of Alvaro Parra, the man who pretended to be Flavius's *aide-de-camp*, Caton Margolies, in Chapter 1, may have influenced Ambler himself. Though Ambler may not have written *Charter*, he certainly read it. The hard focus with which he presents the teeth of characters in *A Kind of Anger* and *Roses*, both of which

came out after *Charter*, implies that the technique of fixing upon a character's prominent body part first came to him in his reading of *Charter*. The book deserves a look by creative writers. Usually capable and sometimes inspired, it can attain a rare stylistic grace. A woman's long grilling by a police inspector in Chapter 13 makes her look as if she had just come out of a "mental mauling." The description of Barnes's loss of consciousness at the end of Chapter 16, "Another blow seemed to split his head into whirling particles," blends accuracy and smoothness in a way reminiscent of Raymond Chandler or Ross Macdonald, two writers praised more often as stylists than either Rodda *or* Ambler. Finally, the verve distinguishing Eliot Reed's description of Barnes being knocked out can come at any time and declare itself in several registers. Just as ex-music critic Rodda enjoys assembling the concert program being performed at the casino in Cannes, so does he delight in recreating Marseille, noting its various landmarks, institutions, and coastal configurations, as Russian Max flies over it en route to the waterways where Ralph may be hidden.

These stylistic gems brighten a fast-moving plot. Things happen quickly after Alicia and her half-brother enter the action in Chapter 4. *Roselle* is discovered missing at the end of the next chapter, and one of its hands turns up a murder victim in Chapter 6. The last paragraph of Chapter 7 reveals that Flavius was kidnapped from his hotel, a crime that recalls Kusitch's abduction and consequent murder in *Tender*. The finale of Chapter 11 heightens our fears. Charging the missing-persons case with a new urgency is the arrival in Cannes of a high-ranking policeman from Paris. But no sooner does Chief Inspector Laurent of the Sûreté enter the search than the real Caton Margolies, as opposed to the man who chartered *Roselle* in his name back in Chapter 1, walks into the action. His explanation that his impersonator has abducted *both* Ralph and Flavius unifies the missing-persons plot. Barnes's personal and professional needs have fused. And now that he knows what has happened to the two missing persons, he can go looking for them.

But the ransom demands made by their abductor add a further complication, one worth mentioning because of its variance from the fictional practice of Ambler, a constructionist who tries to develop or counterpoint the narrative motifs he begins with rather than introducing new ones as his plots move ahead. A motif patently Amblerian does intrude itself, though, at the end of Chapter 15. Unhappy with the slowness of Inspectors Laurent and Guizet, Barnes starts investigating on his own. His freelancing discloses more than he had expected. Like Graham of *Journey* and Foster in *Judgment*, he finds a corpse—that of Jean Seyrac. The discovery comes in a dim, smelly apartment. Just as lowdown and depressing as the slum setting of Seyrac's murder is the way the murder happened. As if his poor skewed neck hadn't already suffered enough, Seyrac dies of strangulation.

Barnes ignores the warnings he gets about the dangers of freelance snooping. After his overflight in Russian Max's plane discloses the barge where

Ralph and Flavius have been stowed, he again acts independently. He and some friends, one of whom is dressed, coiffed, and made up like a woman, invade the barge with the pegged shirt drying on its clothesline. In a disarmingly sour note, Max, the rescuer pretending to be a woman, knocks out Parra from behind after Parra had agreed to help start the supposedly recalcitrant engine of the launch carrying Max and his friends. Then our scruples drown in a squall of action. Five of Parra's helpers pour from the deck-house of the barge, a barehanded fight ensues, and handguns are drawn. The mêlée ends when the police, having heard gunfire from the barge, race up in their speedboat and arrest the kidnappers.

Max's cowardice in clubbing Parra from behind when Parra believes him a woman isn't the only sour note in the rescue scene. Conceding to the commercialism of a happy ending, Eliot Reed lets the rescuers walk away from the brawl on Parra's barge with only minor injuries; Flavius and Ralph Peters aren't even scratched. Rewarding Barnes, his main rescuer, Flavius offers to implement immediately the "great plans" he has in mind for Ralph's future. But the smiles brightening the faces of the good characters at the end of *Charter* are no more senseless than several other aspects of the book. As impressive as they are, the delights *Charter* provides can't offset some serious flaws. The work suffers, first of all, from a plot that's loose and spongy. Reed keeps smuggling in new people to move the action; some of them appear briefly, whereas others are merely discussed. When he reveals in Chapter 22 of the 28-chapter book that the abduction plot hinges upon an old grudge involving minor characters, he forfeits our interest.

Nor does he learn from his mistake. Offstage or baldly summarized action keeps dominating *Charter*, giving the impression of poor planning. Logic can slip from view altogether. Rather than building a personality and value system for a character, Eliot Reed will kill him off in a slipshod way. The murder of Jean Seyrac isn't explained at all, and the suicide of Flavius's abductor, Jean-Louis Merle-Florac, makes no sense. So long as Flavius remains his prisoner, Merle-Florac can collect a fortune in ransom money. More significantly, he can add to this bonanza by buying shares in the firms involved in Flavius's merger plans. He only stands to gain. But even without such brilliant financial prospects, a wily, experienced magnate like Merle-Florac wouldn't lose his millions any more than suffering such a big loss would drive him to suicide.

The book has worse problems. If the kidnap-and-rescue-motif crumbles as the action moves ahead, the love story involving Alicia Mars and Ross Barnes stumbled badly from the outset. Eliot Reed's inability to work Alicia into the narrative shows vividly in the clichés used to describe her in her first sustained appearance before us, in Chapter 15. Reed calls attention to her "moist and tremulous" blue eyes together with "the quivering of her half-parted lips." What he can't do is portray her realistically. Alicia darts in and out of the action more often than Ruth Meriden of *Tender* and Anna Maras combined. Coincidence

materializes her on a busy street in Chapter 10, but she eludes a pursuing Barnes by ducking into a store and then running down an alley. Her need to remain in hiding is overwhelming; in Chapter 14, this singer who studied in Rome, Naples, and Cleveland fails to show up for a singing date in Cannes. No doubt, the possibility that she might have lost her memory, set forth by a friend, is a diversionary tactic; Reed simply wants to gain time. He squanders his gains. Much of Chapter 14 deals with the mystery surrounding her disappearance, an action trivialized by the aerial searches being waged by Russian Max and Barnes.

The only justification for Barnes's interest in her inheres in her alleged resemblance to Mary, his former love. Her frequent practice of popping in and out of the action robs him of the chance to know her, let alone love her. When Max asks him in Chapter 20 if he's in love with her, his answer, "Don't be absurd," sounds reasonable and honest. His revelation three chapters later, "she had become more important to him than anything else," comes as a shock, resting on nothing that had developed between him and Alicia during the intervening days.

Eliot Reed's leaving her out of the rescue mission that dominates the closing chapters stemmed from necessity; she didn't belong in the brawl that helped free the missing persons. Her reappearance in the book's last sentence, "Alicia Mars was waiting for him [*viz.*, Barnes]," also stems from need. The reunion of hero and heroine adds a romantic glow to the success of the rescue mission. Unfortunately, *Charter* is too poorly built to take warmth from this glow. Alicia never helped Barnes find the abductees; their welfare never even touched her. Perhaps Barnes hasn't touched her deeply, either. Though she's waiting for him, she has already left him so often without good reason that she can't be expected to stay with him for long. The life signs of *Charter to Danger*—its plot development, disclosure of character, and emotional interplay—are all so weak that it founders as both literary detection and romantic comedy.

*V*

*Passport to Panic* was written by Charles Rodda alone; so say Chris Steinbrunner and Otto Penzler in their 1976 *Encyclopedia of Mystery and Detection* (8), along with Gerd Haffmans and Franz Cavigelli in the German-language study, *Über Eric Ambler* (1979, 185). They are probably right. But none of them would deny the presence in *Passport* of several motifs identifiable with both the earlier Eliot Reeds and Amblers. There is, first of all, the innocent, somewhat ineffectual hero far from home who drifts into a danger that also menaces a *femme fatale* he meets in the early going. He will cross rough, dangerous ground, as in the Zaleshoff books, *Background* and *Alarm*. The failure of revolutionists to seize political power returns from *Judgment, Maras,* and *Siege*, while a climactic rescue aboard a sailing craft at the end restores to

safety a younger relative of the hero, as in *Charter*. Finally, the three-word title of the 1958 Eliot Reed resembles those of *Charter* and *Tender* by placing a preposition between two nouns.

But familiarity with the Reed canon isn't necessary for the reader of *Passport* to get drawn in quickly. The London businessman Lewis Page has gone bankrupt. Three airmail letters and two cablegrams requesting help from his brother Julian in South America (one of the few places never used as the setting for an Ambler book) have gone ignored, compounding his worries. "A fantastic, a reckless visionary with an overruling talent for the practical," Julian has always replied quickly and generously to Lewis's needs. A puzzled Lewis leaves England in Chapter 3 for Casa Alta, Julian's estate in the small coastal republic of San Mateo. Through him, Eliot Reed seems to be pondering the worth of caution. Of "the stay-at-home" Lewis he says in Chapter 1, "He had walked carefully and never far from home, and now he was bankrupt." Perhaps it's time for this prudent 40-year-old widower to branch out; the recklessness often impelled by foreign travel might sparkle his blood. His brother, after all, acquired great wealth as a coffee planter and worldly fame as an archaeologist in South America. Lewis's decision to uproot himself seems to profit him straightaway. He's intrigued by a foreign beauty he sees on the airplane taking him to Julian. Later, this same intriguing beauty, Leite Mayorga, claims to be Julian's wife.

Other shocks and mysteries assault him. Nobody meets him at the airport, as he expected. Nor could Julian have met him, in any case. At his arrival in Casa Alta, Lewis finds his brother comatose. He's immediately suspicious. The telephone that was out of order when he tried to ring Julian is now working. The man allegedly tending Julian, one Pascual Benevides, calls the sick man "my dearest friend." Yet he hasn't taken Julian to the hospital. Lewis is confused. Benevides's insistence, first, that Julian refused to go to the hospital and, next, that he's being treated by "the great specialist" in the tropical disease that has seized him doesn't quiet Lewis's doubts. Yet like the other Eliot Reed heroes before him, he shrinks from imputing guilt. Instead, he accuses himself of imagining the worst. He's not indulging melodrama, though, when he sees a bandage covering a chest wound on Julian that looks as if it came from a knife. And why, he wonders, did Leite, whom he just saw on an airplane, leave her rich new husband when he was so near death?

His confusion escalates into panic when he's stripped of any authority he may feel entitled to as Julian's brother. He can't muster hard evidence to support the claim that Julian has been mistreated. Moreover, any charges he might make against Leite and Benevides could be construed as self-interest. Problems with money brought him to San Mateo, not brotherly love, and the prospect of Julian's estate, which is rich in both coffee and emeralds, going to the newcomer Leite couldn't be expected to cheer him. All thoughts of money and property vanish, though, when Julian calls him by name from his sickbed

and then, in a barely comprehensible sputter, claims that he's being poisoned. Dr. Larreta's insistence that Julian is hallucinating doesn't calm Lewis, particularly now that he has been placed under house arrest and forbidden from using either the telephone or the local mails.

When he threatens to summon the police, he finds himself looking down the bore of Benevides's revolver. His problems have deepened, but within a playful literary context that distances our involvement with them. If Lewis Page began *Passport* as a tepid Jamesian hero, jostled from his well-worn groove, he resembles, by the book's midpoint, a heroine in a Gothic novel. Captive of a desperate, perhaps evil, man, he lacks options. On one side of Julian's finca, or plantation, lies a sheer cliff; on the other teems a jungle full of poisonous snakes. He does help himself a little by pretending to speak no Spanish (a device used in *Siege*), thereby tricking his captors into talking freely in his presence and giving him useful information. Further help comes from Leite. Usually impassive and toneless, she quarrels with Benevides, who is, revealingly, her half-brother. (In another allusion to Alicia Mars and Jean Seyrac, or wry-neck, of *Charter*, Lewis expresses inwardly of Benevides "the hope that he had broken his neck.") Leite, repelled by Benevides, breaks with him and, with the help of a native guide, flees into the forest with Lewis in hope of reaching civilization.

For the second straight Eliot Reed novel, the mysterious heroine leagues with the hero after turning away from a criminal half-brother (who will later die). Unfortunately, when the couple gets lost in the tropical underbrush, so does Reed. Julian dies at the end of Chapter 13. The following chapter, the book's midpoint, shifts both setting and point of view. Unaware of the troubles in San Mateo, Lewis's daughter Anne, a musician, is sailing there. A little drama occurs during her trip. Aboard the *Atacama*, two men vie for her attentions. Yet she shows more interest in music than in courtship, even though one of her anxious courtiers is the famous South American tenor, Sebastian Byrne. Chapter 15 returns to the jungle tropics, creating a nice contrast. While the fugitives from Casa Alta are plodding through a thick green wilderness, Anne is coasting along the high seas in her smart steamer.

But only the steamer coasts smoothly here. The love triangle that emerges shipboard conveys Eliot Reed's usual ineptitude in the portrayal of sexual attraction. Notably mangled is the motivation behind the union that links Anne and Byrne's love rival, Delbert Wayne, son of a rich copper miner. In Chapter 18, Del shows Anne a wireless message from his father ordering him to buy off the exploiting adventuress he has met during his sea voyage. The reader is as surprised as Anne to learn that *she* is the upstart to whom old Wayne is referring. Nothing that she has revealed conveys the slightest hint that she wants to marry Del. In fact, she hasn't even hinted that she prefers Del to Byrne, so coolly has she behaved to both men. Yet when Del tells her he wants the ship's captain to marry them straightaway, she replies encouragingly, "You'll meet my

father . . . tomorrow. Then we'll talk about it."

But her father doesn't appear dockside the next day, and the eagerly awaited nuptial talk yields to other matters. These are as surprising as they are urgent. Pretending to be Lewis Page's envoy, one of Benevides's henchmen abducts Anne. A series of wild improbabilities leads Del in Chapter 21 to her makeshift jail—a boathouse floating amid marine wreckage in a dismal wharf. This dingy, remote setting and the rescue scene that unfolds there both reflect Reed's awareness of the conventions of popular adventure fiction. But conventions alone do not a good novel make. Reed's awareness runs to waste because his narrative focus shifts so irresponsibly in the book's second half. The reader loses his/her bearings. Leite had become the central intelligence in Chapter 15 after Lewis passed out from exhaustion during the jungle trek. In Chapter 21, Del, whom we have seen even less of than Leite, provides the point of view while searching for the missing Anne. He has nearly taken over the narrative by default; Anne and Lewis, both of whom outstrip him in importance, are either unconscious or delirious. One of the problems besetting *Passport,* as with most of the other Eliot Reed's, consists of the ongoing impression the book gives of being enacted by minor figures. Nearly all the people who steer the action are overshadowed by a close family member. Del and Sebastian Byrne both have powerful, influential fathers; Julian's daring has always surpassed that of Lewis; while Leite has been doing nothing of note, her half-brother, Benevides, is mounting a political *coup.*

Eliot Reed's decision to use Del as his recording intelligence fails to heat up this tepid book. Blocking any flow of warmth that might be coaxed out of Del is scamped plotting. We never learn why Anne had to be drugged, why she needs an armed guard of four men, or why she must be taken to some unknown destination by sea. Rather than providing motivation, Reed smuggles in the police both to stop the culprits and to free Anne and Del. But the danger facing Leite and Lewis must still be defused. Out of the action since Chapter 27, they return in Chapter 33, only to be arrested by rebel forces after slogging their way out of the jungle. Their plight means little to us. By this time, the book has fallen apart. Anne's rescue is very briefly summarized, and the action following it is just as sketchy, Reed relying upon coincidence and other amateurish plot mechanics to resolve matters. An example occurs in Chapter 15, where Lewis inspects an article about a local composer he had torn from a newspaper for Anne. Printed on the reverse side of the article is another one identifying Benevides, his captor, as "the cut-throat instigator" of the revolution being waged against the central government. The unity provided by this coincidence costs Reed too much; he has too blatantly handed Lewis information that a more craftsmanly writer would have let him discover for himself.

A blunder that could have been more easily sidestepped comes two chapters later, in Chapter 17, when Reed, in a stroke of authorial omniscience, says of Lewis, while describing a hair-raising part of his trek to freedom, "There

were moments in the climb that would bring nausea to Lewis whenever he recalled them." This intrusion kills suspense, inferring that Lewis survives the danger facing him. Two pages later, the chapter contains another passage indicative of Reed's wavering of concentration. The author says of Lewis, who had already fainted once during his ordeal, "He lurched, and her [Leite's] hand was at his elbow to steady him." Then, speaking of the guide who had led the couple through the jungle, Reed writes, "Pepe had *passed out* of sight into a narrow belt of scrub" (emphasis added). His word choice is inept. By saying "passed out" rather than "gone to inspect," he misleads the reader into thinking that Pepe, like Lewis, has dropped from exhaustion.

But the blunders in narrative construction marring the book's second half cause greater damage than any stylistic lapse. Poor planning sends the novel adrift and finally sinks it. Groping for thematic unity, Reed makes Anne a prisoner on the same houseboat that holds the guns the rebels are carrying to the capital to fuel their revolution. The revolution itself doesn't revive our interest in the book. To develop it, Reed ignores the characters he had committed us to at the outset, conveying the progress of the fighting in a series of news releases, like the following:

Reports of risings here and there throughout the country were given out by the radio in the next hour, always with the addition that the government troops claimed to have the situation well in hand. Rebellious cadets had been isolated in their own barracks, a rising in the working-class suburb of Santa Teresa had been put down, and at eleven o'clock it was reported that the lost town in the north-east had been recaptured by the government.

When it's not boring us, such dry journalistic summary makes us wonder whose side we're on and why. Neither does Reed help us decide. The disclosure in Chapter 25 that the *junta* has failed leaves us as confused as ever. Benevides, who has been out of view since Chapter 15, dies off stage, and the victorious general, San Martin de la Cerda, never showed us his face at all.

If flaws like this sink the book, they also point an important lesson: that blemishes and oversights metastasize like cancer in a badly built work of fiction. As bad as *Passport* is, Reed had to cheapen it still more to finish it. Already mentioned has been the way the police, led by Inspector Chavez, rescue Anne and Del when all seemed lost for them. But Chavez isn't the book's only *deus ex machina*. The tenor's father, Dr. Byrne, Minister of both Fine Arts and Mines for San Mateo, also helps. (The naming of one of Santiago's main streets Aveñida O'Higgins shows that Byrne isn't the only Irishman who has won eminence as a patriot in South America.) Byrne tells Lewis that Leite wasn't Julian's legal wife. She was out of the country when the wedding took place, and San Mateo doesn't recognize marriage by proxy. What's more, the judge who performed the marriage ceremony has disappeared.

Thus Lewis stands to inherit Julian's estate. But he wants to share this

windfall with Leite. If she was never his brother's wife, he can marry her without violating either civil or church law. As in *Skytip* and *Tender*, the alleged love rival represents no threat, after all; Julian would have been too weak and wasted to consummate any marriage rite that took place at his sickbed. Still one more savior figure, Maria Josefa, Leite's elderly aunt, serves as the keeper of the secrets, a stock figure from opera, an art form that always interested Rodda (one thinks of *Cosi fan Tutti, Don Pasquale,* and *Il Trovatore*). Not only does she tell Lewis how to find Leite, who's now in exile; she also persuades him that Leite is worth finding. Maria Josefa calls the political fanaticism that led her to pose as Julian's wife a "national malady"; Leite wanted Julian's money to finance her half-brother's insurrection. Lewis devours this stupid explanation. The very ending of this careless, rushed book finds him booking a plane reservation to be with Leite; like the Eliot Reeds preceding it, *Passport* ends with hero and heroine about to reunite.

The happiness that awaits them chimes with other joyful notes that sound at the end. Threatened with dismissal, Inspector Chavez, the harried father of eight delegated to find the kidnapped Anne, wins a big promotion. Anne will marry Del Wayne, the promising engineer. As soon as his millionaire father meets her, he blesses their union, renouncing any doubts he may have had regarding her virtue. Money will pour into the same Page exchequer that was so hollow at the outset. In addition to the huge profits earned by the Wayne family's copper mines, the discovery of emeralds on Casa Alta will swell Lewis's inheritance. Virtue and valor pay, runs the implied argument. Brought to Casa Alta by financial need, Lewis opens his heart to both Julian and Leite and then pockets a fortune. Del's bravery in defying, first, his suspicious father and, next, the four thugs guarding Anne in order to rescue her proves his manly worth. Eliot Reed shows his own approval of Del's courage by rushing a squad of policemen to the houseboat where Anne has been held.

This forced happy ending only wins *our* approval at an adolescent level. The plot of *Passport* is so haphazard that it disintegrates under scrutiny. The people actuating it, moreover, lack psychological complexity and depth. Their shallowness rules out both the amplitude and resonance of a moralistic authorial voice, not to mention irony. As in most adventure fiction, dialogue and physical detail in *Passport* replace analysis. The replacement is smoothly managed. Except for the rare barbarism, like the adjective-noun combination from Chapter 1, "accented anxiety," Reed's prose can attain richness and evocative force. It also impresses us with its nimbleness. For the first time in an Eliot Reed, *Passport* uses the stylistic device, suggestive of the *leitmotif* in music, of picking up an epithet spoken in dialogue and, a sentence or two later, directing it in narration to the person to whom it was first applied. Thus a jealous Del Wayne refers to Sebastian Byrne as " 'that confounded opera singer,' " and the next sentence, starting a new paragraph, opens, "That confounded opera singer came swiftly...." Wayne himself is called a " 'fool Americano' " by a police

chief at the end of Chapter 19, and the following chapter begins, two sentences later, with the words, "For two hours the fool Americano waited in Granada."

Although Reed's stylistic skills don't save *Passport,* they do lend a welcome touch. They do so in part by covering a broad range. Besides using epithets both to reveal character and to smooth transitions, Rodda/Reed invokes his love of music to win credibility as a man of culture and taste. His sharp eye enhances the benefits reaped by his sensitive ear. The following passage, from Chapter 6, shows his observational powers realizing quickly and authoritatively the character of the evil Pascual Benevides:

Benevides...was not a figure you were likely to forget. Everything about the heavy-shouldered, thin-hipped body conveyed strength and latent agility, and the face added ruthlessness. The dark small eyes under level brows were intense with a sort of stony intensity, adder-like. The broad countenance, with the wide line of a thin-lipped mouth...was that of the mountain Indian, but there was some evidence of a Spanish infusion, of alien blood filtered through the ages since the conquista. Certainly the narrow, well-shaped nose had come from Spain.

Another notable passage, more impressive because of its greater length, shows Leite, Lewis, and their guide Pepe stubbing through the massed, matted undergrowth of the San Mateo jungle. The haunting effect created by screeching birds and stinging insects gains surrealistic force from the quagmires below foot and the sunlight flashing unpredictably through the fronds and vines overhead. Eliot Reed makes us feel the pounding fatigue and anxiety vexing the weary travelers. His care and descriptive verve convey a jungle madness that mitigates, in part, the letdown caused elsewhere in *Passport.* But the part can't redeem the whole. Reed's rhetorical skills would encourage very few of us to re-read the book, an artistic failure in nearly every way.

## VI

Let nobody complain that the five Eliot Reeds published between 1950 and 1958 are unread and forgotten today. Though rich in detail and sometimes even lushly textured, they ignore the variety of the human personality. Only *Skytip* has the wit, social awareness, and narrative complexity found in the best adventure fiction. The lack of tension and revelation in its four successors all but nullify the merits of Eliot Reed's supple, sensuous prose. Unless it communicates important insights, good prose, no matter how deftly managed, won't stay in the reader's mind. Ambler's reputation will never rest upon his role in the Eliot Reed books. Hamstrung by poor narrative technique, contrived happy endings, and a dearth of adult feelings, these works, except for *Skytip,* only pass muster as diversions best suited to the rigors of coping with the vagaries of airline timetables. The reader may find cheer, if not in a happy outcome in flight scheduling, then in one of Reed's stylistic gems.

## Chapter Seven
## Baiting the Trap

The four novels Ambler published between 1963 and 1969 restore the figure of the passive, resigned hero drawn into intrigue and unable to escape it without facing grave risk. The hero of each of these books, like Foster of *Judgment*, is a journalist living in a foreign country and thus lacking the warm anchoring security of home. Yet he suffers more than Foster; Piet Maas of *A Kind of Anger* (1964) once became so depressed that he tried to kill himself. Some of this suffering stems from the father figure; the dominating male continues to block the hero's quest for self-being. He's still rigid, authoritative, and destructive. Arthur Abdel Simpson in both *The Light of Day* (1962) and *Dirty Story* (1967) works for men who risk his life. Like many of his contemporaries, Ambler plumbs the irrational depths of his childhood, disclosing the insignificance of reason in most human lives. But he has also put his personal mark on this delving operation. Writers of the 1930s like Orwell, Greene, Auden, Malcolm Lowry, and Patrick White (all of whom were born within six years of Ambler) felt dislocated from their roots and suffered, as a result, identity crises. Their sympathy with left-wing politics led many of them to seek the company of the working class. Many lived in and wrote about foreign countries, as well. Clive James has found this same tendency in Ambler's postwar books:

> The truly interesting protagonist in the novels of the second period is the half-hero—the man of mixed blood who has trouble with passports and is not fully accepted anywhere. With the half-hero Ambler seems to be touching on his own psychological condition (68).

Though the half-hero has trouble with male authority, he needn't be a writer. Along with the part-time journalist Simpson, James mentions Girija Krishnan of *Passage*, the Indian operator of a Malaysian bus service. Also belonging in James's category is Michael Howell of *The Levanter* (1972) and Ernesto Castillo, the title character of *The Frigo* (1974). Products of mixed marriages, both men engage in interracial sex; their jobs expose both to danger; both live in battlegrounds coveted by political fanatics. But Castillo's doctor's bag will admit him anywhere, just as his medical diploma will ensure him a living, even if his country's rulers deport him. Howell has banked enough of the profits from his family business to start anew. Besides, both men are living at

home, however precariously. The half-hero James has in mind goes back to Josef Vadassy of *Epitaph*, the foreigner threatened with deportation and death unless he works with the police. Theodore Carter, the Canadian protagonist of *The Intercom Conspiracy* (1969), lives in Switzerland and works, first, for an American and, then, for a Scandinavian and his Low Country partner. Living with the latter, an ex-spy, in Majorca is a young woman as many years his junior as is the daughter Carter shares a Geneva flat with.

These confusions and insecurities meet in Simpson. This con man and petty thief turns *Day* and *Story* into cautionary fables for their day. He's anomalous. Both his dual national and racial heritages have denied him a culture to fit into; Lewis claims that his given names, Arthur Abdel, suggest "an unstable blend" (126). Even his daily routine smudges the shape of his life. He spends little time with his wife, a belly-dancer half his age. Both his inability to hold a decent, steady job and a low self-esteem have steered him to crime, an activity for which he lacks the toughness, the brawn, and the cunning to survive, let alone excel. Constantly on the move because of his attraction to danger, he's also haunted by memories of an unhappy childhood. All of this puts us on familiar psychological turf. No stranger to the backlash of childhood stress himself, Ambler divides his story into two parts (like his own novel-writing career?). The first, *The Light of Day*, won an Edgar award as the best mystery novel of 1962. Let's give its prize-winning credentials a look.

*I*

Born in Cairo of an Egyptian mother and a British Army NCO, Simpson drags the character type of the bungling spy, double agent, or picaro to a new low. The *New Yorker* review of *Day* describes the stateless, cringing Simpson and his woes:

Mr. Ambler has seldom drawn his heroes from among the high and mighty, but...Simpson...is humble to a remarkable degree. Middle aged, sickly, and afraid of heights, he is a sneak thief, a pimp, and a pornographer who calls himself a tourist guide, and when we meet him, he is stranded in Athens with a voided Egyptian passport. (152)

Smelly, sweaty, and overweight, this grubby outsider of 50 would repel most of us. He smokes and drinks too much; the indigestion caused by his bad nerves has soured his breath; a man who shares a room with him accuses him of snoring like a pig. His truckling ways also exude distrust. Those who trust him will soon regret it. He cheats his clients, both padding their fares and getting payoffs from the shops, restaurants, and brothels he takes them to. But he's inept. Regardless of whether he's cheating on a large or a small scale, he usually gets caught and punished. He has already been jailed ten or twelve times by his own admission, and his name appears on the files of Interpol, Scotland

Yard, and the New York Police Department.

The ease with which trouble finds him can surprise us. He speaks four languages, and he'll sometimes impress us with his resourcefulness. For instance, he drives a car from Athens to Istanbul that he suspects may contain narcotics. Protecting himself from arrest by the Turkish border guards, he puts the car on a hydraulic lift to inspect its undercarriage; he examines the air conditioner; he probes the gas tank with a long twig. In Chapter 4, he shows unexpected courage and tenacity by refusing to turn over the car to a man lacking the written authorization to back his demand that the car be given him. Simpson's—and the man's—paymaster, Walter or Robert Karl Harper, had entered the book at the very outset. Like Jimmy Khoo, the Hong Kong chauffeur in *Passage*, Simpson uses his fluency in English to fleece American tourists. In Harper, he sees a likely mark at the Athens airport, and he connives both to drive him to his hotel and to show him around the city.

Simpson's fortunes drop so quickly after meeting Harper that he must have sought him out deliberately. The motives governing his behavior with Harper throughout come from a deep inner source, too. Not content to overcharge Harper on the taxi rate and to take him to places that pay him a commission, he must also try to steal the man's traveler's cheques. He lets himself into Harper's hotel room while Harper is supposedly occupied in a local brothel. The first chapter of *Day*, which covers a great deal of ground, both geographically and psychologically, ends with Harper walking into his room and catching the redhanded Simpson holding $300 worth of his traveler's cheques. Now if some inner demon had led Simpson to Harper, the reverse is equally true; Harper had also been looking for a Simpson. The submissiveness that greets his pounding of Simpson, given right after the two men confront each other in the hotel room, validates his instincts. As cruel as it is, the pounding is just the start. Harper, who has come to Athens for more than fun, has plans for Simpson. These plans he puts into effect immediately. Full of energy, boldness, and menace, he breaks down Simpson's defenses together with his confidence and dignity. First, he blackmails the bruised little grifter into confessing in writing that he broke into Harper's hotel room and stole $300. Then, after paying him a puny $100 to drive a car loaded with contraband to Istanbul, he forces Simpson to help him loot the Topkapi Museum, a one-time royal palace located on a peninsula between the busy Golden Horn and the Sea of Marmara.[1]

In Chapter 10 of this twelve-chapter work, Simpson concedes Harper's tyranny over him when he notes inwardly, "I suppose that obedience to Harper had become almost as instinctive with me as breathing." His instincts have betrayed him. Father figures rescued the hero in *Siege* and *Passage*; they staggered through *Judgment* and *Maras* as infirm elders. Here in *Day*, they have taken on a hard, jagged edge. Never mind that Harper, the first of them we meet, is 15 years Simpson's junior and that he's an outlaw rather than a

lawman. He beats up Simpson, puts him at serious risk, and has sex with a beautiful woman in his range of hearing. Part of Simpson craves this mortification. His anti-social life style, his attraction to danger, and his repeated bids for attention from powerful men nearly insure his self-abasement. But self-abasement uses tactics of its own. It has taught him to strike out at his persecutors indirectly; as a schoolboy, he wrote unsigned letters attacking the moral character of the masters who caned him, and he later denounced an alleged persecutor as a spy to the Egyptian authorities.

His self-degradation has created still deeper reverberations in his psyche. By debasing himself, he believes that he can crawl beneath the scrutiny of the punishing father. He has fooled only himself. As a boy, he attended Coram's, a school outside of London, which had as its motto, *Mens aequa in arduis*, meaning, Keep a level head in adversity. The book's first paragraph shows how this lesson has eluded him. Not only does he gravitate to trouble; believing himself wronged and deprived, he also blames his sorrows on others: "It came down to this: if I had not been arrested by the Turkish police, I would have been arrested by the Greek police. I had no choice but to do as this man Harper told me. He was entirely responsible for what happened to me." Such reasoning befits a person lacking autonomy and self-worth; so despairing is Simpson of looking out for his welfare that he has considered suicide. But he's too cowardly for drastic measures. He prefers the easy way out of blaming his miscues on others. After claiming in Chapter 1 that his last term at Coram's was "completely spoiled," he says immediately, "Jones iv was responsible for that." Later in the chapter, he justifies his attempted robbery of Harper by claiming, "People who leave traveler's cheques about *deserve* to lose them." So adept is he at dodging responsibility that when he makes a comment, like the one in Chapter 6, "Then, in sheer desperation, I did something silly," he seizes us straightaway; we know he has committed a terrible gaffe.

Like this gaffe, the ones he tries to blame on others plague him. His ego is constantly being deflated and bruised. At the end of Chapter 7, he wonders, "How do you wash away the smells of the inside of the body?" Only a person who feels contaminated would ask such a question. Yet he can't escape contamination's stain. Eavesdropping upon Harper and a friend, he hears himself demeaned; the fear of sterility has hurt both of his marriages; one of his most vivid memories of Coram's consists of being pissed on by his schoolmates. The frequency with which he acts against his best interests invites such woe. "I have a unique capacity for self-destruction," he admits in Chapter 11. Simpson is a man at odds with himself. Though he courts danger, he lacks the coolness, foresight, and common sense to defuse it. He accepts Harper's offer to drive Elizabeth Lipp's Lincoln Continental to Istanbul because he has forgotten that his Egyptian passport has lapsed. Had he remembered (the Egyptian government wouldn't have renewed it in any case), he'd have been

able to reject Harper's offer. And save himself grief: within moments of pluming himself on his cleverness, he gets arrested as an arms smuggler. A few setbacks occurring in a short time have brought him to grief. Though he examined the undercarriage, air-conditioning unit, and gas tank of Miss Lipp's sedan, he forgot to look inside the door panels. Unearthed here by Turkish security men are gas masks, grenades, pistols, and 20 rounds of ammunition.

His arresting officer, one Major Tufan, teaches him a lesson that comes to all desperate people—the quick fix never works. The harder Simpson runs from danger, the more deeply he mires himself in it. After his arrest, he must help the police. They want to know why Harper and his friends, who are all carrying false passports, have loaded the door of Miss Lipp's car with contraband, and they demand Simpson's help. Tufan's statement to him in Chapter 3, "No consul is going to intercede on your behalf. You have none. You are stateless," tells him that he must cooperate. Being convicted for the crime of arms smuggling calls for 20 years in prison or even the death sentence. Like Harper, Tufan easily strips away any bargaining power Simpson might pretend to have. He can't rebut Tufan's insult, "You must be a very stupid man, Simpson." When he tries to explain himself, either his logic fails him or he lies himself into a corner. His options soon dry up. While continuing to work for the Harper gang, he must also report daily to the police. What is more, his having to write his reports infers that his welfare means less to Tufan than the operation. His pawn complex persists. Not only is Tufan willing to risk his neck for the operation's success; he'd also trade him for the chance of securing some high-grade intelligence.

As our hearts open grudgingly to this loser buffeted by powerful foes, we feel the suspense build. The Harper gang isn't mounting a drug operation or a political *coup*, as Simpson had thought. Professional thieves, they're planning to steal gems valued at over a million and a half dollars from the Topkapi Museum. The jewel robbery is the book's dramatic climax. Ambler enjoys rehearsing the details going into its implementation—the infiltration of tackle and gear into the Museum together with the precision, nerve, and teamwork on the part of the thieves required to make the operation work. But he also maintains dramatic focus. Despite Simpson's chronic fear of heights, he must lower one of the thieves into a window with a block-and-pulley while standing on a narrow ledge 300 feet above ground. He has no choice, as usual. Having told him about the proposed theft the previous day, Harper can't afford to excuse him from it. Simpson must either climb the roof of the Seraglio and hope he keeps his poise or face instant death.

The finale shows him winning a costive half-victory. After leaving the Topkapi with their prize, the thieves literally throw up a smokescreen of poison gas to foil their pursuers. They reach the airport successfully, too. But while Harper is unscrewing the door panels of the Lincoln to remove the gems hidden there, Simpson, seizing his last chance for revenge, floors the accelerator and

drives away. His revenge recoils upon him. The opening words of the next chapter, Tufan's statement to him, "The Director is not pleased with you," undercut any sense of triumph he and the reader might have shared in witnessing the thieves' frustration. Yes, the jewels have gone back to the Museum, and the police have descriptions of the thieves. But the thieves have fled to Rome, where they're beyond extradition.

Tufan blames their escape, perhaps correctly, on Simpson. But even if Simpson's mistake at the airport didn't help them get away, he'd have been punished, anyway. This petty crook has gotten the worst from both the lawman and the outlaw since accosting Harper at the Athens airport. Those who can't defend themselves have always been victims. He hears from Tufan at the end, "If those jewels had left the country...you would have been the first to be arrested." Perhaps he should feel lucky to be given $500 and a one-way air ticket to Athens. The emblem of this perpetual bottomdog is an out-of-date passport that can't be renewed. His closing cry of protest comes from the have-not whom others use freely but who lacks the power and color either to change his environment or improve his place in it.

His dismal career with women squares with Ambler's picture of him as both an anomaly and a superfluity. After the death of his father, his mother shipped him to school in England in order to enjoy more privacy with her lover. The distress of being discarded by the woman closest to him for the sake of another male recurred when his first wife cast him off. His practice of telling people that Annette died in a bomb raid stems from anger and dismay; being bombed to death is what she deserves in his eyes for throwing him over for her "gallant gentleman." By the time he comes to us, he has grown so accustomed to being betrayed by the women he loves that he courts betrayal. Why else would he have married Nicki, a belly dancer half his age? And why else would he have taken Harper to watch her perform? By spending little time with her, he also gives her plenty of opportunity to deceive him; "Nicki was out, of course. She usually spent the afternoon with friends—or said she did," he says in Chapter 1. Appropriately, he clings to a female statue fouled with bird shit in Chapter 7. He can't escape the image of the sullied woman. Yet his low self-esteem makes him feel that he deserves no better. Many of the deadliest traps he has fallen into he has baited himself. This recurring motif explains why the book opens with a variation of the biter-bit device from Renaissance plays like Ben Jonson's *Volpone*. Nicki occupies surprisingly few of Simpson's thoughts because he's protecting himself. But the pain she inflicts won't subside. It has its roots in the unhappy boyhood he keeps harking back to. The weight of his childhood burdens have nearly crushed him. "The worst thing at school was being caned," he says in Chapter 2 after his beating by Harper revives his feelings of helplessness in the face of physical punishment. No amount of glamor, status, or money can blot out the memory of his schoolboy woes.

Punishment is what he knows and has come to expect; he can't resist it. His deepest personal ties involve men, and they carry a heavy charge of danger. What helps build this danger is the role of punishing headmaster in which he casts the men he subserves. Naturally, he's resentful. While discussing his crimes against the British government in Chapter 3, he says inwardly, "How could I explain...that I had to pay back the caning they have given me?" Vengeance also makes him demand more from his clients than the money he cheats them out of; he must make them feel outsmarted, too.

But the drive to self-punishment persists as the mainspring of his character. Why else would he tell the brothel madam he leaves Harper with in Chapter 1 that he's hungry? He had just dined with Harper, who, sure to hear his explanation from the madam, would instantly grow suspicious. In Chapter 6, Simpson blunders again when he tries to unscrew the door panels behind which Harper had stored his contraband. He has nothing to gain from inspecting the contraband and plenty to lose if he's caught doing it.

Whether Ambler impersonated this abject loser to extend himself artistically or, as James believes (68), to disclose his own psyche can't be known. But it's an intriguing question. *Day* contains several ideas and motifs that mesh with Ambler's ongoing struggle with his father's spirit. Often, the son will prove his intrinsic worth as a way of escaping the father. Reg Ambler, we recall from *Here Lies* (71), was a poor driver. By making Simpson a chauffeur, Ambler shows him surpassing Reg in an activity which the demands of modern mechanized life have endowed with some prestige. But his driving skill is probably the *only* activity where the symbolic son outdoes the father. Ambler hasn't established his own autonomy through Simpson, nor has he pretended to. In fact, judging from both his character's prison record and his grubbiness, Ambler is trying to punish the father who had high ambitions for him by identifying with the cheap lout. But if he has insured his defeat by the father, he may have also robbed the defeat of its sting. He has done this by degrading fatherhood itself. Implied in figures from Dimitrios to General Iskaq of *Passage* is the notion that manly power is worthless if it entails such atavistic ugliness and cruelty. What value has authority if its main purpose is the suppression of the son?

But what if the son suppresses himself? By crawling beneath moral blame to avoid the father's, or headmaster's, cane, hasn't a Simpson encouraged the tyranny he hates? He knows the benefits of fatherhood. In Chapter 1 he says of Nicki, "When she calls me 'Papa'...it means that she is in a friendly mood with me," as if fatherhood were life's greatest prize. He thinks of buying her a stone marten stole as a homecoming gift because "I would be 'papa' for a month." Yet his next thought, "That is, if she hadn't moved out while I had been away," conveys his fears. He has never developed in himself the security and nurture connected with fatherhood, perhaps because of his fear of being sterile. And now his chance to assume the father's role, naturally or symbolically, has

passed him by. For one thing, the category no longer observes the old rules. Both Harper and Major Tufan bully him, even though both men are some 15 years his junior. Harper even calls him "Dad" after pounding him in Chapter 2. His mixed blood expresses the irrelevance of guidelines from the past. The world has become a confusing, overwhelming place, and his knavery has worsened the muddle. What else can he do at the end other than protest being an anomaly, even though nobody will listen?

Anyone like James who believes that his degradation refers to some inner disturbance of his author will note the resemblance between *Day* and other books in the Ambler canon. As in *Dimitrios* and *Journey*, a western visitor to an eastern European city is taken to a cabaret by a local man, even though in *Day* the point of view is that of the local. The *femme fatale* returns from any number of Amblers, and, as in *Frontier*, she's driving a large, powerful car in a high-speed chase that comes near the end. In the car with her is Simpson, a small-timer, like the heroes of *Judgment*, *Siege* and *Passage*, trapped between powerful foes, both of whom want to use him. These motifs from the earlier fiction both explain how Ambler works and help form the book's deep structure. They also chime with new motifs, like the piecemeal disclosure of Simpson's sordid past. Interest comes from other sources, as well, such as the first-person narrative. Simpson is both on the scene and, since he's writing about the past, detached from it. This dual slant creates an admirable contrast— between the benefits conferred by his hindsight and our knowledge that no amount of luck or benefit can improve his plight. A contrast just as brilliant, involving the romance, mystery, and tradition of the Topkapi Museum and the greed of the thieves who have come to rob the place, gives the book's dramatic climax an added charge of tension. This tension, in turn, gains force from the clash between the hysteria gripping Simpson as he performs his small task and the cool poise of his counterparts doing more desperate work on the Treasury roof.

These gripping moments occur often, many stemming from Simpson's love of danger. But they lose impact from our knowledge, inferred by the first-person narrative, that the lucky slob will survive his ordeals. *Day* often fails to satisfy the expectations it builds. More to the point, the book has little forward drive. Much of it consists of testing different explanations—all of them wrong, as it turns out—for the gang's conduct. After learning that the Harper bunch aren't spies, terrorists, or drug dealers, we feel let down, having invested some imaginative effort tracing lines of reason set forth by Simpson. This kind of inconsequence haunts the book. Exciting enough on their own, the scenes comprising *Day* don't knit thematically. Several could be removed without damaging the book's coherence, which is to say that much of what goes on fails to develop into anything important.

Even after allowing for the more relaxed standards of the thriller, or spy

tale, we still find the book wanting. *Day* falls so far short of Ambler's best work, in fact, that one wonders why the Mystery Writers of America gave it an Edgar. Smooth and fast paced it is, and its sharp eye for detail creates a color and warmth that was caught brilliantly by the 1964 film *Topkapi*, which was based on it. But its looseness and its squalid anti-hero both rob it of the challenge rightly expected of prize-winning fiction of any kind.

## II

*A Kind of Anger* lends rich new dimension to Ambler's ruling belief—that the father's spirit must be broken and written off before the son can become whole. But it probes the belief in a way that might have surprised and even alienated contemporary readers; James calls Ambler's 1964 work "the least warmly received...of his second [i.e., postwar] period" (64). The plot is simple. Dogmatic and tyrannical Mr. Cust, the main shareholder and editor-in-chief of the New York-based weekly, *World Reporter*, acts in keeping with the perversity his underlings expect from him. He gives his Paris staffer, ex-mental patient Piet Maas, a "stupid and...malicious" directive. Behaving with more than his usual cussedness, Mr. Cust orders Maas to find the former mistress of Colonel Ahmed Arbil, an Iraqi official slain seven weeks before. Lucia Bernardi fled the Zurich house in which Arbil was shot to death, and Cust wants this leading witness in the murder case interviewed in the *World Reporter* before appearing in either *Paris Match* or *Der Spiegel*.

Cust exerts nearly supernatural force. Called in Chapter 1 "a jealous god," he can issue a command from a distance of 3000 miles and know it will be obeyed. If Maas rejects the Lucia Bernardi assignment, unreasonable as it is, his salary will stop, and, because his contract with *World Reporter* has five more months to run, he can't work for any other magazine. Even Sy Logan, the *Reporter*'s Paris bureau chief, admits to Maas, "The old man's handed you the job. We both know why—because he wants to chalk one up against you." Despite his grimness of outlook, Maas moves ahead quickly. He coaxes Lucia into the open and arranges a meeting with her by the end of Chapter 2. But another authority figure destroys any satisfaction created by this breakthrough. Sensing a scoop, Sy Logan has flown a better-known journalist to the French Riviera, where Lucia is living, to supersede Maas in case the interview yields some big disclosures. Anthony Boucher's review of *Anger* in the *New York Times Book Review* recounts the grief dealt out to Maas up to this point:

> Even as anti-heroes go, Piet Maas is a fairly extreme case. He is a minor journalist recently released from the psychiatric ward after suicidal depression brought on by simultaneous failure in his professional and his emotional life... His publisher (who neurotically hates the mention of mental illness) and his editor (who more simply hates Maas) send him on an assignment with odds a hundred to one against success. (1964, 4)

These long odds haven't sapped Maas's vim. He finds Lucia's former boss, the American-educated Phillip Sanger. Because he knows about Sanger's shady dealings in real estate, he blackmails the Frenchman into helping him; Maas will protect Sanger's privacy if Sanger leads him to Lucia. The pressure he applies is rare in an Ambler hero; usually the hero has to follow orders, whether they consist of fixing broken machinery (*Frontier*, *Siege*) or helping the police catch crooks (*Epitaph*, *Day*). But Maas's power has restrictions. As in Harold Pinter's *The Dumbwaiter* (1958), Maas shows that those who apply pressure are often only hirelings acting to relieve pressure applied on *them*. He's as much of a loner-outsider as any Ambler hero to date. Orphaned as a boy, he was sent overseas to be educated. Setbacks in his adult life such as going bankrupt and finding his live-in girlfriend in bed with another man drove him to attempt suicide. When his gloom persisted, he took shock treatments. And his internal wounds haven't healed. He still needs pills for depression and bad nerves.

His calling himself a coward, a neurotic, and an emotional cripple doesn't make him more complex or vulnerable than Ambler's other loser-heroes. But his pain gets more authorial attention. His rehearsals of his sad past with Logan in Chapter 1 and with Sanger in Chapter 2 disclose in him a sensitivity Ambler hadn't heretofore attempted. Like Simpson, his immediate predecessor (and successor, too), he's a foreigner with an English education who became a journalist and suffered both business setbacks and heartache when his woman betrayed him. Yet he has a better moral character, higher goals, and, at age 34, no prison record. Lacking Simpson's cringe, he also has better social and professional connections, and his common sense would stop him from stealing someone else's traveler's cheques. Finally, whereas Simpson gets bullied, the resourceful Maas convinces both Sanger and Lucia that, by helping him, they'll also be serving their own best interests.

Through it all, Ambler maintains a steady focus on Maas, bringing to life the resistance his man must overcome to win Sanger's and then Lucia's reluctant cooperation. Ambler also describes the flimsiness of these victories— in terms that reveal his sympathy with Maas. His unconscious unifies *Anger*. The depth of his sympathy shows in the thematic power created by his father complex. Boys can't displace or "kill" the father in Ambler, a truth that belies Boucher's argument, "Ambler has changed a trifle over the years.... His anti-heroes are even more anti, and he is shifting from espionage to a more private form of international malefaction" (1964, 39). What happens to Maas shows that, rather than changing, the Ambler of *Anger* had grown into an intensified version of his earlier self. Maas can't escape the threatening father. We have seen how the book opens with his boss in distant New York forcing a thankless chore upon him. The sadistic Cust parodies darkly the Deist God who set the universe going and then stepped aside. Acting on his instructions, Logan not

only betrays Maas by trying to replace him with a more prominent journalist; he also asks Maas for information that Maas couldn't give him without breaking confidence with his source, Phillip Sanger. Sanger betrays this trust himself. He comes back at the end with an offer to represent Maas in his dealings with an Iraqi contingent that wants to buy the late Colonel Arbil's private papers. Sanger's restoration to the action as Maas's agent saves Ambler a good deal of work, Sanger negotiating with General Farisi offstage. But the restoration also rekindles Ambler's Oedipal struggle. Though only ten years Maas's senior, Sanger addresses both him and Lucia in fatherly tones. "Wait, children!" he tells them in the last chapter, along with "Bless you, my children." This rhetoric masks his greed. Sanger has adopted a fatherly pose so he can cheat Lucia and Maas more easily. And cheat them he does, claiming that Farisi paid him only half the agreed-upon price for Arbil's secret reports. His lies help structure the book. The beginning, middle, and end of *Anger* all feature male authority figures who thwart the narrator-hero. Once again, the father has scored at the son's expense, leaving him in flatfooted dismay as he pulls away from the curb in his purring new roadster.

Echoes from Ambler's earlier work describe *Anger* as an outgrowth of his artistic past. Intergenerational sex returns from *Day*; Arbil is twice Lucia's age, just as Simpson was twice Nicki's. Both the automobile chase and the overland trek recur in reduced form from any number of earlier Amblers. But it's *Mask*— perhaps Ambler's most deeply imagined work—that causes most of the echoes in *Anger*, supporting the argument that he invested a great deal of his unconscious self in his 1964 novel. At 181 centimeters tall, Maas stands exactly as high as Dimitrios, according to one police report. The addiction to both heroin and gambling featured in the earlier book recurs as ether drinking in *Anger*. And just as Latimer meets bulky Frederik Peters while looking for old newspaper reports about Dimitrios, so does Maas encounter a fellow seeker for information about Sanger in a Nice archive, the gaunt Greek from Cairo called Skurleti. Skurleti's exaggerated courtesy calls attention to his greed, as did that of Peters. Furthermore, the streetwise pair, Skurleti and Peters, suffer more deeply because of the alliances they form with their innocent counterparts. Peters is shot to death, and Skurleti buys military secrets soon made worthless and unusable because they've also been bought by a rival. Strangers to honor in all forms, Ambler's crooks will cheat and exploit one another every chance they get. As heavy an influence upon *Anger* as *Mask* is classic American literary detection. *Anger* starts as a missing-persons case, as do most of the novels of Hammett, Chandler, and Ross Macdonald. Maas's warnings to Lucia in Chapter 5, "If you're asking me to take the risks involved in making this deal for you, I want to know more" and "Until you tell me exactly what I'm getting into, I can't decide whether I'll help you or not," echo Sam Spade's words to Brigid O'Shaughnessy in *The Maltese Falcon*. Maas, whose initials are the same as those of Philip Marlowe, also follows Chandler's sleuth in being a lonely man

who both understands and respects life's basic decencies. And like Ross Macdonald's Lew Archer, he's not only self-questioning but also self-critical. A. Norman Jeffares did well to note the complexity of the plot of *Anger* (20). He might have added that the book's moral maturity breaks new artistic ground for Ambler.

But if the American detective hero provides access into *Anger*, so do the aesthetics of recent English spy fiction. As in John le Carré, loyalties in *Anger* are obscure, making us ask, Who's on whose side? and Which side is the right one? Maas is told in Chapter 3, "Mixed motives are funny things. You might decide to change your mind." Change his mind he does, just as others re-evaluate *him*. But where does he stand with us? Does he deserve our sympathy? His behavior can rankle. He admits that he's blackmailing Sanger, and he takes a revolver with him to an interview with Skurleti. Then he plays Skurleti against Farisi in order to drive up the bids for Arbil's secret reports, exclusive rights to which he sells to *both* parties. As we wondered earlier, is he a crook or just an ordinary guy looking to make the best deal for himself, using whatever leverage he has?

Any answer to this question entails a look at the book's interpersonal dynamics. As in Hitchcock's *Thirty-nine Steps* (1935), sexual love in *Anger* fuses impulses of contempt and necessity. Lucia and Maas spend more time together than any unmarried Ambler couple to date, creating opportunities for realistic adult feelings to build and flow between them. Though Maas both respects the opportunistic Lucia and finds her fascinating, he can't like her. Nor can she, him. The last sentence of Chapter 5, the book's midmost chapter, reads, "Our mutual dislike was complete." Strong as it is, though, this dislike doesn't stop them from having sex together. Ambler's new awareness of the ambiguity of motives rules out explanations for their behavior. But it does show that sharing both danger and the prospect of getting rich can quicken the loins of two normally sexed adults. Sanger's telling Lucia and Maas at the end of Chapter 8, "You should be very happy together," refers, however sarcastically, to the amalgam of emotions linking the couple—in a way they can experience but not analyze. Lucia and Maas both struggle to endure and look for ways to boost one another's spirits. Their spirits need boosting because of the guilt they share. *Anger* describes hearts in need of help and other hearts sometimes willing to give it. This outgoing of self counts a great deal with Ambler. Moral guilt irradiates the novel. Though the law isn't broken, justice seems to have failed. This failure sharpens the need Lucia and Maas feel for each other. They can't turn elsewhere for comfort and warmth. A whydunit, *Anger* shows why people act the way they do. The emotional stress caused by criminal behavior in the book outstrips any drive to power. The despotic father hasn't crushed the son.

Neither does the odd flub in *Anger* sink the book, even though such defects should be noted. For instance, a news report calls Lucia "most

unbuxom." But Sy Logan, after looking at some photos of her, says she's "well stacked." The title of the novel provides still another problem. Like several of Ambler's other books, *Anger* is either carelessly titled or *mis*titled. Sanger tells Maas in Chapter 4 after being advised to leave town before the *World Reporter* swoops down on him, "You're the man who couldn't be bought for thirty thousand dollars, yet you claim to have no professional pride.... What is it with you, Maas? Self-destruction still, or is there a new kind of anger, now?" The possibility that Maas's ethics are fuelled by anger intrigues us. Lucia has eased the pain inflicted by the archetypal father, as his words at the end of Chapter 3 imply: "I have nothing to lose except a job I don't want and I have a lot of curiosity to satisfy." His instincts merit his trust. Why please a father figure who keeps making new, unfair demands; far better to fix one's attention on a beauty of 24 like Lucia.

The first paragraph of Chapter 4 confirms the wisdom of his decision. This self-styled neurotic and emotional cripple has enough faith both in himself and his recent actions to sleep for four straight hours without the help of sleeping pills for the first time in months. Sanger sees a change in him. "I thought I knew what made you tick. 'A new kind of anger,' I said. How wrong I was! Your kind of anger is as old as the hills.... The point is that you have a taste for larceny. It agrees with you." This insight bypasses the emotional letdown Maas experienced from being bilked of his chance to play the rescuing Galahad with Lucia, who obviously needs no protector. Perhaps Sanger is trying to lower Maas's defense because he's planning to lie about the sum he'll squeeze from General Farisi for the Arbil reports. But there's no sign that Maas, having chanced upon a fortune by dabbling in crime, will become a professional crook. Nor does he give any sign of staying any longer with Lucia than their common interests dictate.

These criticisms hardly detract from the total achievement of the book. Paxton Davis miscued badly when he dismissed *Anger* as "Ambler's slightest and least important book" (10). Bitter the book is, but not thin. Having cast a cold eye on human purpose, Ambler doesn't expect a great deal from people, including perhaps himself. His characters are a cold, pitiless bunch. Lucia's last-chapter comment, "There is no true friendship but only hard self-interest," captures much of the motivation informing the action. The lean and hungry movers of the plot stand light years from either the daring, carefree gentleman-adventurer of *Frontier* or the well-meaning trapped innocents of *Epitaph* and *Alarm*. A self-confessed blackmailer, Maas convinces Sanger that, in view of his shady dealings, he'd be serving his best interests by leading Maas to Lucia. He uses the same logic with Lucia in Chapter 3, arguing, as he did with Sanger, that her best chance for freedom lies in cooperating with him. Pushing this logic still further, he insists that, by interviewing her for *World Reporter*, he's setting her free. In all fairness, neither she nor her ex-boss deserves any better from him. The nastiness of Sanger's business ethics led him to adopt an alias for his

real estate transactions. No stranger to dirty tricks, he hired Lucia to gain an edge in the "psychological warfare" he wages against his male clients. Lucia's job consisted of enticing them. Being roused sexually by her and wanting to take her to bed made them feel guilty, since she was supposedly Sanger's lover. Their guilt would muddle their reason and thus lower their bargaining skills, gaining Sanger a *coup* he'd have otherwise missed.

To her credit, Lucia tired of this swindle and abandoned it for love and Arbil. But even here, she felt the lure of money; money cuts across love in *Anger* as in much of Flaubert and Henry James. She only pretended to be hiding from Arbil's killers. As the owner of Arbil's military secrets, she was safe from attack. The secrets meant more to any Iraqi rebel than did her death. Which Arbil forecasted; before he died, he showed her how to market the secrets in the event of his passing. He also taught her how to attract buyers. She followed his teachings well. By pretending to be in danger, she was indirectly telling the various rivals for Iraqi power—and oil—that she had something of value to sell them. And she needed a Maas to deal with would-be buyers in order to boost her profits.

The book's open, airy, unconcerned style puts an ironic spin on such greed and guile. Self-seeking explains another stylistic effect that bolsters the plot, that of repetition. As Skurleti's excitement builds over the prospect of buying the Arbil secrets, his teeth become increasingly prominent, like those of a hungry dog. "His teeth showed," Maas observes of him during their first extended interview, in Chapter 4. Each disclosure by Maas that makes Skurleti feel closer to his goal creates a bolder show of teeth. The observations, made over a span of five or six pages, "The teeth were fully exposed now," "The teeth showed again, this time with gums," and "Teeth gleamed in the station lights," as if surpassing the lights in brightness, convey an urgency. But Ambler knows how to engross the reader without making him/her feel rushed or manipulated. Sensitive to the benefits of pacing, he delays putting before us the agents Lucia wanted to lure to the Riviera at the start. The smoothness of texture resulting from his patience combines with his even, limber voice to counterpoint the nastiness being described.

Yet this tension, deftly managed as it is, may have cost *Anger* the popularity it deserves. Perhaps Ambler's bleak outlook fits our post-yuppie age of currying favor, cultivating disposable friendships, and striking deals better than it did the world of 1964. Regardless, contemporary readers should have seen in Maas a more realistic narrator-hero than any Ambler had heretofore portrayed. No reformer, Maas doesn't want to improve the world. His efforts to find a place in it sometimes meet grief because of his mistakes. But failure won't stop him. A credible fusion of good and bad traits, he keeps on trying. The advance he represents from the greasy, one-dimensional Simpson proves that neither he nor Ambler is so weary or disgusted that he caves in to the

tyrannical father. The drama uncoiling from the interplay of promise and cynicism in *Anger* justifies by itself a wider and friendlier readership than the book, perhaps Ambler's most misunderstood, has won to date.

### III

Unaccountably, the Ambler of *Dirty Story* (1967) returns to shabby, squalid Arthur Abdel Simpson, narrator of *The Light of Day*. Simpson is as nasty and rundown as ever. No social critic or tragic hero, he recalls Joyce's paralyzed Dubliners in his failure to better himself. We find ourselves as voyeurs, not fascinated or riveted by his paralysis, but resigned to it. This paralysis is moral rather than physical. It covers a wide geographical sweep and includes considerable activity. The titles of four of the book's six parts (the first three and the last) feature the words Departure, Passage, Journey, and Disengagement, all of which convey the instability and transience carrying over from *Day*. Those of Parts Four and Five, Spearhead and Day of Battle, express the conflict Simpson has always gravitated toward, perhaps because of the influence of his soldier-father. They also forecast the outcome of the conflict, upheaval nearly insuring the downfall of this mousy, marginal man.

At the start of the book, he's living in Athens, his home at the outset of *Day*, driving a taxi on a commission basis. He's still married to Nicki, who has gone to Rumania to perform with her dance troupe. Her nonappearance in the action hints at the weakness of the marriage. Little more than a domestic arrangement, it's so shaky that he avoids mentioning it. He wants to dodge the pain caused by his moral certainty that she has been seeing other men. But pain seeks him out, anyway. When he asks a brothel madam where to find actors for a porno movie, he's told, "Ask your wife. She would know." His wife's tie with the unsavory keeps lurching out at him. It meets little resistance because of his pawn complex. He likens two men who browbeat him to schoolmasters. One of them calls him "a cunning rat." Much later, Simpson says, "Just the idea of rats terrifies me." Is this a veiled statement of self-disgust? His poor self-esteem, a function of forever caving in to male authority figures, has bridled his freedom. In Part 1, Chapter 2, he says, "Heights terrify me. Once, on that awful night when I was forced to go on the roof of the Topkapi Museum in Istanbul, I was…helpless with vertigo."

This fear of heights feeds his slave mentality. Unable to soar, he has condemned himself to the gutter, where he'll stay. Sidestepping responsibility whenever he can, he still blames his knocks on others. The beginning of Part One, Chapter 6, finds him blaming three people for his undoing—in one brief paragraph. His problems can only worsen. The structure of *Story* invokes Nietzsche's doctrine of eternal recurrence. As time rolls forward, Simpson will continue to wheel in tired, ever diminishing circles, exhausting options as strength drains out of him. In Part One, he miscues by ordering a forged passport. At the end, he's forging passports himself. He has learned nothing.

Rather than admitting that he's a crook, he claims to be a benefactor, bestowing freedom upon the stateless in a repressive world. He has come full circle. But his special pleading ignores the dangers that await him if he's caught, dangers far greater than those facing him at the outset, when his British passport was revoked.

Gavin Lambert sees his rascality as that of the protesting outsider or sociopath:

In this compelling sour novel, hatred is the underlying criminal motive. The schoolboy tormented by bullies and teachers grows into the swindler, pimp, informer, and spy who hates society. He also hates criminals more successful than himself. . . . His real mission is revenge (127).

People do shout at him, order him around, and even hit him. From the occasional glimpse Ambler provides of him from the standpoint of others, this bullyragging follows logically. Part Two, Chapter 1, shows an acquaintance reluctantly loaning him a razor and then rinsing it after it's returned to him, even though Simpson has already rinsed it thoroughly himself. "You would have thought I had anthrax or something," an indignant Simpson mutters inwardly as he hears a stream of water running over the razor. But the model of the browbeating male is the schoolmaster, not Simpson's blood father. This father nonetheless merits some attention. An NCO and warrant officer commissioned as a Lieutenant in 1915, Arthur Thomas Simpson exerts more force in *Story* than he did in *Day*. He died accidentally while on active service in 1917, when his only child was seven. His never having married that child's mother has added to Simpson's woes, but without having caused them. Simpson was never entitled to British citizenship, to begin with. He jeopardized and then annulled his citizenship himself. He'd have kept it if his recurrent misdeeds hadn't caught the eye of the British Consulate in Athens. His father didn't make him stateless. Simpson acts shocked when told that his parents never married. His shock could be genuine, even though he'd probably admit in a rare moment of self-honesty that his long criminal record would suffice to revoke anybody's passport. His father remains an island of stability amid the turmoil that batters him in *Day*. Impressed by the Lieutenant Quartermaster's rough-and-ready barracks wisdom, he quotes his father often, axioms like "a clean shirt, a crap, and a shave make a new man of you" peppering the action.

This male gruffness provides the only comfort he enjoys in *Story*. Not only does the book begin in Athens, the starting point of his troubles in *Day*; like *Day*, its opening pages also show him being cowed by a younger man. "Sneering and sarcastic, like a schoolmaster," even though he's 20 years younger, the British Vice-Consul revokes Simpson's citizenship. When Simpson protests, he's called a "celebrated nuisance," a "disgusting creature,"

and a "cunning rat" before being dismissed and told not to come back. The knowledge that he's stateless and that no country will take him in addles his judgment. He can't pay for the illegal passport he orders from a local racketeer. But, unlike Simpson, the racketeer knows how to protect himself. What looked like a reprieve only stings Simpson more sharply. He must work off his debt by recruiting actors for a visiting movie company intent on making a blue film. Madame Irma, the bawd he goes to for help, voices moral outrage when she hears his proposition—but only to drive up the asking price for her girls. The next thing he learns is that he and one Yves Goutard, an ex-paratrooper working on the movie, face arrest. Mme. Irma (who also appeared briefly in *Day*) has denounced them to the police for procuring. Goutard had asked the fillies from her stable to work for him as prostitutes on the island where the blue film was being shot. Presumably, he also neglected to offer her a share of the take.

The two men are smuggled out of the country. But where to? Simpson lacks both destination and destiny, having surrendered his will to strangers who care little about him. Fear of extradition and deportation keeps haunting him. Like the card he draws from Mme. Irma's tarot pack, Le Pendu, he's hanging upside down in air and could drop to earth at any time. The juddering fall he fears occurs in Djibouti, capitol of Somaliland on the Red Sea, where his ship has put in for repairs that will take a week—enough time for him and Goutard to quarrel with the ship's captain and get themselves thrown off the crew. Easy prey for any get-rich-quick scheme, the men sign on with SMMAC, or the Sociéte Minière et Métallurgique de l'Afrique Centrale, a consortium mining rare earth elements in equatorial Africa.

At this stage of the action, it has become clear that each of Simpson's schemes to avert a crisis is more self-defeating than its predecessor. Easy money doesn't exist in Ambler; nor has Simpson been hired to mine rare earths. As usual, the lure of a quick fix in the form of ready cash has put him at high risk. Reviewing *Story* for the *New York Times Book Review*, George Grella calls the book "an account of the rude awakening of a squalid, frightened little man who has the decency to be outraged by criminals far worse but infinitely more respectable than he" (59). Grella has overrated Simpson. Lacking a social conscience, Simpson wants a bigger share of any smash-and-grab raid he involves himself in. The constant threats of poverty, arrest, and deportation both fog his judgment and lay waste his bargaining power. He invariably turns out to be somebody's dupe. Perhaps he believes that wrongdoing is his natural milieu, and he secretly welcomes the machinations of those who steer him in the direction of crime. A sharper reading of his shortcomings stems from Ginna: "Ambler's most feckless hero is Arthur Abdel Simpson.... There is nothing so low that Simpson...will not stoop to" (96).

Set forth casually in *Anger*, the truth that wars today in the third world often pit rival multinationals against each other reaches fuller expression in *Story*. SMMAC isn't mining or prospecting for minerals. It has invested both

money and manpower in a dangerous business climate. The security men it sends to equatorial Africa to guard a rare earth area soon learn that they're mercenaries. Why else would the plane flying them to the imaginary republic of Mahindi be carrying mortars, machine guns, and ammunition? SMMAC wants to stabilize the nearby town of Amari before installing heavy machines; the area targeted for mining must be seized before it can be guarded. Simpson has been deceived. Despite the assurances he has been given, he has become a combat soldier in a war zone. He and his cohorts are issued uniforms, boots, and weapons; their movements are restricted; any mail sent from their compound must first be inspected by their commanding officer. Proposed as a business deal, the rare earth expedition is really a military invasion.

SMMAC's rival is an American-West German firm called the United Mining and Development Corporation, or UMAD. The upshot of all the training, the outlay of time and effort, and the bloodshed caused by the rivalry is a stalemate. UMAD and SMMAC agree to divide the spoils of their mining ventures, cheating the locals whose land they've plundered and whose blood they've shed of their share of the profits. Lives have been risked, damaged, and lost for nothing; SMMAC and UMAD might have negotiated a contract for mining rights without wasting money and blood. Obviously, they felt that they could improve their bargaining position if they first enacted some violence. *Story* ends sourly. The ex-communist sympathizer, Ambler, has shown two capitalist giants enacting Marx's argument that market economies will fight each other for both cheap labor and material resources in those nonindustrial outposts known today as the third world. Sensitive to injustice, he also shows the lives lost in this fighting to be mostly native.

Simpson misses his chance to halt the flow of native blood. The wife of a SMMAC colleague tricks him, his unit's radio operator, into warning UMAD when his cohorts are ready to strike. Wisely, he first refuses to betray SMMAC. The discretion with which he fends off Barbara Willens makes his words to her worth quoting: "You've made your point, Mrs. Willens. I think it might be better if you don't tell me this secret of yours.... I think I'll be safer that way." But, as happens routinely with him, no sooner does he act with common sense than he lets himself be dazzled by money, which he always needs. And he's promised a great deal of money if he radioes SMMAC's attack orders to her husband's UMAD friends. Morality and honor notwithstanding, this perpetual bottomdog should have known that he'd never get paid. But he can't resist an appeal or a threat coming from anyone vaguely representing power or authority, in Barbara Willens's case that of the family.

He does send the warning signal, but at a time that suits *him* better than it does UMAD. Nervous about getting caught, he tells his inquisitive UMAD interlocutor to "go and bugger himself" before switching off. When he meets this man some hours later, he's immediately named as the sender of the radio

message. Before being branded a traitor to his SMMAC mates, though, he flees. Part Five of this six-part novel ends well, as he hears Willens, whose orders he failed to carry out as instructed, telling him, "Get your things, Arthur.... It's time to go." Has Willens come to help him or to punish him? As he and many of Ambler's other heroes have done in the past, he has put himself in the hands of a stranger whose motives he can't know. His plight is that of the powerless. Luckily, he makes his way to safety with Willens's help. And to temporary financial ease, too; as has been seen, he's supporting himself nicely at book's end as a seller of stolen passports.

He won't thrive for long. The passion to self-destruct he mentioned in *Day* will do him in, just as his radio message in the Mahindi jungle, one that could have cost him his life, meant nothing; he didn't have to send it. He exudes futility and waste. While the book's title refers to the blue film he recruited actors for in Part One, it also applies directly to him. A disgusted Vice-Consul tells him, in the first chapter, just before cancelling his British citizenship, "Your life is nothing but a long, dirty story." The Vice-Consul is right; sooner or later, Simpson will disgrace himself. But the account of his shame, however predictable, can hold our interest. The writing in *Story* is clean and unaffected. It also includes lively, convincing details. Though inconspicuous, Ambler remains in charge while discussing military strategy or recounting the history, politics, and natural resources of Mahindi. He also knows the value of withholding specific details. Relying on our imaginations to supply the missing data, he ends the second chapter of Part Five, advisedly called A Day of Battle, with a badly shaken Simpson driving through a battle zone past a headless man:

> I did what I was told. From the height of the driver's seat of the bus I could see more of what had been done by the mortar shells. I just tried not to look at it. Mortar shells don't make big craters in the earth but they do horrible things to human beings.

But Ambler's readers wanted more from him than well-turned rhetoric. Many were disappointed. Max Reinhardt, managing director of Bodley Head, the book's British publisher, said in a letter of 28 March 1969 that *Story* sold poorly.[2] Stanley Kauffmann's attack in *New Republic* explains in part this commercial failure: "*Dirty Story* is the worst Ambler I have read," said Kauffmann, adding, "Simpson's new story is more draggy than dirty.... The plot is neither complicated nor excited and is hastily tied up" (38). Ambler did hurry Simpson out of Mahindi; the UMAD radio operator Simpson insulted isn't even named, and he only appears before us for a sentence or two without being described. He points a clear, if embarrassing, lesson: Minor figures like him who move or resolve plots betray authorial jitters. Other problems in *Story* stem from the clichés that weren't edited out of the text. The same rhetoric that delights us with its drypoint sharpness will soften and sag. Successive paragraphs in Part Five include the phrases, "bitten off more than we could

chew" and "see what the score was," and the last chapter finds Simpson voicing SMMAC's wish to come out of the rare earth expedition "smelling of roses."

The book's main problem, though, is Simpson. After portraying in Piet Maas of *Anger* a self-starter who holds his own against the father, Ambler displayed poor judgment by reverting to the squalid loser-narrator of *Day*. Perhaps he couldn't apply Maas's half-victory to his own life. Or perhaps he wanted more from Simpson. When Simpson failed to rouse his rebellious spirit, Ambler lost interest in him. A good novel presents people important to us in themselves. One told in the first person, particularly, should stir curiosity about the person behind the voice telling the story. But Simpson's vulgarity, greed, and mousy opportunism leave us annoyed and bored. His moral failings probably bored and annoyed Ambler, too. As the plot moves forward, Simpson grows more predictable, despite his grousing. The second half of the book gives few insights into him. He has lost all capacity to surprise us. The Mahindi episodes sweep his personality into the action, leaving him a mere recorder.

His grubbiness probably depressed Ambler. The belief that, if given another try, he could have put more iron into Simpson than he did in *Day* must have prompted him to resurrect the fat little crook. A close look at his writing career might have discouraged the resurrection. *Judgment on Deltchev* (1951), that updating and partial reworking of his first book, *The Dark Frontier* (1936), not only blundered artistically but also blighted his return to novel-writing after eleven years of silence. Building a second novel around Simpson frustrated him just as much. Ambler showed his frustration with Simpson by changing publishers after both *Day* and *Story*, just as he had done after the publication of *Judgment*. In fact, the depth of the letdown caused by *Day* might have led him to change *both* his British and American publishers.

The regret caused by *Story* must have cut just as deeply. Yet in 1963 or 1964 he implied that he was blaming Heinemann and Knopf for the artistic shortcomings of *Day* by breaking with both of them. Ironically, such rashness smacks of that poorest of behavioral models, Simpson. Though Ambler acted with more moderation after the reviews and sales figures came in for *Story*, his conduct put forth just as clear a meaning. He did stay with his American publisher, Atheneum, whom he had joined in 1964 after using Knopf to print his first eleven novels. His moving from Bodley Head to Weidenfeld and Nicholson after a partnership that survived only two novels sufficed to confirm his resolve to put Simpson behind him and make a new fictional start. Posterity has proved his decision a wise one.

*IV*

*The Intercom Conspiracy* recalls *Anger*. Both books follow a weak Simpson effort; both center on a journalist and unfold mostly in Switzerland; though told in the first person, both have an obliqueness and a detachment far removed from the sweaty intimacy of their immediate predecessors. But

*Conspiracy* is unique. Published in New York by Atheneum in 1969 and by Weidenfeld and Nicholson of London in 1970, it remains the only Ambler brought out in the United States before appearing in Britain. More significantly, it surpasses *Anger* artistically, together with all of Ambler's earlier postwar books. Part of this success comes from Ambler's practice of focusing on men more recognizable as fathers than as sons. Apart from a love interest involving a couple in their twenties that blooms to the side of the main action, the book takes its life from men in their fifties and sixties. But Ambler loses nothing in the process, both his craftsmanship and sense of purpose maintaining suspense. Interest builds quickly. Unlike that of *The Schirmer Inheritance*, the foreword of *Conspiracy* launches the action rather than supplying historical background. Charles Latimer, last seen in *Mask* (1939), has been declared missing. Now living in Majorca, he came to Switzerland to research a book. But this retiring, methodical elder hasn't been heard of for two weeks; neither has he paid his hotel bill or private secretary.

A police investigation deepens the enigma. Latimer never stayed in the Brussels hotel where he had reserved a room; in fact, he never even flew to Brussels from Geneva on the Sabena Airlines flight on which he had booked a seat. The ending of the foreword brings another surprise rivaling in impact the one released by Ambler's restoration of Latimer. The name at the foot of the foreword belongs to Eric Ambler. Ambler isn't the author, we're to infer, but an editor who has put the various materials comprising the book into consecutive, readable form. By calling himself the editor of what follows his foreword, Ambler gives *Conspiracy* an authenticity and immediacy which he sustains as the book unfolds. *Conspiracy* consists of taped interviews, medical and police reports, narrative reconstructions, dictation tapes, and the odd telegram. Written mostly in the relaxed cadences of speech, it moves in tone from the colloquial to the digressive or the emotional, creating an impromptu, polyphonic effect that makes the telling of the story as vital as the story itself.

That story concerns two veteran spies serving small NATO countries. The Scandinavian Brand and his partner Jost, who is probably Dutch or Belgian, both want to retire comfortably. Formerly combat officers, the two intelligence men see that age has blocked their upward mobility in the spy community. They must grab their first chance to get money. Together, they have decided that the best way to riches lies in confounding the USSR and the United States, those clumsy, overextended rulers of the postwar world. Opportunity comes to them with the death at age 62 of Brigadier General Luther B. Novak (ret.), a right-wing extremist and publisher of the weekly *Intercom Newsletter*. After being retired from the U.S. Army for preaching ultraconservatism to his troops, Novak founded *Intercom* to fight world communism. Nothing as inconvenient as finding hard evidence to back his judgments hobbled his sense of mission. If he imagined that the Soviets had invented a new nuclear weapon system or a device to tamper with the world's climate, he'd say so in *Intercom* without the

help of supporting facts. He'd also send copies of the weekly to every member of Congress and the Senate and to every British and Canadian M. P., whether they were subscribers or not.

The actual writing of *Intercom* was done in Geneva by Theodore Carter, a divorced Canadian journalist of 55 who has spent most of his working career in French-speaking Europe. An unwise drinker who lives with his 23-year-old daughter, Valerie, Carter wonders how he'll support his home now that Novak has died. He can't see anyone buying the libelous, paranoid *Intercom*. To his amazement, a buyer does surface. One Arnold Bloch, an industrial public-relations consultant from Munich, wants the newsletter to promote his friends' business interests. But who is he? Carter unearths nothing about him in the standard reference works; nor did Bloch ever subscribe to *Intercom*. He remains a mystery. At no time during his ownership of *Intercom* does Carter meet him or even speak to him on the telephone. Bloch will only communicate with him by telegram. His first, coming days after his $10,000 offer is accepted by the Novak estate, says that *Intercom* will hold to the same editorial policy and aims that it had under the General. The telegram also alerts Carter that from time to time he'll be receiving special bulletins preceded by the code word Sesame; *Intercom* is to run these immediately without any editorial changes.

Although Carter never knows it, the Sesame bulletins are Bloch's real purpose in buying *Intercom*. They consist of highly classified military secrets, sometimes interpreting them, pointing out their import, and naming the people behind them. The first one Carter gets rehearses problems in speed and stability that will delay the delivery date of a NATO fighter-reconnaissance plane. Then comes another that deals with defective Soviet rocket fuels. What the two Sesame bulletins share both with each other and their successors is that they air military secrets belonging to both NATO and the Warsaw Pact countries. Intelligence officers on both sides of the Iron Curtain are in dismay. Posing as Arnold Bloch, Cols. Brand and Jost have been using security leaks to wreck public confidence in government's ability to protect its people. Their nonpartisan scheme is working brilliantly. Countries can either pour more money and personnel into their already overstuffed security networks or buy the silence of *Intercom*.

Silence carries a big price. When Bloch is offered $50,000 for *Intercom*, five times what he paid for it, he shocks the Basel lawyer representing him by asking for half a million. Dr. Bruchner is shocked again when, after sheepishly relaying this ridiculous-sounding counter-offer, he hears *Intercom*'s prospective buyers accept it. Creating the irony that brings such surprises is timing. Each development in *Conspiracy* creates a new complexity or clash of values between the people while also tightening the suspense another notch. *Conspiracy* challenges Ambler in a new way by unfolding as a series of cables, tapes, and reports rather than as a straightforward narration. Reviewing it in the

*New York Times Book Review*, Allen J. Hubin complained about this strategy, claiming that it "succeeds in removing nearly every element of suspense from the narration" (1969, 14). Hubin's grousing makes sense. Heretofore no technical pioneer, Ambler had never written a book as cunning as *Conspiracy*. But readers like Hubin who expected something more conventional and accessible than what they found should have kept a more open mind. Some have. Cawelti and Rosenberg call the book "possibly, Ambler's most distinctive plot" (112); Davis praises it as "Ambler's wittiest and most sophisticated novel" (11); Lewis claims that its technique is "arguably the most innovative in his [Ambler's] fiction" (153).

What these critics admire is the book's dovetailing of content and form. Let's examine this unity. By forsaking linear narration in favor of developing by means of various electronic messages, this media-based novel enacts the story it tells. Like *Passage* before it, *Conspiracy* describes a complex military operation, military because of the casualties involved. But rather than showing the research, planning, and strategy underlying the operation, the book only gives its effects. *Conspiracy* exudes a strong sense of subtext, the policies of both NATO and eastern bloc security services reaching us as a series of hints, surmises, and ripostes. But the novel's technique does more than invite levels of political and military consequence. It also prefigures an era, portrayed in *Roses*, in which those in power spend more on information or intelligence than on material goods. Here again, Ambler's artistry scores high. A work of fiction that deals with the media *should* depict those advances in communication technology that have changed media's character and impact.

Ambler has more to say on the subject. Not content merely to describe some of the effects of the post-1960 media revolution, he also criticizes it. Advances in electronic communication have increased the value of privacy now that the new technology has made privacy so hard to protect. The sole action of the group that spends half a million dollars to buy *Intercom* is to stop publication immediately. Silence and even emptiness impel this action-filled novel in which an office is raided, a car crashes, and a man is bushwhacked. The identity of Arnold Bloch escapes everybody in the book besides Carter; the solidness of Bloch's name turning out to be illusory. Nobody learns the identity of the person or persons who buy *Intercom* from Bloch, either.

Anonymity can take the extreme form of unreality, and, when it does, it permeates the novel in significant ways. A kidney problem has brought Colonel Brand, one half of the Bloch imposture, near death. General Novak, founder and original owner of *Intercom*, is already dead. And during the course of the action, Latimer, author of a book-in-the-making about *Intercom*, dies. "Latimer progresses from observer to participant" (104), notes Ambrosetti. Little progress is made. Latimer learns the drastic steps people will take to insure silence by getting himself murdered and then buried under tons of Swiss highway concrete.

His murder occurs about a third of the way into the action. Ambler's waiting till the end to tell us about it carries a strong charge. Ambler knew that we'd welcome the restoration of Latimer to the canon. He had also been kindling our hopes to see Latimer again by reproducing, along with his prose, several translations Latimer had done of written reports and taped interviews. The knowledge that Ambler has been encouraging us for the purpose of disappointing us yields a bitter aftertaste. This bitterness touches his portrayal of the electronic revolution, as well. Like the Greene of *The Quiet American* (1955), Ambler believes that our humanity lags behind our technology. Life, meanwhile, stays fundamentally the same, finding the same level it occupied before the new machines began operating. No generator had to empower them. Actions have begotten reactions of equal force, creating a standoff. No sooner will a breakthrough in the area of top-secret military hardware occur than word of it will leak to the security agencies of other countries. The self-cancelling rhythm created by this clash of surveillance and military hardware systems chills progress. It also leads to larger, more heavily financed spy networks, creating an unstable climate in which spies spend increasingly more time watching each other. This expensive new order will be counterproductive. Rather than stopping treason, it will promote it by fostering a mood of suspicion, swelling the bureaucracy, and relying more and more upon machinery at the expense of people. Traitors will thrive.

Wisely, Ambler serves this warning through character, mostly that of *Intercom*'s edgy, heavy-drinking managing editor, Theodore Carter. At the start, Carter and Latimer are linked reluctantly, because, like Latimer and Peters in *Mask*, each has knowledge the other wants. Latimer's cool, dry self-assurance also sharpens the contours of Carter's defensiveness. Sarcastic and bullying when he feels in control, Carter tends to overrate himself. He calls himself at the outset "the one and only horse's mouth" and "the worst hit casualty of the *Intercom* affair." Naturally, he's wrong on both counts, as he is later when he predicts that the Sesame bulletins he's told to print will be "longwinded and dull." Brand and Jost always stay several steps ahead of Carter, but, because they keep their motives private, they always catch their managing editor off stride. They mistreat Carter throughout. Viewing him instrumentally, they unfeelingly expose him to danger. Much of the excitement generated by the action expresses itself through Carter, Ambler using his truculent innocence and self-importance to heighten the danger building around him.

While the belief that he's tougher and more seasoned than he is invites danger, it neither alienates him nor reduces him to a figure of fun. Assuring a balanced human perspective of him is the way he comes to us. Like an Eliot Reed hero, Carter sees that he's being followed. His discovery takes place in Chapter 3, just days after the publication of a Sesame bulletin. While this menace is brewing, Latimer remains missing. Compelling enough on its own,

the menace could relate to Latimer's disappearance. The connection that forms in our minds tightens at the end of the next chapter, which also completes the novel's first part. Part One of *Conspiracy* ends with two CIA men visiting Carter uninvited and unannounced to ask him about the Sesame bulletins. (In another invocation of Ambler's literary past, one of the CIA agents is using his job on the *World Reporter* magazine, from *Anger*, as his cover.) Chapter 6 finds Carter running afoul of the KGB, who bully him more roughly than their CIA counterparts. Three KGB agents first sabotage his car and then take him to a flat, where they question and manhandle him before threatening worse violence if any more Soviet military secrets run in *Intercom*.

This maltreatment opens our hearts to Carter. Ambler will win our grudging sympathy for him in several ways. First, Carter *is* innocent. A mere hireling, he has no say about the contents of the Sesame bulletins. In fact, his earlier recommendation that they be discontinued meets total rejection. The other side of his stubbornness is a quirky integrity. Just as he believes that the halting of the Sesame bulletins will help the circulation of *Intercom*, so does he shrug off his beating by the KGB at the end of Chapter 6. The next chapter shows him going to *Intercom*'s office despite knowing that he's being watched by hostile eyes. His errand says more for his courage than for his common sense. After discovering the office ransacked, he takes a blast of Mace or nerve gas full in the face. Then he crashes his car and loses consciousness while trying to flee his KGB attackers. All of this comes in Chapter 7, which immediately follows his abduction and beating in the previous chapter. He certainly suffers enough in a short span to touch the most callous reader's heart. What's more, Ambler breaks down any residual dislike we may feel toward him by beginning Chapter 7 with a transcribed tape interview with his daughter. Valerie loves her father. Having already portrayed her as sensitive and intelligent, Ambler wins credibility for her sympathetic view of Carter; she has the human credentials to convince us that her father is worth caring about.

Our hearts remain open to him in the book's last chapter, where he goes to Majorca to talk to Colonel Jost. The visit to the master spy derives from *Mask*, where Latimer last appeared. Here, Latimer isn't the visitor. He's a topic of discussion. Because of the shock caused by the news of his death at the hands of Jost's engineer-partner, Brand, the book's verbal climax strikes home. It does so quietly and economically. Carter, the hot-tempered cynic and drunk, has learned to listen. And we listen with him. At one point during his talk with Jost, he resists making a witty comeback; "I was there to listen, not score debating points," he sensibly reasons. Jost judges well to observe of him, "You are a different man from the one I met a year ago. Then you were tired and contemptuous of the work you did. You disliked yourself." He has learned self-objectivity. This lesson springs largely from the run of good luck that has helped him survive. Survival itself has taken on a rich new gleam. He can stop taking himself seriously. Instead, he can be on a level with life. When he hears

of his daughter's coming marriage, he wishes her well. His casual self-acceptance may have helped him overcome the father, too. When the older Jost grouses over not knowing the identity of the new buyers of *Intercom*, Carter answers him, "You have the money. What does it matter where it came from?" He also takes in stride the threat that he may end up dead like Latimer if he repeats Latimer's mistake of violating Jost's privacy. No longer an avenging crusader who must prove his worth to himself, he can shrug off the threat. An unfazed Carter is shown in the book's last sentence enjoying the stroll from Jost's villa back to the inn where he's staying.

The emergence of his new sense of balance closes this illuminating, provocative book. Both literally and figuratively, Carter is moving forward in darkness. This same unforced self-assurance describes Ambler. He can enjoy the unlikely Carter's moral conversion without feeling obliged to explain it step-by-step. Fascinated with mechanical process, he can also show how things work, like a pin-tumbler lock with a mortice tongue, without boasting or forcing his superior knowledge on us. The free, open stride of *The Intercom Conspiracy* displays his sensitive, well-stocked mind with a nimbleness challenging that of the best fictional intrigue coming out of postwar Britain.

# Chapter Eight
## Echoes of Old Lies

Ambler's last four novels, published between 1972 and 1981, combine new features with familiar ones. The father as both a category and an image still frets him. Union with the father remains costly, since it entails surrender to an authority both demanding and cruel. On the other hand, denying the father calls for a toughness the archetypal figure has trouble calling up. Ambler will vary his painful ambivalence. The title figure of *Dr. Frigo* (1974) has let go of his dead father despite feeling certain that he can identify the father's killer. The most ruthless, conniving character in *Send No More Roses* (1977) is a bisexual who has modeled himself on General Sir Robert Baden-Powell, spy, founder of the Boy Scouts, and hero of the Battle of Mafeking in the Boer War. Like his protegé, B-P lived in both northern and southern hemispheres. Christianity influenced him. And *he* was able to influence so many young men like Mat Williamson because, by and large, he never grew up. The title of the latest biography of him, Tim Jeal's *The Boy-Man* (New York: Morrow, 1990), captures his immaturity. He was closer to his mother than to any other woman. He liked uniforms, games, and plays in which men took women's roles. And though he probably wasn't gay, this devotee of skirt dancing directed more energy to men than to women.

The psychological cost tallied by modeling himself on B-P might have exhausted Williamson. Perhaps Julian Symons had exhaustion in mind when he said of Ambler's postwar books, "Something has been lost...a certain world-weariness has replaced enthusiasm and hope" (1972, 239). Though correct in noting the world-weariness found in the mature Ambler, Symons overrated the enthusiasm and hope put forth by his man's prewar work. The American title of *Mask, A Coffin for Dimitrios*, builds expectations that go unmet. The coffin in question holds another man's body. What is more, Dimitrios put it there to foil any investigation leading to him. To bring us to book for holding false expectations, even ones he set up himself, Ambler makes the man in the coffin Dimitrios's murder victim. Presumably, we shouldn't even trust the author in our mean, tricky world. Ambler continues to shut off hope. Though Dimitrios represents a brutal extreme of capitalism, he doesn't prefigure any redeeming social dialectic. All of Ambler's hope for social and economic reform died with the Berlin-Moscow Nonaggression Pact of 1939, the same year *Mask* came out; his mentioning the notorious pact as recently as *Here Lies* (153) shows how much it let him down. The tone of Ambler's late novels, though sometimes

**176**

cooler and dryer than that of their earlier counterparts, isn't any more cynical. The mature Ambler distances his material through irony, self-awareness, and humor. When the main character of *The Levanter* (1972) says that Palestinian zealots are trying to kill him, he adds offhandedly, "This sort of thing is bad for business." *The Care of Time* (1981) slows emotional drive by introducing its key figure near the end and then taking him from view a chapter later.

Ambler's later fiction also introduces subtle discriminations and gradations found less often in the earlier work. Their effectiveness lies not in attaining a fine point but in suggesting unexpected links. These will center on character more than on plot. Ambler's last books are less concerned with crescendos than with the interplay of feelings within complex relationships colored by self-interest. This rhythmicality has fooled readers of his recent fiction. Peter S. Prescott's review of *Dr. Frigo* in *Newsweek* cites the alleged immobility seeping into Ambler's work:

When his most recent novel, *The Levanter*, appeared, I grumbled that nothing *happened* until page 80, a poor showing for a suspense story. It seems I missed Ambler's drift: in his new novel [*Dr. Frigo*] nothing happens until page 240.

Had Prescott wanted his action hot, he might have added that nobody in *Levanter* gets shot until 20 pages from the end (page 287 in the 307-page [New York:] Atheneum edition of the book). Yet this detail, like those he cited in both *Levanter* and *Frigo*, ignores the truth that suspense thrives on stasis. It builds while nothing happens except the running out of time, space, and options. Were a catastrophe to happen, or the threat of one removed, suspense would vanish.

Such explosiveness would also violate both the economy and mood of Ambler's autumnal last novels. Suspense takes longer to build in these works because they take root in a milieu where first-world economics converge upon third-world politics. At stake in the tiny island republic undergoing development in *Roses* is the acquisition of tax shelter laws, a dollar-linked currency, and UN recognition. The tracery of motives and loyalties in such a volatile climate creates a rich design. It also needs a large allotment of pages to take shape. What the books of Ambler's last phase lose in narrative drive they make up for in *leitmotif*, foreshadowing, and interconnectedness. Evenness of texture takes precedence over climax but without denying it, as Ambler's mastery of the harmonics of scenic narrative beget rhythms the undertones and implications of which peak in their own quietly efficient ways.

*I*

*The Levanter* (1972) conveys Ambler's self doubts, though to a lesser degree than the backsliding *Light of Day*. The shifting point of view technique returns from *Conspiracy* to help him hit in obliquely at personal stresses that looked freakish and banal when seen from the unrelieved standpoint of

Simpson. Michael Howell, the Levanter, resembles Simpson enough to sharpen the ways in which he differs from him. Like Simpson, he speaks several languages fluently. He also follows the badgered Simpson (and differs from the polyglot Josef Vadassy of *Epitaph*) in having both a smudged racial and national identity with his Lebanese, Armenian, Cypriot, and English bloodlines. And he, too, not only studied in England but has also remained aware of the punishing schoolmaster image. Yet the image rarely threatens him (it appears but twice in the text of *Levanter*, in which he's sorely tried). His moral character has helped him stave off threats. Though he steps out on his wife, he has higher business standards than Simpson, miscues less often, and reacts more prudently to stress. His cleverness and adaptability have helped him succeed. No crook or small timer, this dignified, responsible entrepreneur runs his 75-year-old family business, the Agence Commerciale et Maritime Howell. Agence Howell of Damascus, Syria, once included in its holdings a tannery, a flour mill, and facilities used for preparing both licorice and tobacco. At the time of the novel, c. 1971, it makes engineering products, all the more effectively because of its chief's engineering degree from England.

The first sentence of *Levanter* identifies that chief as a grudging narrator, unlike Simpson and Carter of *Conspiracy*, men 15 years his senior who both believe that telling their stories will foster the justice heretofore denied them. Throughout, Howell insists on his objectivity and his reluctance to speak out. His disavowals of self-interest persuade us. He avoids arias of self-justification; he presents unflattering evidence without slighting or twisting it; he accepts blame for his own negligence and inefficiency. Good natured and candid, he has the self-confidence to admit his mistakes. A passage in Chapter 2 shows him referring to "my carelessness and inexperience," and the second paragraph of Chapter 6 opens with his confessing, "I was a fool. I admit it." But he doesn't enjoy self-disparagement. If a tendency to underrate himself can make him a prey to authority, it both helps him learn from his missteps and teaches him resiliency.

Yet Ambler will remind us of his faults. Just as he avoided the action principle in his plot structure, so does he portray Howell in the round rather than shaping him to fictional conventions. In fact, his Levanter may well be the most multifaceted figure in the canon to date. His reluctance to soil his hands and scuff his polished shoes at the gate of his battery plant in Chapter 2 not only alienates him from us; it also blunts sympathies we'd have extended to him in the troubles he'll soon face. Though rare in adventure fiction, this emotional distancing helps us see him more fully and thus respond to him as to a person rather than a fiction. Some, unfortunately, have failed to divide him from the narrative conventions whence he stems. This failure has caused confusion and frustration. The German critic Hans C. Blumenberg calls him harmless and politically naive (72), and Lewis describes him as "an ordinary person... inadvertently caught up in a plot rather than being one of its perpetrators" (163).

Caught up he is, but not shackled; Lewis Prescott, the ex-war correspondent and senior American journalist who narrates Chapters 1, 3, and 8, refers to his ability to seize opportunities, to take calculated risks, and to protect himself when he says of Howell in Chapter 3, "At no time did he behave stupidly, and in the end he showed courage." What he does at the end vindicates the courage attributed to him. He is thriving in his native Cyprus with his secretary-lover. Another sign of the wholeness and continuity his courage has earned him is the promise evoked by his business prospects. Though stopped from trading any more in the Levant, his firm has already penetrated Italy, with its tax incentives and low-interest development loans, and it will soon begin testing other CEO markets. Perhaps carrying over from the healthy moral relativism enacted at the end of *Conspiracy*, the belief that mongrels know how to survive, voiced and then dramatized by the hybrid Howell, discloses a cheer missing from the Simpson books.

No product of authorial fiat, this welcome peal of brightness stems from a growing appreciation in Ambler for the richness and complexity of the human self. Nourishing the realism of *Levanter* is a creativity in tune with the forces shaping people's values and personalities. The characters in the book are polygons of influences and drives. Melanie Hammad, the multilingual press agent for a band of Palestinian militants, worked as a high-fashion model while studying at the Sorbonne. This range of activities nearly qualifies her as a feminist heroine. Nor is Melanie the only woman who moves the plot of *Levanter*. Michael Howell's mother, the first mother seen interacting with her children in the canon, displays enough color and attack to justify Howell's secretary-lover calling him "mother-fixated." Teresa Malandra voices this belief in Chapter 5, which she also narrates. This chapter surpasses in both length and quality of insight the one told from Valerie Carter's point of view in *Conspiracy*. A writer whose male characters have always outshone his women, Ambler depicts Teresa with patience and skill. Her point of view in Chapter 5, sustained for 35 pages, supplies the distance needed for a balanced picture of her Levantine lover. Based on a longstanding intimacy, the view of Howell set forth in her narration exudes more warmth than that of the journalist, Prescott. At the same time, it provides a detachment missing from the four chapters Howell narrates.

Ambler wins favor for her narration by having her call Howell a committee rather than a person. This sharp insight discloses the technique of character portrayal practiced by Ambler for the first time in *Levanter*. At times, Howell shows the well-bred nonchalance of the English public school man; then this cool image will melt into that of the near eastern merchant or industrialist. Here is Teresa's account of some of the personae he can supposedly call forth at will to gain himself an edge in a transaction:

Michael...is not one person but a committee of several. There is, for instance, the Greek

money-changer with thin fingers moving unceasingly as he makes lightning calculations on an abacus; there is the brooding, sad-eyed Armenian bazaar trader who pretends to be slow-witted, but is, in fact, devious beyond belief...there is the affable, silk-suited young man of affairs with smile lines at the corners of wide, limpid, con-man eyes....

He needs all the skills he can muster to survive his ordeals. Now that Syria's banks and industries have nationalized, he must win the release of some of the Agence's funds before reinvesting them in a new project. The bureaucrat he petitions is one Dr. Hawa, Minister of Industrial Development. Vain and ruthlessly self-promoting, Hawa will use anyone to advance himself. But he's not the only male authority figure who squeezes Howell. There's also his political opposite, Salah Ghaled, leader of a Palestinian breakaway group pledged to destroy Israel. Ghaled overtakes Howell like a heart attack. When Howell chances upon some of Ghaled's front fighters learning how to make bombs, he's lost. He knows too much to be set free. He will die immediately unless he agrees, first, to turn over part of his factory to Ghaled's Palestinian Action Force and, then, to join the PAF himself. The loyalty oath he signs deepens his gloom. It entails total obedience to his senior officers at pain of death. The death penalty can be invoked at will; he has also confessed in writing to having smuggled contraband into Syria for her Zionist enemies. Suddenly, his security has disappeared, and he sees no way of restoring it:

I was usually able to solve business problems, outwit competitors, get around difficulties, bargain shrewdly.... [But] business skills are not always transferable.... When the commodity is violence and the man you are dealing with is an animal, they don't work.

Contemporary readers would have sensed his grief. *Levanter* belongs to the violent times which culminated in the September 1972 massacre of eleven Israeli athletes at the Munich Olympics by a Palestinian terrorist group called Black September. The Arab-Israeli struggle which led to this slaughter is mentioned early along with Yasir Arafat and the PLO. The PLO spawned Ghaled, who studied medicine and then served with the Arab guerrillas before starting the PAF. Like that other extremist, General Novak of *Conspiracy*, he has a small but avid following. Neither is he afraid of offending others. The engraved lighter he displays in Chapter 4 symbolizes the vanity fueling his fanaticism. Not only a nuisance to Israel, he has also been branded a gangster by the PLO Central Committee for keeping his troops in Jordan after the declaration of a cease-fire. But he has reasons for fighting freelance. Insisting that the PAF shares a common goal with its friends, he denies that he has bolted the Arab alliance. But he knows that his extremism has cost him both the favor and trust of the UAR, and he needs a big score to redress the loss. His waging a successful act of drastic aggression against Israel would force Cairo to take him

seriously again. Thus he has planned to bomb Tel Aviv from one of the Agence Howell's ships.

Even if he didn't have Dr. Hawa to contend with at the same time, Howell would have found the bullying, arrogant Ghaled an infuriating taskmaster. Likened in Chapter 5 to his near namesake, Sir Galahad, this "violent and dangerous animal" has corrupted all ideals linked with knightly purity and nobility; no Grail searcher he, despite his fervor. He makes wild demands on Howell to aid the PAF, like rerouting his ships, violating chains of command, and making precision tools without the proper machines. Then, ignoring the warnings of a PAF colleague, he risks Howell's safety, and perhaps his life, by activating via remote control a dangerous plastic explosive that Howell is carrying. Howell knew from the start that Ghaled would kill him without flinching. He has also seen that he can't expect any help from either Dr. Hawa or Syria's Internal Security Service, which has become riddled by PAF spies.

Even Israeli Intelligence won't take the initiative when he risks his neck to tell one of its officers of Ghaled's plans to bomb Tel Aviv. Regardless of whether his power stems from his high place in the establishment or the rebel camp, the father figure, stern and unyielding, withholds help from the son. Howell can only save himself. Nor can he lower his guard. While he awaits his chance for freedom, he has to avoid making both Hawa and Ghaled suspicious.

He shows both men exaggerated deference, particularly while displaying his technical expertise. But while his truckling panders to the vanity of his chiefs, it also puts them off balance. Perhaps because of his Englishness, he gives them the impression not only that he's holding something back but also that he's condescending. His good manners and breeding rattle them. Exploit him they do, yet they both know that, lacking his training and knowledge, they need him. And his enigmatic ways have gained him the time he needs to seize his chance. Covertly, he sabotages Ghaled's bombing mission by steering his ship, the *Amalia*, beyond firing range of the shore. Nobody on the ship helps him, either. He knows he must keep his own counsel, even if doing so demands lying to both the terrorists and *Amalia*'s captain.

The moral contortions he undergoes finally smooth out. Howell enacts what Lewis calls "the giant-killing theme" in Ambler (171). Like Latimer of *Mask*, Graham of *Journey*, and, to a lesser degree, the Simpson of *Day*, his impulsiveness brings down a figure of power and evil. Ghaled's shooting of the ship's captain who defies him incites Howell into killing Ghaled, but not before repeating the captain's command forbidding him access to the ship's bridge. The wounding and immobilizing of the father figure, Captain Touzani, has installed Howell in his place. After killing Ghaled, Howell reveals a new decisiveness, radioing Ghaled's PAF cohorts on shore to call off the bombing and then telling the Israeli lieutenant who boards *Amalia* from a nearby patrol boat how best to round up the terrorists.

Howell's shooting of Ghaled is puzzling, even to Howell himself. As the

following passage implies, he never owns up to it:

> "Comrade Salah," "I said, nobody can go up to the bridge."
> And then I fired at the *Serinette*.
> I fired three shots from the revolver.
> All were aimed at the music box, the *Serinette*.
> I then went back to the saloon.
> There, for a moment, I didn't quite know what had happened.

Howell can't accept his killing of Ghaled at the conscious level; besides avoiding any mention of his victim, he claims that he aimed his bullets elsewhere. Yet another implication that surfaces shows his shooting of Ghaled to be deliberate. The terrorist's death coincides with the destruction of his death device, the music box which transmits a radio signal tuned to set off the PAF bombs planted in Tel Aviv. Ghaled is a fanatic with no life apart from killing and smashing. Having perverted the harmony and sweetness associated with music, he rightfully dies while his music box shatters. Howell's gunblasts also impart poetic justice. The flight bag that blew up in his hand in Chapter 5 was activated by Ghaled's remote-control *Serinette*. Recalling that the exploding flight bag might have blinded, or even killed, him, he feels no qualms about exacting revenge. The revenge is wordless. But even if he can't verbalize his killing of Ghaled, he both accepts it and develops because of it. This growth contents him. On the book's last page, he tells Prescott, "It could only have been an accident.... I was aiming at the music box." He needs no reassurances from others.

Prescott's narration, here in Chapter 8, pads the jolt of Howell's heroism. The chapter's opening sentence, "Michael Howell should have had better luck," raises doubts about the hope and promise rising from the killing of Ghaled at the end of Chapter 7. The tone of the book's last chapter stays dubious. Until the very end, the action of *Levanter* plays itself out at a distance from its main characters. Prescott, who interviews Howell in Famagusta, Cyprus, a venue where the action had never before touched down, gets little usable information. What's more, in describing the interview from his frustrated point of view, Ambler focuses on the character we have both spent less time with and care less about. This skewing of the book's lines of dramatic force was planned. Ambler's building to a climax only to devalue it helps bring *Levanter* closer to life than would linear development, which would take him predictably from Point A to Point B. Besides dispensing with one of the most stable conventions of plot structure, he also thwarts any expectations we may have entertained for some kind of climactic event, plot twist, or vision to crown the novel.

The vision has been there, even if it goes unspoken. And it goes unspoken for a good reason. Why should Howell rehearse the coping mechanisms he used to stall, outmaneuver, and finally defeat the terrorist Ghaled after silence has

served him so well? Ambler hasn't downgraded his revelation. But he presents it as a function of repetition and cross-referencing rather than of intensification. By skewing it away from conventional narrative technique, he provokes questions about heroism in our confusing postwar age. Is heroism so difficult to attain and so easily misunderstood that, rather than accepting its just acclaim, it must hide or disguise itself in order to do its good work? It must certainly practice patience. The complexities and muddles of cold war life rule out the straightforward exercise of will and rigorous follow-through characteristic of the more self-confident Victorians. Goals, even high-minded ones, are to be approached crabwise rather than head on.

Illumination touched Howell in Chapter 4, pointing a consummation that didn't occur till Chapter 7. After calling Ghaled an animal who "for over twenty years...had dealt in death and violence," he says that "the only way for me to 'deal' with Ghaled would be to kill him." His recognition begets no resolve. He says immediately that he could never kill Ghaled even if given the opportunity. But his sabotaging of Ghaled's plans for *Amalia* in the next chapter builds his courage. Much of this growth occurs offstage. His saying at the end of the chapter, after Ghaled's exploding flight bag scorches him, "I think it's time to stick our neck out," shows both a resolve and an anger that energize him during *Amalia*'s voyage.

Ambler's recounting of his ordeals with the PAF is one of the book's outstanding merits. Howell discovers in Chapter 2 that an employee named Issa has been using an Agence laboratory to teach midnight classes in the manufacture of bombs. Too much the artist to squander the chance to profit fully from Howell's discovery, Ambler then shows the Levanter shocked by a hard jab to the kidneys given by a carbine butt. The humiliation following this burst of pain carries an added charge because it takes place on his own property. When he confronts Issa, he's ignored. He's snubbed again when he tries to fire a night watchman present at Issa's lecture. Here his confusion chills to terror because the night watchman is the notorious Ghaled. Quickly, Howell has lost control over both his business and his life. Ghaled has been using part of an Agence plant as an operations office, and, as has been seen, forces Howell to join the PAF on dire terms. But Ambler delays recounting this dreadful act. Having confirmed Ghaled's cunning and violence at the end of Chapter 2, he cuts away to Lewis Prescott in Chapter 3. The first two chapters had both ended with their respective narrators meeting Ghaled in the presence of a woman. And just as Prescott mentions Howell in the first sentence of Chapter 3, so does the Howell-told fourth chapter begin with a reference to Prescott. This parallel foreshadows a crisscrossing pattern that emerges in Chapter 6, where Ghaled shows Howell the same photos of alleged Israeli atrocities he had shown Prescott in Chapter 3. The meeting of Prescott and Howell in the last chapter creates a sharpness of focus the novel had been building toward. But in line with Ambler's skepticism, the meeting resolves little.

Perhaps clarity and closure had to be withheld. *Levanter* fends off conclusive judgments. The climax aboard *Amalia* introduces a character named Hadaya and a place called Hadera. Lines blur elsewhere, too. Howell's name not only sounds like that of his browbeating Minister of Industrial Development, Dr. Hawa. At 40 or so, Hawa, Howell, and Ghaled are all about the same age. Furthermore, Howell plays backgammon with both of his tormentors at his home. And finally, if the destruction of Ghaled coincides with that of his *Serinette*, impulses from this violent conflation touch Howell, too. He tells Prescott at the end that the name of Howell as a business symbol is one with his person. Would the collapse of Agence Howell, we wonder, cause his death? Ghaled had already proved that the lack of a freestanding existence can be fatal.

The question of Howell's welfare invites itself because the parallel teased out between him and Ghaled tallies with the masterful detailing elsewhere in the book. *Levanter* describes, together with problems caused by the Soviet penetration of the Middle East, the effect of public policy upon investment, labor costs, and exchange rates. Perhaps John Fowles had such realities in mind when he told Ambler in a letter of 17 July 1972 that "The 'feel' of Syria [which Fowles had just visited] is very right indeed"[1] in *Levanter*. More concerned with people than with scenery, Ambler shows Syria's one-party regime suppressing stories about mishaps caused by defective materials or workmanship; he depicts the common practice of blaming Palestinian guerrilla raids on Israeli spies; he lets us see divisions within the UAR on subjects like imports and exports. Ever the engineer, he will also use his engineer-eponym to rehearse technical lore, like the recipe for a wet battery in Chapter 2:

The cathode consists of a porous ceramic pot, which we could easily make, packed with manganese dioxide and carbon around a carbon plate. The anode is a zinc rod. The two of them stand in a jar.... The electrolyte is a solution of ammonium chloride, a very cheap material, in ordinary tap water.

No flight from adult feelings, such rehearsals, besides lending the book authority, meet an important need for Ambler. The data comprising them are second nature to him. He relishes them, expands into them, and satisfies a key part of himself by detailing and combining them. But the deep feeling that the setting forth of physical data probes can also disconcert. The following description of the horrors of violent death, from Ghaled's photo album, confuses fascination with repulsion:

The attitudes of violent death do not vary much. When the cause has been sudden, the rag-doll effect is usual, though muscular spasm can sometimes freeze the limbs in strange ways; when death comes less suddenly the knees and arms are often drawn up together in the fetal position; a human being incinerated by napalm becomes a gray-

black clinker effigy of a dwarf boxer with fists up ready to do battle.

The issue this passage invites is not whether Ambler is riveted by human suffering. What the passage shows is that *Levanter*, no dry treatise, howls with pain. The photos of the victims displayed in Chapter 3 come before us again in Chapter 6. Also, Ghaled is shot to death, and Howell undergoes as much physical trauma as did Carter and Simpson, heroes of the two novels immediately preceding *Levanter*. Ambler's ability to keep us alongside human muscle and sinew strengthens the claim that *Levanter*, in the words of Clive James, is "one of Ambler's best" (69).

## II

*Dr. Frigo* (1974) justifies Lewis's calling it "Ambler's bleakest novel since *Judgment on Deltchev*" (185). The book starts in a hospital. Its main character and narrator is a doctor, who, like many of Ambler's other recent heroes, has a dubious national identity aggravating his shaky sense of self. The nurse helping him has an ugly neck wart. And the book's three parts are called The Patient; Symptoms, Signs and Diagnosis; and The Treatment. But the patient referred to in Part One is chronically sick and thus untreatable; he dies in the book's third part from bullet wounds. Had he responded to treatment, he'd have died anyway. The futility overhanging the action thickens. Taking his cue from T. S. Eliot's "Love Song of J. Alfred Prufrock," Ambler uses both the hospital where the book begins and the various medical professionals he introduces along the way as a metaphor for a sick society. Besides the patient who can't benefit from the treatment referred to in the title of the book's first part is his would-be healer. Dr. Frigo is the derisive nickname of 31-year-old Ernesto Castillo, M.D. Meaning, in Spanish, frozen meat, it refers not only to his aloofness but also to a corpse stretched out in a morgue, a ghoulish updating of Eliot's patient etherized on an operating table (line 3). Castillo needs to worry more about freshening his own blood than about healing others.

Like Michael Howell of *The Levanter*, he'll have to worry alone. Most of *Frigo* unfolds in St. Paul-Les Alizés, a backward, politically corrupt island in the French Antilles. Fort Louis, St. Paul's capital, boasts supermarkets, low-income housing projects, satellite dishes, and an airport whose runway can accommodate jumbo jets. But these advances bypass most of the locals, the majority of whom can't afford an air ticket. Ft. Louis remains as "ugly, overcrowded, ramshackle, noisy, and...squalid" as it was two decades ago. Nor is help likely. Funds earmarked to replace the city's archaic plumbing system have been diverted to air condition government buildings. Later, the action will swing to a Spanish-speaking country in Central America that is undergoing a revolution. Like its Balkan counterparts in *Judgment* and *The Maras Affair*, neither the country nor its capital is named. Castillo calls it a coffee republic, and a fellow doctor in practice there refers to it as a mosquito swamp.

Perhaps their terms of disparagement are too mild. This stricken place, with its reeking open drains, teeming barrios, and rubbish-strewn, fire-gutted shopping district, has a grimmer outlook than St. Paul. Castillo's return, after an absence of 12 years, shows him that he can only rely upon himself in his quest for self-being; devastation and horror only beget more of the same. Perhaps Ambler set *Frigo* in the western hemisphere to liken Castillo to American literary figures like Fitzgerald's Gatsby and Ralph Ellison's Invisible Man, loner-outsiders who create identities by throwing off those parts of the past they find burdensome or irrelevant.

The book's opening words put Castillo a great distance from the energetic, self-creating hero of American fiction. In the fourth paragraph, he announces his intention to "put my side of this Villegas business down on paper...as evidence of my good intentions—if not my good sense." His modesty sets him apart from figures outside of American literature as well as within. Unlike the Watson of "The Final Problem" (1893) or the Hastings of Agatha Christie's *Mysterious Affair at Styles* (1920), he's not claiming to share definitive knowledge about a controversial event in order to end controversy. He's only going to say what the event means to *him*. But, in addressing the event, he's also confronting a personal crisis, as he knows. If the diary entry announcing his intent starts modestly, it ends on a note of urgency, with his saying, "I must make up for lost time."

What he means by "this Villegas business" takes root in the possibility that, 12 years ago, Manuel Villegas conspired in the murder of his Democratic Socialist Party colleague and leader, Clemente Castillo, Dr. Frigo's father. Whoever paid for the bullets that ended Clemente Castillo's life was very thorough. The getaway car used by the assassins was mined with explosives, blowing them to pieces before they could be caught and questioned. In distant New York at the time of the carnage, Villegas claims to be innocent. Yet he has roused Castilo's suspicions. Whereas he recalls learning about Clemente's murder from a TV news flash, one of his chief aides insists that word of the murder first reached him in a newspaper report the next day. Castillo would like to forget this inconsistency, reasoning that it proves nothing. But Villegas is spending several weeks in St. Paul en route to his native country, where he's expected to lead a *coup* and then become President. Saddled by health problems, he has asked that the Spanish-speaking son of his old friend and leader be put in charge of restoring his well-being.

The job of doctoring Villegas puts Castillo through psychological and emotional whirligigs. He has been ordered to report to the local police every week. The government's vital interest in Villegas's health has put special demands on Castillo because of Villegas's possible involvement in Clemente's murder. Castillo's powers of restraint will be tested as never before. As a physician-healer, he'll assume control and authority over his patient, even though the patient is exactly a generation his senior and an important political

leader. This power collides with his being an only son expected to avenge himself on his father's killer. Further complications deepen his distress. To endear himself to his subjects, Villegas offers Castillo a post in his cabinet. But the post stands outside the flow of political power. This son of a national martyr could easily rally the public support to become President; a faction of the Party living in Florida has already proposed making him President-in-exile. While Villegas wants to profit from an old party tie without being threatened by it, other pressures beat down on his circle from outside Latin America. A Montreal-based insurance firm has taken out a five-million-dollar policy on his life. The firm is part of the large multinational oil consortium he will give digging rights to once he becomes his country's leader. The firm has also empowered an agent St. to offer Castillo $5000 for his medical reports on Villegas. Rumored to be seriously ill, Villegas could be a high insurance risk and a worthless business partner.

Barraged by forces both external and internal, both longstanding and new, Castillo operates from a more complex motivational base than any other Ambler hero. Enriching the pattern is the possibility that, secretly grateful to his father's killers, he has no quarrel with Villegas. Though he loved Clemente, he despised him as both a lawyer and a politician. He admits that the man was no John Kennedy, Martin Luther King, or Patrice Lumumba. The social conscience that drew him to politics lost out to expediency when his draft of his Party's platform excluded an island tribe of Indians dying out for lack of food, water, and medical care. Perhaps he committed other crimes. Castillo doesn't refute an ex-colleague of his father who claims that Clemente had to die to prevent a civil war. The sordidness of both politics and the law drove Castillo into medicine, a profession he has since come to see as flawed, imprecise, and compromised.

Did Ambler feel the same letdown after becoming an engineer, an advertising executive, and a writer instead of following his father upon the musical stage? *Dr. Frigo* suggests that, like Castillo, he had to confront the spirit of his father before putting it to rest. None of the other characters in the book believe Castillo's disclaimers of interest in his father's death. Castillo's father complex is slacker than that of Ambler (who was *not* an only son). Villegas, who is *both* a surrogate son and father, dies before savoring the fruits of his attainments. He left the Ciudad Universitaria of Mexico City before earning his Professorship on the engineering faculty. That Ambler, and not Reg, was an engineer both fends off a flat one-to-one correspondence and adds an intriguing inversion: as in Wordsworth and Joyce, the child is father of the man, Castillo attending in the birth of his own soul.

The shooting of Villegas at age 51, within minutes of his becoming president, or father, of his country, a legacy of *Judgment* and *Maras*, robs him of both the challenges and spoils of his office. Now *Here Lies* doesn't give Reg Ambler's age at the time of his death. But, judging from internal evidence, he probably died in the 1920s (91), before he could witness his son's emergence as

an important writer of both intrigue novels and screenplays. Born in 1882 (*Here Lies* 20), he could have died at around the same age as Villegas and, for that matter, that other chief of his country's Democratic Socialist Party, Clemente. Villegas's son, who slouches to the presidential funeral as sullenly as did Castillo that of Clemente, isn't merely the same age as Castillo was when Clemente died of bullet wounds a short walk from Villegas's death site. He's also an aspiring engineer, like his father and Ambler himself at age 19. Finally, his father's murder will remain unsolved, like that of Clemente, because, once again, the police have stopped investigating.

The key figure in the 12-year drama of political and family life and the one through whom Ambler conveys most of his own anxieties is Castillo. Castillo often affects the stuffiness or formality that has earned him the sobriquet of Dr. Frigo. He uses the affectation to hide his anomalousness. First seen working on the night shift in his Ft. Louis hospital, he appears from the start to be out of step with life. The impression holds. Besides reversing the normal day-night cycle, he has drifted from the realities that shaped his life. His parents are both dead, and his sisters are living in Mexico or the United States. After leaving his native land to study medicine in Paris, he settled in French-speaking St. Paul. Life in his adoptive homeland has withheld the hominess he craves. He rarely, if ever, speaks Spanish, his cradle tongue, a constant reminder that he's a foreigner. The reminder will persist. His passport allows him to travel everywhere except the country that issued it, namely, the land of his roots.

He mocks his banishment. "I may not be a Frenchman born but France is my adopted country," he says early on. Yet Paris and Ft. Louis have little in common. A cosmopolite in "a parochial little society," he's a misfit in St. Paul. Besides being a trained specialist in a land plagued by joblessness and illiteracy, he's reserved and withdrawn, unlike his hot, impetuous neighbors. But prestige hasn't lulled his outsider's loneliness and vulnerability. "I was an alien in government service and therefore in some way suspect," he says in response to a summons from the local police. His interview with Commissaire Gillon worsens his anxieties. The outsider can't protect himself against the establishment. If he refuses to help, he faces the threats of being denied citizenship, having his license revoked, and being deported. Prospects are just as grim in his native country for this man whose "formative years have been spent in exile." Told that "There must be so many things you don't know about...your native land," he comes to see that time has severed him from his national roots. He can't adapt to the life those roots send forth. During his visit at the end to his fatherland, he never gets his bearings. The visit finds him being inconvenienced, peeved, and rattled between the extremes of prestige and danger as others try to force their will on him.

A problem with adaptation has always hampered him. In St. Paul, he drives a motocyclette, "an insufficiently dignified mode of transport for a doctor," even though he can afford a car. Perhaps he keeps the sputtering old

moto to defy his garage mechanic and his hospital supervisor, both of whom tell him to get rid of it. His stubbornness describes him as contrasuggestible. Castillo lives by opposition because his life lacks internal substance and meaning. The lone positive force in his life is work. Several times in the action, he will show his worth as a doctor. He works long hours, and his diagnoses, based on accurate readings of a patient's complaint, reflect real insight. He also has a reassuring professional manner with both his colleagues and patients at the hospital. Quickly, he puts testy, balky Villegas at ease.

The clinical detachment that wins him Villegas's confidence colors his narration. *Frigo* is both subtle and robust, a fact sometimes hidden, particularly in the book's first half, by a cool, dry tone. Ernesto Castillo is neither hearty nor outgoing. Though amiable at times, he's not easily approachable. Rarely will he protest the validity of the name, Dr. Frigo. Though he may not try to distance himself from people, he does little to raze barriers erected by both his job and his foreignness.

But if he's cold, he's not surly or heartless. He's capable of self-criticism, and he freely admits his mistakes. In Part Two, after citing his "glib misinterpretation of the signs and symptoms" of a patient, he's "appalled by my own incompetence." He has also been having an affaire with another expatriate, the Belgian gallery owner and artist, Elizabeth Duplessis. His ability to sustain the affaire offers further proof of his humanity. His blood hasn't been tamed. Yet it doesn't surge or glitter. Elizabeth can't threaten his routine. Though she lives alone, her Catholic faith keeps her from divorcing the husband she left five years ago. What's more, Castillo seems to spend most of his nights away from her without hearing any protests that she feels neglected. The allusion to Eliot's "Prufrock" made by both the book's opening and the clinical-sounding titles of its three parts refer not merely to western society but to Castillo, as well. Like the eponym of Eliot's 1917 poem, that of *Frigo*, though cultured and well bred, is evasive about his own needs, preoccupied with the past, and, for much of the way, passive in his insecure outsider's tendency to give in to others. Another tie-in suggested by "Prufrock" is Shakespeare's Hamlet, whom Eliot mentions (line 111). Castillo is a tropical Hamlet. He has studied abroad. He has a love interest he won't or can't marry. His father's murder is bound up with politics at the highest national level. He shrinks from avenging the murder. The parallels between him and Hamlet fit his cultural context. Besides having an equivocal nature, he sets little store by *machismo*, or manly pride, as a sign of virility, a quality prized by so many of his associates. These need not be men. In Part Two, Elizabeth shows more interest in Clemente's murder than his son does. Her interest runs so high, in fact, that the son has to quiet her.

His rebuff, though, could stem from guilt. As early as his first diary entry, he wondered, "And why, if the pompous young Dr. Frigo has really ceased to care about the circumstances of his father's death, does he now start scratching at those well-healed wounds?" Like Thomas Fowler, the narrator of Greene's

*Quiet American,* his involvement in the events he recounts cuts deeper than he admits. The self-disgust that always rises from guilt might explain the directness and defiance he manifests with male authority figures in the book's second half. Why *not* lash out? Could recklessness hurt him more than the caution that has shackled his spirits for the past 12 years? This question has built up so much internal pressure in him by Part Two that he asks Villegas outright, "Don Manuel, who did organize the plot against my father?" That same day, he calls for a meeting with Gillon, the commissaire of police who assigned him to Villegas. As further signs of his new boldness, he dictates the terms of the meeting, refuses to divulge the meeting's subject, and then hangs up on the angry, befuddled commissaire.

Later that week he defies Armand Delvert, a French Secret Service Commandant sent from Paris to keep the security net protecting Villegas tightly in place. Castillo again has information he won't convey on the telephone. His resolve impresses Delvert as much as it does us. He not only agrees to see Castilllo in person but also drops what he's doing to join Castillo in five minutes. Castillo's courage keeps building. Three days later, when he crosses Delvert in another matter, the only response he elicits is the feeble, "You seem singularly bellicose." Heretofore more deferential than assertive, he discovers that his daring both wins the respect of others and gives him the self-esteem he needs to feel solid. No more caving in for him: he has attacked male authority and survived. The son can strike the father short of committing murder and come out a winner.

Castillo becomes more daring as the plot builds, challenging the secret service officer Delvert, the policeman Gillon, the political kingpin Villegas, and the hospital supervisor Brissac, i.e., people who could hurt him. His boldness diminishes the aptness of the term, Dr. Frigo. It may even invalidate the term in its old sense. It certainly commands our attention. The more we see of Castillo, the more we wonder if he's disdainful and aloof or observant and clearminded. People who resist the will of others usually get accused of coldness. But heat rather than cold drives him to lash out at those who try to control him, regardless of the force they exert. He wastes no time seizing the initiative with Villegas at the height of the latter's political power. Also, armed with a secure sense of self, he leaves at his first opportunity the unnamed Central American land of his birth, resisting a public groundswell in favor of installing him as President in place of the slain Villegas.

He can be assertive without forfeiting his humanity. When given the chance to end the life of a General who conspired in Clemente's death, he asks straightaway, "Has he [the General] any children?" He gives the order a minute later, "Send him home," even though he could punish the guilty General without lifting a finger. The scene in which he extends mercy to General Escalón takes place amid a swarm of flies, agents of retribution in Euripedes and Sartre. But he has foresworn the revenge evoked by the buzzing, stinging

flies, by the *machismo* ethic, and by the example of Hamlet. This evocation draws strength from materials of three different cultures and eras. Castillo must, therefore, overcome a great deal to forgo vengeance against his father's killer. His control serves him well. While his future seems doubtful, the story he has told implies success. Escalón is an alcoholic wreck, and the sickly Villegas, who knew of the plot against Clemente, is close to death. Why waste time and effort on either man?

And why should Castillo stay in his native land? He knows political power to be nothing more than a butcher's shop. His ability to walk away from both his father and his fatherland makes him a new kind of hero for adventure fiction. His faith in natural justice has calmed his nerves. Having seen the folly of trying to square accounts, he can both extend mercy to Escalón and resist striking out at Villegas. Though he can't know what awaits him in St. Paul, he realizes that his well-being depends upon turning away from a past full of pain and danger. *Dr. Frigo* subverts the aesthetics of crime fiction to grant him his vision. A reluctant sleuth, he shames himself into investigating his father's murder. Little energy goes into his haphazard investigation. He neither examines physical evidence nor reconstructs criminal motives. People tell him things to quiet their own guilt.

His triumph consists, not in punishing culprits, but in walking away from them with a Frigo-like contempt. Having already paid for their crimes, they can be forgotten in favor of an unknowable future. This future, though, is one he had elected ten years before when he moved to St. Paul. He's no exile. Nor has he rejected life, governing his daily routine by love and work, those two staples of human existence according to Freud. By staying in his native country, he would become the target of another *attentat*, regardless of his disavowal of politics. Those covetous of the Presidency couldn't afford to let him change his mind and declare his candidacy. Going back to the seedy, but less dangerous, St. Paul allows him to carry forward a life mode with guidelines and expectations he has put in place himself.

This life includes Elizabeth, a descendent of the Empress Maria Theresa of Austria. Perhaps more haunted by her family heritage than Castillo is by his, she enjoys comparing Villegas's entourage with the Hapsburg court. The humor generated by these comparisons relieves the sobriety of Castillo's deadpan, fact-centered narration. Her anecdotes also remind us, as Franz Ferdinand, Emperor Maximilian of Mexico, and the lovers of Mayerling proved, that the powerful and the exalted often die violently. They can also be silly or mad. Like the Hapsburgs, today's rulers are rarely aristocrats of the spirit or intellect. Villegas is only "an astute, politically experienced technocrat" who has learned the catchphrases of leadership, a talent amply borne out by his inaugural speech:

This was only the beginning.... There was much work to be done, but for a truly united people it would be an era of unprecedented peace and prosperity. Not peace for a few,

not prosperity for a few, but, through firm policies of social justice, peace and prosperity for all. He asked for their trust, hoped to earn their affection.

Who could quarrel with these goals? But who wouldn't want to hear about his policies for implementing them?

Behind his high-sounding words lie shrewdness and cunning. He knows what to omit from his public speeches as well as what to include. A big oil consortium that wants to set up offshore drilling rigs has installed him as President. He knows that he'll have to do some advance political dirty work to keep the consortium happy. Brilliantly, Ambler aligns his greed for petrodollars with the disease wasting him. Villegas confirms Rebecca West's belief, set forth in books like *The Court and the Castle* (1957) and *The New Meaning of Treason* (1964), that the modern political leader, unlike the paragons of yore, is either mediocre or defective. The Hapsburgs have a more baleful influence on postwar politics than Elizabeth's anecdotes suggest.

An inheritor of the legacy of inferiority carrying into our century from the Hapsburgs, Villegas has Amyotrophic Lateral Sclerosis (ALS), or Lou Gehrig's Disease, an incurable disorder of the central nervous system that attacks the muscles and then the brain. So advanced is his ALS that he can't speak for more than ten minutes without his tongue and facial muscles twitching uncontrollably. His having to be rushed into office before dwindling into a drooling, spastic wreck conveys once more Ambler's disdain for political solutions. Both Villegas and Clemente die so close to the time of their assuming their country's leadership that their deaths and their crowning political triumphs must be seen as one act. Success at the highest political level is lethal. The lives of public leaders like these two men hang by so slender a thread that the men can't look after themselves, let alone others.

Villegas's layover in St. Paul reinstates the pattern of natural justice governing the book. The pattern began with Clemente, whose death will have to be faced and put to rest before his son can stop running from the past. The son's way to Clemente is through Villegas, a man defined by death. Villegas knew of the murder plot against Clemente. At the time of the novel, he's about the same age as Clemente, proving that high-level politics, like poverty, has a similarizing, rather than an ennobling, effect. While he prides himself on his Presidency, he's really looking at death, either slowly in the form of ALS, or quickly, from a gunman's bullet. He also spends time in St. Paul, till sent for by his advisers at home to mount his *coup*. Paris has approved his visit to St. Paul, France being a member of the multinational energy consortium that has struck a deal with him. By assuring that he's heavily guarded, she's protecting her national interest. His role in serving this interest is vital. Acting from political expediency, the French Secret Service, or SDECE, browbeats an eminent neurologist into leaving his Paris laboratory in order to examine Villegas an ocean away. Then it makes Castillo take a leave of absence from his hospital

(not to be charged against his annual leave) so this son of a national martyr can win Villegas public favor by returning home with him.

The time-dating of the action that ends with his 12-day visit to his birthplace generates intrigue. The days of the week in the diary that serve as this 1974 book's chapters match those of 1969 and 1975. Like the engineering expertise in *Levanter*, Ambler's mastery of both pathology and life in the ramshackle tropics reduces the likelihood that the book's time setting is random or imaginary. Ambler is simply too careful about authenticating certain details to be careless over others. In favor of setting the action in 1969 are the revolutionary politics dominating the book's beginning and end; in fact, Castillo was in Paris during the May 1968 student risings there. But the book's ambience favors 1975, a date that would make *Frigo* Ambler's only novel set in the future as well as his only Caribbean book. Worries about petroleum vexed the early 1970s. In *The Underground Man* (1971), Ross Macdonald built his best-known novel around an oil spill off the southern California coast. Two years later, when Ambler was writing *Frigo*, an oil shortage raised gasoline prices all over the world. The quest for petrodollars dominates *Frigo*, even though the subject is barely mentioned. The eagerness of big multinationals to join the quest didn't merely transcend national frontiers; it even made nations subsidiaries of businesses.

Less coercive forms of internationalism flicker over the action. Most of them stem from the United States, where third-world countries had been sending gifted students for training since 1950 or so. Thus a hospital director in Castillo's native land took his medical degree at Johns Hopkins, a physical therapist working under him trained at the University of California-San Diego, and Villegas's son hopes to study engineering at M.I.T. Minnesota's Mayo Clinic and Watergate (President Nixon, another casualty of presidential politics, resigned in 1975) are also mentioned, though with less anger than the covert CIA activities that helped set up dictatorships in Latin America obedient to Washington.

This elegant, cosmopolitan novel that focuses on basic drives and needs starts in a manner patently Amblerian. Like the heroes of *Alarm*, *Epitaph*, *Judgment* and *Story*, Castillo (who, like *Epitaph*'s Josef Vadassy, has made photography his hobby) reports to a threatening public official very early in the action. Commissaire Gillon both orders him to serve as Villegas's personal physician and to spy on the Villegas household. He can't escape spying. Later, an insurance agent tries to coax information out of him pertaining to Villegas's health. Here's the stuff of a political thriller. But even though the materials comprising Frigo are melodramatic, their treatment is meditative. Climaxes drown in the bogginess of prosaic everyday reality. The world-class neurologist who flies to St. Paul from Paris can't help the dying Villegas. The would-be savior of his country dies before enacting one law. But his death promotes the healing of *his* doctor, a man whose long-deferred, roundabout father search ends

happily with a denial of both father and fatherland.

But *Frigo* is no satire on wasted effort. Like Jerry of Edward Albee's *Zoo Story* (1958), Castillo has to go a long distance out of his way before traveling a short distance correctly. His pilgrimage build suspense. The sick leader of a poor Central American country must be sworn into office before he deteriorates noticeably. Otherwise, the contract with a big oil firm he helped negotiate will come to grief. The way he protects the contract shows true courage. Not only must he speak persuasively to worldwide audiences; he also has to finish speaking before his words thicken and slur. Any hint of his illness must be suppressed. Unlike Scheherazade, he doesn't delay his death by talking. Talking puts his career and life at risk, since the effort that goes into his speeches will sooner or later undermine his health. Success for him means combining the toughness and strength of a ruler with the docility of a good patient. It's no wonder that Ambler uses him as a Christ figure. The ability both to give and take orders would challenge a healthy man, let alone a dying one.

As a member of his personal staff, Castillo feels the force of the bad omens greeting the presidential party on its arrival home. The country Villegas has been picked to rule denies his plane permission to land. Then, after this security problem is cleared up, Villegas commandeers a suite in the same hotel before which Clemente was killed 12 years before. This skilful foreshadowing allows Ambler to underplay Villegas's death, which occurs three days after his return. "The shots when they came didn't sound like shots at all," Castillo says of the bullets that lodge fatally in Villegas's chest. It's as though, expected and overdue ("when they came"), the bullets had to be coaxed out of the reluctant pistol which held them. Castillo's epitaph, "He died in the ambulance without speaking," shows that Villegas had no wisdom to share with his survivors—and knew it. His death was pointless, revolutionary politics being incompatible with justice and reason. The only revelation he might have imparted was that he should have expected his violent death, but he'd never have admitted that he conspired in the death himself.

His opposite number, Castillo, succeeds where he fails. In our complex modern era, skepticism outpaces involvement as a means of survival. Castillo finds peace by negating what is negative rather than by directly attaining a positive goal. Thus he shuns the temptation of politics. Besides ignoring the Florida faction of his father's party that wants to name him President-in-exile, he resigns from the cabinet post forced on him by Villegas. He could have easily followed the example of Claudius (10-54 A.D.), the Roman who became powerful despite his disdain for power. He has learned enough in his wounded native land to take a new sense of self-preservation with him back to St. Paul. No savior's complex misleads him into believing himself immune from a gunman's bullet. The detachment that helps him see his country's presidency as a coffin also tells him that being Dr. Frigo has some advantages. He needn't shed his whole past. When he asks himself if he'll go back to being Dr. Frigo in

St. Paul, he replies, "Only occasionally now, I think, and in a modified version." He hasn't cast off all fathers, either, even though the denial of Villegas helps him discard Clemente. This inversion of the Christian doctrine of the Procession ("Those who seek the Father must proceed through me") prefigures the optimism marking the book's finale. Like Stephen Dedalus at the end of Joyce's *A Portrait*, Castillo accepts a father figure before saying goodbye both to us and his homeland.

He lingers at the airport, where he's to board a plane to Ft. Louis with one Monsignor Montanaro, who had earlier driven him to his father's gravesite. Castillo's laying of a wreath on Clemente's grave helped him put closure on a painful tie. But the Monsignor, whose poor driving and association with cars labels him a father in Ambler's inner world, has more help to offer. His touching insights into the carnage both men have just witnessed put forth both a pathos and a confidence in human nature that will strengthen Castillo. But the Monsignor's very presence at Castillo's leave-taking counts as a blessing; fathers can nurture sons as well as cheat them. This lesson confirms Castillo's self-trust. Whatever good he can do for others will express itself individually rather than collectively. A true son of the new world, he functions best by avoiding social and political formulas.

His return to St. Paul can't be scorned as irresponsibility or escapism. Yes, his native land is a dreadful place, mangled by ugliness, crime, and poverty. But this wretchedness hasn't killed hope. So long as Dr. Torres (no first name given), the hardworking, inspired director of the General Hospital, serves the uplift of the country, hope will survive. The patriotic Torres returned home after taking his medical degree at Johns Hopkins, despite qualifying to practice in the United States. Like Castillo, he knows the importance of making a new start. Under Villegas, he explains, his homeland is a sick, broken place led by a sick, broken man; its uplift demands healthy leadership.

Torres also resembles Castillo in being ridden by a dead father. These resemblances help Castillo learn from him. After their final interview, Castillo shows a new inner calm and strength. When Villegas names General Escalón as Clemente's murderer, he replies that his father's death is a closed issue. And so is his native country's dubious future. He can admire Torres without following his example. The Dr. Frigo side of his nature can't be sunk. Nor should it be. It has helped him distance himself from his own impulses. No Torres, he can best fulfill himself and thus serve his country by leaving it. Advisedly, the people of St. Paul, where he will settle, refer to their country by the feminine pronoun, *elle*, as do those of France (*la patrie*) and her other possessions. His renunciation of the fatherland hasn't orphaned him.

Despite his beautifully modulated triumph, Cawelti and Rosenberg call *Frigo* "one of Ambler's least successful efforts" (109-10). And there is evidence to back this negative stand. The affaire of Castillo and Elizabeth never takes life. Most of the couple's encounters are handled sketchily or summarized

after the fact. The ones Ambler dramatizes usually occur in the presence of a third person. Never strong at domestic realism, he slights the everydayness of sexual love as well as the bursts of passion. Without excusing this shortcoming, though, one can concede its possible irrelevance to the book. The halfheartedness of Elizabeth's tie to Castillo could well strengthen Ambler's ongoing description of Dr. Frigo's inability to love. A more reasonable complaint about the book inheres in the slackness smudging the closing chapters. The scenes unfolding in Castillo's native land include several characters whose roles, though essential, aren't sufficiently dramatic. As a result, the plot seems agglomerative, Ambler bringing in new characters to keep the book afloat. The flurry of events surrounding the death of Villegas fails artistically because the events are built around people Ambler didn't trouble to develop, i.e., people we've hardly seen and care little about.

Despite this flaw, *Frigo* has many fine compensations, as several readers have said. Calling it "a first-class novel of suspense," Priscilla L. Buckley, writing in the *National Review*, praises its atmosphere, plot, and deft use of the past (1475). Lewis puts it among Ambler's "best novels" (134), and, going still further in his praise, Symons calls it Ambler's "finest book" (1981, 3). He may be right. *Frigo* is just as absorbing as *Mask* and much more ambitious. Ambler's writing in it is clear, poised, and resonant, recreating an exotic locale with instinctive warmth. Both the tactile values and the unstable politics of the Latin America where the action unfolds have a vibrancy that suggests longstanding intimacy. Though Ambler only wrote one novel set in Latin America, the immediacy of *Frigo* does full justice to this moody, tropical place. Proof of the dynamism of the tie between author and setting comes in the way setting galvanizes descriptions that aren't scenic. In a fine example of skewed language, Part 2 shows Villegas reciting crucial information he can't finish getting out because he's silenced by the twitching of his face and tongue. The following description of a drunken priest ends with a Céline-like detail all the more chilling for being recounted in a level, restrained voice:

The priest made an effort to get to his feet, failed, leered at me and mumbled a benediction. Out of a corner of my eye I could see El Lobo watching as if a snack-sized gobbet of raw flesh had just drifted down trailing blood.

More apparent in *Frigo* are the ongoing gains Ambler reaps from having learned diagnostic techniques and other medical procedures along with the politics of hospital administration. In Part One, he fabricates, under Castillo's name, a report that, besides being factually convincing, catches the tone and manner of the clinical dossier. Nothing about the report sounds strained or artificial. Here and elsewhere, Ambler brings a great deal of medical insight to the novel without being pedantic or sententious about it. He also handles dialogue well, never trying to be literary, a welcome benefit since *Frigo*

contains more dialogue proportionally than any other Ambler to date.

Though it avoids literary flourishes, *Frigo* manages to achieve effects usually found in important writing alone. The book is cast in the form of a political thriller, but its main lines are much more cultural than actional. The way its references to the Hapsburgs, to Eliot, and to Shakespeare enrich the plot have already been mentioned. There's also an important allusion to *Oedipus Rex*, namely, that sick leadership dooms any people. *Frigo* endorses Sophocles' belief that if the head of a state is ailing, the body politic will also droop and die. European literature fortifies the plot of *Frigo* as much as the classical strain. The eminent medical specialist who travels a great distance to examine a dying patient he can't help comes from Flaubert's *Madame Bovary*. Ambler's thematic use of character also draws upon English-language fiction. The narrator who claims that he's emotionally detached from the events he narrates recalls any number of voices from Henry James, Ford Madox Ford, Christopher Isherwood, and Graham Greene. But it's Greene who casts the longest, and most intriguing, shadow on *Frigo*. A drunken priest shows great courage before falling victim to matters of state. And it's perhaps the warmth, delicacy, and expansiveness of insight marking his epitaph, spoken by a brother priest, or church father, Monsignor Montanaro, that gives Castillo the strength to face the ordeals ahead: "If one is going to blame a man for a great crime one ought to know everything about him. Difficult, unless one is God."

The counterpoint of such refined vision and the bloodiest violence, of the cosmopolitan and the rank, and of political and personal themes both give *Dr. Frigo* more bite than any book in the Ambler canon and make it the strongest of his postwar phase.

### III

The characters peopling *Send No More Roses* are older, dryer, and more cynical than any comparable lot Ambler has presented to date; at 33, the book's youngest character of note, a criminologist, is two years older than Castillo. This Ph.D. in sociology and her counterparts have used their years to cultivate learning and cleverness. Ambler's 1977 novel deals with tax evasion, or avoidance, i.e., the use of expertise in tax law to protect income without committing a crime. The skill needed to manage this kind of tricky financing within the bounds of the law demands both up-to-date knowledge and quick, precise thinking. As Paul Gray noted in his *Time* review, aptly called "Capital Gains," *Roses* rates cunning of perception over narrative drive. The book, says Gray, "has more than enough cerebral twists and sophisticated wit to offset its comparative bloodlessness" (97). Gray's qualification—"comparative"—is well judged. The book's vital signs run high. Even before a car bomb kills a man whose hands were wired to the car's steering wheel, plenty happens in *Roses* to dry the throat and keep pages turning.

This plenty is carefully orchestrated. Two years before the present-tense

action, the book's narrator, Paul Firmin, sponsored a seminar in Brussels attended by some 120 bankers, tax experts, international lawyers, and government revenue officers. Firmin fits smoothly in the mainstream of Ambler heroes since Simpson of *Day* (1962). As an Argentinian-born Briton, he has a dual nationality ("All very schizoid," he says) made more burdensome by his early training. His family, having been settled in Argentina for more than a century, believes itself more Argentine than British. Yet family tradition has decreed that the children be reared by a nanny and then sent to England for their formal schooling. Firmin was shipped to an English boarding school at age eight. His student days may have passed more smoothly than Simpson's. Perhaps he began developing the practiced, polished style that has served him so well professionally by using his wit to "endure the torments" of an English public school education.

His ability to avoid the sting of the headmaster's cane has carried into his adult life. Cautious and clever, this quadrilingual financier of 55 or so knows how to protect himself. At his firm's Brussels seminar, he was recognized as the man who once bribed a Zurich bank officer to release confidential information about depositors. The Dutch criminologist who made the connection uses it to win an extended interview with Firmin. The site chosen for the interview is the Villa Esmaralda, near Cap D'Ail, on the French Riviera. To gain an edge for himself, Firmin puts Professor Frits Bühler Krom and his two colleagues through the ordeal of a long, hot drive. Then, rather than directing them to the door of the villa, he has them stop some distance away, a stratagem devised to make them carry their luggage up a slope. But, ever the strategist, he's not only disconcerting his visitors to test their poise. He's also watching them through a pair of binoculars; he wants to make sure that they've kept their promise to leave behind all devices of detection or surveillance. Aware of the fruits of surveillance himself, he has fitted the visitors' rooms with listening devices, and, at dinner, some hours after the visitors' arrival, he also chills the wine to hide its potency. His trick of making the white dinner wine taste like water succeeds. The visitors, hot and thirsty after their long trip, gulp it and get dizzy, if not drunk. They also find themselves, to their dismay, dull and sluggish during the after-dinner business meeting in which they had hoped to cow their host.

Though Firmin blames the butler for serving the wine too cold, he gladly profits from the mistake. And he reveals himself just as capable of pressing an advantage over breakfast as over dinner. The next morning, he makes sure that the coffee served to his guests lacks the goodness of the cup he drinks himself. But he doesn't need food and drink to whet his keen sense of gamesmanship. In Chapter 8, he stands at an angle from Krom during an argument that forces Krom to lean uncomfortably in order to see his face. Then, ever the gamesman, he walks away after firing off an insult to trick Krom into following him into a room equipped with electronic bugs.

But if Firmin's machinations show him to be unappealing, they don't make him any scurvier than the American academic George Connell, his British counterpart Geraldine "Hennie" Henson, or their leader, Krom. A professional maverick, Krom claims to have found "an entire criminal species or sub-genus about which nothing is known: that of the Able Criminal." The Able Criminal's mystique comes from his being almost non-catchable. Heretofore unknown, he has caught Krom's attention because of the implementation of new tax evasion laws. Krom wants to use Firmin to test his theories about the Able Criminal. He already knows enough about Firmin to send him to jail. But he promises to safeguard Firmin's anonymity in exchange for information that would help him compile "a complete, full-scale case study."

Firmin consents to the meeting, but not before setting down rules and guidelines. Though he dismisses as a fluke the logic that led to Krom's citing him an Able Criminal, he will shield both himself and his organization, the Symposia Company, from prosecution as well as he can. Besides bugging the villa, he inspects his guests' belongings. His inspection reveals that the guests have breached their security agreement. Connell has smuggled a tape recorder into the villa, and Henson, some ninhydrin spray with which she plans to make fingerprints which could later be compared to those on file in various security networks. Firmin's original idea of throwing his guests some chicken feed while keeping the crown jewels hidden has been threatened. Like Ghaled of *Levanter*, Krom has fallen into disrepute among his peers, and he needs a victory to recoup lost esteem. His first talk with Firmin, over drinks in Brussels, showed his determination. It also showed Firmin's. Fencing hard, both men mingled hints, bluffs, and half-truths in order to shake the other's composure and to trick the other into committing an indiscretion.

What Firmin most wants to protect is the link between Symposia and its chief officer, Mat Williamson, or Tuakana, who is trying to turn his birthplace in the South Pacific, Placid Island, into a tax haven for first-world investors. The son of an Australian sea captain and a Melanesian mother, Mat has the mettle to bring about his tax-haven scheme. This mettle has long been in place. So impressive was he to the Methodist ministers who taught him as a boy in Fiji that he was sent to the London School of Economics, where he took his degree. Several other influences helped form his ingenuity and value system. Before earning his first million by age 25, he became an avid Boy Scout, studied law at Stanford University, and learned witchcraft. As a schoolboy, he cast a spell on an older student that defied all medical treatment. Like Simpson, he's an illegitimate half-caste who lost his father during wartime at an early age. But his hopes, accomplishments, and ruthlessness all surpass those of the grubby small-timer Simpson. The son acquires power originally belonging to the father in Ambler's late work. A brilliant organizer, Mat has put together an elaborate network of cut-outs and number codes, false passports and matching cover names, to protect his investment in Symposia. He has also purged his business

ethics of loyalty and sentiment. Now that the Krom group has made his ex-mentor Firmin a security risk, Mat plans to kill him.

Mat schedules the Krom conference to overlap with Bastille Day, 14 July, a time when the villa's servants will be out celebrating. In an action that recalls the climax of Len Deighton's *Funeral in Berlin* (1964), he orders the villa bombed under cover of the annual fireworks display. Some hired thugs posing as drunken partygoers on a yacht nearby are launching signal flares and other pyrotechnics along with the odd rocket to hide their intent from the locals. This attack from the sea builds pressure within the villa. One of the two security experts helping Firmin handle Krom is working for Mat. The Tunisian Yves Boularis stymies the others at the villa by cutting the telephone lines; now the police can't be called for help. He's also found to be the only person at the villa with a firearm.

This crisis can be traced to an idea devised some 25 years before by a lawyer from Trieste called Carlo Lech. Seeing no reason to break the law when it could be bent, Lech turned his attention to the thin, sometimes disputable, line between tax evasion and tax avoidance. He founded Symposia allegedly to protect money earned by American servicemen from the sale of stolen PX goods, quartermaster supplies, or truck tires. The soldiers couldn't convert the Italian lire or German marks they earned on the black market without explaining where the money came from. Promising that he could make the money both convertible and respectable, Lech would invest it for them in gold-backed bonds to be deposited in a Swiss bank. His depositors were given other assurances. They could use the receipt he gave them when they transferred their funds to him to claim the funds at any time.

But they wouldn't claim them happily. The problems that hampered the depositors from taking the money home in the first place would have compounded. To begin with, they'd know that they were cheated. The investments that doubled in value for them after seven years will have earned Symposia many times this figure. Next, the investor will see that his money is still illicit. He can't show the IRS a copy of the probated will or of any other document confirming the legitimacy of his new wealth. At best, he faces a big capital gains tax based on back audits of his earnings. He may also go to jail both for failing to declare earned income and for stealing government property. Should he try to strike back at Lech for cheating him, he'd be reminded that the IRS pays a 10% reward to any informer who can prove that a U.S. citizen has filed a fraudulent tax return.

Symposia not only forecasts the money-laundering schemes devised in Miami and the Caribbean by drug lords in the 1970s. It also depicts the evils of the leveraged buyouts of the 1980s. Aside from creating fat legal fees, the buyouts generated corporate wealth rather than services and goods. They certainly didn't bring about new jobs or help launch R&D programs that might improve the quality of products or speed their shipment. What Mat proves is

that they concentrated more and more power in fewer and fewer hands and thus disabled the middle class, that source of vitality and inventiveness in the industrialized West for the past two centuries.

Ambler describes the various by-products of an economy whose leaders pay more for advice and information than for material goods. One of these by-products is communication technology. Early Ambler novels like *Frontier* and *Background* used moving trains and train stations as plotting devices, as did Greene's *Stamboul Train* (1932) and *England Made Me* (1935) along with the 1940 Carol Reed film, *Night Train*. Rapid advances in communication techniques in the postwar decades account for the electronic eavesdropping, jet travel (within a couple of days, Firmin goes from Zurich to the Bahamas via Geneva, Paris, Milan, New York, and Miami), and telephone technology taken in stride in *Roses*. The advances can outpace the human factor. A character in Chapter 10 says, "They say dialled calls are hard to trace, but that was last year. Who knows how hard or easy it may be now?" And who knows the effect of rapid scientific advance upon morality? Krom accuses Firmin of running an extortion racket under the cover of a collection agency. But doesn't Krom twist arms himself to win an interview with Firmin? The business ethic monitored by the new technology has scrambled traditional guidelines and expectations. When Krom accuses Firmin of lying, he's answered, "Where…did you get the extraordinary idea that you have a prescriptive right to the truth?" A minute later, instead of apologizing for or feeling embarrassed by his lie, Firmin tells Krom, "The only time you'll hear a truth from me is when it happens to suit me. …Truth games are dangerous…. All I'm playing for is safety." The idea that safety prefers falsehood to truth is shocking; so is the idea that truth lacks absolute value. Yet Ambler mutes the shock by making his truthseeker Krom so unpleasant. A nasty piece of work like him, Ambler makes us feel, deserves to be thwarted by any means.

He even offends his cohorts, O'Connell and Henson, vindicating Firmin's reference to "that overweight super-ego he carries around." On matters of policy, he insists on deciding for his group unilaterally. This high-handedness makes *Roses* the second straight Ambler that invokes the doctrine of the Procession (the rose of the book's title is a major Christian symbol). Here is Krom in Chapter 3, his messiah complex in full flower, demanding complete control of the investigation:

It was agreed between us…that all inquiries of whatever kind will be made by me. Here, everything will be conducted throughout in the way that I decide, and only in the way that I decide. That was positively agreed.

Only he may question Firmin. Only he may inspect the materials Firmin circulates. Why? He wants to stop his cohorts from publishing their own accounts of the Symposia investigation. But his stripping them of initiative goes

beyond the professional. Eager to assert his leadership, he denies O'Connell the morning coffee O'Connell claims he needs to start functioning. His eagerness defeats him. Besides alienating O'Connell, he later looks foolish to Firmin. His claim that he chose a certain room for a secret strategy meeting because the room is free of bugs reaches us by means of a bug he had overlooked in his inspection of the room.

Yet he may be more than the power-mad bungler Firmin claims, as Panek shows:

Ambler's methods of presentation become more complex in the most recent novels.... *The Siege of the Villa Lipp* [*Rose*'s American title], for instance, gives Firmin's story... but it also contains an Afterword by Professor Krom, and this sheds new light on the whole narration: in the body of the novel, Firmin shows Krom to be incompetent and weak. But the Afterword shows him to be rational, perceptive, and human. (154-55)

*Der Kompetente Kriminelle*, the book that grows out of Krom's investigation, hurts Symposia. Attendance at Symposia seminars drops by 60%-70%, and all but one of the featured speakers slated to appear at the seminars cancels. Exiled on a Bahamian island once owned by Carlo Lech, Firmin, in riposte, writes his own book about Symposia. The Afterword that Panek refers to consists of a 15-page commentary Krom appends to the book as a condition of publication. Were the book to appear without his commentary, he'd sue for libel. And we'd be deprived of an intellectual challenge. As Panek says, the commentary describes Krom favorably. In fact, Mat, his Placid Island interview with whom the commentary recounts, complains more about Firmin than Krom does.

As with *Conspiracy* and *Levanter*, the last chapter of *Roses* features an interview in a new setting that skews the impressions and beliefs that had been forming in our minds. Firmin claimed of Krom, near the end of Chapter 1, "Far from being the villain of the piece, I am his principal victim." He doesn't act like anybody's victim. He can hardly mention Krom without referring to his outsize, jutting teeth and his habit of spraying saliva when he talks. Neither has he the victim's innocence and passivity—two features of the Ambler archetype through *Passage* (1959). He admits in Chapter 1 to having been called "sly, treacherous, ruthless and rapacious, vindictive, devious, sadistic and generally vile." Also impugning his character is his use of several different aliases; were he honest, he'd not need to hide behind a false name. In fact, the name he uses with us, Paul Firmin, isn't his real one. How can we trust him? In his second straight novel, Ambler has subverted the conventions of adventure fiction both to free it from the clichés hobbling it and to send it into the open, where it's more responsive to other changes. Firmin represents an important innovation on his own. He questions his credibility as a narrator. Though he scathes Krom for being physically repulsive, vain, and self-deceiving, he also puzzles over his

own honesty, describing the truth as elusive, problematical, and perhaps dangerous:

I happen to be one of those who believe that the ability to tell the whole truth about anything at all is so rare that anyone who claims it...should be regarded with deepest suspicion.

I can only attempt to be truthful.

Do such disclosures damn him? Or do they convey a depth and self-honesty meant to impress us? These questions remain open. But Ambler wants them to be asked. Krom's Afterword introduces episodes from Firmin's past about which Firmin had said nothing, like the great setback of his life—the suicide of his son. Firmin's silence on this fraught subject in the two-page subchapter following the Afterword proves nothing. But it does help make *Roses* a deconstructionist critic's delight. Admittedly the text isn't plotless. And certain patterns take shape in it that impart closure, but usually for comic relief. Johann Kramer's funeral service in Zurich features the music of another Johann, namely, Bach. Mat's Melanesian mother invokes an industrial spy named Melanie, who helps set up security precautions at the villa before Krom's visit. Lastly, Firmin acts more like a firebug than a fireman when he starts a blaze in the villa's garage that brings in the local fire department and probably saves five lives.

On the other hand, meaning in *Roses* is ambiguous. Despite the verbal brilliance of the characters, language is indeterminate and unstable; the action, messy and stubbornly unresolved. The individual is also more of a metaphor than a solid reality. Ambler's decision to set the book's last two scenes on islands conveys an isolation, loneliness, and fragmentation that fight clarity and closure. Yet all this is deliberate. *Roses* is the novel Ambler wanted it to be. Its willed imperfection befits people who make their living along the fringes of the law. The shakiness of these livelihoods demands a narrative mode that withholds the cozy assurances and affirmations found in most popular fiction.

But the Ambler of *Roses* isn't too much the smooth old pro. His technique is adroit—neatly understated and obliquely efficient—without being lifeless. Things happen for a purpose in this book about people who exist a little off center. Part of the purpose is underscored by narrative structure. Though plot doesn't hamstring the characters, it does shape and control what they do. It declares itself in the book's midmost unit, Chapter 6, in which the Zurich bank employee Johann Kramer dies after being questioned by the police about his tie to Symposia. Like poor Bulic, the Belgrade civil servant suborned by Grodek and Dimitrios, his handing over of restricted information brings him to grief. Firmin, his recruiter, learns of his death and goes to Zurich to collect the papers documenting his tie with Symposia. The generosity that prompted Firmin's bouquet of funeral roses, the item that supplies the book's title, recoils on both

him and Symposia. Kramer's angry widow identifies him as he passes through the line of mourners; he's also spotted by Professor Krom, who uses the incident to force a meeting with him two years later. But the incident spawns more immediate problems. The news that Symposia breached the secrecy laws governing Swiss banks both shuts down the firm's European operation and banishes Firmin to Lech's Bahamian island, a place he loathes.

This long time glide ends by bouncing us back to the present. Three cars are parked outside the villa in such a way that their occupants can stop anyone trying to leave. The cars have been sent by Mat, who learned about the conference at the villa and wants to frighten the conferees into bolting before any information is divulged that threatens Symposia. As has been seen, he has also planted his own spy in the villa in Yves Boularis, an electronics surveillance expert. These new developments have shifted allegiances. Heretofore at odds, the Krom group and the Firmin faction, except for Boularis, now take up the cause of promoting their joint survival. Their efforts put pressure on Boularis, the spy within the gates. He has angered Mat, his chief, by permitting Firmin to bring the local fire department to the villa by starting a fire. Then he fails to induce the panic in the conferees that would trick them into fleeing from the villa and thus presenting easy targets to the gunmen parked outside. Understandably, Firmin shows no surprise when he learns of Boularis's death in a car mined with explosives. Boularis had to be punished to discourage carelessness in other Symposia agents. He also knew too much about Symposia's dirty tricks.

In keeping with the linguistic wit irradiating the book's dialogue, Firmin intuited Boularis's treachery because the Tunisian used a word ("ditching") he could only have picked up from one of Mat's closest aides. *Roses* is more profuse in verbal and psychological discrimination than any earlier Ambler. The diversions, sideswipes, and bluffs used by Firmin, Krom, and Mat disclose brilliant conversational capework. These skilled talkers balance their sentences, use foreign terms, and indulge arcane allusions, some of them threatening, in order to score on an interlocutor. In their world of accomplished oral fencing, a nuance or a pause can count heavily. Nor can the same trick work twice with these fast learners. Firmin says of one of the participants in an oral joust in Chapter 8, "She had succeeded with him before; but that had been a half hour ago and he had learned a lot since." As in Henry James, whose people delight in executing series of small conversational hits, obliquely delivered, prepositions mean a great deal in *Roses*. When Firmin asks Lech if Symposia plans to make a fortune out of the army, he's told, "No, no...! *In* the army, not *from* or *out of* the army." Later, one of Mat's henchmen uses prepositions to try to convince a trapped Firmin of his friendship and loyalty:

I don't have to tell you, Paul, that we've both been worried. Not about how you'd handle yourself...but worried *for* and *with* you.

Mat takes verbal gamesmanship into the realm of sorcery and the casting of spells. At home in both northern and southern hemispheres, in a crowded industrial city or a third-world backwater, or with male or female sexual partners, he has set store by the teachings of his hero, General Sir Robert Baden-Powell, identified above as a spy, the founder of the Boy Scouts, and the engineer of the British victory at Mafeking during the Boer War. B-P believed that both spies and Boy Scouts need to blend with their surroundings; they must use landscape rather than letting it hamper them. The ex-Boy Scout Mat Williamson, or Tuakana, has mastered the art of adaptation. Besides moving easily in different physical environments, he knows different languages and does vocal impersonations. He also uses his early training in witchcraft as a weapon in the psychological warfare he wages against Firmin while the Villa Esmaralda is under siege. Drawing upon B-P's belief in the supremacy of mind over matter, he tries reverse psychology on Firmin. He advises Firmin to stay in the villa until the attack from the yacht nearby stops. But this master of intimidation has advised Firmin to freeze because he wants him to run; he knows he has lost Firmin's trust. Fortunately, Firmin understands the meaning behind this hypnotic suggestion, and he survives the murder plot Mat has orchestrated for him.

Whether his survival harks to the imperialism and racism scattered in some of Ambler's early books is hard to say. If this prejudice exists in *Roses*, it's muted. Firmin isn't the victorious Englishman of virtue and honor any more than Mat is the defeated, darkhued savage, even though Mat's criminal cunning outstrips that of any figure in the canon since Dimitrios. Both Mat and Firmin are living on islands more than an ocean apart at book's end, and, as his country's Chief Minister, Mat enjoys happier prospects than Firmin. A more valid complaint about *Roses* stems from the centricity of the Zurich banker, Kramer. The death of a character who never shows us his living face shouldn't exert as much force as it does in *Roses*. What's more, Ambler's unfortunate title calls attention to this lapse, as does the book's structure. (Kramer's funeral service, to which Firmin brings his bouquet of roses, occurs, as has been seen, in Chapter 6, midway into the eleven-chapter book.) Finding good titles for his books continues to worry Ambler. The American title of his 1977 novel, *The Siege of the Villa Lipp*, recalls the jewel thief, Elizabeth Lipp, from *Day*. It does still more. Besides alluding to the prominence enjoyed by speech in the book, it also gives the danger uncoiling from the plot an immediacy and a vividness (*Lipp*-lip). But the book's British edition has no Villa Lipp, the house under attack from the sea going under the name, Villa Esmaralda. Now Esmaralda is the name of a much-loved pet goat in another novel set in France, Victor Hugo's *Hunchback of Notre Dame*. Perhaps Ambler had Hugo's novel in mind. Scapegoats are mentioned in a conversation in Chapter 8, and the figure of the Judas goat who leads lambs to slaughter suggests itself, too. But the suggestion is too clever. The search for name symbolism in the book is distracting. Neither

the flatly descriptive *Siege of the Villa Lipp* nor the more evocative, but also more embarrassing, *Send No More Roses* works well as a title, since they both refer to isolated scenes in the action.

Much more impressive than the book's title is its shifting of time. Ambler violates chronology to develop issues more freely and flexibly than a linear time scheme would permit. For instance, in Chapter 2, Krom mentions the death of Kramer, whose funeral will be shown in Chapter 6, even though it occurred two years earlier. Firmin attended the funeral under the code name of Reinhardt Oberholzer, an alias he denied ever using when confronted by Krom in Chapter 2, but which he confesses to having adopted in Chapter 5. Ambler continues both to touch in background and tease out various plot strands with a firm, delicate hand. The last subchapter of Chapter 6 takes the action back to the finale of Chapter 3. But the issues ignited in the three-chapter interval provide fresh, new slants into the one rising from the earlier incident. Our perspective has been enriched. The incident's meaning resonates more than it would have if presented in straight chronological sequence.

A motif as important as time shifting in *Roses* is Ambler's Oedipus complex. The fatherly Krom says in Chapter 8, "You must be good, my children, *please*," when he's reaching for something he knows isn't his. And, for the first time in Ambler since the bureaucrat Petlarov did it with Foster in *Judgment* (1951), he touches another man's knee as a persuader. But these instances are rare. Rather than exploiting their sons, fathers in *Roses* cringe from them. Lech's son saddens him "profoundly" by becoming a priest; perhaps he sought in the church fathers a warmth and security his busy natural father withheld from him. *Frigo* used a church father as a surrogate for both the blood father and the fatherland. Also, the alleged suicide of Firmin's son depressed Firmin so much that he became a recluse. Fathers continue to be victims. Although in their early days together Mat treated Firmin "with the deference due to an elder statesman," he later tries to kill him. Then, one of his angry young charges, after calling Firmin "Dad" and "old-timer," tells him that he has been fired from Symposia. That the young charge is Japanese and Mat, his boss, is dark skinned (Firmin refers to his "black butt") shows that, though still in force, Ambler's anxiety has shifted from the father to the son. Again, the archetype can't defend himself. The son's cruelty has taken on an added measure of menace by rooting itself in a different race as well as generation. He may be more frightening than the father because he's more mysterious and harder to understand.

The book's deep structure conveys Ambler's anxiety. Selfhood itself is elusive and shadowy in *Roses*. By denying Carlo Lech's existence in Chapter 5, Krom calls identity itself into question. It remains there. Mat denies to Krom that he's the Mat Williamson of Firmin's memoir. And there's no evidence besides Mat's dubious testimony that Firmin ever had a son, let alone one that killed himself. The atmosphere of *Roses* thwarts human purpose. Though the

book makes subtle Jamesian discriminations, it reveals no Jamesian expansion of moral consciousness. People only become more clever. All is sacrificed to style and power. The sharp dealers are no wiser and no more virtuous at the end of the book than they were at the start. Committed to the gods of commerce, they merely swell into larger-than-life versions of their earlier selves. Nor do their prospects for illumination improve. The expert mimic Mat is impersonating an imaginative, committed head of state on his remote island. Firmin is even more trapped and isolated on his Bahamian Out Island. Through him, Ambler conveys the anxiety of entrapment—in his own case by age. Nearing 70, he has seen younger writers of international intrigue fiction like Deighton and le Carré both win big readerships and see their books turned into popular films. But neither they nor a host of mainstream novelists took the pulse of a fast-changing world better than Ambler did in *Roses*. And he had more to say. Happily, his old man's anxiety didn't stop him from writing one more novel, a work that would rival its most distinguished predecessors in flair and outstrip them in sales, the best-selling *Care of Time*.

## *IV*

Excluding the prologue of *Anger*, *The Care of Time* is the first Ambler since *The Schirmer Inheritance* (1953) to use the United States as a setting. The book gives vent to Ambler's imagination. The name of its main figure and narrator, Robert Halliday, alludes to the razing of barriers between popular and important mainstream fiction, a feat performed by Greene, le Carré, and Ambler himself. More pointedly, it refers to Ambler's boldness. To crown his 45-year fiction-writing career, he builds a novel around a man with the name of a matinee idol or a hero in a novelette. Then he defies us not to take him seriously. He also shapes him to the curve of the archetypal hero of his earlier books. Like a John Buchan hero, Halliday goes on an adventure that takes him from security and comfort into danger.

The adventure also finds him reacting to the plans of others rather than taking the initiative. He's living in rural Bucks County, Pennsylvania, where he supports himself as a journalist, editor, and freelance ghost writer, mostly of autobiographies of politicians and entertainers. He must be reasonably successful. He has a housekeeper, a part-time secretary, and a New York agent who thinks enough of him to keep him busy with writing jobs. Of his past little is known, except that he has worked as both a television interviewer and a CIA agent in the Middle East. Neither he nor Ambler says anything about his height, weight, age, education, and religious training. He seems to have no family, and he never speaks of the ex-wife to whom he pays alimony.

The burden of alimony payments sharpens his interest in a $50,000 fee offered by an Italian publisher. Casa Editrice Pacioli of Milan wants him to edit a two-part book consisting of a memoir by the real-life Russian anarchist, Sergei Nechayev (1847-82), followed by an "informed commentary." The

writer of the commentary and the memoir's owner, one Dr. Luccio, sees Nechayev as a forerunner of today's terrorism in the Near East. The memoir, which may be a fake, is the first of the novel's many red herrings. The purpose of the book it will help make up is to turn governments everywhere against international terrorism. As a call to arms, the commentary is intended to get more attention and stir more interest than the disputed memoir. Ironically, Pacioli of Milan is using a terrorist document to launch anti-terrorist action.

But this irony is overturned quickly. Halliday is to work as a television interviewer, not as an editor, Pacioli being a subsidiary of the powerful international conglomerate, Syncom-Sentinel, and acting on its instructions. Ambler has more to say in *Care* (1981) about the power wielded by large multinational firms like Syncom and Symposia of *Roses*, which have diversified and grown to the point where they run governments. The person Syncom wants to reach is a Persian Gulf potentate called The Ruler, who governs one of the seven oil sheikdoms comprising the United Arab Emirates. This most powerful person in all of Ambler is also the most demented. Through him, Ambler describes the emptiness of power. Despite his money, property, influence, and the rings of lawyers and thugs protecting him, he barely exists. His namelessness and the capital letters used always to refer to the title he's known by capture both his eminence and his nothingness. His namelessness also infers his anxiety. It's no accident that this childless man's fear of sterility and impotence has made him the only member of his entourage who wears a beard.

Michael Gilbert calls him accurately "a manic-depressive paranoic" (626). In the lone chapter in which he appears, he shows himself to be predatory, vicious, and deranged beyond redemption. His self-revelation in a TV interview with Halliday provides one of the greatest shocks in the whole canon, Ambler's own worries about aging informing his portrayal of the fear-ridden sheikh. The Ruler wants to build a modern clinic for the treatment of respiratory diseases on the site of the disused Austrian silver mine where he's living. But rumors have been spreading that he wants to use the old mine as a fall-out shelter in the event of chemical warfare. The rumors rise from his secrecy. Besides refusing to submit building plans to local authorities, he has also hired no Austrian engineers or electricians to help with the revamping project. The friction caused by his stubbornness has spread because NATO wants to build a naval base at Abra Bay, in his country, to offset recent Soviet entrenchments in Ethiopia, Socotra, and South Yemen.

The big question surrounding the Abra Bay project is his asking price. The Ruler's fears that he's a sexual cipher have honed his destructive instinct. Part of his joy in taking refuge in a fall-out shelter during a chemical weapons attack would come both from excluding others and imagining the spasms and convulsions these others would suffer before dying. The Ruler's TV interview with Halliday in Chapter 13, during which his aims become clear, forms the book's moral climax. Professing only an academic interest in the central

nervous system, he describes with shocking relish the agonizing, deadly effects of nerve gas. In his description lies his price for permitting NATO to build at Abra Bay. He wants to use people for his private experiments with nerve gas. Equally jarring is the revelation that NATO agrees in principle with his disgusting condition; those in charge of weapons systems always find human animal tests useful for information gathering.

But NATO and The Ruler never complete their deal. What moral outrage couldn't kill is crushed by public opinion. Any telecasting of the interview with Halliday would disqualify The Ruler as a business partner. Esteemed as leaders of the civilized West, NATO and Syncom, the financial force behind the Abra Bay contract, could never risk being caught at the bargaining table with a criminal psychopath. Understandably, The Ruler's inner circle wants to confiscate the interview film before it airs on TV. Much of the scandal they fear stems from Halliday's interviewing skills. Prescott misfired when he complained that *Care* "contains no real heroes, only opportunists committed to survival" (26). First, it takes more than opportunism to survive in the book's deceit-ridden world . One also needs courage, quickness, and imagination to hold off foes as determined and rugged as Syncom or The Ruler.

In Chapter 11, the seemingly mediocre Halliday, who normally backs down to power, tells a power broker, when asked how he'd react if another war broke out, "By getting drunk." A sense of humor can foil authority. As in *Frigo*, the mighty can be both confronted and defied. Outclassing and outmaneuvering The Ruler, Halliday tricks him into baring his moral darkness. He keeps impressing us. The next chapter shows him leavening cleverness with compassion. While fleeing a hit team under contract to The Ruler, he gives the alleged Dr. Luccio and his daughter a reel of film containing some of the crucial interview of an hour before. He reasons that Luccio, or Karlis Zander, and Simone will win the favor of the officials of the country they're defecting to if they bring with them a token of good will.

Nor is Halliday the only figure who transcends opportunism. Conveying some of Ambler's creative intent, Michael Demarest, *Time*'s reviewer, spoke of "an all-too-familiar world of doublecross and blackmail where the heroes are unheroic and the villains almost likable" (98). Ambler respects human ambiguity. Though driven by evil, The Ruler deserves our understanding. Both his pain and lack of control convince us of his need for help. Having inherited a legacy of madness from his homicidal father, he didn't choose evil. But he lacked the moral strength to resist it when it beckoned. Appropriately, he's a patient at a mental home, where he has belonged for years, at novel's end. Karlis Zander portrays the same lesson in reverse. He shows that being human and vulnerable includes a capacity for tenderness. In the first chapter, he's described as a high-level middleman: "He's the one who knows exactly who has to be paid off and exactly how much each of them rates." He needs this expertise. As defense adviser to The Ruler, he deals in billions of dollars

negotiating contracts for docking facilities and air-defense systems. His clients are also ruthless enough to exact punishment when thwarted. They have taught him the uses of menace. At the very outset, he seizes Halliday's attention by advising him by postcard to expect a package bomb. The postcard, moreover, shows a picture of a hotel in Baghdad, the city where Halliday spent eight months in prison some years before.

Zander has mastered the art of persuasion. He has had some good teachers. A multilingual native of Estonia, he served, first, in Hitler's infantry and intelligence corps and, next, in the French Foreign Legion. His name as a legionnaire, Charles Brochet, like the others he has used, such as Carl Hecht, Dr. Luccio, and even Karlis Zander, all refer to the fish known as the pike. Obviously, he enjoys warming the trail to himself, since most of the swimmers in his choppy waters can easily infer his identity from his aliases. But if he's a villain, he's a human one. The Ruler has hired him as defense adviser because he's trusted by the six other UAE heads of state. His good name in the UAE community can speed plans to put NATO military bases on Abra Bay. But because the plans violate an agreement The Ruler made with his six princely colleagues, they must remain a secret. What is more important, their implementation calls for a scapegoat. Thus The Ruler has put out a contract on Zander. Functionaries in Ambler can die for performing both well and badly. Two attempts on Zander's life have already been made, and his head still has a price on it. Knowing about his anxiety improves our opinion of him. He keeps moving from one safe house or cheap hotel to another to protect not only himself but also his family. Though he misses his wife and children, he can't see them for fear of endangering them; the contract The Ruler has put out includes his family. This man who deals with the rich and the mighty cares much less about privilege than about his family's safety.

But *Care* concerns itself with issues as well as a story. Ambler told Herbert Mitgang in the *New York Times Book Review* that social conscience moved him to write *Care*. Particularly dreadful to him were the dangers of chemical warfare, which he saw as worse than those of nuclear fall-out (22). As was later shown in the Persian Gulf in the late 1980s, organized terrorists will use chemical weapons with the backing of big business and big government. *Care* portrays the shocking political and military by-products of a global economy run by a fistful of multinationals. Business trends that occurred within a decade of the book's appearance justified the portrayal. If the Whitman Corporation in the United States could absorb firms as varied as Pet Foods, Pepsi-Cola General Bottlers, Midas International Muffler, and the Hussmann Corporation, then why can't a large producer of goods as benign as milk products make explosives? And why can't black money laundered in Iran find its way, with the Pentagon's help, to distant Nicaragua? The growth of multinationals has created what C. P. Snow in a former decade called interlocking rings of power. Today they're called diversified assets, and they

still curb people's freedom and safety.

Ambler deserves credit for forecasting this danger. And his forecast gains strength from his skill in handling the details of narration. Exposition in *Care* is managed smoothly, if somewhat mechanically. Early in the first chapter, an unnamed news service librarian who never re-enters the action tells Halliday about Zander, the sender of the postcard announcing the coming of the package bomb. Then there's the picture on the card, of Baghdad's Mansour Hotel. Zander wants Halliday's help, and both his postcard view and the bomb he sends two days later spell out his resolve in getting it. Further evidence that he has won Halliday's attention for his next approach comes from a police captain's words to Halliday in Chapter 1: "I've had you checked out. You've had some bad times that you don't like talking about." Halliday is vulnerable. His bad times feature his eight-month jail sentence, an ordeal whose import Ambler develops surehandedly. Both sides of the postcard—its picture and its written message—are displayed in the novel's second paragraph. Playing out tension, Ambler waits till the chapter's last sentence before saying that Halliday stayed at the Mansour. The Baghdad ordeal resurfaces in Chapter 5, when Halliday is surprised in his Milan hotel room by a team of security men, including his case officer during his CIA stint in Baghdad. Only here, a third of the way into the book, do we learn of Halliday's prison term.

The slow precision with which the exposition is teased out also marks the finale. Here, the hit team hired by The Ruler follows the Zander-Halliday group into Italy. The occupants of the getaway car need to stay alive until the interview with The Ruler shows on TV, an event that will both shame The Ruler everywhere and bring them safety. No organized team of killers will either accept or honor a contract issued by a person whose name has been smirched as much as The Ruler's. To build suspense, Ambler makes us wonder if the getaway car will either run out of fuel or be overtaken by its pursuer. Then, after describing some *tour de force* driving, he continues the pursuit on foot.

But, alas, his concentration flags. Even though the murderous stalkers are using walkie-talkies to help them close in on their prey, suspense unravels. This unravelling has been noted. Reviewing *Care* in *Newsweek*, Prescott, who was expecting a story hotter and grittier, complains, "Ambler's thrillers are now so refined that the obligatory violence, even the most rudimentary physical violence, has been reduced to a perfunctory flourish" (63). Following suit, Lewis finds *Care* "disappointing." In his view, it fails to "sustain... equilibrium between narrative excitement and serious political and social issues" (198). This complaint, that the story fails both to support and to move the book's plot, deserves our attention. Because Ambler focuses upon the motives underlying violence rather than violence itself, crime has become in his late fiction an activity largely cerebral. Finesse replaces brute force as a means of achieving one's goals. The concluding chase scene in *Care* makes this point. Unlike its counterpart in *Dark Frontier*, a book published 45 years earlier, it features

nuanced wit, cultured backchat, and the subtle examination of motives. While dodging bullets from the van pursuing them, Halliday and Zander mention figures like Robespierre, Kropotkin, and Toynbee to lend their rhetoric a sophisticated sheen.

This aplomb surpasses Hemingway's creed of grace under pressure. It strains credibility. It also shows, along with The Ruler's madness, how the shakers and movers of our global economy lack any power beyond their conversational skills. The sour, indeterminate ending of *Care* clarifies Ambler's belief that economic and political progress are illusions. All the toil and bloodshed that took place so that the reel containing Halliday's filmed interview with The Ruler could safely reach the West turns out to be wasted. Syncom doesn't want the interview shown on television. Now that The Ruler has entered a hospital for the mentally sick, he's off limits as a target. The interview with him is unusable. As in Greene, weakness has ironically proved a better defense than strength. To show the world the filmed interview would recoil on the showers, as Halliday understands: "By showing this film now, we'd be persecuting a sick man who couldn't defend himself. We'd be exposing a manic-depressive who's not responsible for his actions and utterances, and is, in fact, hospitalized, to public ridicule and hatred."

Nobody suffers the sting of dejection more keenly than Halliday. The best effort of his professional career, and the one that came closest to killing him, has gone to waste. His getting a postcard on the book's last page from Simone Zander recalls the one her father sent at the outset. Between them, the cards convey the futility of action. The Austrian *Gasthaus* or hotel depicted on Simone's card, where Halliday stayed before meeting The Ruler, is a place he'll always associate with danger and defeat. The $50,000 he collects for interviewing The Ruler is too trifling to Syncom to change any of their plans or policies. Perhaps his fee refers menacingly to the disarmed package bomb of Chapter 1. Rather than pleasing Halliday, it merely reminds him of his insignificance. He can perform brilliantly and risk his neck in the process. But to what end? The two postcards he reads at either end of the book tell him that, regardless of how well he performs, he can only wheel in diminishing circles.

Disturbingly, the opening sentence of this novel about the futility of positive endeavor implies an excitement that never takes shape: "The warning message arrived on Monday, the bomb itself on Wednesday." The bomb turns out to be what Hitchcock called a MacGuffin, a motif that sets the plot in motion and then drops from view. Also whipped from sight, unfortunately, is narrative tempo. Talk replaces action in *Care*, but talk that barely touches matters of weight. One high-level negotiator, expressing the aims of his approaching conference with The Ruler, refers to "talks about talks." As stylistically accomplished as the book is, it will creep and backtrack, consisting largely of conversations that exert little influence on what follows them. Lewis did well to cite the book's imbalance. The long rehearsal of the political and

ideological background of the Nechayev memoir in Chapter 2, with its references to Herzen, Bakunin, and Marcuse, reflects poor narrative economy. Ambler could have sent Halliday to Milan without having first allotted so many pages to his interview with the New York lawyer representing Pacioli publishers. A briefer description of the interview, in fact, would have been in order, since the memoir, like the package bomb before, it, soon materializes as another MacGuffin.

Too much in *Care* leads nowhere, like the elaborate fallbacks, contingency plans, and cover operations preceding the visit to The Ruler which never go into effect. The book probably squeezes in more red herrings than all the others in the canon combined. Perhaps Ambler is saying that the best plans, even those backed by state-of-the-art technology, will fail unless the human factor is in place. But he mishandles this important argument. The various negotiators, politicians, and media experts in the book use so many smokescreens to hide their true aims that they wrap everything in mist. They never break through to clarity, either. Protocol must be respected in any major international transaction. But the long discussions about The Ruler's problems with local authorities and ex-employees have little thematic bearing, the transaction that they apply to never taking place.

Nor does Halliday's interview with The Ruler matter, despite the elaborate diplomatic jockeying and maneuvering that helped it happen. Perhaps Ambler intended *Care* itself to be a red herring. It has pages of eventlessness punctuated by alarms that quickly subside. *Care* suffers from dead spots. For instance, Ambler will go back to the Middle Ages to supply background for the area surrounding The Ruler's silver mine. Having brought his survey to date, he then discusses techniques of mining, including drainage, ventilation, and hauling. Then he rehearses the arrangements made for the lights, cables, camera equipment and crew filming the interview. Such information lends authority. But it also imparts a distanced, pedagogical tone. Still worse, it both wrecks dramatic pacing and pushes the people into the wings.

The data that supplants the human drama must have mattered a great deal to Ambler in view of its nearly prohibitive artistic cost. At issue is his judgment. If *Care* includes too much that's extraneous, it also omits essentials. For the first time, Ambler will lead up to key disclosures and then pull away. This coy violation of narrative consistency occurs at least three times. The first appears at the end of Chapter 5:

"If some of our NATO allies choose secretly to conspire with the man known as Karlis Zander . . . how were we to stop them?"
"I see. Is that what Zander has to sell?"
So then he explained what the deal was. After that he told me what our initial reply to the Zander proposal was to be. . . .

Ambler also cuts short a telephone conversation in Chapter 10 between Halliday

and his agent by withholding information that would have integrated the conversation with the plot:

> "It's nothing to do with the memoirs.... The man calling will be a current affairs producer.... Here's what he'll say."
> It was two-thirty before I got back to bed.

In Chapter 14, a character hears something that Ambler chooses to keep from us:

> "I'd like a little help from you in the packaging area."
> "What kind of help?"
> He sighed a little when I told him, but he agreed.

Poor timing conspires with selection to rob *Care* of tension or a current of expectancy. As chilling as The Ruler's sadism is, it forfeits some of its grip because the depravity feeding it is a given. Before he shows his bearded face, Halliday has already condemned him on hearsay. The Ruler's self-damning words, for all their slamming recoil, are more justification than surprise.

A lesser complaint, but one that invites itself more often, stems from the book's style. Because Halliday is American, he speaks in an idiom intended to be more American than British. A police captain discussing Zander's bomb with him in Chapter 1 asks of its sender, "Did you notice...that this Zander says parcel when he means package? That's British usage." The Captain's insight (which bypassed the author of *Siege* 25 years before) rests upon Ambler's knowledge of differences between British and American speech. But it belies the gaps in his knowledge. Having lived in America between 1958 and 1969 (Lewis 15, 18), he might have reproduced the American voice better than he did. A New York lawyer says *lot* for *group* or *faction*. In Chapter 5, Halliday uses the colloquialism, *boobed*, in place of *goofed*. A *wheelchair* in the following chapter is called an *invalid chair*, as it is in Great Britain, and a *parking lot* at the end of Chapter 11 is referred to as a *car-park*.

The novel's flat, noncommittal title stirs one last regret. In a passage from the Nechayev memoir, written by Ambler himself, the wife of Alexander Herzen muttered of someone she found irksome, "Time...will take care of *him*.." Is the statement worth making? As Ambler says in the very next sentence, "Time, of course, will take care of all of us." By and large, we do get both the faces and the fates we deserve. We shape our own lives. As Tolstoy claimed, what happens to us is what was meant to happen, because we made it happen simply by being ourselves. The Ambler of *Care* shares some of Tolstoy's disdain for single causes. The thunderclap windfall or catastrophe merely speeds outcomes that would have occurred sooner or later, anyway. Perhaps Ambler's title echoes the faith in natural justice enacted in *Frigo*. But

how? Clearly, the social mobility, passion for personal advancement, and faith in the partnership of science, industry, and government to improve lives everywhere can bring us to grief. But if Ambler favors an ontology based on family, church, and neighborhood to replace the creed of secular progress, he hasn't said so.

A treat *Care* does supply is its sentimental amble through the canon. Much of the fun that compensates in part for the book's flaws inheres in revisiting old landmarks. Not only does *Care* restore the high-speed auto chases that crowned both *Frontier* and *Day*. Also recurring from *Day* is the use of a museum (a wing of The Ruler's cave) as a setting. The Pennsylvania setting and the historical recitation both return from *Schirmer*. But rather than inserting all of his restorations full cloth into the action, Ambler will fit them to the plot. Thus the motif of the writer-narrator being taken to the hiding place of a controversial figure recurs with a jagged edge in Halliday's abduction from his hotel room prior to his meeting with Zander. And, as Zander and Halliday both show, *Care* follows *Roses* by developing its plot with characters either middle aged or mature.

A last legacy is Ambler's Oedipus complex. *Care* carries forward the process by which it has become the Laius complex, an anxiety that betrays the father into killing the son who threatens him. Zander's daughter Simone calls the young Algerian hit man hired to kill her and her father, "Brother Raoul"; the son plans to kill the sister along with the father. But the father shoots the son instead. The simile concluding the remarkably casual description of Raoul Bourger's death shows Ambler's disapproval of the shooting: "I saw Bourger die. I didn't see him hit. What happened was that his body landed on the trail as if it had been tossed there by some monster who had no further use for it." Ambler's reference moments later to Zander's elegant mohair suit and silk handkerchief capture the man's vanity; Zander could be an actor preening himself just before taking the stage. But he'd be a tired actor. "He looked strangely old, I thought," notes Halliday of him. The ordeal of killing Raoul Bourger has depleted him. As it might; later, when he learns that a young colleague may survive the bullet wounds heretofore feared as fatal, he can only mumble the mechanical, "We may hope." Then he falls asleep.

But he deserves his rest. And so does Ambler. Perhaps like Paul Firmin of *Roses*, he has found truth-seeking dangerous and difficult. The title of his next book, the autobiographical ramble, *Here Lies*, playfully disavows truth-seeking. We commend the disavowal. Having shifted its focus, his lifelong struggle with male authority left him more weary than illuminated. It also outlasted his craftsmanship. But if *Care* is an artistic comedown, it still commands our attention. The snags in it caused by problems with selection didn't blunt his sense of responsibility. Besides showing the dangers of power, Eric Ambler's last novel also testifies to his attempt to know both himself and the violence-prone, technology-ridden world that he, as an engineer, helped form.

# Conclusion

Eric Ambler is a writer awaiting discovery and acclaim by the serious reader. His work fits no fictional category, despite depicting the changing political, industrial, and social trends of the 45-year time span in which it unfolds. Though it uses many of the conventions of popular adventure fiction, it has never attracted flocks of admirers. But the achievement it reflects has been steady, and it also shows artistic development. Never is Ambler less than interesting.

On the other hand, his books suffer from drawbacks. Though craftsmanly, smooth, and committed, in the main, they nonetheless seem underimagined. They're wanting, first of all, in emotional range. Because his women lack the dimension of his men, he says little about the limits and renewals of sexual love, parenting, or the stresses that surface when people spend extended time together; no domestic realist he. Also, his prose lacks the resonance and mystery found in important writers. Even though his books have a broad geographical sweep, they don't describe journeys undertaken to probe our primitive drives and origins. Ambler could risk more. If he's a man of deep passion, he has kept it to himself. His characters don't suffer in the depths of their hearts. Very little that is transcendent or numinous shimmers through his books, either.

One may argue in his defense that he writes in a mode that rates wit and polish over deep feelings and poignancy. Intrigue fiction doesn't speak to the soul, lacking the simplicity of opera and poetry. Yet this argument is flawed. Ambler lacks the desolation of John le Carré, a writer to whom he is often compared when someone is making a claim for his artistic stature. The abyss he ponders isn't very deep. For instance, the clash between patriotism and conscience that drives le Carré's Magnus Pym to suicide in *A Perfect Spy* (1986) reveals a boldness and fertility that leaves Ambler behind. Nor is life as passionately observed and considered in Ambler as in Graham Greene, another writer sometimes bracketed with him. The bracketing, though convenient, is misjudged. Writing in the *London Review of Books* in 1989, John Bayley praises Greene's power both to seize and hold our attention at Ambler's expense:

Eric Ambler, a craftsman much admired by Greene, would seem not to have needed to make any pact with the Grub Street Mephistopheles: he stays the same whatever he writes.... We respond not to Greene the man but to Greene the man-author, a compelling creation who...exercises far more fascination than an Ambler could do. (3)

Bayley is right. Greene looks and sounds as if he wants to merge with his writing, a sign of which is his uncanny grasp of foreign settings. The force of his settings flows through him. Faith in the oneness of himself and his writing led him to say of Henry Scobie of Freetown, Sierra Leone, in *The Heart of the Matter* (1948), that his policeman's job helps him love people as God does, knowing their worst. This immersion in place rarely occurs in Ambler. And when it does, it can find him echoing Greene's invocations of tropical seediness and spiritual ambiguity. Though more than a tourist carrying a camera, he won't defy danger as much as Greene does or dig as deeply into his heart. Ambler's journeys include maps.

These shortcomings label him a minor writer. His work misses the sense of something deeply felt. It doesn't threaten our security either by making judgments that resonate in our psyches or by showing traits we all share that are as frightening as death. Yet he can't be dismissed as lightweight and clever. In *Mask* and *Frigo*, published 35 years apart, he wrote books that transcended their subjects. What's more, he wrote them without trying to be something he was not. Most of his books touch us because he responds emotionally to the events recounted in them. These books also convey a sense that they had to be written. Ambler was trapped inside a boyhood drama that gave him a horrible fear of betrayal—being left curbside in a puff of exhaust as his father drove off in a snappy new roadster bought with Eric's tuition money.

Yes, Ambler's Oedipal complex lacks the religious undertones found in Kafka. But what of it? The overall quest for autonomy runs like a dark thread through the canon. The recurring clash with male authority is so traumatic and pervasive that it threatens both the personal stability and integrity of his heroes. It suggests other alarms, too. Dark secrets that may have tormented Ambler, based on a fear of masculine inadequacy, occur so often that they imply gender confusion. The archetypal hero in Ambler is both passive and fragile, a loner-outsider drawn into intrigue. Nor will others protect him. Repeated many times in the canon is the motif of the hero's hotel room being violated by unwelcome guests, burglars, abductors, or would-be assassins who are usually bigger and older than he. These violators can also belong to large, powerful organizations, which symbolize the family the hero lacks. More than once, they work in pairs. Ambler's hero is staying in hotels, to begin with, because he's a transient. His transience brings pain. In *Siege*, *Anger*, and the two Simpson books, his woman betrays him with another man. *Judgment* shows him losing her to death. Few of his ilk come to us settled in their jobs, homes, or lives. Uprooted and alienated, they can be tourists (*Passage*), professionals on assignment (*Schirmer*, *Care*), or functionaries en route home after finishing a job (*Journey*, *Siege*). (The hero of *Levanter* finds himself forced to help the terrorist who has commandeered part of his factory.) Their hotel rooms, as home surrogates, confer a security the violation of which sharpens their rootlessness and Oedipal fears. This is where

the father figure attacks. Not content to drive them from the family, he invades and despoils the temporary homes they improvise for themselves. The two postcard views of hotels framing the action of *Care,* significantly Ambler's last novel, underscores the archetypal figure's anxiety.

Along with Ambler's limitations goes some durable force. His ability to touch our psyches has helped him perform well over a long career. He's good enough to conjure up a more deeply imagined fictional world just beyond his reach. But despite leaving important things unsaid, he knows the throat-catching sensation of feeling menaced. His work is moving, and much of it is true, though not the whole truth. To say that he writes unusually well in a genre rarely termed literature is to disparage him. The combined effect of the honors he has earned bespeaks his importance. He won Britain's Crime Writers Association Award in 1959, 1962, 1967, and 1972; the Mystery Writers of America gave him an Edgar in 1964 and a Grand Master Award in 1975; a Swedish Grand Master Award was bestowed the same year; finally, he won an O.B.E. in 1981 (Reilly 18). His fellow writers have added accolades of their own. Tony Hillerman said, "He never wrote the same book, or anything like the same book, twice" (130), and Dorothy Salisbury Davis calls him "simply a master" (77). These tributes have merit. Eric Ambler has the storyteller's instinct. He has also cultivated the skills to bring his psychodrama to life. His engineer's respect for the details of narration creates realistic dialogue and nuanced, flavorsome description. Above all it tempers the emotional candor infusing his plots. Though he writes from his intimate self, he maintains artistic balance. Self-revelation in his work won't curdle into self-indulgence. Thus his social and political insights command our attention. And so does the smell of fear emitted by his plots. Foremost among his gifts is the way he gives danger a force and an urgency by ratifying the dread of those gripped by it.

Necessity quieted this dread. Novel-writing failed to provide the therapy Ambler needed. In having sex with Jasmine, at her behest, moreover, Robert Halliday of *Care* acts out the unspoken longings of Barstow/Carruthers of *Frontier* and Simpson of *Day.* He beds the foreign beauty who confirms her power by driving a car during the high-speed car chase that forms the book's dramatic climax. Yet the lovemaking means little to him. His companion in the speeding car, Jasmine's father, a man about his own age, will soon commit, in symbolic form, the ultimate betrayal of killing his son. More than four decades of probing his psyche hadn't brought Ambler peace. That he made the symbolic son and daughter of *Care* non-Caucasians doesn't mask his pain. Whatever small gift he had as a constructionist having already left him, he felt too tired and disillusioned to keep probing. He was gripped by a darkness welling up from within that claimed him for its own. A victim he would always feel. He needed a rest. Providing the logical outlet for the residue of his writing ambitions was *Here Lies.* Whatever comfort this autobiographical pastiche of evasions, half-truths, and veiled self-disclosures gave him, he deserved.

# Notes

### Chapter 1

[1] Ambler admitted being influenced by W. Somerset Maugham's *Ashenden*; Introduction, *To Catch a Spy: An Anthology of Favorite Spy Stories* (New York: Atheneum, 1965) 20.

### Chapter 3

[1] The Eric Ambler Archive, Special Collections Department, Mugar Memorial Library, Boston University, Box 37, Folder 5.

[2] Eric Ambler, "Footnote," *Epitaph for a Spy* (New York: Knopf, 1952) n.p. [263]

[3] *Ibid.*

[4] Howard Haycraft, "Introduction," *Five Spy Novels* (Garden City, NY: Doubleday, c. 1962) viii.

### Chapter 4

[1] Eric Ambler, "Introduction," Sir Arthur Conan Doyle, *The Adventures of Sherlock Holmes* (London: John Murray and Jonathan Cape, 1974) 10.

### Chapter 5

[1] Mentioned twice in the novel, as was the Petkov trial in *Judgment*, the Garrett Case, involving an estate of over $17 million, ran for 22 years. Nearly 26,000 claims were made on the estate, many by Germans with names like Schwarz, Schuessler, and Kretschmer. In the course of some 2,000 hearings, the court examined over 1,100 witnesses. The record of the case totals 390 volumes and covers more than 115,000 pages. See "Garrett Estate," *Pennsylvania State Reports, Containing Cases Decided by the Supreme Court of Pennsylvania*, reported by Laurence H. Eldredge (Sayre, PA: Murrelle Printing, 1953) 438-50. See also the 1939 report (287-300) and the 1952 report (284-90).

### Chapter 6

[1] The Ambler Archive (see Chapter 3, note 1), Box 22.

### Chapter 7

[1] See Feliz Cagman, "The Topkapi Collection," photographed by Ergun Cagatay, *Aramco World Magazine* (March-April, 1987) 6-37; also John Russell, "Summer Reading: Art," *New York Times Book Review* 31 May 1987: 11.

[2] The Ambler Archive (see Chapter 3, note 1), Box 37, Folder 10.

*Chapter 8*

[1] The Ambler Archive (see Chapter 3, note 1), Box 44, Folder 1.

# Works Cited

Note: Only the first English and American editions are listed, except where later editions appeared under changed titles.

*Novels*

Ambler, Eric. *The Dark Frontier*. London: Hodder and Stoughton, 1936.

_____.*Uncommon Danger*. London: Hodder and Stoughton, 1937. Rpt. as *Background to Danger*. New York: Knopf, 1937 .

_____.*Epitaph for a Spy*. London: Hodder and Stoughton, 1938. Rev. version. New York: Knopf, 1952.

_____.*Cause for Alarm*. London: Hodder and Stoughton, 1938. New York: Knopf, 1939.

_____.*The Mask of Dimitrios*. London: Hodder and Stoughton, 1939. Rpt. as *A Coffin for Dimitrios*. New York: Knopf, 1939.

_____.*Journey into Fear*. London: Hodder and Stoughton, 1940. New York: Knopf, 1940.

_____.*Judgment on Deltchev*. London: Hodder and Stoughton, 1951. New York: Knopf, 1951.

_____.*The Schirmer Inheritance*. London: Heinemann, 1953. New York: Knopf, 1953.

_____.*The Night-Comers*. London: Heinemann, 1956. Rpt. as *State of Siege*. New York: Knopf, 1956.

_____.*Passage of Arms*. London: Heinemann, 1959. New York: Knopf, 1960.

_____.*The Light of Day*. London: Heinemann, 1962. New York: Knopf, 1963. Rpt. as *Topkapi*, New York: Bantam, 1964.

_____.*A Kind of Anger*. London: Bodley Head, 1964. New York: Atheneum, 1964.

_____.*Dirty Story: A Further Account of the Life and Adventures of Arthur Abdel Simpson*. London: Bodley Hill, 1967. New York: Atheneum, 1967.

_____.*The Intercom Conspiracy*. New York: Atheneum, 1969. London: Weidenfeld and Nicolson, 1970. Rpt. as *A Quiet Conspiracy*. Glasgow: Fontana/Collins, 1989.

_____.*The Levanter*. London: Weidenfeld and Nicolson, 1972. New York: Atheneum, 1972.

_____.*Doctor Frigo*. London: Weidenfeld and Nicolson, 1974. New York: Atheneum, 1974.

_____.*Send No More Roses*. London: Weidenfeld and Nicolson, 1977. Rpt. as *The Siege of the Villa Lipp*. New York: Random House, 1977.

_____.*The Care of Time*. London: Weidenfeld and Nicolson, 1981. New York: Farrar, Straus, and Giroux, 1981.

*Other Books*

Ambler, Eric. *The Ability to Kill and Other Pieces*. London: Bodley Head, 1963. Rpt. as *The Ability to Kill: True Tales of Bloody Murder*. New York and London: Mysterious P, 1987.

_____.*To Catch a Spy: An Anthology of Favorite Spy Stories*. Ed. Eric Ambler. London: Bodley Head, 1964. New York: Atheneum, 1965.

_____.*Here Lies: An Autobiography*. London: Weidenfeld and Nicolson, 1985. New York: Farrar, Straus, and Giroux, 1986.

*Short Stories*

Ambler, Eric. "The Army of the Shadows." *The Queen's Book of the Red Cross*. London: Hodder and Stoughton, 1939. Rpt. as *World's Greatest Spy Stories*. Ed. Vincent Starrett. Cleveland: World, 1944, 46-61.

_____."Belgrade 1926." In *To Catch a Spy* , 156-80.

_____."The Blood Bargain." *Winter's Crimes* 2. Ed. George Hardinge. London: Macmillan, 1970, 9-26. *Ellery Queen's Windows of Mystery*. Ed. Ellery Queen. New York: Dial, 1980. See also *The Best of Winter's Crimes*. Ed. George Hardinge. London: Macmillan, 1986; and *The Mammoth Book of Modern Crime Stories*. Ed. George Hardinge. London: Robinson, 1987.

*Six tales comprising The Intrusions of Dr. Czissar:*

"The Case of the Pinchbeck Locket." *The [London] Sketch* 3 July 1940, 24-6. *Ellery Queen's Mystery Magazine* 6.25 (Nov. 1945): 97-101 *Best Mystery Stories*. Ed. Maurice Richardson. London: Faber, 1948: 157-68.

_____."The Case of the Emerald Sky." *The Sketch, 191.* 10 July 1940. *EQMM* 6.21 (March 1945): 38-45. *To the Queen's Taste*. Ed. Ellery Queen. Boston: Little, Brown, 1946: 281-90. See also *The Arbor House Treasury of Mystery and Suspense*. Eds. Bill Pronzini, Barry H. Malzberg, and Martin H. Greenberg. New York: Arbor House, 1981.

_____."The Case of the Cycling Chauffeur." *The Sketch* 17 July 1940: 88, 90. Rpt. as "A Bird in the Tree." *EQMM* 9.42 (May 1947): 42-7.

_____."The Case of the Overheated Service Flat." *The Sketch* 24 July 1940: 120, 122. Rpt. as "Case of the Overheated Flat." *EQMM* 11.53 (April 1948): 35-9.

_____."The Case of the Drunken Socrates." *The Sketch* 31 July 1940: 150, 152. Rpt. as "Case of the Landlady's Brother." *EQMM* 13.63 (Feb. 1949): 121-5. *Best Mystery Stories*. Ed. Maurice Richardson. London: Faber, 1948: 169-78.

_____."The Case of the Gentleman Poet." *The Sketch* 7 August 1940: 186, 188. Rpt. as "Case of the Gentleman Poet." *EQMM* 10.46 Sept. 1947: 76-83.

*Novels*

The "Reed, Eliot." *Skytip*. Garden City: Doubleday, 1950. London: Hodder and Stoughton, 1951.

_____.*Tender to Danger*. Garden City: Doubleday, 1951. Rpt. as *Tender to Moonlight*.

London: Hodder and Stoughton, 1952.

_____.*The Maras Affair*. Garden City: Doubleday, 1952. London: Collins, 1953.

_____.*Charter to Danger*. London: Collins, 1954.

_____.*Passport to Panic*. London: Collins, 1958.

*Uncollected Essays*

"The Novelist and Films." *Crime in Good Company: Essays on Criminals and Crime-Writing*. Ed. Michael Gilbert. Boston: The Writer, 1959: 192-209.

"Introduction." *The Adventures of Sherlock Holmes*. By Sir Arthur Conan Doyle. London: John Murray and Jonathan Cape, 1974: 7-11.

"A Better Sort of Rubbish: An Inquiry into the State of the Thriller." *The Times Saturday Review* 30 November 1974: 8.

"The End of the Affair." *New Statesman* 13 January 1978: 56.

"Voyages—and Shipwrecks." *Whodunit? A Guide to Crime, Suspense, and Spy Fiction*. Ed. H. R. F. Keating. London: Windward, 1982; New York: Van Nostrand Reinhold, 1982: 104-7.

*Archival Material*

The Eric Ambler Archive. Special Collections Department. Mugar Memorial Library, Boston University (02215).

*Criticism and Commentary*

Adams, Phoebe. "This Trade of Gunrunning." *Atlantic* April 1960: 114.

Ambrosetti, Ronald. "The World of Eric Ambler: From Detective to Spy." *Dimensions of Detective Fiction*. Eds. Larry N. Landrum, Pat Browne, and Ray B. Browne. Bowling Green: Bowling Green State University Popular Press, 1976: 102-09.

Amory, Mark. "The Ambler Way." *Sunday Times Magazine* 5 Jan. 1975: 30-2.

Anderson, Isaac. "A Spy Story." *New York Times Book Review* 29 Jan. 1939: 7.

Barzun, Jacques and Wendell Hertig Taylor. *A Catalogue of Crime*. New York: Harper and Row, 1971.

Bayley, John. "Madly Excited." *London Review of Books* 1 June 1989: 3, 5.

Blumenberg, Hans C. "Ein britischer Romancier." *Haffmans*: 70-5.

Boucher, Anthony. "Trouble in Sunda." *New York Times Book Review* 23 Sept. 1956, 31.

_____."The Witness in the Bikini." *New York Times Book Review* 18 Oct. 1964: 4, 39.

Buckley, Priscilla L. "Of Banana Republics and Habsburgs." *National Review* 20 Dec. 1974: 1475.

Cagman, Filiz. "The Topkapi Collection." Phot. by Ergun Cagatay. *Aramco World Magazine* March-April 1987: 6-37.

Cain, James M. "Color of the East." *New York Times Book Review* 6 March 1960: 38.

Cawelti, John G. and Bruce A. Rosenberg. *The Spy Story*. Chicago: U of Chicago P, 1987: 101-14.

Confidential Agents." *TLS* 20 July 1956: 434.

Davis, Dorothy Salisbury. "Some of the Truth." *Colloquium on Crime: Eleven*

*Renowned Mystery Writers Discuss Their Work.* Ed. Robin Winks. New York: Scribners, 1986: 63-78.

Davis, Paxton. "The World We Live In: The Novels of Eric Ambler." *Hollins Critic* 8 (Feb. 1971): 1-11.

Day Lewis, C. "With a Flair for Creating Alarm." *New York Times Book Review* 26 July 1953: 5.

Demarest, Michael. "Forever Ambler." *Time* 14 Sept. 1981: 98.

Du Bois, William. "Journey into Terror." *New York Times Book Review* 18 March 1951: 5.

Elliott, Charles. "Ambling On." *Time* 26 June 1972: 92-3.

Fenton, James. "The Ambler Memorandum." *Vogue* (UK) July 1977: 100-02.

Fuller, Roy. "Warts and All." *TLS* 22 Nov. 1974: 1307.

Gilbert, Michael. "The Professionals and the Predatory Pikes." *TLS* 5 June 1981: 626.

Gray, Paul. "Capital Gains." *Time* 6 June 1977: 97.

Ginna, Robert Emmett. "Bio: Outside His Window, Within His Heart, Eric Ambler Finds the Stuff of Great Spy Novels." *People* 6 June 1977: 92-5, 100.

Greene, Graham. "The Sense of Apprehension." *The Month* July 1951: 49-51.

Grella, George. "Who's for Treachery." *New York Times Book Review* 8 Oct. 1967: 58-9.

Haffmans, Gerd, with Franz Cavigelli. *Über Eric Ambler.* Zurich: Diogenes, 1979.

Haycraft, Howard. Introduction. *Five Spy Novels, Selected and Introduced by Howard Haycraft.* Garden City: Doubleday, c. 1962.

Heald, Tim. "Chilled Vintage Old Ambler." *The Times* 13 June 1985: 9.

Hillerman, Tony. "Mystery, Country Boys, and the Big Reservation." *Colloquium on Crime: Eleven Renowned Mystery Writers Discuss Their Work.* Ed. Robin Winks. New York: Scribners, 1986: 127-47.

Hitchcock, Alfred. Introduction. *Intrigue: The Great Spy Novels of Eric Ambler.* New York: Knopf, 1943: vii-xi.

Hogan, William. "Eric Ambler Covers a Coup in the Indies." *San Francisco Chronicle* 1 Oct. 1956: 25.

Hopkins, Joel. "An Interview with Eric Ambler." *Journal of Popular Culture* 9 (Fall 1975): 285-93.

Hubin, Allen J. "The Intercom Conspiracy." *New York Times Book Review* 21 Sept. 1969: 44.

_____.*Crime Fiction 1749-1980: A Comprehensive Bibliography.* New York and London: Garland: 1984: 63-9.

James, Clive. "Prisoners of Clarity-2: Eric Ambler." *The New Review* Sept. 1974: 63-9.

Jeffares, A. Norman. "Eric Ambler." Reilly: 19-20.

Kauffmann, Stanley. "Simple Simenon." *New Republic* 9 Dec. 1967: 24, 38.

Krim, Seymour. "Suspense." *Commonweal* 7 Aug. 1953: 450-1.

Krutch, Joseph Wood. "Mr. Ambler's Spies." *New York Times Book Review* 16 March 1952: 4.

Lambert, Gavin. *The Dangerous Edge.* New York: Grossman, 1976: 104-31.

Levant, Oscar. *The Unimportance of Being Oscar.* New York: Putnam's, 1968.

Lewis, Peter. *Eric Ambler*. New York: Continuum, 1990.

Mitgang, Herbert. "Interview: The Thrilling Eric Ambler." *New York Times Book Review* 13 Sept. 1981: 3, 22, 24.

"Mystery and Crime." *The New Yorker* 2 March 1963: 152.

*New York Herald Tribune Book* Review 15 April 1951: 15.

Offord, Lenore Glen. "Melodrama in Sumatra in the Ambler Manner." *This Week, The San Francisco Chronicle* 27 March 1960: 25.

Oram, Malcolm. "Eric Ambler." *Publishers Weekly* 9 Sept. 1974: 6, 7.

Panek, Le Roy L. *The Special Branch: The British Spy Story, 1890-1980*. Bowling Green: Bowling Green State University Popular Press, 1981: 138-54.

Prescott, Peter S. "I Spy." *Newsweek* 14 Oct. 1974: 125-26.

_____."Ambling Along." *Newsweek* 31 Aug. 1981: 63-64.

Reilly, John M., ed. *Twentieth-Century Crime and Mystery Writers. 2d ed*. New York: St. Martins, 1985.

"Return to the Balkans." *Time* 19 March 1951: 118.

Russell, John. "Summer Reading: Art." *New York Times Book Review* 31 May 1987: 11.

Scott, J. D. "New Novels." *New Statesman and Nation* 25 Aug. 1951: 211.

Steinbrunner, Chris, and Otto Penzler, eds. *Encyclopedia of Mystery and Detection*. New York: McGraw-Hill, 1976: 7-9.

Symons, Julian. *Mortal Consequences: A History—From the Detective Story to the Crime Novel*. New York: Harper and Row, 1972.

_____."Subtleties of Power." *New York Times Book Review* 13 Sept. 1981: 3, 24, 26.

Taylor, David. "Passing Through: Eric Ambler Talks to David Taylor." *Punch* 6 Sept. 1972: 310.

Wegmann, Karl Heinz. "Filmographic Eric Ambler." *Filmkritik* 26.12 (Dec. 1982): 595-99.

Young, Stanley. "Intrigue, 1937 Style." *New York Times Book Review* 8 Aug. 1937: 37.

# Index

Adams, Phoebe 112
Albee, Edward, *The Zoo Story* 194
Allen, Woody 8
Ambler, Eric
   literary influences 3, 4, 15-16, 90
   style 9-15, 90, 101-02, 163, 168-69, 196-97, 204
   view of science and technology 20-23
   Marxism 4, 27, 28, 40, 62, 84, 85
   archetypal hero 5-8, 20, 27, 114-16, 120, 150, 159, 198, 202, 217
   the sea 22
   women 24, 25, 157
   homosexuality 30, 65-66, 81
   figure of the father 25-27, 39, 42, 57-59, 77-80, 89, 92-93, 98, 102, 114-16, 152-53, 156, 160, 176, 181, 187, 190, 195, 206, 215, 218
Works By
   *The Ability to Kill* 13, 14, 20, 21
   "Army of the Shadows" 7, 91
   *Background to Danger* 1-3, 6-9, 13, 18, 19, 21, 24, 27, 28, 31, *40-47*, 50, 55, 57, 58, 60, 64, 66, 79, 84, 91, 96, 107, 132, 138, 140, 143, 201
   "A Better Sort of Rubbish" 18
   "The Blood Bargain" 99
   *The Care of Time* 15, 21, 26, 28, 29, 30, 124, 177, *207-15*, 217, 218
   "The Case of the Emerald Sky" 10
   *Cause for Alarm* 1, 3, 7, 9, 13, 20-22, 27, 31, 46, 54, *55-63*, 64, 91, 96, 103, 118, 128, 132, 139, 143, 162, 193
   *A Coffin for Dimitrios* 73; see also *The Mask of Dimitrios*
   *The Dark Frontier* 1-3, 8-12, 16, 19, 24, 21, 27, 28, 30, 31, *32-39*, 40-42, 46, 47, 57, 60, 84, 99, 102, 103, 118, 127, 132, 136, 138, 140, 157, 159, 162, 169, 201, 211, 215, 218
   *Dirty Story* 8, 11, 13, 17, 18, 24, 26, 28, 39, 115, 151, *164-69*, 193, 217
   *Dr. Frigo* 2, 8-10, 20, 23, 26, 28, 29,

81, 99, 124, 150, 176, *185-97*, 206, 209, 214, 217
*Epitaph for a Spy* 3, 4, 6, 13, 16, 18, 24, 26, 28, 31, *47-53*, 64, 66, 79, 80, 84, 96, 118, 151, 159, 162, 178, 193
*Here Lies* 11, 21-23, 25, 27, 30, 34, 35, 39, 40, 47, 85, 91-93, 115, 117, 119, 156, 162, 176, 187-88, 215, 218
*Hotel Reserve* 84
*The Intercom Conspiracy* 7, 21 24, 25, 27, 28, 112, 118, 138-39, 151, *169-75*, 177, 179, 180, 202
"The Intrusions of Dr. Czissar" 3
*Journey into Fear* 2, 7, 8, 14, 18, 20-22, 24, 28, 54, 57, 64, *74-82* 83, 86, 89, 96, 103, 106, 118, 125-27, 131, 141, 157, 181, 217
*Judgment on Deltchev* 6-8, 12, 15, 21, 24, 25, 27, 30, 83, *84-91*, 99, 100, 113, 115, 124, 132, 134, 138, 141, 143, 150, 152, 157, 169, 185, 187, 193, 206, 217
*A Kind of Anger* 6, 20, 21, 23, 25, 112, 121, 138, 140, 150, *158-64*, 166, 173, 207, 217
*The Levanter* 2, 3, 5, 8, 10, 12, 15, 20, 22, 24, 25, 28, 30, 139, 150, *177-85*, 193, 199, 202, 217
*The Light of Day* 6, 8, 17, 21, 24, 26, 39, 114, 150, *151-58*, 159, 160, 164-66, 168, 169, 177, 181, 198, 215, 217, 218
*The Mask of Dimitrios* 1, 5, 7, 14, 16, 19, 22, 24, 27, 28, 54, *63-74*, 75, 77, 81, 84, 86, 106, 115, 119, 124, 138, 156-57, 160, 170, 176, 181, 196, 203, 217
*The Night-Comers* 104; see also *State of Siege*
*Passage of Arms* 3, 5-7, 9, 10, 20, 25, 83, 103, *106-16*, 139, 150, 152, 156-57, 172, 202, 217
*The Schirmer Inheritance* 1, 11, 28, 83, *91-99*, 103, 105, 108, 111, 113, 118, 131, 133, 170, 207, 215, 217
*Send No More Roses* 1-3, 10, 22-24,

30, 112, 138, 140, 172, 176, 177, *197-207*, 208, 215
  *The Siege of the Villa Lipp* 205-06; see also *Send No More Roses*
  *State of Siege* 1, 3, 9, 10, 13, 14, 20-21, 24-26, 28, 83, *99-106*, 110, 113, 116, 125, 136, 143, 145, 152, 157, 159, 214, 217
  *To Catch a Spy* 72
  *Topkapi* 158
  *Uncommon Danger* See *Background to Danger*
Ambler, Reg (Alfred Percy Ambler) 23, 89, 93, 102, 115, 116, 156, 187-88
Ambrose, Amy 23
Ambrosetti, Ronald 42, 172
Andropov, Yuri 136
Arafat, Yasir 180
Auden, W.H. 39, 150
Bach, J.S. 203
Baden-Powell, Sir Robert 176, 205
Bakunin, Mikhail 213
Barzun, Jacques and Wendell Hertig Taylor
  *A Catalogue of Crime* 118
Bayley, John 216-17
Bellow, Saul 50
Bennett, Arnold
  *Clayhanger* 102
Bergman, Ingmar
  *The Seventh Seal* 52
Berlin-Moscow Nonaggression Pact of 1939 4, 27, 57, 62, 176
Blumenberg, Hans C. 74, 178
Borodin, Alexander 135
Boucher, Anthony 10, 11, 158-59
Bowen, Elizabeth
  *The Death of the Hearth* 5
Brecht, Bertolt 136
Brezhnev, Leonid 136
Brooks, C.H. 132
Brooks, Mel 8
Buchan, John 2, 32, 39, 102, 207
Buckley, Priscilla 12, 196
Cain, James M. 5, 10, 11
*The Caine Mutiny Court Martial* (Herman Wouk) 85
Cawelti, John and Bruce Rosenberg 4, 10, 11, 81, 85, 172, 195
  *The Spy Story* 17
Céline, Louis-Ferdinand 196

Cervantes, Miguel 138
  *Don Quixote* 34, 139
Chandler, Raymond 41, 141, 160
  *The Big Sleep* 123
  "Nevada Gas" 38
Chaplin, Charlie 8
  *The Great Dictator* 56
Chekhov, Anton 121
Chernenko, Konstantin 136
Chesterton, G.K. 3
Cheyney, Peter 19
Childers, Erskine
  *The Riddle of the Sands* 33
Christie, Agatha
  *The Mousetrap* 50
  *The Mysterious Affair at Sytles* 186
  *Ten Little Indians* 50
  *Witness for the Prosecution* 85
Clancy, Tom 12
Claudius (Emperor) 194
Codreanu, Corneliu Zelia 44
Collins, Wilkie
  "A Terribly Strange Bed" 19
Conrad, Joseph 14, 67, 101
*Cosi fan tutti* (Mozart) 148
Cousteau, Jacques-Yves
  *The Cruel Sea* 22
Coward, Noël 37
Crombie, Louise 57, 77
Darwin, Charles 97
Davis, Dorothy Salisbury 218
Davis, Paxton 99, 162, 172
Day Lewis, C. (Nicholas Blake) 4, 11, 33
Deighton, Len 18, 207
  *Funeral in Berlin* 200
  *The Ipcress File* 81
de Rougemont, Denis
  *Love in the Western World* 65
Desjardins, Éduoard
  *Les lauriers sont coupés* 138
Demarest, Michael 209
Dickens, Charles 139
*Don Pasquale* (Donizetti) 148
Doyle, Sir A.C. 61
  *The Adventures of Sherlock Holmes* 4
  "The Final Problem" 5, 186
  "The Musgrave Ritual" 4
  "A Scandal in Bohemia" 3
Durrell, Lawrence 1
Eliot, T.S. 197
  "The Love Song of J. Alfred Prufrock"

185, 189
Elliott, Charles 12
Ellison, Ralph 105, 186
Euripedes 190
Fenton, James 89
Fielding, Henry 8
Fitzgerald, F. Scott 186
Flaubert, Gustave 163
  *Madame Bovary* 29, 197
Ford, Ford Madox 197
Forster, E.M.
  *A Passage to India* 102
Fowles, John 184
  *The Magus* 43
Franz Ferdinand (Emperor) 191
Freud, Sigmund 92, 184, 191
Fuller, Roy 9
Garrett, Henrietta 92
Gilbert, Michael 208
Ginna, Robert Emmett 9, 166
Gray, Paul 197
Green, Henry
  *Party Going* 126
Greene, Graham 1, 12, 15, 32, 35, 54, 90,
  91, 105, 113, 135, 150, 189, 197, 212,
  216
  *Brighton Rock* 45, 69
  *The Confidential Agent* 56
  *England Made Me* 201
  *A Gun for Sale* 56
  *The Heart of the Matter* 123, 217
  *The Honorary Consul* 56
  *The Ministry of Fear* 48, 79
  *Our Man in Havana* 52
  *The Quiet American* 5, 82, 113, 173,
  190, 207, 212
  *Stamboul Train* 201
  *The Third Man* 70
Greenstreet, Sydney 66
Grella, George 166
Grimm Brothers 113
Haffmans, Gerd and Franz Cavigelli
  *Über Eric Ambler* 143
Haigh, J.C. 20
Hammett, Dashiell
  *The Glass Key* 4, 19
  *The Maltese Falcon* 66, 68, 107, 119,
  160
  *The Thin Man* 57
Haycraft, Howard 52
Heald, Tim 15

Hemingway, Ernest 212
Herzen, Alexander 213, 214
Hillerman, Tony 219
Hitchcock, Alfred 5, 31, 128, 212
  *Foreign Correspondent* 128
  *The Lady Vanishes* 38
  *Lifeboat* 79
  *North by Northwest* 48
  *The Thirty-nine Steps* 127, 161
Hitler, Adolf 52, 120, 130, 134, 210
Hogan, William 106
Hopkins, Joel 5, 10, 21, 54
Horler, Sidney 18
Hubin, Allen J. 54, 117, 171-72
Hugo, Victor
  *The Hunchback of Notre Dame* 205
Huston, John 83
Huxley, Aldous
  *Point Counter Point* 119
*Il Trovatore* (Verdi) 148
Inge, William
  *Bus Stop* 126
*Inherit the Wind* (Lawrence and Lee) 85
Isherwood, Christopher 197
  *The Last of Mr. Norris* 8
James, Clive 37, 62, 84, 150, 151, 156,
  157-58, 185
James, Henry 17, 63, 88, 110, 145, 163,
  204, 207
  *The Aspern Papers* 64
  *Washington Square* 110
  *The Wings of the Dove* 110-11
Jeal, Tim
  *The Boy-Man* 176
Jeffares, A. Norman 161
Jonson, Ben
  *Volpone* 155
Joyce, James 14, 64, 138, 164, 187, 197
  *A Portrait* 195
Jung, C.G. 1
Kafka, Franz 14, 120, 217
  "The Penal Colony" 25-26
Kauffmann, Stanley 168
Kennedy, John 187
King, Martin Luther 187
Kipling, Rudyard 19, 113
  "The Ballad of East and West" 94
Krim, Seymour 99
Krutch, Joseph Wood 63
Lambert, Gavin 70, 165
  *The Dangerous Edge* 29, 68

Lawrence, D.H. 97, 122
le Carré, John 6, 18, 35, 161, 207
    *A Perfect Spy* 216
    *Smiley's People* 98
    *Tinker, Tailor, Soldier, Spy* 81
Lenin, V.I. 89, 138
Le Queux, William 18, 39
Levant, Oscar
    *The Unimportance of Being Oscar* 25, 78
Lewis, Peter 32, 100, 105, 112, 151, 178,
    181, 185, 196, 211, 212, 214
Lockridge, Richard and Frances 57
Lowry, Malcolm 150
Ludlum, Robert 12
Lumumba, Patrice 187
Macdonald, Ross 28, 141, 160-61
    *The Underground Man* 193
Mailer, Norman 50
Mann, Thomas
    *The Magic Mountain* 138
Marcuse, Herbert 213
Maria Theresa (Empress) 191
Marx, Karl 167
Maugham, W. Somerset
    *Ashenden* 2, 14
Maximilian (Emperor) 191
Middleton, Thomas
    *A Game of Chess* 52
    *Women Beware Women* 52
Mishima, Yukio 50
Mitgang, Herbert 210
Mosley, Oswald 125
Moussorgsky, Modest 135
Mussolini, Benito 51, 55, 60
Naipaul, V.S. 1
Napoleon 91
Napoleon III 98
Nechayev, Sergei 207, 208, 213
Nietzsche, Friedrich 93, 164
*A Night to Remember* (Richard Wallace)
    22
*Night Train* (Carol Reed) 201
Nixon, Richard M. 193
Offord, Lenore Glen 112
Oram, Malcolm 39
Orwell, George 150
    *1984* 40
Panek, Le Roy L. 1, 4, 48, 51, 68, 202
Peckinpah, Sam
    *Straw Dogs* 119
*Perry Mason* (Erle Stanley Gardner) 85

Petkov, Nikola Dimitrov 85, 87
Picasso, Pablo 64
Pinter, Harold
    *The Birthday Party* 119
    *The Dumbwaiter* 159
Plato
    *The Crito* 88
Poe, Edgar Allan
    "The Gold-Bug" 107
    "The Purloined Letter" 122
Pollinger, Laurence 118
Prescott, Peter 177, 209, 211
Reed, Eliot 93, 116-49, 173
    *Charter to Danger* 6, 117, *138-43*, 144
    *The Maras Affair* 26, 27, 99, 117, 118,
        *132-38*, 139, 143, 152, 185, 187
    *Passport to Panic* 117, *143-49*
    *Skytip* 8, 24, 117, *118-25*, 126-27, 130,
        133-34, 138-39, 140, 148, 149
    *Tender to Danger* 8, 22, 28, 93, *125-32*,
        133-34, 138, 141-42, 144, 148
    *Tender to Moonlight* 128-29; see also
        *Tender to Danger*
Reinhardt, Max 168
Rimsky-Korsakov, Nikolai 134
Robbe-Grillet, Alain 112
Rodda, (Percival) Charles 8, 24, 93, 116-
    118, 125, 127, 132, 138, 139, 141, 143;
    see also Eliot Reed
Sapper (Bulldog Drummond) 3, 66
Satre, Jean-Paul 190
Scott, J.D. 88
Shakespeare, William 69, 189, 197
Snow, C.P. 210
Shelley, P.B. 78
Sollers, Philippe 112
Sophocles 197
    *Oedipus Rex* 29, 160, 197
Sprigg, Christopher St. John 4
Stalin, Josef 85
Stambulisky, Alexander 68-69, 71
Stein, Gertrude 64
Steinbeck, John
    *The Grapes of Wrath* 8
    *The Pearl* 107
Steinbrunner, Chris and Otto Penzler
    *Encyclopedia of Mystery and Detection*
    143
St. Francis 73
Stravinsky, Igor 64
Sullivan, Ed 132

*Swan Lake* (Tchaikowsky) 132, 135, 137
Symons, Julian 63, 176, 196
Taylor, David 5
Tchaikowsky, P.I. 135
Theroux, Paul 1
Tolstoy, Leo 36, 214
*Trotsky, Lean 45*
*Twelve Angry Men* (Paddy Chayefsky) 85
von Clausewitz, Karl 33
West, Nathanael
  *Miss Lonelyhearts* 8
West, Rebecca

*The Court and the Castle* 192
*The New Meaning of Treason* 192
White, Patrick 97, 150
Whitman, Walt 78, 100
Williams, Tennessee 96
Winchell, Walter 132
*Witness for the Prosecution* (Agatha Christie) 85
Wordsworth, William 187
*The Wreck of the Mary Deare* (Michael Anderson) 22
Young, Stanley, 40